THE
STRUCTURE
OF ARTISTIC
REVOLUTIONS

THE STRUCTURE
OF ARTISTIC
REVOLUTIONS

REMI
CLIGNET

UNIVERSITY
OF PENNSYLVANIA PRESS

PHILADELPHIA

Copyright © 1985 by the University of Pennsylvania Press
All rights reserved

Library of Congress Cataloging in Publication Data

Clignet, Remi.
 The structure of artistic revolutions.

 Bibliography: p.
 Includes index.
 1. Arts and society. 2. Arts—Psychological aspects. I. Title.
NX180.S6C55 1985 700'.1 '03 84-25625
ISBN 0-8122-7978-6

Printed in the United States of America

CONTENTS

PREFACE

My interest in the arts has long been buried under the mask of sociological respectability. Yet, like any other middle-class French boy of my childhood, I was taught how to play the piano, an instrument that I still practice (or rather torture) whenever I have the opportunity. I also loved to act on stage and have performed and directed on and off for the past thirty years. In addition, for as many years, I have lived near many painters and musicians. I believe that I have developed—directly as well as vicariously—a sufficient passion for the arts to want to share with artists my thoughts on their activities.

Nevertheless, how can I present this present work to my fellow sociologists? Of course, it is likely to offend the "rationalizing functionaries" or the "functional irrationalizers" castigated by Philip Rieff. But as I completed the nth draft of the manuscript, I realized how much I owe to the friendship of Scott Greer and of John Kitsuse, who acted as my mentors when I entered into American academia and showed me how important it was to close the gap that supposedly holds the arts and the social sciences so far apart. This book clearly owes a great deal to social scientists such as George Kubler, Norman Ryder, and Norval Glenn, who have emphasized the role that time plays in any analysis of social phenom-

ena. And the book also owes a great deal to the works of social scientists who have sought to elucidate and demystify the workings of scientific scenes and undertakings. I sincerely hope that Don Campbell, Robert Merton, Thomas Kuhn, Derek de Solla Price, and Serge Moscovici—if they ever read this book—will appreciate how much their writings have influenced my thinking and how much I respect their work.

In the task of writing and rewriting the manuscript, I received help from Richard Press and Rachel Schwartz, who called my attention to various relevant books and articles; from Richard Brown and Carroll Long, who stimulated my imagination; from Marshall Shumsky, who kept pressing me closer to my ideal; from Susan Lourenço, Bonnie Litowitz, John Paden, and Sam Gilmore, who were willing to share ideas and act as sounding boards for my own; from John Cozolwski, who tried to tell me where my own score "would hurt musical ears"; from Bob Wilson, who gave me the right encouragement at the right time; and last, but not least, from Joe Valadez, who accepted the difficult role of stage manager and impresario and kept me on target. For all its worth and for all its warts, I dedicate the book to Bertram Phillips, painter and photographer, and to Marshall Shumsky, sociologist. Indeed, they represent both what the book stands for and what it aims to achieve.

1

An Invitation to a Sociology of the Arts

In Anton Chekhov's short story "The Darling," the heroine, Olga Semionova, claims that "the theater renders people more humane and cultivated"—a position taken by her first husband, a theater director. Later, under the influence of her second husband (a lumberyard manager), she asserts that "serious people have no time to waste in foolish pastimes such as attending a play."[1]

To be like Chekhov's heroine and to hold inconsistent views on the theater's merits is not uncommon. At certain times in our lives, we believe that plays purge actors, playwrights, and audiences alike of their respective passions, and we assert that such cathartic experiences engender feelings of communion among all participants. Yet at other times we view the theater—or art in general—as a diversion that keeps us from striving toward the attainment of our political, religious, or economic ideals.[2] Thus, the passage of time reveals the contradictory stances we hold successively toward the theater. The same contradictions which also characterize the views held *simultaneously* by various individuals or social groups may be generated by a specific play (e.g., *A Chorus Line*), specific theatrical genres (e.g., musical comedies), or by the theater as a whole. In short, the theater both creates and mirrors a variety of social and psychological cleavages.[3] In the same way that the theater brings playwrights, actors, and audiences together or, conversely, pulls them apart, dialectics of inclusion and exclusion

1

characterize other cultural forms and aesthetic experiences as well. As certain artworks are placed in the category of masterpieces and others are rejected as ugly, irrelevant, or trivial, their respective authors and publics are adulated or condemned and ridiculed. These patterns of inclusion and rejection, far from being stable, change with the passage of time.

Because of the ambiguities produced by and reflected in the arts, artistic communities keep challenging one another and their own pasts. In France, for example, artists and patrons eager to free themselves from the restraints both of tradition and of the authority of existing communities tend to castigate their opponents as *pompiers* (a term that the French artists of the nineteenth century coined to show their contempt for the pompous and uninspired quality of the official art of the period). Or they twist the word *académique* (which used to be a positive or at least neutral term) to which they now give a pejorative connotation. In turn, the same *pompiers* or *académiques* label as obscene any endeavor of the champions of change. The significant changes that are both products and producers of such conflicts constitute artistic revolutions.

The purpose of this book is to analyze the structures of these revolutions. Both the title of the book and the use of the term *revolution* make it clear that the analysis presented here owes a great deal to Thomas Kuhn's work on scientific development. Kuhn makes two basic propositions concerning the relationship between scientific development and scientific revolutions. First, he suggests that scientific development involves two alternating phases. During the first phase, that which he calls Normal Science, researchers are engaged in puzzle-solving activities, as they all agree both on the ways of testing the limits of the problems they have set for themselves and on the challenges provided by such a test. During the second phase, that which Kuhn calls Scientific Revolution, scientists become aware of both the fallacies attached to the puzzle on which they have been working and the limitations of the tools supposed to help solve it. There is a revolution because the majority of researchers adopt the definitions that revolutionaries offer of the tasks to be accomplished and of the tools to be used in order to escape the limitations and contradictions with which the entire profession is confronted.

Second, Kuhn suggests that while scientific revolutions become invisible because their results are absorbed into the body of traditions of the discipline or field under study, their succession has two

opposite effects. On the one hand, the succession of revolutions involves a logic of parsimony. In contrast to the early stages of scientific development that are characterized by the coexistence of competing assumptions, theories, or models, the assumptions, theories, or models provided by revolutions which occur during subsequent stages of scientific development chase away those assumptions, theories, or models that are considered to have become obsolete as well as invalid. In short, the succession of revolutions occuring in each discipline renders its orthodoxy increasingly tighter. On the other hand, scientific revolutions are conducive to a greater differentiation of existing fields or disciplines. As an example, molecular biology has become an autonomous discipline, independent of both biology and chemistry, with its own problems and tools.

The question arises, then, whether revolutions in the systems of scientific and artistic productions present similar structures and whether the determinants of such structures are similar in both cases. Kuhn argues that they are not when he writes, "The innovative component of artistic ideology has done for the arts what internal crises have done to promote revolutions in science."[4] In other words, Kuhn sees innovations as gratuitous within the artistic realm. Conversely, scientific innovations are necessities that result from the gap between the problems researchers set for themselves and the inadequacy of the responses they have elaborated. Less frequent and less valued insofar as they result from the crises experienced by researchers, scientific innovations would be also more drastic than their artistic counterparts. Indeed, crises render innovations more compelling.

Before proceeding further, we should ascertain whether the ideas of innovation or internal crisis are Kuhn's own or whether such constructs correspond to experiences shared by artists and scientists. The question is not academic; some analysts suggest that "originality, novelty [and I would add revolution] are not peculiar qualities of the act but constitute retrospective judgments passed on their results or their forms."[5] The word *retrospective* is essential here, as it raises the question of identifying the authors of such judgments. Are they the artists and the scientists themselves? Or outside observers? When Kuhn distinguishes between innovations produced by ideology and ones produced by crisis, he seems to imply that the meanings of these terms are universal and constant. Further, he appears to believe that the relationship between

the value assigned to innovations and their incidence is independent of existing systems of cultural production. But does the evidence support Kuhn's contention? Could it be that novelty, crisis, and revolution all follow distinct dynamics in the arts and in the sciences? Furthermore, could it be that there is divergence as well as convergence in the dynamics of these two systems?

First, even though it is customary to contrast the rationality of the creative process in scientific fields with the irrationality of artistic inspiration, the fact remains that the structures of artistic and scientific works are in certain ways analogous.[6] In ancient Greece and during the Renaissance, mathematics, music, and the visual arts were all based on a conscious or unconscious exploration of the "golden ratio." Similarly, artists and scientists today emphasize the role played by symbolic modes of thinking in their respective endeavors and they rely on structurally analogous metaphors in their explorations of the links between imaginary and empirical orders. The science fiction genre epitomizes converging scientific and literary approaches.

Second, although Kuhn stresses the essential property of the tension that pits tradition against innovation in scientific fields, the same essential tension may characterize artistic endeavors as well. When Kuhn writes, "What was known, produced, or appreciated in spite of the mental equipment of the community at large as well as of each practitioner, before the revolution, is known, produced, or appreciated afterwards, precisely because of this mental equipment," is he addressing his remarks exclusively toward scientific fields or do these remarks also apply to artistic disciplines? One could argue that writing, painting, filming, or composing techniques could not be the same after surrealism. Similarly, when Kuhn writes that "[scientific] work is produced and appreciated within a well defined and deeply ingrained tradition but is also productive of tradition-shattering novelties," the same may hold true for the arts.[7] To use the same example, surrealism itself is part of a well-established tradition, which is invoked by surrealist writers themselves as a source of significant artistic changes.

Whether in the arts or in the sciences, revolutions are therefore contingent on the "unexpected, inevitable and economic properties" attached to the works that illustrate them best and that Kuhn calls exemplars. What makes such exemplars unexpected is that they produce a new vision of the world. What makes them inevitable is that they constitute what is considered to be an irrefutable

statement about the world. Finally, what makes them economic is that they go directly to the heart of what is accepted to be the central problem of the discipline. For these reasons, artistic and scientific revolutions should present analogous if not strictly similar structures or properties. In the sciences, revolutions concern definitions of both the phenomena to be explained and the tools and methods of analysis to be used. Thus, Einstein's revolution involved both a comparison between the expected and observed positions of a specific planet and an evaluation of the validity of the evidence produced by the photographs of that planet. Likewise, in the arts, revolutions concern the choice of aesthetic objects (for example, the shift from figurative to nonfigurative compositions). But these revolutions also pertain to the choice of appropriate symbolic translations; in the visual arts, they pertain, for example, to the mixed use of materials (e.g., acrylic and clay) originally deemed to belong to distinct fields. In this regard, scientific and artistic revolutions are not necessarily entirely different from each other.

As I will show, however, they differ from each other on at least two counts. First, while scientific revolutions involve simultaneous changes in the definition of phenomena and the appropriate tools of analysis, these changes may be independent of one another in the case of artistic revolutions. Whereas the introduction of photography as a new source of scientific evidence was problematic only insofar as it modified the procedures used to evaluate the validity of competing theories, the introduction of new aesthetic objects and of new techniques or tools of symbolic translation may constitute two analytically and historically distinct instances of artistic revolutions. Second, communication between practitioner and audience is a more central aspect of artistic than of scientific revolutions. As far as the theater is concerned, the expulsion of spectators from the stage—where they had been allowed to sit initially—was a revolution that modified acting techniques and the disposition of sets and props on stage, and hence, the principles of theatrical illusions.

Let us then summarize the objectives of this undertaking. Initially, the analysis of artistic revolutions is derived from the work of Kuhn on scientific development. My initial goal has been to examine whether Kuhn's argument could be transcribed into various artistic keys and to ascertain whether the properties he assigns to scientific revolutions are generalizable to other systems of cultural

production. Since Kuhn considers that such a generalization is unwarranted, I am obliged to explore further similarities and contrasts in the organization and validation of both scientific and artistic works and, in so doing, to evaluate the merits of the concepts and methods used by Kuhn. In this sense, this book also focuses on what a study of artistic revolutions enables us to learn about the determinants and implications of paradigmatic shifts in scientific fields. Thus, the transcription I planned initially turns out to be an exercise not only on the limits of the transcription per se but also of the original score itself—from which I will deviate whenever the need arises.

Like their scientific counterparts, artistic revolutions can be examined from two apparently distinct perspectives. To adopt an internalist perspective is to recognize the psychological, social, and political autonomy of aesthetic endeavors.[8] "In the same way that one writes about poetic beauty, one should write about geometric or medical beauty. Yet one does not do so, for the very simple reason that while the object of geometry is to establish proofs and the object of medicine is to find cures, nobody knows the natural model that poets should imitate."[9] So Pascal described the specificity of aesthetic problems. In praising poets, painters, and musicians as great men and women, social scientists who adopt an internalist perspective try to think as artists. Recognizing that artists or their most significant critics often owe their fame to unintended processes and results, these social scientists examine the problems artists and critics have worked on and how they learned to see their tasks as problematic. In their reconstruction of the creative act or, for that matter, the appreciative one, such social scientists attend to the apparent "errors" of their subjects because these "errors" reveal much more of the creative process than do the statements that are seemingly universal or constant. As an internalist analysis tries to identify the autonomous aspects of creativity, it seeks to reconstruct the history of such errors in order to explain how revolutions take place within artistic communities and hence to assess the discontinuities that mark the distribution of individual talents and tastes.

Alternatively, social scientists who adopt an externalist mode of analysis seek primarily to identify the extent and the form of the influence that major societal institutions exert on the various artistic disciplines. Thus, they do not satisfy themselves with demonstrating how the omnipotence of the Church during the Middle

Ages induced parallels between the forms of the then-prevailing scholastic philosophy and the structures of musical or architectural styles.[10] As this approach would be too static, these social scientists are equally keen to show how the declining influence of institutionalized religion has facilitated artistic revolutions and how the form and timing of these revolutions vary across the arts. Externalist social scientists are also interested in showing how the markets of distinct artistic disciplines affect the orthodoxies to which their respective practitioners are subjected, and how the differential evolutions of these markets explain the specific properties of revolutions which upset the relations that various classes of artists develop with one another and with their respective audiences.

Far from being mutually exclusive, however, internalist and externalist perspectives are complementary. To be sure, the practitioners of a "mature" artistic discipline are trained in an increasingly sophisticated body of theories and techniques. The problems on which they work are informed by the challenges of their peers, who want to increase the scope of the fit between existing theories or conventions and the products of their work. And the tools artists use to accomplish their tasks are also close relatives of those supplied by their communities. But what are the boundaries between the insulation actually experienced by artists or their communities and the insulation they hope to enjoy from the larger society? Leon Trotski contended that "the arts must make their own way by their own means because Marxist methods are not the same as the artistic ones."[11] His plea has been reinforced by members of the Frankfurt School such as Theodore Adorno, Herbert Marcuse, or Bertolt Brecht, who have all asserted, in one form or the other, that the "potential radical of the arts lies primarily in innovations in artistic forms."[12]

Despite these stances, the fact remains that the autonomy of the arts remains a pious wish in the case of socialist and many other countries. In addition, this autonomy is selective. The validity of externalist explanations of revolutions seems to be greater in the case of literature and particularly of novels or of painting than in the case of music.[13] Furthermore, as changes in the organization or the products of a particular discipline are often dependent on the prior development of another field, the question is raised as to whether such changes are internal or external. In other words, boundaries between "internal" and "external" are not necessarily as clear as may appear at first glance. Last, it is only selectively,

through various filters, that the essential tensions between tradition and progress that crisscross the worlds of economic, political, or religious institutions affect the access of individuals to distinct artistic fields, the direction artists give to their works, and the fate reserved for such works. The study of artistic revolutions depends therefore on the dialectics that bind internalist and externalist approaches to each other.

The Limits of Sociological Analysis of Artistic Revolutions

Artistic revolutions are multifaceted, and so their study requires the analysis of multiple sets of interactions. The first mode of analysis focuses on artistic works. It examines how such works affect and are affected by the characteristics of the environment in which they are produced or evaluated. The second perspective examines the reciprocal influences that artists exert on one another in terms of the performance as well as the evaluation of the tasks they have set for themselves. Finally, the third mode of analysis concerns the ways in which audiences tend to shape their appreciation of the works offered to their scrutiny. The difficulty lies in identifying the variety of theoretical links underlying these sets of interactions and their respective analyses. Sociologists have often arbitrarily reduced the focus of their research to only one of these sets. In so doing, they have oversimplified the theoretical problems raised by the internally or externally induced tensions between tradition and innovation, and hence the problems raised by artistic revolutions.

Limits of the Emphasis on the Results of Artistic Work

Initially, sociologists studied the external rather than internal determinants of artworks. They were primarily interested in specifying the natural and cultural factors that shape the production rather than the appreciation of these works. Thus, Madame de Staël and, later, Hippolyte Taine both sought to establish significant relationships between painting or writing styles and the dominant

features of the natural or social environments in which they were produced.[14] For these two authors, contrasts between the cloudy and the sunny skies of northern and southern countries imply parallel differences in the colors used by local artists. In the same vein, Ferdinand Brunetière was sufficiently impressed by the work of Charles Darwin to establish parallels between the evolution of animal or vegetable species on the one hand and of literary genres or styles on the other.[15]

Later, sociologists and historians turned their attention to the influence of political or economic factors on the history of artistic paradigms. They showed, for instance, how the differential political structures of France and the Netherlands during the seventeenth and eighteenth centuries were paralleled by contrasts in the organization of their artistic communities, as well as their artists' social background and aesthetic style.[16] As French centralization facilitated the progressive institutionalization of academies and made painting careers more attractive for relatively well-off individuals, it stimulated the development of an official and rather solemn orthodoxy—at the expense of more spontaneous techniques. In contrast, the greater egalitarianism of Dutch political life encouraged greater diversity in the social origin of local artists, in the objects they painted, and in the styles they used to attract or retain their clients. Such differences should have affected the frequency and form of artistic revolutions in the two countries.

Similarly, there seems to be a close relationship between the history of the French bourgeoisie and the successive forms taken by French rationalism over the years.[17] Initially, the very emergence of a Third Estate striving to obtain a social status commensurate with its economic achievement fostered the rationalism of Descartes, who tried to demonstrate that the purpose of conscious activities was to modify individual knowledge and hence behavior. As the middle classes of the eighteenth century began to master their physical or social surroundings, the philosophy of Voltaire sought to accelerate an appropriate "tinkering" of social arrangements.[18] Finally, the modern bourgeoisie's decline, provoked by a succession of wars and economic depressions, facilitated the disenchanted skepticism of Paul Valéry, who disassociated conscious activities from individual or social behaviors.

The arts are also often seen as a mere replication of economic forces. Broadly speaking, the support that the mighty and affluent bestow on artists can be seen as resulting from the exploitation of

other social groups.[19] This exploitation creates surpluses, which finance artistic ventures. The construction of Versailles, the systematic purchase of paintings by the French nobility or by the Dutch bourgeois offer as many cases in point. Similarly, colonies have provided imperial powers with both the raw materials needed to produce various artifacts and the models from which new art forms could be derived.

From a dynamic viewpoint, changes in technology introduce new modes of division of labor not only in the society at large but also in artistic communities themselves. Thus, the shift from a similarity-based, or "mechanical," to a complementarity-based, or "organic," form of social solidarity during the Renaissance was paralleled by a change from a universal Gregorian to a differentiated polyphonic musical style.[20] In the visual arts, periods of economic growth are associated with an accentuation of geometric forms but periods of economic decline are dominated by a simplification of existing artistic styles. Furthermore, threats to the status of dominant classes provoke stylistic rigidity, but a blurring of class distinctions stimulates a more ambiguous aesthetic vision, as exemplified by abstract expressionism.[21] In literature, the decline of the tragedy at the end of the eighteenth century and the subsequent development of the novel may be attributed to the shift from a centralized mercantilist economic system to a laissez-faire regime, in which the fate of individuals becomes more problematic.[22]

Finally—and regardless of the discipline examined—it appears that as soon as aesthetic statements become treated as just another commodity and source of financial profit, the marketplace becomes the focal point of aesthetic orthodoxies or revolutions.[23] In short, this first mode of analysis, which emphasizes the influence of societal institutions on works of art, tends to evaluate artistic revolutions in terms of results rather than intentions. What makes revolutions are the discontinuities in the structures of artworks that the passage of time reveals to the analyst.

Whether this first type of research emphasizes natural or cultural determinism, it is based on two questionable assumptions. First, it underplays the distinction between the genotypic and phenotypic manifestations of the arts.[24] In other words, the approach does not differentiate the entire production of an artist from his or her specific works; the competing styles of various artists living in the same sociohistorical contexts; or the art forms typical of distinct but contemporary cultural environments. As this view can

hardly explain the processes of retention, mutation, and selective adaptation present in the creativity of individuals or of communities, it obscures the concept of artistic revolutions.[25] At the individual level, it is impossible to ascertain which of the paintings of David dating from different periods in his life or which of the canvases painted simultaneously by Rembrandt throughout his life are revolutionary whenever the ways in which the biographies of these two artists are used prevent the specific "voices" of their different works from being heard. In addition, the approach cannot elucidate whether the concept of revolution applies equally to discontinuities in the works of one artist and to discontinuities in the works of entire communities. Nor can the approach elucidate whether artistic revolutions are universal or affect only specific schools in specific countries.

As researchers bypass the rhetoric of artists, they unduly privilege the explanatory power of unconscious or nonconscious forces.[26] Yet, in so doing, they fall prey to the fallacies of paralogics and anachronisms.[27] In other words, researchers superimpose on the works of artists a world view that reflects the cumulative experiences derived from successive contemplations of these works and of those following. For example, some critics have recently argued that Dutch paintings such as Metsu's *The Gift of the Hunter* or Van Meiris's *The Escaping Bird* have a double meaning and present superficially hidden sexual overtones.[28] These critics see the birds of these paintings as phalli, the cages as vaginas, and the "sewing" activities of the women depicted as symbolic of their desire to "screw." But as the very concept of double entendre implies a double audience, it follows that selling canvases with a double entendre makes sense only when there is another audience with access to the work able to both understand its other meaning and keep it secret. This presupposes, then, that Dutch painters formed a sufficiently cohesive group to share various ideas and symbols (notably with regard to sexual slang) that they did not communicate to outsiders and had an easy access to one another's paintings, both in their studios and in the homes of their patrons.[29] But is there evidence to support the claim that the meanings imputed to such paintings by their buyers and by their authors and their fellow artists differed from one another in the way I just indicated? Is not such a claim an illustration of the fallacy which goes with anachronism?

In sum, to focus the analysis of artistic revolutions on the changing properties of artistic works is to leave artistic scenes

without actors. As a consequence, one cannot determine whether a revolution is an individual or a collective behavior. One cannot either determine whether the criteria used to assess revolutions are merely ex post facto constructs or whether they in fact correspond to the artists' intentions.

Limits of the Emphasis on the Process of Artistic Work

In contrast to the first conception, which creates images of revolutions devoid of actors, other sociologists emphasize the need to evaluate the role played by specific organizational profiles of artistic communities in the making of revolutions. Even today, when the various artistic scenes are obviously dominated by individualistic ideologies, these analysts remind us that art should still be viewed as a collective action.[30] These analysts emphasize, therefore, the notion that differing modes of division of labor generate differing forms of inter-individual cooperation and, thus, promote contrasts in the substance and the institutionalization of the rules regulating the activities of professional communities.[31] Whenever communities within the same discipline do not share the same rules of division of labor, they do not share either the same definitions of the objects to be described, of the techniques to be used, or of the mechanisms by which artworks should enter the public domain. As French academic and impressionist painters of the nineteenth century did not work in the same locales, and did not deal with the same models or with the same patrons, they did not choose the same aesthetic objects. Nor did they use the same colors or styles. Nor did they embrace similar definitions of the public they were eager to convince.

However, when these analysts attempt to demonstrate how the hierarchically ordered networks of artists shape individual activities, they risk falling prey to the fallacies of a pure functionalist analysis that exaggerates the importance that the search for equilibrium plays in the life of social organisms, and hence of artistic communities. Although artists cooperate with one another and with the support personnel they need to perform their work in the context of a collective action, their relations are also subject to conflicts and tensions. Division of labor stimulates not only the coordination but also the competition of individuals with different roles and ranks. To stress the cooperative nature of the relations at

the expense of their competitive aspects unduly minimizes the fact that communities may shift from one set of rules to another one. Worse, such an emphasis minimizes the problems raised by such shifts. Are the changes gradual and peaceful, or are they revolutionary and conflict ridden?[32] Are such changes generated by the internal contradictions within artistic communities, by conflicts among various groups of patrons, or by tensions between artistic communities and their surroundings? For example, the writings of Pascal may be viewed as a systematization of the Jansenist world view adopted by a particular segment of the French nobility ("noblesse de robe") under the reign of Louis XIV.[33] But such a view does not explain the editing of Pascal's text by Antoine Arnaud and Pierre Nicole, the official representatives of the Jansenist movement. In fact, both the decision to edit Pascal's text and its printed outcome reveal the relative power that the Jansenists imputed to the competing philosophy of Descartes and his rationalist patrons. As such, this editing illustrates the political and ideological conflicts that took place within and between French intellectual circles at the time.

In short, although a sociology based on the analysis of collective actions describes the actors of artistic communities and their immediate behaviors, it leaves untouched the larger plot in which they play a part.[34] This view minimizes the effects that convergences and divergences in the modes of division of labor operating in artistic communities located within the same field or within differing disciplines exert on the conflicts experienced by such communities. As a result, this view not only underestimates the frequency of artistic revolutions; it also fails to place these revolutions in a larger context.

Limits of the Emphasis on the Appreciation of Artworks

Sociologists have also been keen to identify the social functions of the artist's relationship with his or her public. Talcott Parsons, for example, argues that artists either supply a want or meet a need of the public, in return for which they receive admiration and appreciation.[35] This stance, however, presupposes a homogeneous public and does not address the ambiguities and limitations of the public consensus governing, for example, the definition of "masterpieces." Yet, to the extent that the same work of art performs differ-

ent functions for different social categories, aesthetic communica-
tions reflect diverging and conflicting processes. Thus, to argue
that "we do not read Newton the same way we read Shakespeare"
is misleading as long as the "we" is not specified.[36] To contrast
Newton and Shakespeare in this way is to underplay the different
expectations that various groups—men and women, old and young,
etc.—bring to these authors. Similarly, depending on whether read-
ers are artists or scientists and whether their motivations are pro-
fessional or mundane, they do not read these two authors in the
same way and are, accordingly, prone to reach distinct conclusions.

Finally, just as it does not make sense to minimize the effects of
social and cultural discontinuities—and hence of the segmentation
of social space—it does not make sense to neglect the significance of
temporal discontinuities. Indeed, it is naive to assume that objects
gradually accumulate or lose value with the passage of time.[37] For
example, English collectors initially evaluated the paintings they
acquired in terms of how their colors reacted to the smoke from the
fireplaces of the rooms in which they resided. The later introduc-
tion of central heating modified the attitudes of these English col-
lectors toward canvases with dark or dull colors, whose market
values increased accordingly.[38] Thus, changes in the criteria used
by patrons imply discontinuities in the value they assign to the
same artifact over time. Not only are there "rediscoveries" in
the appreciation of artworks but also these rediscoveries are cur-
rently subject to an acceleration. Two hundred years passed before
collectors discovered the paintings of the eighteenth century, but
art deco became fashionable again less than fifty years after it was
declared an outdated art form.[39] In short, far from taking place in a
social vacuum, the timing, the procedures, and the objects of revo-
lutions occurring in one discipline depend on the public. Such
revolutions may merely reflect drastic changes in tastes, but they
may also result from changes in the distribution of cultural power
among social groups.

For the same reasons, the timing of revolutions differs across
disciplines. For example, the legitimation of animals as aesthetic
objects, an example of a revolution, did not occur simultaneously
in all fields. Animals entered the world of painters before being ad-
mitted to the worlds of novelists, playwrights, and choreogra-
phers.[40] Similarly, even though all of the arts may at times have
playful orientations, the various disciplines have not simultane-
ously integrated humor or fun as socially acceptable cultural forms.

Comedies were treated as a form of high art before comic dances, which for a longer period of time remained relegated to the status of lower-class, circuslike activities. Until the recent past, cartoons and caricatures were excluded from museums for similar reasons.[41] They entered the "temples of high art" only after the aging of some of these cartoons or caricatures made the entire genre more respectable or after their authors derived a high status from a more "dignified" activity, such as painting.

To conclude, works of art cannot be understood as fixed entities. Any artistic communication involves a dialectical interrelation between artists, the public, and the works offered to the public's scrutiny. The consciousness that an artist derives from producing a work and the consciousness that audiences derive from inspecting it are related to the totality of their respective worlds, "including the congealing experiences of their respective pasts."[42]

Themes of the Present Score

The preceding review of the literature has served as a preview to a systematic exploration of two major aspects of artistic revolutions. The first object of these revolutions is to modify the discrete and specific mediations of the duality between nature and culture that the "normal" production of artworks represents in various disciplines. As such modifications often tend to result from changes in the material bases of social life, the second object of such revolutions is to modify the existing patterns of division of labor operating in the corresponding communities.

Whether a work of art is literary, musical, pictorial, theatrical, or cinematic, it requires as such an appropriate taming of nature. Thus, the visual arts involve the controlled use of wood, canvas, oil, water, or other chemical or natural substances, such as feathers or butterfly wings, as exemplied in some modern folk art. Similarly, the performance of a musical score presupposes the construction of appropriate string, wind, or percussion instruments. Furthermore, both the production and appreciation of any work of art are also based on the network of opportunities and constraints of perceptual processes. Although we learn how to see and hear signs that are not self-evident, such learning is still embedded in the

natural structures both of the media utilized and of the human body. To learn how to appreciate a particular sound or a particular color presupposes that their production is compatible with the internal structures of the ear or of the eye of artists and audiences alike. Finally, in overt or covert terms, each work of art represents an ideological confirmation or denial of the power that nature holds over human feelings.

Despite this anchoring of art in nature, its production and appreciation are shaped by cultural factors. These factors specify the materials and instruments that might legitimately be utilized in various artistic endeavors and hence the range of mechanisms that artists can use in order to structure the raw space and time that constitute the basic components of aesthetic experiences. The same cultural factors also condition the creation of symbolic languages designed to amplify or reduce the perceptual illusions that we experience, as our position in space and time enables us to see only a fragmented and immobile part of our surroundings and to hear a succession of instantaneous rather than enduring sounds. Finally, the same cultural factors dictate what an imitation of nature consists of and whether such an imitation should be encouraged or rejected. The study of artistic revolutions consists therefore in identifying how paradigmatic shifts represent changes in the dialectical relations between nature and culture.

Because every paradigm represents a coherent framework designed to solve tensions between nature and culture, we must distinguish the innovations that do not modify existing frameworks from the innovations that foster new conceptions of the tasks or tools to be mastered and that, as such, constitute artistic revolutions.

Insofar as the emergence of such new conceptions results from changes in the material basis of artistic life, revolutions also concern patterns of division of labor within and among artistic communities. Far from being monolithic and stable, culture is constantly affected by changes in such patterns. These changes contribute to the relative individuation of each discipline, of its organizational structure, or of its ideology. They modify the boundaries between disciplines. They transform the modes of communication of their members with one another and with their audiences, as well as the segmentation of the audiences themselves. Correspondingly, artistic revolutions imply the fragmentation of cultures into discrete subunits and, within such subunits, drastic changes in the roles al-

located to individuals. For example, what determines shifts in the distinctions between arts and crafts, between sculpture and pottery, or between photography and painting? How do these shifts affect the status of the relevant categories of artists or audiences? And in what sense are such shifts revolutionary?

In the following pages, I intend to suggest that these revolutions are partial; that their structures vary with the time dimensions used to identify their components; that these structures vary across disciplines; and that these structures are constructs whose validity is contingent on the theoretical and methodological tools used by observers.

The Substantive Relativity of Artistic Revolutions

In the same way that Kuhn contrasts normal science and scientific revolutions, my first objective is to identify boundaries between normal and revolutionary practices in the arts. Although all artistic communications are negotiated, both the processes and the outcomes of these negotiations are subject to significant limitations that vary across disciplines, countries, or historical periods.

From a sociological viewpoint, the artist who keeps his or her manuscripts or paintings secret has not produced a work of art, so long as the product does not enter the public domain. Such entry presupposes negotiation. These negotiations are, at least in part, self-fulfilling prophecies as suggested by the following anecdote, which pertains to an exhibition of artists' self-portraits in a New York gallery. A dealer who asked Marcel Duchamp to participate in the show received from the painter the following telegram: "This is my portrait if I say this is my portrait." The dealer duly framed the telegram, which was exhibited with the other portraits. When Duchamp later requested payment, the dealer replied with a telegram saying: "This is a check if I say it is a check." Thus, the story suggests that anything goes[43] as far as a definition of the arts is concerned.

Nevertheless, this looseness is socially relative. The power of any definition of the arts depends on the qualities imputed to the individuals involved in the relevant negotiations. Such individuals are not necessarily the artists themselves. In a sociological perspective, the paintings of Facteur Cheval or the writings of Anne Frank became artistic only as a result of actions taken by significant spon-

sors. The same is true, of course, in the case of renaissances or re-
discoveries. The "academic" paintings of William Bouguereau or
the "frivolous" theater of Marivaux have become fashionable again
as a result of campaigns orchestrated by influential reviewers.

Yet the problematic nature of aesthetic negotiations and hence
of the distinction between normal and revolutionary moments in
the arts does not result only from variations in the status and bar-
gaining power of the actors involved. It resides primarily in their
very object. The purpose of these negotiations is to achieve a so-
cially acceptable definition of the aesthetic qualities imputed to
the objects described. Such definitions are necessarily relative. In
painting, the introduction of banal landscapes devoid of Roman or
Greek ruins into the catalogue of legitimate aesthetic categories is
a relatively recent phenomenon.[44] In literature, the emotional in-
volvement between individuals from different social classes was
not considered acceptable until the end of the eighteenth century,
as a result of the legitimation of egalitarian ideologies. Similarly,
the novel's treatment of love excluded concrete descriptions of
sexual intercourse until the sexual revolution preached by D. H.
Lawrence made the act of intercourse an integral part of love. In
the cinema, it is only recently that homosexual relations have been
treated in explicitly dramatic terms or that incest has become an
object of tender and humorous scrutiny, as in Louis Malle's "Mur-
mur of the Heart."[45]

Aesthetic negotiations also concern the symbols and techniques
that should legitimately be used in order to describe the objects of
aesthetic statements. Thus, a painting remains "unacceptable" as
long as the appropriate communities do not legitimate the use of
tempera or of acrylic. Similarly, a painting is unacceptable when
the purpose of its author is to anticipate the chemical changes of
colors on the canvas—a challenge that is ignored or belittled by
the community. The same holds true, of course, for a painting's con-
struction. Thus, artists of the Renaissance focused on the introduc-
tion of the laws of perspective, while modern painters have been
concerned with the relativization of these laws. In the case of novels
or poems, negotiations have concerned the use of different typo-
graphical characters as symbols of tenses or of the times simul-
taneously experienced by distinct individuals or groups. The ty-
pography of John Dos Passos's The 42nd Parallel or of Stéphane
Mallarmé's sonnet "Un Coup de Dés" is a case in point. As another
illustration, the introduction of straight dialogues in a novel may

aim at blurring boundaries between this particular genre and the theater (as in the case of Denis Diderot's *Le Neveu de Rameau*) or between this particular genre and lyrical poetry (as in the case of Ernest Hemingway's novels). In music, the negotiations have concerned the legitimation of a new grammar, exemplified by the introduction of a dodecaphonic scale or by the mix of "aristocratic" and popular melodies (apparent in, for example, works by Igor Stravinski and Béla Bartók). Finally, in film these negotiations have initially concerned the introduction of sound tracks which modified both the range of aesthetic objects that could be treated by this particular medium and the qualities demanded of actors. Later on, these negotiations have been focused on more specific problems and have, for example, concerned the elaboration of flashbacks or the differential use of color and black and white in order to contrast objective and subjective accounts of the same reality.

Furthermore, aesthetic negotiations also concern how a work is to be published. In painting, negotiations specify not only the size but also the shape and color of the frame. Impressionist painters sought to expand the properties of their styles to the frames themselves. In addition, there are also significant variations in the number and the disposition of the canvases to be hung on a museum's walls, as well as in the themes around which an exhibition can be articulated.[46] In the opera, there are recurrent controversies as to whether the orchestra should be heard and not seen.[47] Finally, in the theater, there are significant variations in the definition of the optimal distance between actors and audiences. In certain cultural contexts, this distance should be both maximized and standardized, but in others, audiences are expected to gather as close to the stage as possible.

The last aspect of aesthetic negotiations concerns the marketing of artifacts. There are significant cultural and historical variations in the mechanisms by which an artwork enters and remains in the public domain. As we shall see, there are contrasts not only in the definition of property rights that musicians and writers on the one hand and painters on the other retain over their respective works but also in the extent to which such rights are effectively protected across countries or across historical periods.

These negotiations rarely occur simultaneously. As Einstein retained various Newtonian principles in discovering the theory of relativity, artistic revolutions often challenge only one of the concerns of artistic negotiations. Like their scientific counterparts,

they are therefore limited. They often concern only the objects of a discipline, or its techniques, or the social and economic mechanisms by which its works enter the public domain. Thus, at least in the short term, these negotiations have only a limited impact on the centrality of the works that are considered most typical of the achievements of the discipline and that Kuhn calls "exemplars." Of course, in the long term, the changes brought about by negotiations are more encompassing. As already suggested, the introduction of sound tracks in the cinema modified the range of screenplays considered for production, the organization of screenings (the pianists or orchestras who accompanied the projection of the film disappeared), and the rank ordering of directors, scenarists, or actors.

Although the outcomes of the negotiations concerning specific works of art enable the relevant disciplines to confirm or refute normative definitions of the dialectic between nature and culture, this dialectic is only a reconstruction that is constantly revised after the inspection of other exemplars. In the arts as in the sciences, the treatment accorded to ambiguous facts or statements is a reminder of the uncertain boundaries between anomalies and falsehoods. Whether the negotiation of artistic works leads to their celebration or to their rejection, their adjudication is not independent of the cognitive or political framework adopted by their evaluators. As such, celebrations or condemnations tell us as much about judges as artists. Nor is the judgment of these evaluators immune to appeals or revisions. Thus, aberrant or erroneous artworks may later be relabeled as mere anomalies announcing revolutions to come—or vice versa. Indeed, because art is related to ideology, dominant forms of ideology should be contrasted with their residual, emergent, oppositional, or alternative counterparts. It is because these various forms of ideology compete with one another that judgments passed about works of art are never stable and oscillate between praise and condemnation. In other words, revolutions are constructs elaborated in order to confirm or to invalidate the claims that artists or audiences make regarding the normal or revolutionary properties of their works or judgments. Correspondingly, the first objective of this book is not only to explore the ambiguities of the distinction between normal and revolutionary practices but also to delineate the various forces that render artistic revolutions partial rather than total, and reversible rather than irreversible.

The Various Times of Artistic Revolutions

Because I have emphasized the relativity of revolutions, my second objective here is to emphasize the variety of time dimensions within which such revolutions occur. First, insofar as each artistic statement involves the passion of becoming or of constructing an "other" and of abolishing the boundaries that separate social spaces or social times from one another, any artwork can be seen as revolutionary.[48] This interpretation helps us discover another sense to the word *alienation*. Because of the influence exerted by nineteenth-century psychiatrists and then by Karl Marx himself, we have become accustomed to attaching a passive and pejorative meaning to this word that, willy nilly, we consider to be synonymous with the concept of reification.[49] Both the alienists and the socialists of that period have induced us to believe that alienation refers exclusively to the psychological processes by which others, whether employers or doctors, deprive us of our identity and transform us into "things." But the point is that the word *alienation* originally referred as well to the process by which individuals strive to transcend the boundaries of their own identity and project themselves into the outside world. Insofar as the intention of many artists is to actively transcend the limitations of their own physical or psychological condition and to become the characters they perform or write about, or even to become the landscapes they paint, aesthetic alienation is ipso facto a positive phenomenon. Alienation may in fact constitute the very essence of revolutions.

When placed in this positive light, aesthetic alienation can take two opposite forms. Dionysiac painters, poets, and actors learn to drift and to feel directed, dominated, and possessed, in order to be ultimately absorbed by the whirlpool of the alien forces that make up physical and human nature.[50] To undertake a direct aesthetic translation of our dreams, to engage in automatic writing, or to whirl with dervishes are all illustrations of the ways in which we dissolve our consciousness into the natural order from which we originate and of which we might claim to be mere epiphenomena. If so, revolutions imply merely reasserting the dominance of nature over the arts.

The opposite form of aesthetic alienation is more orderly. As Apollonian artists and their audiences focus their attention on a particular component of the outside world that they absorb and transform into an integral part of their personalities, the abolition

of boundaries between social spaces takes the form of mimicry. When it is successful, this mimicry generates archetypes that become universal as well as eternal. The French use the word *harpagon* to mean a miser, after the model created by Molière. Similarly, we say of a woman we love that she is a Renoir, a Goya, or a Botticelli, and, in the same vein, we tend to view Humphrey Bogart less as a human actor than as the cool, adventuresome, and skeptical character he played.[51] In short, artistic works can be seen as revolutionary insofar as aesthetic alienation produces multifaceted constructions, which loom larger than nature.

Individual artistic statements can also be seen as alienations, and hence as revolutions, when they try to abolish the boundaries between "to be" and "to become" or between present and future.[52] As such, they correspond to utopias. At one end of the continuum they mediate an anticipation of experiences to come and constitute therefore a gamble on the possibilities that the future offers. During the eighteenth century, as the French architect Claude Ledoux designed the city of Arc et Sénans with an eye toward fostering harmonious relations, he anticipated contemporary research on the relationships underlying various architectural and social arrangements. At the other end, artistic statements can also be seen as revolutionary insofar as they blur the boundaries between present and past and recapture the lost paradises of dead illusions. Gérard de Nerval wrote about a "very ancient melody for which he would have given up all Rossini, all Mozart and all Weber, because it reminded him of a blonde lady sitting at a high window, whom he had already seen in a previous existence and whom he remembered."[53]

But the fact remains that the abolitions of boundaries between spaces or times that revolutionary statements represent are not dated randomly. Indeed, the acceptance of such statements depends on the constant negotiations in which artists are engaged both with one another and with their audiences. As artistic revolutions are to be contrasted with phases of normal activities, the first step of the analysis is to identify the processes by which artistic communities reach a significant equilibrium in the definition of the tasks to be accomplished, in the evaluation of these tasks when they are completed, and in the underlying relations among their members or between such members and the outside world. To engage in this analysis is to embrace a limited period of time and to emphasize the importance of the short term at the expense of the

long term. Within the confines of such limited periods of time, artists, critics, and audiences are engaged in a process of give and take, until their interaction stabilizes sufficiently to facilitate and justify the emergence of an aesthetic system.[54] Thus, the purpose of this analysis is twofold. It is to identify the properties and duration of the successive stages underlying the unfolding of artistic negotiations. It is also to show how such negotiations crystallize into paradigms that regulate the definitions of the tasks of the discipline, of the techniques and tools to be used by artists, and of the exemplars summarizing what has already been done and what still needs to be accomplished.[55]

However, these negotiations do not constitute timeless and ahistorical patterns of adaptation. Sources of short-term balances in the organization of artistic activities, they are also both products and producers of long-term discontinuities in the shuffling of the cards of power. As such, they are also subject to pressures associated with the historical forces of disorder.[56]

Thus, any analysis of artistic revolutions also requires references to the long term and the use of large units of time. But even though disorder creates revolutions both in the process and outcome of artistic negotiations, the effects of disorder remain limited. For example, many medieval paintings borrowed their forms from classical models but retained a Christian meaning. Alternatively, paintings that received their substantive inspiration from classical poetry, legend, history, or mythology were innovative in their styles or techniques.[57] This example suggests that artistic revolutions are neither cumulative nor unilinear. For this reason, it is necessary to identify the mechanisms by which a particular paradigm's dominant features are selectively retained or modified as an adaptive response to a changing external as well as internal environment.[58]

Hence, we must locate artistic revolutions by using dialectics between short- and long-term perspectives or between micro and macro units of time. Fluctuations in the "career" of a specific canvas, book, play, musical score, or movie reflect changes in the generic social definitions of aesthetic objects, of their symbolic translations, and of the channels by which they are expected to enter the public domain. Alternatively, the fate or career of specific works also conditions and shapes the generic social definition of these three components of all aesthetic communications. Indeed, individual works tend to be used as precedents that justify the intro-

duction of a particular innovation and, later on, rationalize the formation of a consistent paradigm.[59] As an example, the legitimation of existentialist novels has required the rediscovery and the glorification of such authors as Pascal and Kierkegaard. Similarly, the higher status currently assigned to thrillers in the cinema has necessitated a preliminary homage to the works of Alfred Hitchcock.

Thus far, I have emphasized the need to use differentiated units of time to show how artistic revolutions involve a dialectical tension between the careers of individual works and the generic styles they represent. The same differentiation is required in the analysis of revolutionary shifts in the careers of distinct aesthetic cultures. Along these lines, it is necessary to examine how boundaries between communities of painters have shifted from territorial to functional bases. Initial contrasts between the linear perspectives adopted by the Italian painters of the Renaissance and the principles of *Hochraum*, *Nachraum*, and *Schrägraum* used by their German counterparts persisted as long as the two countries were relatively inaccessible to each other and communication between the two communities was sporadic.[60] Yet such contrasts declined over the years, as German and Italian artists increasingly came into contact with one another. The subsequent formation of artistic subcultures transcending geographic boundaries has been associated with the growing individuation of their ideological orientations. Although members of the Dada movement came from various nationalities and belonged to a wide range of artistic fields, they still sought to differentiate and isolate themselves from those they viewed as opponents. Thus in the arts, as in other fields, the distinction between local and cosmopolitan orientations carries a fixed meaning in the short term but tends in the long term to present successively territorial, professional, and ideological connotations.

Similarly, analyses of artistic revolutions require the examination of changes in relations among initially distinct artistic communities. To what extent is the diffusion of symbols, techniques, or organizational patterns across fields gradual or revolutionary? Changes in the status of various disciplines imply changes in the composition of their personnel, in the symbols they use, and in the organization of their activities. For instance, the need of filmmakers to achieve a higher status has induced a growing number of them to borrow from novelists the grammar governing the symbolic translation of feelings, memories, anticipations, dreams, or behaviors.[61] Nevertheless, this borrowing has also required the in-

vention of symbols corresponding to the specific structure of the medium (soft versus hard focus, color versus black and white or sepia, etc.). In turn, the status achieved by the cinema has facilitated the diffusion of these symbols to the theater, and playwrights, directors, and audiences alike have learned how to understand the meaning to be attached, for example, to the differential lighting of different parts of the stage. Brecht and the Berliner Ensemble, for example, played a significant role in the socialization of theatrical audiences in this regard.

Patterns of diffusion also affect the organizational patterns of artistic communities. In France, the political and economic control of national academies has spread from the most to the least prestigious and from the most to the least organized disciplines (and for example from literature to music). Alternatively, the control of these academies lost its effectiveness among writers before it began to be challenged by musicians or painters, and the corresponding time lag probably reflects the differential changes in the modes of division of labor at work in these various fields.[62] But the question remains to determine whether these successive patterns of convergences and divergences are revolutionary or not.

To summarize, the second objective of this book is to emphasize the variety of times that should be used in order to distinguish normal from revolutionary practices. Whereas this distinction depends on the dialectic between micro- and macrotime, the forms of the dialectic vary with the life cycles of the production of each artistic statement, of each artist, and of artistic communities. Their respective life spans and stages follow a distinct logic. But the "seasons" of works, of their authors and of their audiences, and the revolutions to which they correspond, are both objective phenomena and subjective constructs that are contingent on the seasons of observers. For one thing, there are peaks and troughs in the interest that successive social observers nourish toward various types of art. For another, the explanatory power of the "theories" these observers would like to derive from their analyses is not invariant.

The study of revolutions is rendered even more difficult as a result of two additional factors. First, it is possible to repudiate Brecht's statement that as reality changes, so must change its modes of representation.[63] Indeed to accept Brecht's view is to reduce art to an ideology and to consider that ideology is only a "superstructural" construct dictated by the environment. Yet, the aesthetic recognition of changes in the environment is always selective. As I

will show, the perception of, say, the Eiffel Tower or of the railroads as aesthetic objects did not come about immediately without resistance. While the airplane has entered the category of legitimate aesthetic objects, as far as the cinema is concerned, it has not yet acquired a legitimate status in other visual arts. Furthermore, there may be changes in the modes of aesthetic representation without specific changes in the surroundings. As an example, is it possible to attribute the introduction of nonfigurative art to a specific change in the technological environment of the early part of the twentieth century?

But if the study of revolutions is made more difficult by the relativity of the conceptions we hold toward the interaction between the changes undergone by the environment and those undergone by the arts, it is also made more difficult by the conflicting views we hold about time. Indeed, the reconstruction of revolutions presupposes the adoption of an appropriate dialectic to resolve the tensions between the sociological and historical properties of time.[64] The cumulative and reversible characteristics imputed to the life cycle or successive seasons of various artworks, individual artists, artistic communities, or observers can be contrasted with the discrete and irreversible consequences ascribed to cohort or period effects. When one adopts a purely sociological perspective, the analysis focuses on the positive or negative cumulative influence of aging on the constraints and opportunities confronted by men and women and their ideas in order to identify the successive phases that characterize their careers, regardless of history. Conversely, when one embraces the historical perspective, the focus is on the role played by the succession of historical years, and hence of historical accidents, in order to highlight the specific features of artistic revolutions and counterrevolutions. In short, the visibility of artistic revolutions is diminished when one uses only a sociological time but enhanced when one uses only a historical time.

The Relativity of Revolutions Across Artistic Disciplines

The third objective of this book is to identify the relativity of revolutions across the arts. Clearly, some sociologists recognize the significance of this problem when they distinguish the study of the arts from the study of science by using the plural form in the for-

mer case and the singular in the latter. To contrast a sociology of the arts and a sociology of science presupposes that beauty takes changing and relative forms while the mask of scientific truth remains both permanent and universal.[65] During the Renaissance, for example, there was considerable pressure to create architectural innovation in Italy, but very little in the Netherlands. Alternatively, Dutch musicians of the period were engaged in a revolution that did not affect their Italian counterparts at all.[66]

Variations in the timing, the form, and the objects of revolutions across the arts reflect the specific scarcities represented by the raw materials that each discipline uses. The natural materials that musicians, painters, or writers need in order to create are obviously not alike. Furthermore, scientific or technological innovations do not similarly enhance the opportunities faced by each type of artist. Not only are the technological breakthroughs relevant to painting, writing, or musical activities differentially dated, but also their adoption does not always stir the same resistance or enthusiasm. In addition, contrasts in the "natural" structuring of acoustic or visual communications are both blurred and magnified by contrasts in the history of our understanding of the relevant structures or in the history of the techniques by which such structures might be modified. The histories of the psychology of the eye and of the ear—and of their impact on various arts—clearly differ from each other. Finally, musicians, writers, painters, and their respective audiences entertain varying expectations as to whether art should confirm the pre-eminence of nature over culture or whether art should conversely symbolize the Promethean revolt of man against the blind and unintelligible deities of an irrational nature. The definitions of what nature consists of and of what its imitation implies differ across fields, and the differences among them never remain constant.

Thus, the scarcities with which each art form must deal are not unchanging. There are both conscious and unconscious convergences in the solutions adopted by various fields. In some cases, these convergences reflect mere patterns of diffusion, and a particular discipline simply borrows tools or concepts from another. For example, the use of individuated symbols to deal with the distinct psychological experiences of time (such as the use of reversible jumps between relative pasts and presents) has spread from novels to movies and to plays. Similarly, the institutionalization of academies spread from the literary to the visual and musical arts.

In contrast, convergences may also mirror patterns of independent inventions, as the number of solutions that communities may invent to solve their scarcities is not infinite.

However, to distinguish the relative role played by diffusions and independent inventions in the convergences that characterize changes in the definitions of various disciplines or in their respective organizational profiles, and, *a fortiori*, to decide whether these instances of diffusion or of independent invention are just as many instances of artistic revolutions often represent hopeless tasks. The modern history of painting and photography offers a case in point.[67] For example, the impressionistic depiction of pedestrians on a street—with a few smudged brushstrokes—may be seen as a case of diffusion and more specifically as a by-product of the technical shortcomings of photography at the time, but it may also be seen, conversely, as an instance of independent invention and, thus, as a revolutionary way of dealing with human movement.[68]

Regardless of this ambiguity, the growing differentiation between photography and painting has also been conducive to sharp divergences in the aesthetic and rhetorical choices made by the practitioners in both fields. Early on, both technological and ideological factors induced a growing number of photographers to shift from an urban emphasis to a focus on the exotic aspects of nature, while, simultaneously, many painters undertook the opposite aesthetic journey and shifted their curiosity from rural to urban landscapes. Despite these seemingly contrary journeys, many photographers continued to be interested in the gratuitous collection of unique specimens, visions, or illusions without regard for underlying themes, while many painters kept striving for universal statements.

Yet the two communities have also recently experienced convergent forms of change. Their respective rhetorics have ceased to emphasize the distinctions between the beautiful and the ugly, the unique and the general, the important and the trivial, the dramatic and the comic, or the past-oriented reject and the future-oriented project.[69] Furthermore, as photographers have been legitimated as artists through the admission of their works into established museums and galleries, they have been increasingly prone to claim, as painters often do, that their artistic statements concern their art alone and not some reality to be explored or imitated.

From these remarks, can we infer that the revolutions in photography and painting have been identical? Have these revolutions

spread from one field to the other? Conversely, is it the very differ-
entiation of these two fields, of their respective organization and
ideology, that represents the corresponding revolutions? To summa-
rize, my third objective is to identify similarities and differences in
the changes that affect not only the organizational patterns, norms,
and rhetorics of specific arts but also the relationships of these
worlds to the remaining parts of the social systems in which they
are embedded. In brief, do artistic revolutions present a single
structure or a variety of structures?

The Relativity of Revolutions as Sociological Constructs

The fourth and final objective of the book (which both includes
and underlies the three others) is to take advantage of the substan-
tive conclusions reached about the arts and to meditate about the
methodological and theoretical weaknesses and strengths of the so-
ciological discipline. In this sense, my undertaking is reflexive.[70] In
the sociology of the arts, as in other fields, research findings tell us
as much about the tools used as about the realities described and
interpreted for our benefit.[71] In this sense, these findings inform us
about the common and the specific properties of the tensions be-
tween nature and culture, as they are experienced by artists on the
one hand and sociologists on the other. This information is chan-
neled through the processes by which sociologists select specific
artists, art forms, or art problems as problematic. Why is it, after
all, that Maurice Merleau-Ponty had a strong affinity for Cézanne
and Adorno chose Wagner as exemplifying the problems raised by
the sociology of music?

This information is also channeled through the theories chosen
by sociologists to account for the artistic phenomena they claim to
explain. The resolution of the tensions between nature and culture
concerns sociologists as much as the various artistic communities
they claim to examine. To adopt an exclusively internalist perspec-
tive and to treat artistic communities as though they were islands
isolated from the conflicts within society is to risk confusing an
analysis of an artistic endeavor with an apology for it. Alternatively,
to reduce such an interpretation to an externalist perspective is to
risk removing the role of nature from the creative act, to risk treat-
ing artistic communities as purely conventional, and hence inter-
changeable, and (implicitly or explicitly) to claim unduly that so-

ciology alone can create and impose a legitimate cultural order on the unintelligible noises and agitations of other cultural groups.

Last, this information is channeled through the methodologies retained by sociologists. The validity of sociological generalizations clearly depends on the way they integrate the worlds of actions and perceptions at work in artistic phenomena. Correspondingly, the validity of sociological generalizations depends on the richness of the interactions that observers examine between the conscious models of artists or audiences and the unconscious models that analysis can generate. For example, both artists and audiences elaborate rules and recipes (or conscious models) in order to justify individual access to artistic careers, modes of socialization to such careers, and the organization of artistic activities. More relevant to our goal, they may assert or deny that particular works or practices are revolutionary—and sociologists may be tempted to take their word for it. But insofar as such models are simultaneously a posteriori rationalizations of past practices and previews of practices to come, they are contaminated by the fallacies of paralogics since they evolve within two distinct frameworks that are separate from the creative process per se.

Accordingly, it may be tempting to identify artistic revolutions with the help of unobtrusive measures (for example, to examine how historians of architecture can be clustered into discrete groups defined in terms of the practitioners or of the individual works their studies include or exclude).[72] In so doing, one can identify spatial and historical boundaries of distinct networks and isolate the discontinuities that are the trademarks of revolutions. This particular approach identifies the elements of architectural revolutions as they are reconstructed by critics or historians. But one can also trace more directly the natural history of the choices that architects make with regard to aspects such as materials, rhythms, and forms. In entering these choices into discrete clusters that bypass the explicit value judgments made by these architects on the works of their predecessors or their contemporaries and that are not contingent either on the observations that historians or critics derive from such judgments, one uses an approach which is more independent of conscious models than the first one.

Nonetheless, to ignore conscious models is to arbitrarily enhance the indeterminate character of works of art. In so doing, analysts risk contaminating their analyses of revolutions with the ideological biases generated by the uncertain social status assigned to their own activities.

This cautionary tale about the difficulties of a sociology of the arts betrays my increased concern over the functions of the discipline. Claude Lévi-Strauss distinguishes a first type of social science—which seeks to regulate, forecast, regularize, and more generally enhance social control—from a second one, which seeks to overcome the limitations attached to the social system in which sociological analysis is embedded and hence to achieve a better understanding of all possible, real, or imaginary social structures.[73] To the extent that this distinction is useful, a sociology of the arts requires also a systematic history of the social surveys concerning the arts. Indeed, the function of this history is to differentiate the relative social standing of sociologists and artists and, in so doing, to distinguish sociology as a technique of social control from sociology as a projection of imaginary, albeit plausible, social arrangements.

Therefore, to explore the structure of artistic revolutions from a sociological perspective raises questions about sociology itself. First, there is room for a sociology of the arts only insofar as sociologists acknowledge the unavoidable tension between the autonomous and superstructural properties of specific artistic endeavors. Because the form and intensity of this tension reflect the specific mediation of the dialectical relations between nature and culture that each artistic endeavor represents, there is room for a sociology of the arts only insofar as sociologists acknowledge that their quest follows logically as well as chronologically the quest of artists.

Second, even if there is a place for a sociology of the arts, what is the use of exploring the structure of artistic revolutions? This exploration could in fact promote the control of the art world by privileged segments of the population. But this exploration could also result in an aesthetic construct that may enable different segments of the cultural community to dream of other arrangements and other art forms. In brief, like the arts, sociology is not immune to the tensions between replications of the existing social order on the one hand and revolutions on the other.

The Outline of the Book

In the previous pages, I have underlined the significance of the triad consisting of works of art, artists, and audiences in the reso-

lution of the specific tensions between nature and culture that each artistic discipline represents. I have also emphasized that the concept of artistic revolutions is necessarily relative. This relativity is multifaceted. It reflects the partial properties of the changes provoked by such revolutions. It also reflects the variety of times within which the creation and the appreciation of art evolve. It also reflects the differentiation of the sets of rules governing the definitions of the work to be accomplished by various artistic communities. Finally the concept of artistic revolution is relative because of the relativity of the sociological discipline itself.

Before proceeding further, I must acknowledge that my own enterprise betrays this relativity. To rely exclusively on the quantified responses of individuals who attend concerts, plays, or films or visit exhibitions would certainly have been misleading, for two reasons. Questions regarding aesthetics are automatically loaded with aesthetic values, which would have introduced uncontrolled biases in the responses collected. Similarly, to use only the interviews of artists would involve their rationalizations of their own deeds and misdeeds. (We should remember in this regard that Matisse wanted all artists to remain silent.) In both cases, the analysis would be contaminated by the fallacies which accompany the exclusive use of conscious models. Not only this, but as the analysis would be focused on current artistic landscapes, it would generate distorted images of what artistic revolutions have been about, and of what they may become in the future. At the other end of the continuum, to build unconscious models derived from an analysis of existing networks demands a vast amount of data, which is generally available only for a specific artistic style and a limited period of time; such an approach precludes generalization. Accordingly, the methods and data used here are mixed, which means that the hypotheses and conclusions presented in the following pages are necessarily tentative.

Two additional caveats are necessary at this juncture. First, I may be criticized for developing examples that do not concern non-Western art. Yet, my intent is to explore some of the structures of artistic revolutions and not to draw a catalogue of all the forms taken by all artistic revolutions in all contexts. Second, I may be criticized for relying heavily upon articles published in the *New York Times*. However, it seems to me that journalists of that particular newspaper are often better fieldworkers and historians than many social scientists; their analyses present more often than not a diachronic dimension that is essential for an exploration of revo-

lutions. Furthermore, when the material borrowed from their articles involves value judgments, I would submit that given the influence and prestige of the publication, such value judgments constitute significant indicators as well as generators of tensions between normal and revolutionary views of artistic work.

As the thrust of the enterprise is derived from a critical examination of the themes developed by Kuhn with regard to scientific revolutions, I follow chronologically these themes in the subsequent chapters. Thus, because Kuhn's ideas on scientific revolutions center on the notion of paradigm, the second chapter of this book explores how the concept of paradigm applies to distinct artistic fields and disciplines. More specifically, I delineate the formal properties of the systems of symbolic generalizations, models, and exemplars that are adopted by some or all of the practitioners of various disciplines. However, since the word *discipline* refers not only to the coherence that binds together certain sets of values, ideas, and techniques but also to the social control that their authors exert on one another, I examine both the internal characteristics of artistic communities and their relative vulnerability to outside influences.

At that point, I will have discussed only the structures of normal art. In the same way that the notion of scientific revolutions derives its meaning from the contrasts it offers to the notion of normal science, the third chapter is devoted to an examination of the problems raised by the concept of artistic revolutions and their structure. More specifically, I examine whether the scope and direction of such revolutions are similar for both the sciences and the arts. Most important, I will show that an analysis of the distributions of such revolutions over time is insufficient and that it is still necessary to identify the properties of each one of these revolutions and of the boundaries they form between two successive paradigms.

Yet because paradigms and revolutions represent social constructs, the power of such constructs depends on the beliefs and behaviors adopted by individual artists. To state that there are revolutions is to ask who makes them. Thus, the fourth chapter of the book examines the interplay of the distinction between normal arts and artistic revolution with the life cycle of individual artists. The role played by artists in artistic revolutions often depends on the particular phases of their careers they happen to be in. Yet the profile of these phases varies not only with the organizational characteristics of each type of art but also with the social affiliation

of each artist—and hence with patterns of social stratification. In this sense, the distinction between normal art and artistic revolutions shapes the development of individual careers; but such a development in turn affects the incidence and the properties of artistic revolutions.

To show interrelations between artistic revolutions on the one hand, and the various moments of the life cycle of individual artists as well as their social affiliations on the other, helps introduce a new dimension in the analysis. As artistic revolutions upset the existing systems of interaction between and among artistic communities and their respective publics, the fifth chapter is devoted to a critical evaluation of the determinants and consequences of the patterns of stratification of various art forms within a particular discipline and of the artistic disciplines themselves. In other words, to answer the question "Who makes revolutions?" one must also answer the question "Who accepts or rejects them?" To the extent that the major thesis of the book concerns the relativity of artistic revolutions, the major thrust of this fifth chapter is to emphasize the relativity of the rank-ordering of art forms and artistic disciplines, of their creators and their audiences.

At that point, I will have examined the effects of the distinctions between normal artistic activities and artistic revolutions, between the phases of artistic careers, and between the differing segments of the public. Thus, I will have identified the form, the object, and the relativity of discontinuities and tensions between artistic activities and ideals as well as between the relevant actors or groups of actors. To these discontinuities and tensions correspond recurrent conflicts between the need that artistic communities or their audiences experience to maintain stable and unifying myths and the need to denounce such myths as corrupt and obsolete mystifications. The sixth chapter correspondingly will show that shifts in artistic paradigms are revolutionary only insofar as they do generate and reflect dramatic power struggles among various artistic communities or between them and limited segments of the state as well as of the public at large.

My intention is to show that the transformation of an artistic controversy into a revolution—and hence into a full-fledged "social problem"—depends on a network of dynamic interactions between various forces. First, there is the dramatic potential of the controversy. Dependent upon the nature of the specific issues at stake, the procedures by which they are brought to the public's at-

tention, and the risks which go with the resolution of these tensions, this dramatic potential varies across historical or cultural settings. Second, there are the immediate dramatizing or dedramatizing strategies adopted by claimants, suspects, "courts," and witnesses in order to bring about revolutions or to maintain the status quo. Thus the purpose of chapter 6 is to elucidate the realities and illusions of revolutions in the production or the consumption of the arts, as they are hidden behind the conservative label "social problem." This purpose is also to demonstrate that the dynamics and the relativity of artistic revolutions are not the same when the underlying controversies concern policies *in* the arts (and, more specifically, innovations in the definitions of the tasks to be accomplished by artistic communities and of their organizational profiles) and when such controversies concern policies *for* the arts (and, more specifically, the relations of such communities with political authorities).

In the conclusion, I summarize the similarities and contrasts between artistic and scientific revolutions. But I also demonstrate that the relativity of this comparison reflects the limitations of sociology itself. The reader would like to have a punch line. Yet the power of punch lines in this regard depends on the characteristics of sociological work. Is the discipline an art or a science? If it is "only" an art, how can sociologists claim the ability to offer a convincing understanding of other arts? Are sociologists condemned to pursue their own shadows and confuse them with the "realities" they claim to interpret for the benefit of their fellow men and women? Alternatively, can they, like certain "artists," "alienate" themselves and achieve a more universalistic vision of the social bases of artistic life?

The question clearly is not an academic one, and it has many political implications. Thus, I will conclude the journey by assessing the conditions under which the sociology of art may be more than hidden or overt propaganda for or against specific artistic styles and hence a body of ego- as well as sociocentric statements about revolutions. To bypass the question would be to trick the reader. But it is not enough to plead for a value-free sociology, since this may simply favor the perpetuation of the current social order, as the French philosopher Alain suggested long ago. I therefore conclude my journey by pleading for a reconsideration of the ties that should exist between arts and social sciences on the one hand and between the arts and ethics on the other.

2

The Structure of Artistic Paradigms

All forms of creativity involve risks.[1] When artists begin their work, they cannot be sure that the results they will obtain will be commensurate with their economic, cognitive, emotional, and moral investments. As the inspiration of so many poets, playwrights, or novelists might dry up or generate a product they would like to disavow, their preoccupation with the myth of Pygmalion is certainly not fortuitous.

Nor can artists be sure that the work they offer to public scrutiny will be welcome. Such a work may jeopardize the established economic, political, religious, or aesthetic orders, and their authors may be subjected to various sanctions. During the nineteenth century, Gustave Flaubert was prosecuted for having created in *Madame Bovary* an image of a woman that did not correspond to the contemporary social conventions of womanhood. Similarly, as impressionist painters were accused of overemphasizing fleeting appearances at the expense of stable reality, they were excluded from salons and galleries where they would have been most likely to find clients eager to buy their canvases.

Thus, the assertion is unwarranted that painters or poets can behave like Robinson Crusoe and that, unlike their scientific counterparts, they are free from the obligation to join invisible colleges.[2] The limitation of the risks inherent in the production of culture always requires the institutionalization of the corresponding

activities. To be sure, the form of these invisible colleges varies between the sciences and the arts and among the arts themselves. In contrast to scientific worlds, within which practitioners are directly involved in the production or the evaluation of theories, experiments, and evidence, the affiliation of certain primitive painters (e.g., naive artists, children, mental patients) with art worlds is only indirect. It is mediated by the significant others (dealers, critics) who discover their works and interpret them for the benefit of crucial segments of the public.[3] Similarly, certain painters, musicians, and writers maintain an apparently adversarial relationship with their audiences or their support personnel. Although Charles Ives continued to experiment with polyrhythms and polytonalities despite the claims that other musicians made about the impossibility of performing his scores, the survival of most artists and their works necessitates the existence of communities ready to absorb them and to ease their entry into the public domain.

The functions of these communities are twofold. They facilitate the adoption of a shared definition of the objects and methodologies of artistic endeavors. This sharing of ideas and methods cannot take place without a body of multifaceted social rules. When Johann Sebastian Bach asserts that parts of a composition should behave like members of a selected company who converse together, he reminds us that the rules governing the interaction of ideas and those governing the interaction of their authors are interdependent.[4]

Artistic Paradigms as Shared Definitions of Aesthetic Research

As coined by Kuhn, the concept of paradigm reflects the dual nature of the functions to be performed by scientific communities. On the one hand, the concept refers to the structure and the organization of scientific ideas and values as well as to their integration into a coherent system. On the other hand, the concept refers also to the mechanisms of social control that bind together the practitioners of the same discipline in their professional activities. But can Kuhn's notion of scientific paradigm also explain the functioning of art worlds? For Kuhn, paradigms that are "what the mem-

bers of a scientific community, and they alone, share" have three essential properties.[5] They involve a system of (1) symbolic generalizations, that is, a set of correspondence rules that connect symbols to other symbols as well as to nature; (2) models; and (3) exemplars.

Is it valid to apply these properties to art worlds? To be sure, as early as the nineteenth century, philosophers contrasted the positive nature of science with the romantic character of the arts.[6] Science has been described as the search for truth, striving through the use of objective evidence to identify the determinisms that explain events in the external world. Conversely, art has been described as a search for beauty, trying by means of subjective interpretation to assert the freedom to interpret internal feelings and meanings. Not only are exactitudes of any kind often held to be fatal to poetry, but also beauty is often deemed to preserve us from truth. Even though both scientific and artistic endeavors rest upon a common metaphysical belief in the possibility of overcoming the accidental, scientists are often believed to interpret events in terms of the most consistent generalizations, and artists to look for the symbols that translate most effectively the nature and functions of things into individual experience.[7] "The scientist's personality should be absent of his work, but the seal that the artist's personality imprints upon his production is what makes it a work of art," wrote Eugène Delacroix at the peak of the Romantic period.[8]

These apparent contrasts between the sciences and the arts supposedly affect their respective patterns of growth. The history of science shows cumulative progress, both because and in spite of discarded theories and paradigms that have ceased to serve beneficial functions. In contrast, as artists are believed to consider innovations as ends in themselves, they are supposed to tolerate more easily the simultaneous presence of incompatible traditions or schools.[9]

Yet such differences between the sciences and the arts may be more apparent than real. The rhetorics that contrast these two modes of cultural production are historically relative. During the Renaissance, engineers argued successfully that the arts were impossible without sciences (ars sine scientia nihil est).[10] During the Romantic period, Baudelaire complained that "the deplorable condition of painting was the result of an anarchic freedom which glorifies the individual, however feeble he may be, at the expense of communities, that is, of schools which are nothing but the orga-

nization of inventive forces."[11] John Constable went even further when he wrote, "Painting is a science of which canvases are an experiment."[12]

In addition, while this particular stream of rhetoric subordinates the shape of all artistic paradigms to the shape of their scientific counterparts, another stream suggests that similarities between the two modes of cultural production reflect homologies in their internal differentiation and in their partial subservience to competing philosophical assumptions. "There is more in common between Picasso and Einstein than between Picasso and Rockwell or than between Einstein and any stolid practitioner of dust-bowl empiricism," commented Robert Nisbet some twenty years ago.[13]

Furthermore, both the sciences and the arts are crisscrossed by conflicting definitions of facts. Although in etymological terms facts are things that are made, it remains a problem to ascertain who or what makes them. In the case of both the sciences and the arts, the meaning of symbols is contingent on the isomorphism of the relations between nature and the producers of symbols on the one hand, the artifacts produced and the consumers of symbols on the other. In the case of both the sciences and the arts, there are ensuing tensions between facts and their symbolic translations, which reflect more fundamental tensions between mind and brain, or between the soft- and hardware of human intelligence. Hence emerges the notion of "strange loops," that is, the logical structures of ambiguities that govern the works of mathematicians such as Kurt Gödel, the paintings and prints of Mauritz Escher and the music of Bach.[14] Are the strange loops buried in physical nature? If so, the creativity of Gödel, Escher, and Bach consists merely in isolating the variety of mathematical, pictorial, and musical forms that these loops might take. Or are these loops a by-product of the inadequate relations between the human mind and the human brain? In this latter case the creativity of these three men has consisted in mastering these inadequacies and playing with them. Depending on the meaning given to this riddle, creativity takes two distinct forms.

In both scientific and artistic cultures, terms such as *finding, invention*, and *discovery* suggest that nature precedes human activities and that facts are mere natural creations that human beings seek to capture. This view has generated a long-established artistic tradition that ranges from some artists in ancient Greece and China to Marcel Duchamp. In this tradition, the artist's major responsi-

bility consists of making available to the public the most remarkable signs traced by nature on leaves, driftwood, rocks, or insects. In brief, artists are only privileged witnesses of nature.[15]

In contrast, terms such as *creation* and, above all, *design* suggest that facts are artifacts, that is, syntheses that satisfy their own functional requirements and break the windowpane separating all producers of culture, scientists and artists alike, from the outside world.[16] Hence, the celebrated comment of Georges Braque: "Writers, painters, and musicians are aiming at constructing an esthetic fact," a comment amplified by Picasso's tongue-in-cheek retort to a critic who complained that his portrait of Gertrude Stein did not look like her: "Never mind, it will."[17]

As already noted, the genre of science fiction epitomizes the converging properties of artistic and scientific endeavors based on facts as artifacts. Science fiction novels may stress the liberating effects that this particular conception of facts exerts on the way the human condition is experienced. They may also emphasize the constraints which go with such a conception. Indeed, the expression "brave new world" might be taken at face value, but it might also be read with an ironical twist.

In addition, the work of artists and scientists is shaped by standardized sets of prescriptions and proscriptions concerning the definition and treatment of reality.[18] As both modes of cultural production presuppose perspectives that provide the vocabulary for defining problems and the tools for solving them, they are equally susceptible to tensions between tradition and innovation; and those tensions affect relations between practitioners as much as they affect the creative process of each practitioner. Indeed, the paradox encountered by all paradigm makers, whether in the sciences or in the arts, is that they must posit the innovative properties of a reality that they themselves create and that is, as such, nothing but the product of a specific tradition, if not of a specific biography.[19]

Finally, because of such tensions, it is impossible in science or art to see the concepts of paradigm and of discipline as being permanently coterminous. The development of science involves a continuous succession of "preparadigmatic" periods, during which the practitioners of the same discipline are split among competing schools, each claiming competence for the same subject matter but approaching it in different ways, and of "postparadigmatic" periods characterized by the disappearance of most schools and the

adoption of common converging standards by the survivors. The same holds true for the arts, even though the timing and the sequential order of these periods differ from those observed for the sciences.[20]

Furthermore, Kuhn notes that as a science reaches a sufficient level of complexity, it uses an increasing number of irreducible distinct forms.[21] Is it valid to generalize his remarks to the arts? When some sociologists use the word *conventions* to describe the body of rules governing artistic work, they insist arbitrarily on their dispensability and their idiosyncratic qualities. In so doing, they fall prey to the fallacies of anachronism because the rhetorical and ideological rejection of any code in the arts is a recent and socially limited phenomenon. Indeed, these sociologists forget that for a long time, artists referred to the "canons" of their arts. In music, for example, the word *canon* refers not only to a particular type of musical composition but also to the highest standards to which this type of composition should abide. True, there are differences between the life cycles of scientific and artistic paradigms. True, the banishment of ideas, models, and exemplars deemed to be invalid tends to be total and irreversible in the sciences but not in the arts. But contrasts between the two systems should not be exaggerated. To be labeled abstract expressionist in the American scene implies that an artist respects various specific rules, belongs to a particular network, and is excluded from others. To be part of the French New Wave implies the sharing of common aesthetic goals, an easier access to certain producers or distributors at the exclusion of others. Furthermore, to emphasize differences between the sciences and the arts is to minimize arbitrarily the differences within these two cultural systems. In the same way that paradigms vary across scientific disciplines, they differ between the visual and the performing arts. Similarly, in the same way that paradigms have evolved in physics, they have evolved in the case of architecture.

The Formal Properties of Artistic Paradigms

Insofar as my purpose is to assess whether Kuhn's argument is generalizable to various artistic endeavors, my first step consists of examining whether symbolic generalizations, models, and exemplars—the three properties he assigns to scientific paradigms—

can be applied to artistic communities. In both cases, of course, the function of these paradigms is to define the puzzles to be solved and the techniques or concepts most helpful in resolving them. In both cases, they define the *what* and the *how*.

Symbolic generalizations imply the elaboration of rules of correspondence between form and content. In painting, these rules define on the one hand the ordering of the relations between the size or the form of the canvas used, the dominant shapes or colors found on the same canvas, the relative concentration of lights and shadows, and on the other hand the feelings or meanings to be conveyed. These rules of correspondence imply as well a rank ordering of the objects depicted. The notion of the picturesque requires the elaboration of why trees should be healthy or tortured, why waters should be dormant or stormy, and why buildings should be mansions or ruins. Thus, the notion of the picturesque specifies various conceptions of the position occupied by human beings and their cultures within the realm of nature. These landscapes may be seen as holy texts that reveal truth; but they may also be seen as texts which need to be interpreted, in which case artists can choose what to transcribe and interpret.[22] In prose and poetry, the same rules of correspondence govern the use of vowels and consonants, or of tenses. The accumulation of the letter *a* centered around the imperfect tense in the celebrated opening sentence of Flaubert's *Salammbo* ("C'était à Mégara, faubourg de Carthage.") previews Arthur Rimbaud's more ambitious attempt to impose parallels between vowels and colors.[23] As in painting, however, rules of correspondence may also be more abstract as they relate the rank ordering of meanings and feelings to the social hierarchy of characters, in which case noblemen evoke noble feelings, while common people evoke debased or evil attitudes and behaviors.

In music, rules of correspondence imply the ordering of the relations deemed to exist between the right or the left hand, as far as the piano is concerned; between instruments (as made ironically or humorously explicit by Prokofiev in *Peter and the Wolf*); between performing styles (e.g., glissando or vibrato); scales (notably through the use of sharp or flat notes); or between genres (e.g., sonatas or concertos). These various types of differentiation represent distinct feelings, ideas, or values.

In the cinema, the same rules of correspondence regulate the distinctions between the properties of color as opposed to black and white shots, or of off-screen as opposed to on-screen voices.

Thus, black and white shots in a color movie often evoke a charac-
ter's dreams or memories. Similarly, an off-screen voice may sym-
bolize the consciousness of a detached observer or the memories or
dreams of a protagonist.

In contrast to these rules of correspondence, which are specific
to each discipline, others cut across all artistic fields. Whether in
the visual or the performing arts, this second family of rules of cor-
respondence governs the definition of the optimal context within
which the reactions expected from the public can effectively be
produced. In the case of the visual arts, these rules specify the
color, shape, and size of the frames to be placed around the paint-
ings to be displayed, the number of paintings or sculptures to be
disposed in each room, the light of the background against which
they should stand, and the sequential order in which they should
be presented. In the theater, these rules specify the shape and the
size of the stage, the relationship between décors, costumes, and
lights, as well as the optimal duration of each performance (for ex-
ample, whether a play should be performed in its complete or in its
abbreviated form). Similarly, these rules determine the optimal
length of films as well as the sequential order in which the body of
the work and the credits are introduced. Finally, in musical perfor-
mances, the same rules govern not only the choice of instruments
(e.g., piano versus harpsichord) or of different versions of the same
score but also the sequential order of the pieces presented and the
characteristics of the room in which the public is to listen.

Certain rules of correspondence cut across various disciplines
because they can be understood by all audiences. These rules may
also be universal because of the diffusion of the technological inno-
vations adopted by one discipline across other fields. As an illus-
tration, the successful experimentation of film directors in using
flashbacks to convey the fragmentation of time has been trans-
posed by many playwrights and theater directors. But these seem-
ingly universal rules of correspondence may also reflect the domi-
nance of a particular religious or political philosophy over all art
forms. The dominance exerted by scholastic philosophies during
the Middle Ages has been conducive to a transposition of their
structures in musical or architectural forms.[24] Closer to us, the So-
viet government has sought to impose a transcription of Marxist-
Leninist imperatives into a variety of socialist realist canons appli-
cable to the various artistic disciplines.

Models constitute the second essential component of paradigms.

They may be heuristic and regulate therefore the internal grammar of the symbols used by each discipline to deal with illusions. In the visual arts, these models define the basic elements of composition or of perspective and the color theories to be mastered. In poetry, the same heuristic models specify the principles of poetic perception and hence the structure of verses as well as the forms taken by various kinds of poems.[25] Models reflect metaphysical commitments as well. Thus, all of the arts constantly face tensions between on the one hand the Apollonian faith in the necessity of ordering and sublimating one's feelings and, on the other, the Dionysiac faith in the spontaneous expression of one's raw intuitions or impulses. Similarly, the arts are also characterized by recurrent tensions between the forces of Thanatos, which reduce objects into something immutable, and the forces of Eros, which induce artists to achieve an imaginative and "open" comprehension of the flux of relations among human beings or between them and their surroundings.[26]

Exemplars constitute the final essential component of paradigms. Because artists imitate already established modes of representation as much as they imitate nature, they remind us that while nature is a history, it also has a history.[27] Nature has a history, insofar as artists keep selecting in the archives of their disciplines, the concrete solutions to the problem they face in dealing with nature. These concrete solutions specify the very objects of aesthetic research. "Not until they had looked upon the landscapes of Claude Lorrain, Ruysdael or Salvator Rosa, could [Englishmen] relish the land around them." Alternatively, when Oscar Wilde wrote that there was no fog in London before Turner, he dated the appearance of fog as a socially acceptable object of research in painting.[28] Similarly, we could say that collages became legitimate tools of aesthetic research only after Picasso used them.

These concrete solutions are also stylistic. Artists often rely on paraphrasing, borrowing, or simulating the forms initially elaborated by their predecessors.[29] When paraphrasing, artists introduce a discrete modification of a theme or structure already in the public domain. For instance, Stravinski's *Pulcinella* elaborates the original score of Pergolesi. Similarly, Picasso's *Demoiselles d'Avignon* used *Las Meninas* of Velasquez and *Les Femmes d'Algers* as starting points. When borrowing, artists "steal," purely and simply, parts of a preceding work. Tchaikovsky reproduced some of the rhythms in *La Marseillaise* in the overture *1812*, and Manet, in his portrait of

Emile Zola, reproduced some components of his own *Olympia*. In the cinema, Bernardo Bertolucci took the dance hall sequence from *The Conformist* to make it one of the high points of his *Last Tango in Paris*. When simulating, artists drastically transform the basic elements of the stylistic structures by which they are inspired. In *Play Bach*, Jacques Loussier simulates in jazz the rhythms and melodies typical of Bach, and in many of his paintings, Picasso has accentuated, distorted, or elaborated the patterns that are considered to be typical of African masks and statues.

Finally, the concrete solutions offered by exemplars concern the tools deemed to be most appropriate for obtaining a particular effect. In painting, these solutions refer to the choices that artists make regarding the support, ground priming, paint layers, and protective coating of their canvases. Florentine painters, for instance, started their works with a light ground, while their Venetian counterparts and individuals such as Titian, Tintoretto, and Veronese adopted the opposite approach and started their works with an initially dark ground.[30] In drawing, these solutions concern the choice of vegetal as opposed to animal pens, of various kinds of papers, or of differing kinds of stones (Italian stone, sanguine, and chalk).[31] In music, these concrete solutions imply the selection of a particular type of piano or violin or of a particular method of fingering, and in the cinema they refer to the choice of specific camera techniques.

In contrast to symbolic generalizations and models that represent the more formal universal and abstract properties of paradigms, exemplars make explicit references to places and periods. Indeed, as they symbolize the solutions adopted to cope with a particular problem, they also involve a parallel selection of "heroes" and "masters." Many impressionist painters explicitly referred to the work of Gustave Courbet. Although the painters of the Renaissance contrasted the noble character of their endeavors with the vulgar character of sculpture and argued that, unlike sculptors, they did not need to learn from a master, they still indicated their need to understand the "nobles sciences" available in selected books.[32] In this sense, they still acknowledged the place of individual creativity within a particular tradition, in this case mathematics.

To conclude, symbolic generalizations, models, and exemplars help both artists and scientists to define the puzzles to be solved and the techniques or concepts crucial for such solutions. In the

two systems of cultural production, some of these generalizations, models, and exemplars are shared as minimal requirements by all practitioners. However, in various sciences, some of these components are shared only by the members of a subfield or area of specialization. In the arts, some of the corresponding components are retained by practitioners of the same field and in music, for instance, composers abide by the same general body of rules when they write their scores. But some of the corresponding components may also be retained by artists who, although belonging to different fields, share nevertheless the same artistic commitments. Surrealism offers a case in point. Thus, paradigms are not only fuzzier in the case of the arts than in the case of the sciences, but they are also, as already indicated, less binding in the first than in the second context. Paradigms tend to succeed one another within science but to coexist within art. Furthermore, whereas the obsolescence of symbolic generalizations, models, or exemplars means their death in the case of the sciences, this obsolescence may be temporary in the case of the arts.

Paradigms as Mediations Between Nature and Culture

Although all modes of cultural production correspond to the belief in the possibility of overcoming the accidental, that is, overcoming the blind occurrence of events caused by nature, they are still embedded in the natural realm for two distinct reasons. On the one hand, nature shapes space and time, the two basic categories within which all human experiences are located. Thus, producers of culture suffer from unavoidable natural limitations in their perceptions of visual or auditory stimuli. Their sensitivity to visual illusions such as the Mueller-Lyer figure or the Sanders parallelogram or to the differential length of horizontal as opposed to vertical lines varies with the dominant features of the ecological properties of their environments.[33] In the same way, their responses to sounds depend on whether these sounds are absorbed or reverberated by the surroundings. The dominance of these spatial aspects of nature might explain why it is tempting to attribute contrasts among paradigms to the climate and the light of the countries where artists have grown up or spent most of their lives.[34] Whether consciously or unconsciously, the work of artists may therefore follow "natural" patterns. But neither is the impact of time on these

natural limitations negligible. The music of Beethoven was certainly affected by his growing deafness, as well as the style of Renoir by the crippling effects of a progressive arthritis that caused him ultimately to lose control over his brushes. Similarly, a pianist has recently explained how "Playing on a dull piano, particularly so in the two octaves above middle C, is often conducive to a permanent injury of the right fourth finger."[35] These crippling effects induce changes not only in fingering techniques but also in the relative prominence accorded to the left or right hand by artists in their repertoires.

Nature also affects the distribution of the raw materials that are necessary for creating artifacts. The differential availability of various kinds of clay across regions or countries accounts, at least in part, for the differential geographic development of ceramics. In the same way, geographic variations in the distribution of the vegetal materials with which wind musical instruments are built explain, again at least in part, variations in the growth patterns of the communities of musicians writing for or performing on these instruments.

Yet the arts, like the sciences, also represent the dominance of culture over nature. First, socialization helps artists overcome the limitations that nature imposes on their perceptions of visual or auditory stimuli. Not only does an artist's understanding of a particular literary, musical, or pictorial style increase with the frequency or the duration of his or her exposure to it, but also this understanding is enhanced by the influence of the significant others within the community in which the artist works. This socialization is further facilitated by the cumulative knowledge that artists acquire of perceptive structures. Capitalizing on such knowledge, some of them reconcile nature and culture when they seek through the use of particular drugs (such as opium and mescaline) to modify their creative or performing experiences.

Second, technological changes modify the range of natural opportunities available to artists. The series of graphites and crayons created by Nicolas Conté at the end of the eighteenth century induced artists of the following period (notably Seurat) to explore the entire range of nuances offered by that particular medium. But while these innovations represent specific modes of cultural control over nature, their adoption and retention are themselves culturally relative. The use of pastels was initially exported from France to Italy by Parreal at the end of the fifteenth century and

fell into oblivion in France until the eighteenth century, when Rosalba Carriera, probably the most famous female Italian artist, reintroduced it to France and enhanced its status.[36] Similarly, as far as the cinema is concerned, the widespread diffusion of sound tracks should be contrasted with the geographically and functionally limited character of the diffusion of multiple screens in the showing of films.

Third, the choice of aesthetic objects is influenced by the Janus-like character of nature and culture. Indeed nature *is* a history, because it is made of evolving processes and a succession of patterns of growth and decay. As an example, rivers' profiles are not fixed and, as another illustration, plants go through a succession of phases before rotting in the soil where their growth began. Thus, artistic creation is necessarily limited by the changes undergone by nature; for instance, the painting of still lifes is ultimately contingent upon the rhythm of seasons. Yet, nature also *has* a history, as the human understanding of the evolving processes and life cycles embedded in nature is historically dated. Not only is the human understanding of, say, rivers, contingent upon the emergence and development of geology and hydrography as sciences, but in addition, the use and the particular rendition of rivers as legitimate aesthetic objects are dependent on crucial moments in the history of aesthetics and of the arts.

A parallel distinction applies to culture as well. Culture *is* a history because its major components evolve selectively and because the processes of selection, retention, and mutation that affect the development of the arts escape the consciousness of individual artists and their communities. At the same time, culture also *has* a history, for the conceptions of what culture and cultural changes consist of are all historically dated and vary, *inter alia*, with the turns and twists of anthropology. To return to the example of still lifes, the choice of vegetals or animals considered to be aesthetically acceptable results both from culture as history and from the history of culture.

Furthermore, as the concept of aesthetic nature is a social construct, the forms of which vary with the modes of division of labor, the processes of differentiation and segmentation that affect the relations of people with nature affect as well their relations with one another. These processes modify the human emotions and situations that artists want to describe. They modify as well the organization of artistic work and hence the system of interaction among

all the individuals participating in such a work. In this sense, the arts always loom larger than reality.[37]

However, although both scientific and artistic paradigms represent specific mediations of the tensions between nature and culture, the latter lean more toward the side of culture than do the former. Whereas the validation of scientific paradigms is anchored in the intractable properties of nature (the lack of results with a faulty scientific paradigm becomes self-evident), the same does not hold true for the arts. To be sure, the notion of validation concerns sculpture, ceramics, paintings, architecture, or the cinema, because the aesthetic properties of technical or stylistic innovations must be weighed against their effects on the life span of the work. The same notion also applies to music insofar as musical innovations make a social or cultural difference only if they do not exceed the range of sounds that various performers can produce. On the whole, however, the discovery of the advantages and shortcomings of artistic paradigms leads to rewards and sanctions that are the products of culture rather than of nature. As I shall suggest in chapter five, this is the result of contrasts in the profiles of artistic and scientific audiences.

Artistic Paradigms as Political Institutions

Paradigms organize relations between artistic values and means only insofar as they also regulate patterns of interaction among artists themselves. For example, the canons and fugues written by Bach in *The Musical Offering* were constructed as puzzles to be solved first by Frederick of Prussia and then by all musicians who understood the structure of the underlying paradigm. Bach's use of the word *ricercare* in this context constitutes both the definition of a particular score and an invitation to look for the enigmas he placed in that score. More generally, the range of creative possibilities available to individuals depends on the cooperative relations they establish with their peers, and with the support personnel they need in order to perform their activities. For example, the successful painting of portraits or of nudes requires negotiations between painters on the one hand, sitters and gallery owners on the other. Similarly, the success of recordings or of some live concerts de-

pends on the performance of musicians and on the skills of conductors as well as of sound engineers.[38]

Because division of labor and specialization also generate a formal and informal rank ordering of individual activities, they also generate competition. Thus, a major purpose of artistic communities is to regulate ensuing conflicts. Several mechanisms facilitate the regulation of these conflicts. First, the creation of artistic communities implies the creation of boundaries between insiders and outsiders. These boundaries may be formal. The purpose of guilds during the Middle Ages, of academies during the Renaissance, or of unions during contemporary times has been to limit the accessibility of artistic jobs to fortunate insiders. Such organizations seek to control the kind of work practitioners perform, the materials they may use, the organization of their activities, and the relationships they may have with their patrons.[39] For example, as late as the nineteenth century outsiders such as women could not paint nudes because they were excluded from the academies, which enjoyed a complete monopoly over the use of live models. Similarly, actors today must belong to the Actors' Equity in order to perform certain plays in certain theaters; musicians are confronted with a parallel obligation.

These boundaries may also be informal. Artists who do not share similar definitions of the major stylistic problems to be solved by the discipline enter different groups. In response to the official French painters of the mid-nineteenth century who used the term *impressionism* to ridicule the innovations of such painters as Manet, Monet, and Renoir, these artists in effect closed their ranks to protect themselves from such attacks. They not only sought to formalize theoretical statements acceptable to all of them, but they also tried to enter their canvases into common shows or exhibitions. Informal distinctions between insiders and outsiders also reflect the ambivalent feelings that artists experience toward certain segments of the public. For instance, the jazz that black musicians play in white-dominated nightclubs often differs from the soul sounds they produce in jam sessions.[40] In painting, artists have often sought to hide the seriousness of their statements behind pranks designed to shock the philistines. In all the arts, the frustrations generated by the economic necessity of giving the public what it wants must be compensated for by offering the "real thing" to a select few.

Formal or informal, the boundaries created by artistic communities also involve a rank ordering of the insiders themselves and a differentiation of their central and peripheral members. Like scientists, artists would often like the hierarchy they construct to mirror universal and permanent canons. Thus, at the beginning of the eighteenth century, Roger de Pilhes, an associate member of the French academy, went as far as to suggest the institutionalization of a scale that could rank the painters of all periods and all countries.[41] Even though painters no longer believe in the validity of a universal rank ordering of their talents, the *Ceramic Monthly*, an official magazine of the potters' community, created a scandal in 1981 when it published the names of the ten "best" ceramists in the world. This belief in the quantifiable measurement of talent still characterizes film communities, with their systems of awards. Because of these overt or covert aspirations toward universalism, the differentiation of core and peripheral positions within artistic communities implies contrasts in the amount of contact that artists maintain with one another, in their relative awareness of one another's existence, and in how they make use of one another's works—as well as in the relative visibility of such works among various segments of the public.

In addition, artistic communities are instrumental in socializing artists and audiences to the cognitive norms of the corresponding fields. In other words, they contribute to the formation of the Eminent Domain and, hence, to the accumulation of the knowledge used to evaluate current productions.[42] Insofar as this eminent domain helps practitioners delineate the key problems that they must address, it pertains as much to the "how" (or to the solution) as to the "what" (or to the problem itself).[43] Thus, plays or operas about Joan of Arc necessarily redirect the attention of the public toward the processes underlying the construction of the plot rather than to the plot itself. Most people know the story of Joan of Arc and can accordingly examine more carefully innovations in the rendition or the interpretation of the myth. As I shall demonstrate, however, there may be significant variations in the time orientations that artistic communities hold toward the eminent domain. At one end of the spectrum, the training of new painters previously involved almost exclusively the copying of old masters and was hence based on a glorification of the past. At the other end, there may be a partial or total rejection of such a past, and many current

practitioners may be willing to subscribe to the view that "far from preventing artists from creating, past works forbid them to redo the same thing."[44]

Finally, artistic communities facilitate a routinized coordination of individual roles. In painting, the monopoly that French academies exerted over figure drawing ensured not only a stable rank ordering of genres but also a stable definition of the poses that painters could expect from their models.[45] In music, the role of a conductor is both to guarantee that the musicians' distance from the first chair is paralleled by contrasts in the opportunities and rewards they enjoy, and to coordinate their respective activities.[46] In the same vein, the success of an operatic performance depends on prompters who relay the conductor's tempo, signal entrances, and identify the points at which the singers should start singing.[47] More generally, the difficulties raised by a routinization of individual tasks increase with the accentuation of the division of artistic labor. These difficulties are most marked in multimedia arts such as ballet. The frequent invidious comparisons that dancers and musicians make about their respective contributions induced the famous dancer Margot Fonteyn to be pleasantly surprised when she was asked by the famous conductor Ernest Ansermet whether his tempo was acceptable to her; against this exception, complaints about the poor quality of ballet orchestras are numerous; during the 1970s, a young conductor left the Royal Ballet of Great Britain because he felt he could not maintain his own standards in the face of the dancers' demands.[48]

While the control of artistic communities over individual practitioners depends on the available mechanisms of selection, socialization, and coordination, the effectiveness of this control depends also on the level of individual commitment to the norms regulating the production of culture.[49]

This commitment varies with the tensions between tradition and innovation. Although generally stronger in the sciences than in the arts, this commitment has lessened when scientific research has explored previously uncharted territories, as illustrated by the Apollo expeditions to the moon.[50] In the arts, this commitment depends on two conflicting forces. As all modes of cultural production have the same origin, some artistic fields retain the same imperatives as those dominating scientific life. But other artistic disciplines also experience the increasing weight of individualistic ideologies that consider any rule as inhibiting the authentic ex-

pression of genius. Thus, the norms that govern the social organization and the production of culture tend, at least today, to be more muted within the arts.

The first of these norms is communalism. In order to become social phenomena, artistic works must enter the public domain. Yet there have been significant historical and cultural variations both in the type of art that has been submitted to public scrutiny and in the processes by which such works are effectively displayed. Certain artists, ranging from Hieronymous Bosch to Pierre Bonnard, have protected their privacy and remained silent regarding the history of their creative projects. Other artists have been eager to reveal as much about themselves as possible. Thus, André Gide accompanied the publication of his novel *The Counterfeiters* with the publication of a diary commenting on his experiences while he was writing the novel. Similarly, some painters present to the public only their masterpieces, while others display preceding studies as well. For example, the sketches and details that Seurat completed in preparation for *Un Dimanche d'Eté à La Grande Jatte* have entered the public domain with the final canvas. The evidence made public by artists may also be incomplete. Stendhal's unfinished novel, *Lucien Leuwen*, and Sergei Eisenstein's unfinished film, *Que Viva Mexico!*, offer cases in point, and the same holds true of the unfinished piano sonatas of Schubert, even though some of them have recently been "completed" by the pianist Noël Lee. Similarly, while artistic evidence may be broken or missing, as exemplified by the Venus de Milo, this quality allows other sculptors to present "unfinished" pieces of work, such as Henry Moore's *Warrior with a Shield*, a statue whose left leg is missing. Finally, the norm of communalism, as it affects the art world, may involve different categories of actors. In this regard, we must distinguish among primitive artists individuals such as Facteur Cheval, who, ignoring aesthetic conventions, have produced "raw art" (to use Jean Dubuffet's term) and owed their success to some influential art critics or dealers, from individuals such as Henri Rousseau, whose styles reflect a deliberate choice of techniques at odds with the high art forms of the time.

The second norm to which artists are supposed to subscribe concerns disinterestedness. Invidious comparisons between pure and applied art or between art for art's sake and commercial art reveal the significance of such a norm. In the theater, for example, expressions such as "Broadway" or "théâtre de boulevard" are

often pejorative terms that actors and directors use to castigate other artists for supposedly prostituting themselves. In formal terms, the norm of disinterestedness is used to justify the specific and limited property rights that artists retain over their works; these artists should only aspire to see their works entered in the "estate" or eminent domain of their country or of their discipline. As we shall see, however, the definition and protection of such rights differ across aesthetic disciplines and across countries.[51]

The third norm, universalism, presupposes that the definition of artistic masterpieces does not depend on the personal or social attributes of artists or audiences. Commitment to beauty is expected to override the peculiarities of personal, political, social, or economic allegiances. Yet certain types of art are designed to be appreciated exclusively by insiders, regardless of whether such a word is defined in ascriptive terms (sex, ethnic background, etc.) or in terms of an achievement shared by discrete categories of the population and hence by the members following the same paradigm or school.[52] Most significant, even though the norm of universalism requires aesthetic judgments to be invariant, the same work may successively serve apologetic, conservative, revolutionary, and decadent functions.[53]

The fourth and final norm, organized skepticism, presupposes that artists recognize the relative nature of their creativity and doubt their own works as well as those of others. While this norm justifies the existence of art critics, its effects vary with the relative institutionalization of aesthetic orthodoxies, and with the system of reward and punishment that artistic communities use in order to limit deviance. In certain contexts, artistic deviants cannot gain access to the raw materials they need in order to perform their activities, or their works are boycotted or censored. In other contexts, artistic communities reward the champions of current orthodoxies by offering them awards and other forms of publicity. The point is that contrasts between negative and positive reinforcers and between their technological and economic features cannot but affect the frequency and the types of challenges to existing aesthetic orders. The fact that the Bollingen Prize was offered to Ezra Pound in 1948 has often been criticized as a symbolic attempt by the jury's members (who had come under the poet's influence as an impresario or a teacher) to perpetuate the poetical paradigm of which Pound's work was the most famous exemplar.

Variations in the Functions of Artistic Paradigms as Political Institutions

To emphasize the variability of the political functions performed by artistic communities is to emphasize as well the variability of their structures. The boundaries of such communities may be conterminous with the boundaries of political units, as exemplified in the labeling of certain schools of painting as German, Dutch, or Italian. These boundaries may be institutionalized, as was the case with guilds and later on with academies, or they may correspond more simply to a shared commitment to specific values and methodologies. The coexistence of cubism and surrealism during the same period reminds us in this regard of the links between artistic paradigms and ideologies, as the suffix *ism* suggests the partial nature of the corresponding world views.[54] Finally, while these communities may distinguish individuals who are active in the profession from those who are not, they may also regroup individuals who, regardless of what they do, feel a similar commitment toward a particular style. Musical communities were and still are more homogeneous in this regard than their counterparts in other fields. Writers such as Diderot, Baudelaire, or Kleist exerted a significant influence over painters of their times, and surrealism has attracted painters, novelists, poets, critics, as well as intellectual amateurs.[55]

The structure of these communities varies. Changes in the size and the profile of their memberships, or in the distribution of contacts and professional exchanges among their members reflect, at least in part, technological innovations and changes in the appropriate marketplaces.[56] As technological and economic changes accentuate the overall patterns of division of labor operating in the society at large, they also entail a segmentation of the structures, functions, and orientations of specific artistic disciplines. However, technological and economic changes lead not only to a segmentation of artistic disciplines but also to an accentuated differentiation of individual roles within each discipline. Correspondingly, there are accentuated differences both between and within artistic fields.

The Impact of Technological Change

Technological innovations clearly have modified communications among painters, musicians, and writers, as well as their techniques of production. In other words, technology has modified the terms of the tensions between nature and culture that any type of artistic endeavor seeks to resolve.

Innovations in the Technology of Communication

The development of an artistic community requires that its members have access to their respective works. Thus, the structures of artistic communities depend on the relative development of the technology of communication. Innovations in this technology have had certain uniform effects on the spatial and social arrangements of communities. Scattered over the years, such innovations have consistently lessened the importance of face-to-face contacts and modified the tensions regulating the modes of cooperation and competition at work in various fields.

Painters were the first to be affected by innovations in the technology of communication. Historically, the systematic replication of pictorial statements preceded the systematic replication of written words.[57] However, the possibilities initially offered by such a replication were few both because of the restricted access to the necessary tools or raw materials and because of the lack of standardization of the appropriate techniques. Copies were limited, as was the homogeneity of the symbols used to describe the specific nature of objects and the relationships between volumes and voids. Correspondingly, the range of aesthetic problems that communities of painters could share was quite narrow. During the Renaissance, the different aesthetic orientations of German and Italian schools reflected in part their geographic isolation and in part variations in their techniques of reproduction. Furthermore, the qualities of craftmanship that such techniques required made the choice of the objects to be replicated highly problematic. In contrast to painters who based their selection on the intrinsic merits they assigned to original statements, engravers' choices revealed, above all, their desires to display their skill.

The subsequent differentiation and rationalization of replica-

tion techniques have increased divergences between the require-
ments of visual creation and of visual communication. Engraving
became an autonomous artistic discipline when the systematiza-
tion of lithography liberated artists, craftsmen, and audiences
from the quantitative and qualitative constraints attached to ear-
lier and more primitive techniques of reproduction. This greater
rationalization of replication techniques had two opposite effects.
As it enlarged the number and the complexity of the problems
shared by individual painters or designers working in different
cities or countries, it enhanced the universality of their commu-
nities. As it lowered the importance of the socialization functions
of artistic communities by reducing the need for face-to-face con-
tacts, it made these communities less homogeneous. For that very
reason, paradigms and disciplines ceased to be conterminous.

Later on, the introduction of photography had similar conse-
quences. During the mid-nineteenth century, photographers tried
primarily to obtain a less expensive, easily reproducible, suffi-
ciently accurate, and aesthetically pleasing rendition of the human
face.[58] Because they were competing with traditional portraitists,
they did not hesitate to retain already established codes and ask
their models to pose picturesquely. Neither did they hesitate to re-
touch their prints and, for instance, to add colors in order to mini-
mize the "revolutionary" aspects of their medium and satisfy the
needs of a middle-class clientele ready to accept only tame innova-
tions. The portraitists' response to the commercial success of pho-
tographers was equivocal. Renoir wrote that artists should be
grateful to Daguerre for having liberated them from the tedious
work required by portraiture—a genre increasingly considered
to be minor and debasing—and for having opened new fields of
aesthetic research.[59] At the same time, however, Renoir criticized
Daguerre for having discouraged upper-class women from making
amateur portraits since the activity had enabled them, despite the
mediocrity of their talents, to understand and appreciate the work
of professionals.

The evolution of photography has changed both its aesthetic
status and its relationship with painting. On the one hand, it has
become an increasingly affordable and more exact tool of reproduc-
tion. Providing an easier access not only to past and contemporary
masterpieces but also to the raw materials (landscapes, animals,
etc.) of aesthetic objects, photography has inspired a greater diffu-
sion of various types of aesthetic statements and lowered even fur-

ther the control that the artistic establishment could exert over individual artists.[60] On the other hand, photography has become a legitimate art form, borrowing its themes and its techniques from painting, but stimulating also the imagination of painters themselves.[61]

More recent events in music present an analogous example of the effects of the technology of communication. The mass production of records has reduced the need for face-to-face contact among musicians. The availability of recorded music has freed many amateurs and certain categories of students from the obligation of learning how to read a score: they can learn music simply by playing tapes or records over and over again.[62] Further, this mass production of music has fostered a split in musical communities; certain performers prefer to work in studios while others consider the concert hall as the privileged locale of their activities.[63] Last and most important, the production of recorded music has intensified competition among young performers. The improved quality of recorded music raises the level of performance that musicians expect of themselves—and enables them to compare their activities with an external standard.[64]

Although it is too early to reach valid conclusions concerning videotapes, their introduction may have a similar effect on acting and dancing. As videotaping becomes both a more accurate technique of documentation and an autonomous aesthetic system, it liberates apprentices from the control exerted by established masters, and it sharpens the existing differentiation of tastes and of careers by creating new opportunities. But it also exacerbates competition because it enables actors and dancers to compare their successive performances and to internalize with greater ease the requirements of their own standards.[65]

Finally, innovations in the technology of communication have also reduced face-to-face contacts for writers. Gone are the days when the absence of typewriters obliged writers to read aloud their manuscript to a select group of friends, critics, or sponsors rather than send it to them for criticism. Gone are the days when Flaubert read aloud the 1,500-page manuscript of *Madame Bovary* to Maxime Du Camp and the editor of a provincial literary magazine.[66] The introduction of the typewriter and more generally of various kinds of printed documents has also modified the internal organization of literary activities. In the past, an aspiring writer could begin his career by acting as secretary for an established literary fig-

ure (Stendhal described the apprenticeship of Julien Sorel during his stay with the De La Mole family in *The Red and the Black*). But the diffusion of typewriters had two consequences. It lowered the status of secretarial roles. Furthermore, as it enhanced the legibility of the successive versions of a manuscript and facilitated increase in the number of their copies, these versions lost their imputed qualities of scarcity. The depersonalization of manuscripts rendered authors less likely to retain their first drafts and to allow them to enter the public domain. In turn, this probably changed the role of literary experts whose original tasks were, among others, to establish critical editions of a masterpiece and evaluate the successive modifications introduced by the author.[67]

Innovations in the Technology of Production

The development of a community depends also upon the range of tools and techniques that its members might use to produce their works. Changes in the technology of production have inspired more diversified effects. Not only have these changes encouraged the formation of new disciplines but they have also modified the nature of existing ones. Such changes have been conducive to the fragmentation of paradigms in painting and to the institutionalization of such paradigms in the cinema. These changes have had contradictory effects in the case of music, as they have simultaneously reinforced some aspects of existing paradigms while weakening others.

The invention of paint tubes in the mid-nineteenth century liberated artists from dealing with the scarcity of essential materials, whose source was usually concentrated in such privileged places as art schools or academies.[68] The effects of this innovation were twofold. Individual painters were able to leave their studios and to broaden the scope of the aesthetic problems deemed to be significant by attacking more directly and more systematically the difficulties raised by urban or rural landscapes. As a result, their communities became centered on shared values rather than shared necessities. The same innovation also abolished existing patterns of division of labor within the profession. As the earlier scarcity of painting materials necessitated a rank ordering of the tasks to be accomplished by students and by masters, it accentuated competition between schools rather than between individuals. In contrast,

the new availability of mobile sources of paint marked the abolition of a formal hierarchy of activities within a school and enabled individuals to compete more freely with one another.

Other technological changes have fragmented artistic paradigms and modifed the patterns of division of labor within artistic communities. Thus, the introduction of computers (e.g., Hiroshi Kawano in his *Artificial Mondrian*), of laser holography (e.g., Margaret Benyon), or of closed-circuit television has generated a new set of relations between painters and engineers and reduced the common problems that most members of the profession shared.[69] In this sense, innovations have both broadened and differentiated the ways in which the visual arts deal with the tensions between nature and culture. Through the use of new instruments, technology enables some artists to explore the randomness imputed to nature; it enables others to achieve a tighter control on the regularities imputed to the natural realm.

At the other end of the spectrum, the concentration of cinematic means of production, the growing complexity of the economic organizations specializing in such production, and the corresponding accentuation of patterns of division of labor have acted as necessary, albeit insufficient, conditions for the establishment of film communities isolated from the society at large. Without the emergence of such structures, filmmakers would have been unable to elaborate collective styles.[70] In this sense, innovations have simultaneously enlarged the ways in which the cinema handles the tensions between nature and culture, and reduced the number of choices permissible to individual practitioners. Despite the wider range of technical solutions available, directors are increasingly subjected to the scrutiny of professional communities.

The musical world has been subjected to a series of opposite forces. The mass production of standardized high-quality musical instruments initially minimized variations in the range and the sound of the notes produced. Accordingly, it has facilitated the development of paradigms binding composers and performers alike.[71] As long as this standardization remained limited, the development of certain musical genres (such as piano duets) was restricted—because of disparities in the size or properties of keyboards and of the resulting adjustments that performers had to make.[72] More recently, the development of electronics has entailed a new set of relations between composers, performers, and sound engineers through the creation of new instruments (e.g., the Moog

synthesizer) and hence of new roles. Finally, as composers, like painters, increasingly rely on computers to write aleatory pieces, their communities become further fragmented by the corresponding emergence of new discontinuities in musical grammars.[73] In this sense, innovations have not only broadened the scope of potential musical solutions to the tensions between nature and culture; they have also encouraged the fragmentation of paradigms available to individual musicians.

In contrast to the universal effects of innovations in the technology of communication, the effects of innovations in the technology of production are therefore more diversified. While they have been instrumental in the institutionalization of a dominant world view in the case of certain disciplines, such innovations have blurred the boundaries that previously differentiated artistic from technological requirements in the case of other disciplines whose initial unity has been subsequently jeopardized.[74]

The Changing Effects of External Economic Forces on Artistic Communities

The social control that artistic communities exert on the activities of individual artists involves the definition of truthfulness. Indeed, despite the divergent routes followed by scientists and artists, artists have remained bound by critical sets of beliefs concerning the definition of nature, reality, and creativity. The control that artistic communities exert in this regard depends on their vulnerability to outside economic forces. This vulnerability reflects the patterns of division of labor prevailing at the level of society at large and hence the status of artists and of their publics, considered both independently and in relation to each other.[75]

Initially, the social distance separating artists from their patrons enabled patrons to control both the social definition of the literary, pictorial, theatrical, or musical problems to be solved and more generally the professional and personal lives of painters, writers, musicians, actors, and other types of artists.[76] During the early part of the seventeenth century, Salvator Rosa was one of the first painters to challenge the excessive vulnerability of visual paradigms to external forces and to claim that he was "painting for

his own satisfaction and pleasure rather than to please his clients."[77] Similarly, in the early eighteenth century, Henry Bannister was one of the first composers to have his music performed without the assistance of the sponsors who dominated the musical scene during earlier periods.[78]

But as writers, painters, composers, and performers began to choose their own means in their search for public recognition, their endeavors heightened the anxieties of audiences, who feared that they would be mystified or cheated by individuals they treated with a mixture of disdain and jealousy.[79] Afraid that their approval or rejection of a particular style would condemn them as philistines, audiences increasingly sought the services of experts, whose role was to interpret texts, canvases, scores, etc., and hence to help such publics form an educated opinion of the works to which they were exposed.[80] Correspondingly, critics who acted initially as the guardians of orthodoxy or truthfulness among practitioners, became go-betweens, educating the public but also preparing the artists for the vagaries of the market.

However, changes in patterns of division of labor and social stratification have not affected all artistic disciplines simultaneously with the same intensity. Correspondingly, variations in the relations of critics with the producers of specific cultural forms and with their respective audiences tend to increase. Because of these greater variations, there are also greater contrasts in the ideal definitions that disciplines give of their relations with nature.

The Segmentation of Critics' Roles Across Disciplines

Around the middle part of the past century, the role initially played by writers as critics of other artistic activities began to decline. For a long time, the pre-eminence accorded to literary arts enabled poets, novelists, and playwrights to pass judgment on the merits of the works of painters and musicians. Even though Diderot's pictorial assessments, for example, were severely criticized by Renoir, the *Salons* served to either confirm or invalidate the notoriety and fame of many eighteenth-century painters. During the mid-nineteenth century, Baudelaire was instrumental in enhancing Delacroix's success, and Eugène Fromentin tried to achieve fame by being simultaneously a novelist and an art critic seeking to rediscover the significance of certain early Dutch painters. Al-

though contemporary writers may still want to evaluate the contributions of other artistic forms (Robert Brasillach, for example, is as famous for his novels as for his history of the cinema as an art form), the number and the salience of their reviews have declined. In short, division of labor has fostered a greater individuation of artistic communities. Versatility, which used to be highly rewarded, has become a stigma, as it becomes increasingly believed that a jack of all trades is a master of none.

The Segmentation of Critics' Roles Within Disciplines

Although division of labor also entails a differentiation of the critics' role within each discipline, the evolution of such a role differs between the visual and the literary arts on the one hand and the performing arts on the other. Until the nineteenth century, boundaries between painters and critics were often loose. Painters often acted as externalist critics insofar as they advised wealthy collectors concerning the authenticity and quality of the objets d'art they intended to acquire. Painters used this mode of survival not only in the Netherlands but also in France, where the fame of Charles Lebrun, for instance, reflected partly his skill at rediscovering certain old masters whose canvases had fallen into oblivion.[81]

Today, however, the boundaries between the roles of painters on the one hand and various types of critics on the other are more clearly delineated. These critics who hold internalist aspirations seek primarily to define the standards toward which artists should strive. Those who hold externalist functions are primarily interested in shaping the tastes of potential collectors or sponsors and in orienting their investments. The French contemporary theoretician André Lhote, for example, is especially known for his critical definition of what a landscape should look like. Alternatively, Clement Greenberg has contributed to the growth of the abstract expressionist market. In so doing, he has offered a definition of what modern art should look like. But because such a definition is externalist, its status is fraught with uncertainties.[82]

The same segmentation has occurred in literature as well. Initially, the distinction between the roles of poets or playwrights and of internal critics was not particularly visible; Samuel Coleridge and Alexander Pope, for example, owed their reputations as much to their critical essays as to their poetry. However, as early as the

nineteenth century, Charles Sainte Beuve established his creden-
tials as a significant and influential evaluator of literary produc-
tions, but he failed simultaneously in his endeavors as a novelist.
Today, the boundaries between the roles of writer and of internalist
critic continue to be loosely defined (T. S. Eliot, Ezra Pound, and
Jean Paul Sartre are known both for their theoretical statements
about what literature should be and for the exemplars they offer of
the corresponding styles), but the number of critics whose func-
tions are to identify best sellers and to enhance their commercial
success has increased with the diffusion of mass media and the cor-
responding broadening of the market.

In contrast, the position that critics occupy within the perform-
ing arts has remained virtually unchanged. Musical critics gen-
erally have remained separate from composers and performers:
Franz Liszt is one of the few musicians who owed his fame to his
reviews as well as to his compositions and his performances. Con-
versely, the boundaries between reviewers and playwrights have
been and remain fuzzy. Since the first public performances, theater
critics have been suspected of biases either for or against the play-
wrights whose works they are supposed to evaluate. The failure of
certain contemporary plays continues to be imputed to conspir-
acies; the weight of such charges is, of course, accentuated by the
short life span of most productions.[83] The recurrent economic crises
experienced by the theater in America or in other countries of
the Western world generate such a fear of unfavorable judgments
that some plays, such as A Chorus Line, run for weeks or even
months before being officially evaluated by the specialized press.
Frequently enough, the situation is further complicated by the fact
that a critic has written a play and wants to see it performed. As a
matter of fact, the same pattern characterizes the cinema as well;
in France, for example, many reviewers of the Cahiers du Cinema
are also directors (e.g., François Truffaut, Jacques Doniol Valcroze,
and Eric Rohmer).

The Segmentation of the Concept of Truthfulness Within and Across Disciplines

As division of labor regulates the functioning of specialized art
markets, it also influences how distinctions between high and low
art forms affect the creation and perpetuation of specific paradigms.

Thus, although initially all artistic disciplines have stressed the dependence of aesthetic statements on their "truthfulness" (that is, their conformity with a certain model of nature), the definitions of this term have followed different trajectories in each field.

In the visual arts, patrons initially controlled the supposed truthfulness of paintings by specifying the objects to be depicted, or the shape and colors to be used. Between the seventeenth and nineteenth centuries, the role of these patrons declined in various parts of the Western world as academies became institutionalized. In France, the monopoly that these academies exerted on the sales of individual canvases liberated artists from the whims of private collectors. But this centralization also obliged painters to adopt an orthodox style that left little room for idiosyncratic variation. In contrast, the increased decentralization characteristic of the seventeenth- and eighteenth-century English and Dutch art worlds allowed a greater variability in styles and hence a looser definition of the term *truthfulness*.[84]

At the end of the past century, the development of numerous privately owned galleries—stimulated as much by the growing cultural aspirations of the bourgeoisie as by the abolition of the monopoly previously exerted by academies—provided an economic infrastructure indispensable to the coexistence of competing paradigms. This infrastructure has been further reinforced by changes in the acquisition policies of museums. Driven out of the market of ancient paintings, they began supporting new painters under the assumption that a work that enters a permanent collection gains a value that benefits the other works of the same artist or of his or her peers.[85] These changes in the economic infrastructures of the art world induced an institutionalization of the notion of avant-garde and a parallel shift in the criteria underlying aesthetic judgments.[86] Correspondingly, the equating of "better" and "newer" became as salient as the equating of "better" and "older."[87] It is therefore sheer nonsense to claim that "there is no longer a questioning of the veridicality of an aesthetic statement."[88] The fact is that communities of painters entertain different definitions of veridicality. Their laudative or derogatory use of the word simply reveals their differential vulnerability to various groups of patrons.

In music, the notion of truthfulness reflects both the invariant spatio-temporal constraints of performance and the variable appeal of distinct syntactic structures. As already noted by Leonardo, music must die as soon as it is born.[89] In other words, music is con-

sumed in the very act of its birth. Furthermore, a concert or an opera involves the offering of a succession of works (rather than their simultaneous presentation) to a limited audience that is gathered at a particular moment in a specific location. These constraints have always enhanced the risks that musicians take vis-à-vis the public and have induced them accordingly to equate truthfulness with acceptability.

Yet this acceptability is also contingent on the structural properties of each musical genre. Musical styles can be differentiated from one another in terms of their positions on two distinctive continua.[90] On the one hand, these styles specify a varying number of organizational principles (melody, rhythm, pitch, timber, among others). Thus, classical music specifies a larger number of such principles than the various forms of its popular counterparts. On the other hand, these principles can act independently of one another or be integrated into more encompassing schemes. Thus, jazz is independent insofar as each soloist enjoys numerous melodic and rhythmic choices that are constrained only by chord structures. In contrast, serial music is highly integrated, insofar as the organization of notes, rhythms, pitches, and themes reflects an ever-encompassing larger scheme.

To the extent that a style based on a limited number of independent organizational principles (e.g., popular music) leads to the production of discontinuous series of structurally invariant works, its acceptability is often a function of how it is packaged. In other words, this acceptability often depends on the choices made by sponsors or musical directors with regard to sound, light effects, lyrics, or the artist's public image.

Alternatively, in the case of styles characterized by a varying number of organizational principles differentially related to one another, innovations imply either successive distortions of the initial structure (e.g., acceleration of the rhythm or addition of chords in the case of jazz) or a slow metamorphosis of each component and their interaction (e.g., classical music, Mozart, and Brahms). The acceptability of such innovations by the public requires an a priori knowledge of initial structures. This acceptability therefore depends on the risks that performers and composers independently or jointly take in handling those structures. The negotiations of such risks are culturally and historically contingent. Since the Romantic period, these risks have been influenced by two competing forces. While "historicism" induced Robert Schumann to posit the

pre-eminence of written scores over performing styles, the opacity imputed to higher musical forms induced performers to emphasize the pre-eminence of their own styles in this regard.[91] Thus, the truthfulness of musical forms is often contingent on the status that the public derives from hearing the music of a well-known composer, or alternatively, from appreciating the style of a well-known performer.

In the cinema, the notion of truthfulness is often associated with the audience's acceptance of cinematic statements. In other words, such statements must be able to be read legitimately in different, but not mutually exclusive, ways. In early films, this truthfulness was socially unstructured and tended to be achieved accidentally by artists who were able to reconcile the conflicting demands of their financial backers with their own individual— hence idiosyncratic—aesthetic needs. The films of Charlie Chaplin offer a case in point. The later development of more coherent film paradigms reflects the combined intervention of industrialization and ideological developments. The industrialization of studios induced the integration of initially segmented roles into a rationalized and bureaucratized network. The effects of this new structure have been reinforced by the markedly ideological responses of certain directors and producers to deep societal crises, such as wars or revolutions. Thus, the first full-fledged film paradigms were developed in Germany after World War I (expressionism), in Russia after the revolution (dynamic realism), and in Italy after World War II (neorealism).[92]

This first crystallization of cinematic paradigms enabled an increasing number of directors to claim a higher status for their activities and hence to define the truthfulness of their works in terms of the precedents borrowed from other artistic forms or from movies already entered into the category of art. As a journalist recently suggested, "modern artists finding themselves with no shared conventions tend to build on older works of art."[93] Thus, the film *Henry V* was inspired by medieval miniatures and imagery that it tried to replicate. During the 1970s, the even higher status attained by film paradigms has allowed the use of specific references to prior cinematic works. Thus, Antonioni's preoccupation with voyeurism in *Blow-up* becomes transformed in Francis Ford Coppola's *The Conversation* into an examination of the ambiguities surrounding eavesdropping.

Finally, it is in literature that the evolution of the concept of

truthfulness is most complex. The particular nature of this medium has always induced writers to elaborate extensively on the properties of the term. During the seventeenth century, the search for truthfulness implied the borrowing of substantive themes and stylistic artifacts from classical Roman and Greek writers. The term was therefore synonymous with faithfulness to the truths embodied in ancient literature. During the eighteenth and nineteenth centuries, the term began to refer more explicitly to the abstract conceptions of nature and history, which were viewed as regulating both the human relations deserving literary statements and the symbols to be used in describing them. At the end of the nineteenth century, however, the development of a mass market blurred the boundaries that had separated "high" and "low" literary cultures. As has been the case, later on, with films, the creation of a literary mass market has made truthfulness contingent on whether a book can be read innocuously in different ways by distinct populations of readers. But increases in the overall level of formal schooling have facilitated a succession of challenges against the prevailing definitions of which human relations should be the objects of literary statements and of their appropriate symbolic translations. Thus, as is currently the case for painting, the segmentation of literary tastes produced by such challenges leads to a parallel fragmentation of the definition of truthfulness and its desirability.

To summarize, changes in the effects of marketplaces on artistic paradigms are as diverse as those of technological innovation. Although these changes have uniformly modified boundaries between pure and applied art forms, they have also produced divergences in the time orientations of the various art forms. The worlds of painters and, to a more limited extent, of musicians and writers have become dominated as much by the fear of obsolescence as by the glorification of precedents. In contrast, the shift of the cinema from popular to high art has entailed a progressive accentuation of the virtues imputed to the past. These divergences in the time orientations of various art forms have generated diverging modes of socialization. Thus, the abolition of the privileged status accorded to past paintings has led to both a decline in the socialization functions of museums—which have become increasingly regarded as the cemeteries or hospitals of the arts—and a lowering in the pedagogical significance attached to the copying of older canvases.[94] In contrast, the privileged status according to past artworks by the

cinema has implied a concomitant rise in the socialization functions performed by film clubs, societies, or cinematheques.

Conclusions

This chapter has been devoted to an examination of the differential influence that paradigms exert on the organization of distinct aesthetic activities. Within each paradigmatic framework, "normal art" enables artists within a community to share the same sets of symbolic generalizations, models, and exemplars, and it accordingly offers a specific resolution of the dialectical tension between nature and culture. Like their scientific counterparts, artistic paradigms are binding insofar as they define both the puzzles to be solved and the means of solving them. The distinction between figurative and nonfigurative objects in painting, between "ancient" and "modern" writers in seventeenth-century French literature, or between octaphonic and dodecaphonic grammars in music offer examples of the boundaries between artistic paradigms. Indeed, they specify not only what the puzzles consist of, or the frameworks within which solutions are to be found, but also the kind of support that practitioners who follow the rules may expect from their peers and their audiences.

Unlike scientific paradigms, however, artistic paradigms have an increasingly variable scope. In painting, they may bind practitioners in terms of the objects of artistic research, of the symbols used to represent such objects, or of the materials (brushes, types of paint) to be used; but they may also be more limited and pertain to only one of these variables. In music, certain paradigms specify only the scores to be played, but others specify what fingering or instruments performers should use (as in the case of the music of the Baroque period). The same variations characterize the theater; the Berliner Ensemble under the direction of Brecht or the theater directed by Stanislavski were notorious not only for the types of plays they performed and type of discipline they imposed on actors but also for their definition of sets and lights—in short, for their conception of the entire communication to be established with the public.

The greater variability of artistic paradigms reflects the greater variability of the extent and the form of control that artistic communities impose on the relations of cooperation and competition that their members develop with one another. These variations result from the differential internal properties of these communities and, more specifically, from the composition and socialization patterns of their respective memberships. These variations result also from external factors, and more specifically, from differential changes in the technology of production and communication used by these communities, as well as from changes in the markets to which they cater. In both the past and the present, these changes have affected not only the definition of the values of truthfulness and of innovations to which artists are expected to subscribe but also the extent and the form of the conflicts between these values. Thus, while successful scientific revolutions alter the outlook of an entire discipline, successful artistic revolutions have a more limited impact. They imply the creation of new communities both within and across disciplines, even though the longevity of these communities is often problematic.

This analysis so far has focused on the structures and functions of artistic works and of the communities within which they are embedded. Yet to stress the relationships existing between artistic paradigms and communities from a synchronic perspective is to focus exclusively on the significance of normal art. This focus is arbitrary, for the meaning of the notion of such normal art depends on its contrast with the notion of artistic revolutions.

3

The Structure of Artistic Revolutions

To merely state that artistic activities, like their scientific counterparts, involve paradigms that regulate patterns of interaction between facts, tools, and values, and hence between individual practitioners, is to adopt an atemporal or ahistorical stance. As the production of culture is subject to an essential tension between tradition and innovation, the processes by which cultural communities manage such tension and shift paradigms remain uncertain. In this sense, the meaning of normal art, far from being absolute, is contingent on the meaning of artistic revolutions.

Therefore, we must distinguish revolutions from mere changes. This distinction is clearer when the notion of paradigm is equated with the concept of puzzle solving. Insofar as this particular metaphor suggests that aesthetic objects are endowed with finite properties, paradigms are analogous to mathematical series.[1] In both cases, the choice of any position reduces the number of remaining alternatives. Indeed, this choice both defines and reduces the range of options still available. For example, the number of changes introduced in French classical tragedy declined significantly from the middle to the later part of the seventeenth century. The number and significance of innovations adopted by Pierre Corneille or Jean Racine decreased as they got older and the repertoire from which they borrowed their themes became depleted. In other words, the revolution introducing drama as a legitimate theatrical genre was

71

possible only after the opportunities offered by tragedy had been exhausted. The same holds true for painting. The early stages of pointillism enabled painters to remain within the confines of the same paradigm, when they could change the color, size, and shape of the points in order to describe the effects of light. But after a time, they progressively exhausted the solutions initially sketched by Seurat. Thus, the cubist or fauvist revolutions could not take place before impressionism and pointillism had run their full courses. Within the confines of canons and fugues sketched by Bach and his contemporaries, composers could experiment with the rhythm of the repetition as opposed to that of the introductory theme; the pitch of the initial theme and its repetition; the timing used to introduce the repetition itself; and the direction of the reproduction, which could reproduce the introductory theme directly or in a reverse form. But when these possibilities were exhausted, it became necessary for composers to change the paradigm itself.

Insofar as revolutions correspond therefore to the end of a series, they represent abrupt changes of content and expression, which involve the development of a new language characterized by a set of new morphemes and an unfamiliar grammar. As Georges Kubler notes, the Western system of artistic inventions was transformed around 1910, almost as though people all over had suddenly become aware that the inherited repertoire of aesthetic objects, techniques of symbolic translation, and mechanisms regulating the entry of artworks into the public domain no longer corresponded to the meaning of existence. Yet, the observation of Kubler which amplifies an analogous remark—or was it warning, or a hope?—of Virginia Woolf privileges unduly one event or period at the expense of previous or more recent revolutions.[2]

The fact of the matter is that the breadth of revolutions is highly variable. They can involve changes in fundamental ideologies underlying artistic pursuits. Tensions between the forces of Eros and Thanatos, between Dionysiac and Apollonian aesthetic ideals, or between gratuitous and politically oriented conceptions of the arts not only represent conflicts between opposite logical or ethical principles; their resolutions also take different forms at different historical moments.

Revolutions may be more limited, concerning only one component of existing paradigms (symbolic generalizations, models, or exemplars). First, they may involve shifts in the definition of aesthetic objects. In literature, these revolutions concern changes in

the cast of characters or behaviors deemed to be problematic. "Unnatural" forms of love (e.g., homosexuality), which belonged to the world of the "unspeakable" until the end of the nineteenth century, became acceptable concerns after the publication of novels by Gide or Jean Cocteau. In painting, the mechanized décor of modern cities with their streetcars, cranes, railroads, and other Eiffel Towers was legitimate only after the pioneering work of Manet, Pissarro, and Sonia Delaunay.

Artistic revolutions can also concern the use of new symbolic or material tools. In literature, transformations in the structure of verses, the relativization of the meanings assigned to personal pronouns whose referents are rendered ambiguous, the introduction of automatic writing styles based on the unconscious, and the differentiation of the typography used are all cases in point. In the visual arts, these revolutions can involve the introduction of a new medium (such as acrylic) or the juxtaposition of media exemplified by Ruth Duckworth's recent work with three-dimensional ceramics and two-dimensional backgrounds. In sculpture, revolutions can consist in introducing new materials such as papier-mâché or iron. In music, such revolutions have led to the adoption of a new grammar (dodecaphonic or atonal music), new instruments (e.g., Ondes Martenot, Moog synthesizer), or instruments previously considered to belong to lower art forms (Jean Wiener, for instance, wrote a concerto for accordion).

Finally, as paradigms regulate artistic communications between practitioners and audiences, revolutions drastically alter the ways in which works enter the public domain. In the visual arts, "happenings" or "earthworks" seek to minimize the limitations imputed to museums. In the theater, the elimination of spectators from the stage constitutes an example of an internally induced revolution insofar as it enabled actors and set designers to explore new theatrical illusions. But it also illustrates an externally induced revolution, not only insofar as it reflected the growing professionalization of theatrical companies and the end of their domestication by prelates and princes, but also as it transformed the physical symbols of the stratification of audiences.[3]

Artistic and scientific revolutions therefore share the following properties.[4] Both involve a dialectical relationship between newer and older paradigms. A new paradigm is continuous with its predecessors to the extent that it grows from the failures imputed to their symbolic generalizations, models, or exemplars. Even though

the new paradigm takes over many components of its predecessors, it revises their meanings to fit with the new definition of the task to be undertaken. Accordingly, revolutions take two distinct forms. On the one hand, they legitimate objects, styles, and tools that were considered previously to be anomalous or erroneous. On the other hand, revolutions impose a new perception of objects or styles that are already part of the eminent domain, as illustrated by both the ironical transformations that the Mona Lisa has undergone over the years and the reinterpretation of well-known myths in modern theater (e.g., Hamlet, Antigone, etc.).

Both scientific and artistic revolutions can be imputed to internal and external causes. From an internalist perspective, increases in the number of practitioners conforming to an established aesthetic or scientific philosophy end up limiting the opportunities that the philosophy first offered, and which accordingly necessitates innovation. In other words, as artistic or scientific communities grow, so grows the likelihood of revolutions, simply because of the wear and tear of established ideas and techniques. From an externalist perspective, changes in patterns of social stratification cannot but modify the expectations held by various segments of the population toward the production of culture. As artistic or scientific communities draw their new members from new social strata, they experience both new constraints and new opportunities.

At the same time, artistic revolutions differ from their scientific counterparts in terms of the number and profile of their respective actors. On the whole, a scientific revolution is successful when it immediately lures a critical number of key practitioners from competing models, despite notable exceptions such as Mendel's work in genetics, which was not immediately used by researchers in the field. In contrast, the revolutionary achievements of a painter or musician are not necessarily incorporated immediately within the two fields. In the sciences, the primary arbiters of a revolution are a researcher's peers. In the arts, the general public plays a more significant role in this regard. Rather than eliminating the paradigms under attack, artistic revolutions tend to generate a mere shift in the audiences to which the corresponding works of art are directed. In this sense they are more partial than their scientific counterparts.

Against this definition of the formal properties of artistic revolutions, we must examine how their history reveals a dialectical resolution of specific tensions between simplification and differ-

entiation in the definition of subjects and objects. Following this historical account, I will discuss the relativity of the notion of revolution and evaluate the degree to which it stands for progress or for regression, after which I will attempt to describe its empirical properties.

The History of Artistic Paradigms

The histories of artistic and scientific paradigms in the Western world show marked convergences. These convergences have resulted from the diffusion of certain assumptions or techniques across fields, as exemplified by the explicit references that the artists of the Renaissance made to mathematics or the references that Seurat made to the works of Eugène Chevreul and O. N. Rood concerning the theory of color.[5] But revolutions in both systems of cultural production may also reflect processes of independent inventions; it is noteworthy in this regard that certain contemporary painters have considered fortuitous the similarities of their works with the outlook of microbiological plates.[6]

These convergences suggest that the secularization of cultures, which is a trademark of the Renaissance, has been initially conducive to an analytical differentiation of the relations deemed to exist between human beings and nature and hence between human beings themselves. This analytical differentiation has followed a definite sequential order. First, it has involved a systematic exploration of the universal properties of the location of objects in space, which has been followed both by a similar exploration of the properties of time and a reconsideration of the position occupied by subjects themselves on the spatio-temporal continuum.[7]

Medieval Modes of Cultural Production

Until the end of the sixteenth century, all artistic and scientific endeavors were dominated by a common set of religious preoccupations. The universe was believed to mirror a divine design, that is, a divine intention and structure that evenly pervaded human and natural activities and experiences. The purpose of artistic en-

terprises was to open the doors to a better understanding of God's ideas and desires.[8] The search for this understanding was accompanied by a marked differentiation in the concept of similitude. *Convenentia* referred to similarities resulting from the proximity of things and beings. It differed from *aemulatio*, which described the tendency for things and beings to imitate one another without direct physical contact. On a more abstract level, *analogies* concerned similarities between the relationships that bind together parts of the same entity. Analogies differed in this sense from *sympathies*, forces that could render things identical to one another, causing them to lose parts of their identity. These distinctions, between immediate and intermediate and between material and spiritual effects, were used to demonstrate and glorify the pervasive and permanent influence of God on cultural phenomena. The arts of the period illustrate the complex web of interactions between the sacred and the profane. In painting, the attributes of God, man, and nature are juxtaposed on the same plane. In the theater, actors and audiences are juxtaposed in front of cathedrals, and in literature grotesque and heroic characters or behaviors are similarly juxtaposed.[9] Shared preoccupations over the divine properties of diagonal lines that were seen as binding various natural orders to one another account for the structural commonalities that characterize the musical, architectural, and philosophical styles of the period.[10]

The Exploration of Space and Matter

With the secularization of human societies during the Renaissance, artists began to adopt a more experimental approach in their treatment of aesthetic objects and notably of the relationship between perception and illusion. In the context of slowly emerging new paradigms, artists and scientists attempted to reduce the tension between subjects and objects by postulating that the positions held by subjects were constant and universal and hence that all people shared the same understanding of the external world. The simultaneously descriptive and normative properties of the Cartesian "cogito, ergo sum" made it possible to explore more systematically the qualities of space and matter. In other words, both artistic and scientific endeavors focused on the identification of the pre-

hensive (or integrating) and separative properties of space, to use here the terminology of Alfred North Whitehead.

In painting, the systematic exploration of the continuity, measurability, and infinity of space induced a corresponding analysis of the relations between space and matter, void and volumes, distance and intervals. Thus, experiments made with the camera obscura facilitated the identification of a grammar that could illustrate the geometric unity of the universe. To be sure, this general paradigm evolved slowly and its early members (such as Masaccio) used the rules of perspective and of the vanishing point more accurately in treating the backgrounds than in treating the foregrounds of most of their canvases. Regardless of the paradigm's relative progress, its testing required two sets of assumptions limiting the variability of the perspectives held by painters or viewers. The treatment of canvases as theatrical stages demanded not only a universally fixed distance between the subject (the eye of the artist or of the spectator) and the object, or between the subject and the ground, but also a restricted range of objects (types of landscapes, still lifes, body postures) deemed to be aesthetically problematic.[11] In short, the paradigm relied upon a number of significant constants or restrictions.

The paradigmatic preoccupations shared by writers during the Renaissance and the following periods were analogous. In the theater, the growing recognition of tensions between subjects and objects induced a rationalization of the theatrical illusion and a more systematic definition of the distance between stages and audiences.[12] In other words, the same principles of continuity, measurability, and infinity that dominated the space of canvases also dominated the space of theatrical stages. The growing concern over the essential properties of human nature, viewed as the primary object of theatrical research, necessitated the use of other methodological rules as well. The unity of action, space, and time imposed on tragedy aimed at enhancing the simplicity and hence the dramatic appeal of the human quest for a better understanding of man's fate. The rationalization of rhetorical illusions served the same purpose, with its shift from a descriptive to a prescriptive type of grammar, and a parallel increase in the number of restrictions imposed on stylistic effects.[13] Finally, the full exploration of theatrical or literary illusions was accompanied by the introduction of an appropriate rank ordering of the corresponding genres

and of the types of characters that each of the genres was supposed to evoke. The casting of princes and kings in tragedies implied man's nobility; the presence of servants only enabled the major characters to verbalize their doubts and hesitations without being artificial. The social transparence of servants therefore highlighted the public nature of the personalities they served.[14]

The Introduction of Time, Experimentation, and Relativity in Artistic Paradigms

By the end of the eighteenth century, artists and scientists began to turn their attention to a more systematic investigation of the prehensive (or integrating) and separative properties of time. In addition, the growing emphasis on the notion of experimentation induced the introduction of systematic variations in the position held by subjects. The notion of nature became more problematic, a development that was accompanied by a diversification of both the objects considered aesthetically legitimate and the relations seen as binding such objects to artists on the one hand and to the public on the other.

The increased investigation of time corresponds to a growing consciousness of evolving processes. In painting, this consciousness generated a parallel preoccupation with the problems raised by fluids, light, and movement. In this context, the description of objects ceased to be an end in itself. Rather, objects came to be used primarily as a support or a background for the light playing on them. The paintings of Georges de La Tour offered previews of this new problem, which later was treated more systematically by Monet in his *Nympheas* and his series of Seine canvases, in which he charted how the effects of colors vary with light—that is, with the passage of hours or seasons. This notion of light was further explored by Russian Rayonists, notably Mikhail Larionov, who sought to show the colliding and coupling effects of rays on objects and on their relations. Finally, in his celebrated *Nude Descending a Staircase*, Duchamp tried to transcend the instantaneous but static property of the space offered by a canvas and, hence, the human inability to render the temporal component of movement. Giacomo Balla pursued the same goal in *Dynamism of a Dog on a Leash*. Their endeavors were paralleled even more abstractly by the Russian painter Leon Chasnik in his *Suprematist Color Lines in*

Horizontal Motions, in which he attempted to identify the blurring effects of movement on perception.

A similar evolution has characterized literature. Inspired as they were by Newton's discoveries regarding light, English poets such as Pope celebrated that discovery directly.[15] Guillaume Apollinaire later evoked the fluidity of the spatio-temporal framework of human experience in his famous verse "Sous le pont Mirabeau coule la Seine et nos amours." More explicitly, the recognition of the various properties of time has facilitated the transformation of tragedies into dramas, which allow a more differentiated manipulation of time. Above all, this recognition has facilitated the systematic development of novels and the exploration of the tensions between individual biographies and the history of their social surroundings.[16] The exploration of the multifaceted properties of time has been conducive to a parallel differentiation of novels. Thus, the discovery of the fragmentation of time caused by the growing bureaucratization of social systems has modified the choice of aesthetic objects made by novelists and hence, the character of their heroes. While early novels focused on the crises experienced by the central characters, the key figures of more recent works have become "anti-heroes," mere witnesses of disintegrating social relations.[17] But the exploration of the multifaceted properties of time has also been paralleled by a search for the literary symbols that capture most faithfully its complexity. Marcel Proust, James Joyce, and their followers sought to identify the symbols that would render most adequately the weight of duration in the flow of consciousness. Dos Passos and the writers he influenced have intended to find the symbols most appropriate for translating the discontinuities of the various times experienced by differing individuals or groups.

The performing arts have followed a parallel evolution. In the theater, August Strindberg focused on the cumulative effects of past events on current modes of social interaction, while Chekhov focused his research on the infinite series of mirrors between past and present experiences.[18] Similarly, musicians began to differentiate pure tempo from pure rhythm, as illustrated by Maurice Ravel in his famous *Bolero*. More recently, the multidimensionality of time has been differentially explored by jazz artists like John Coltrane, who tried to play as many notes as possible within a single bar, and Miles Davis, who creates tensions through the manipulation of silences.

The second change affecting aesthetic paradigms concerns the notion of experimentation and the introduction of systematic variations in the position held by artists or viewers vis-à-vis the object. Renoir capitalized on these variations in order to identify the properties of a tactile as opposed to a visual space.[19] Similarly, Degas and Toulouse-Lautrec attempted to emphasize the dominant qualities of an object seen from below or above the viewer. In literature, the systematization of experimentation has generated two differing types of research. It has fostered an exploration of the boundaries between the conscious and the unconscious and, hence, the introduction of uncensored dreams as an acceptable aesthetic object. Experimentation has also encouraged an erosion of the fixed boundaries between tenses and between personal pronouns. As an example, the boundaries of the pronoun I—which used to refer consistently to one character at a time—have become increasingly blurred, its referents increasingly contingent on context.

The third change in the profile of artistic paradigms has involved a growing stress on the constructed nature of aesthetic realities or facts. In this sense, there has been a shift from a logic of facts to a logic of propositions.[20] This emphasis leads to a systematic diversification of aesthetic objects. From the middle part of the past century onward, painters began to acknowledge the aesthetic meaning of technological artifacts (Monet and the Saint Lazare Station, Delaunay and the Eiffel Tower, etc.). This evolution culminated in the elaboration of pure colors, shapes, and lines as major aesthetic problems, and painting became increasingly detached from traditional material supports and increasingly oriented toward pure methodological research. In ceramics, there has been a parallel blurring of the distinction between functional and purely aesthetic objects. In sculpture, this evolution has been conducive to the substitution of open planes for solid masses. In literature, this evolution has inspired not only an increase in the number of social relations deemed to be aesthetically significant but also an increase in the attention paid to the interaction between the process and outcome of creativity. Thus, in *Six Characters in Search of an Author*, Luigi Pirandello reminds us of the double reality of the relations between the characters and the actors who play them, and between the characters and the author. Similarly, in *The Horrors of Love*, Jean Dutourd builds a dialogue between "him" and "me," that is, between the author as writer and the author as witness or collector of experiences, in order to identify the key di-

mensions of the creative process. The dialogue, in turn, acts as the background against which Dutourd develops his substantive plot. In short, regardless of their disciplines, modern artists place more emphasis on the construction of reality and on its relativity than on reality itself.

But although all artistic disciplines have increasingly tried to overcome the limitations of time and of the irreducible "otherness" separating object from subject and producer from consumer, the corresponding dilemmas have been resolved in a variety of ways. Today, some painters try to transcend the boundaries of time by engaging in "performance," works that usually involve several media and aim at being an ephemeral rather than enduring statement. Others seek to transcend the boundaries of the canvas by doing earthworks, artificial landscapes which attempt to abolish the restrictions of traditional definitions of pictorial space. Another group of painters try to transcend the unavoidable inadequacy of the relationship between objects and their symbolic supports. Some of them attempt to achieve their goals by translating their intentions into purely conceptual and hence written comments. Others transfer the burden of proof to the viewer, who is either expected to create specific aesthetic spaces, as in the case of installations, or is asked to state what he or she would like to have seen within the blank space offered for inspection. Yet another group capitalizes on the well-established tradition of the *trompe l'oeil*, making ironical comments on the deluding effects of illusions on the distinctions said to exist between painting and architecture, or between reality and fakery.[21]

Parallel preoccupations characterize the current literary scene. Thus, "lettrist" poets or playwrights seek to play with the properties of raw linguistic symbols, regardless of their references to particular meanings, while other writers seek to de-emphasize their own input, as exemplified by Truman Capote and Norman Mailer in *In Cold Blood* and *The Executioner's Song*.

The same concern over the fundamental inadequacies of symbolic systems and of aesthetic communications has affected the musical world as well. In his work *4′ 33″*, John Cage asks the pianist to walk on stage, to sit at the piano for an amount of time equal to the title of the piece, and to depart without playing a single note. Furthermore, Knud Viktor collects the sounds of shivering leaves or swallowing snails, but other composers seek to reproduce faithfully the sounds of an industrial environment. These last two "solu-

tions" to the inadequacies of musical symbols cannot but confirm the power of the tensions between nature and culture present in all artistic endeavors. In one case, what is left is the fact as data; in the other, the fact as a pure construction.

To summarize, both artistic and scientific revolutions have successively distinguished the concepts pertaining to space, to time, and to the relations between subjects and objects. Both types of revolutions contain contradictory movements toward parsimony on the one hand and a proliferation of distinct subcultural forms on the other.[22] More specifically, the substitution of humanism for the initial mystical vision of the world has been accompanied by both a broadening of scientific and aesthetic problems and a parallel restriction of the solutions for coping with them. As early as the turn of the last century, the systematic introduction of time as a scientific or an aesthetic problem, the growing sense of the ambiguity underlying the relations between subject and object, and the resulting challenges launched against the idea of nature have all simultaneously blurred and accentuated boundaries between disciplines. Accelerating the succession of scientific paradigms, they have fragmented further the variety of paradigms that govern artistic disciplines.

The Relativity of the Direction of Artistic Revolutions

To use the notion of revolution in order to describe shifts in paradigms—as I have done here—raises once more the question of whether any comparison between the development of the sciences and the arts can be valid. The history of science is often described as a history of scientific progress for two opposite reasons. On the one hand, scientists immediately discard less efficient paradigms in favor of new versions that supposedly explain more fully the phenomena being described. On the other hand, scientists often minimize the significance of ensuing paradigmatic shifts in order to emphasize the continuity of the work undertaken by successive schools or generations. In other words, there are scientific revolutions only insofar as they are later rendered invisible.[23]

The situation is necessarily different in the arts that lend themselves more easily to the coexistence of competing paradigms: the

same works are simultaneously as well as successively susceptible to competing interpretations. Both the coexistence of competing artistic paradigms and their respective as well as relative survival induce art historians and philosophers not only to assess whether artistic changes are evolutionary or revolutionary but also to ask whether these changes imply progress or alternatively decay. Thus, some of these historians and philosophers decry the supposed decadence that marks modern art "for being a denial of culture and going over to the side of the latest and most original forms of individualism."[24] Others seek to establish parallels between the evolution of painting and the developmental patterns of individual cognitive growth and conclude accordingly that the history of the arts is conterminous with the notion of progress.[25]

This second school of critics labels pre-Renaissance paintings as *enactive*. For these critics, these paintings reflect a lack of differentiation between psychological and physical realities and suffer in this sense from egocentric and sociocentric biases, to use here the terminology of Jean Piaget, the source of their inspiration.[26] These critics consider the period stretching from the Renaissance to the end of the nineteenth century as *iconic*. They contend that the artistic research of that period seeks primarily to enhance the verisimilitude of its representations, an objective that assumes nature's invariant and universal properties. Methodologically, the painters of that period sought to solve the problems raised by the projection of objects into a Euclidean space and therefore emphasized the notions of perspective, shadowing, and rotation in space. Finally, these critics call modern art *symbolic*, because it is essentially concerned with the construction of logical systems that cease to refer to empirical reality. Intending to discover a logic of propositions, *symbolic* artists are concerned no longer with the relations between objects but rather with the relations between parts of the same logical constructions.

It is tempting to apply the same evolutionary scheme to the histories of other disciplines. Although music, for instance, is intrinsically more abstract than painting, its history could be viewed as containing alternating cycles of enactive, iconic, and symbolic modes. While the enactive modes would characterize Gregorian music, many composers, ranging from Jean Philippe Rameau (in *The Hen*) to Claude Debussy (with his *Garden Under the Rain*), or even Arthur Honnegger (in his *Pacific 231*) have sought to build an iconic music and to make explicit reference to empirical reality.

While the symbolic mode is already present in the work of J. S. Bach, it is primarily with the emergence of dodecaphonic or serial music that composers have tried to elaborate purely abstract propositions or systems.

However, to claim that parallels exist between the evolution of artistic paradigms and the dynamic set of interactions of individual learning and maturation raises several disturbing questions. For one thing, these parallels are alien to Piaget's own position. To be sure, he emphasized analogies between sensorimotor, symbolic preoperatory, and abstract modes of thinking at the individual level and techniques, ideologies, and sciences at the collective level. But if he demonstrated that shifts from one stage to the next follow a definite sequence in the case of individuals, he was careful not to suggest a similar evolutionary sequence as far as the development of culture is concerned. In the same way, it can easily be demonstrated that the wisdom acquired by successive cohorts of artists is not always cumulative. Modes of selection and retention in the cultural legacies that various groups of painters, musicians, and writers borrow from their predecessors or transmit to their successors vary over time. The range of aesthetic choices may be restricted by natural factors, and, for instance, by the amount of differences in colors, shapes, sounds, etc., that individuals living in the same physical environment are able to perceive. Although the range of individual choices is broadened through maturation and learning, the elaboration and restructuring of these choices nevertheless reflect major discontinuities in the history of each field and the history of the larger societies in which artistic activities are embedded. As an example, the wealth of inventions displayed by Russian painters during the first two decades of this century has not been systematically exploited or coded by their successors both because of the marginal position occupied by Russian artists in the dominant Western art world and because of the rejection of such innovations by Soviet authorities. In short, although the development of individual creativity between birth and adulthood tends to be linear and cumulative, that is not the case with the development of artistic disciplines.

In addition, while each stage of individual cognitive growth implies changes in the resolution of the tensions between inward-oriented (assimilation-dominated) and outward-oriented (accommodation-dominated) patterns of adaptation, these changes are supposedly independent of the environment. Again, this is not the

case as far as stages of cultural development are concerned, because their evolution involves institutional changes as well. Indeed, each of these stages is characterized by specific trends not only in the average features of individual works of art but also in their variability. This is because of the specific modes of socialization and social control used by the artistic communities of each period.

Thus, although the iconic stage or period presupposed a focus on an accommodation-dominated mode of aesthetic adaptation, the acquisition of such a mode was still contingent on an assimilation-dominated mode of teaching that forced students and apprentices to imitate established masters and to accommodate to both their requirements and those of nature.[27] As existing modes of social control obliged individual artists to move slowly from an accommodation- to an assimilation-dominated mode of adaptation both in their works and in their professional interactions, they limited necessarily the number of paradigms artists could generate or follow during their careers. In contrast, insofar as the symbolic stage assigns a higher value to assimilation and to the pre-existing logical or emotional outlooks of individual artists, the current teaching of artistic techniques requires art instructors to accommodate to the needs and aspirations of students. The resulting contradictions between the practice and the teaching of the arts induce necessarily a greater differentiation and instability of existing paradigms. In contrast to the institutional arrangements of the past, contemporary patterns of artistic socialization accentuate individual differences, and this evolution is quite revealing of the ambiguities underlying the concept of abstraction. The term implies not only generalization and simplification but also subtraction, and more specifically the progressive removal of the bonds that artists used to experience through the sharing of a common purpose.[28]

Like its counterparts, regression or decadence, the notion of progress in the arts presupposes unduly that beauty, like truth, is a transcendental and fixed entity. Yet in the sciences as in the arts, revolutions seem simply to entail a greater differentiation of the definitions of the tasks to be mastered and of the methodologies required to that effect.[29] To paraphrase Donald Campbell's remarks abouts the relativity of scientific revolutions, to argue that "the vessels of the arts change the planks of their hulls one at a time," illuminates the effects that changes in the number, size, and color

of these "planks" exert on the overall appearance of the vessels; it does not say anything, however, about their bearings.[30]

Under these conditions, revolutions may be constructs that vary as much with the evolving characteristics of paradigms as with the evolving positions of observers. Instead of passing definitive judgments on the progress or decadence of the arts, it seems therefore more appropriate to merely identify temporal discontinuities in the succession of paradigms that follow one another over time. Revolutions, then, correspond to significant contrasts among the distinct sequences or series of definitions of the tasks to be accomplished by various disciplines. In this sense, revolutions are merely a posteriori reconstructions of art history.

Revolutions as Social Constructs

To see artistic revolutions as social constructs helps emphasize their inherent ambiguities. Scientific revolutions can be tested in terms of the relative attraction that the new paradigm exerts immediately on most of the significant practitioners in the field. Conversely, artistic revolutions have different meanings when they emanate from the artists themselves and when they are made by outside observers. The increased value assigned to individualism and innovation causes many painters or writers to assert that their works are revolutionary. In contrast, art historians and critics are more inclined to test the limits of artistic revolutions, to trace the origins of their exemplars, and to evaluate them in terms of their systematic age—that is, of the position they occupy within the system to which they seem to belong. In other words, artists would like to see their works as an open class of events, but historians and critics tend to see such works as belonging to a closed series and to stress the relativity of revolutions. In other words, historians and critics, like artists, accept the notion that revolutions represent a major discontinuity in the solutions adopted to resolve the tensions that constantly oppose tradition to progress; unlike artists, however, these historians and critics emphasize the problems raised by the notion of discontinuity. In identifying various types of series and their respective properties and in establishing connections be-

tween the notion of series and the notion of revolution, they seek to determine in what sense revolutions are relative. More specifically, they seek to demonstrate that revolutions constitute the very discontinuity that separates series from one another. Kubler has identified four such series.[31]

The first two types (intermittent and arrested series) emphasize the cyclical nature of artistic revolutions. In other words, they show how the thrusts of particular paradigms often become temporarily submerged because of either pressures toward innovation or the constraints of an environment hostile to the art forms characteristic of such paradigms. In this sense, these first two types minimize the importance of artistic revolutions. The changes in the choice of aesthetic objects, symbolic techniques, or the mechanisms of entry of artworks in the public domain that revolutions claim to have produced seem to be more apparent that real. Indeed, these choices have already been made once (as in the case of arrested series), or more than once (as in the case of intermittent series). In short: "Plus cela change, plus c'est la même chose."

An intermittent series is characterized by the cyclical preoccupation of artistic communities over a particular aesthetic object or methodology. In painting, for instance, the use of tempera fell into near oblivion after the discovery of oil painting in the fifteenth century, before being rediscovered by Andrew Wyeth, or by the artists painting the federally sponsored frescoes and murals during the Depression. The same holds true of the theater regarding plays within plays, a style that had been used successfully during the seventeenth century by Corneille in *L'Illusion Comique* and then underwent a long eclipse before being resuscitated by Pirandello in *Six Characters in Search of an Author*. Similarly, in jazz, Jean-Luc Ponty has rediscovered the possibilities offered by the violin, many years after the use of that particular instrument by Stéphane Grappelli.

An arrested series refers to a paradigm that is renewed after its rejection by a hostile environment. Such a paradigm may regroup the succession of works inspired by the artist who was "misunderstood" during his or her career. In architecture, Ledoux's neoclassical use of pure geometric forms in his utopian community of Les Salines, built in 1779, inspired the hard abstractions of the twentieth century's international style. Similarly, in writing *La Princesse de Clèves*, Marie Madeleine de La Fayette paved the way for

the systematic growth of psychological novels. Finally, in the cinema, the fruitless efforts of Abel Gance or D. W. Griffith to enhance the dramatic power of the film image were ultimately incorporated in this medium after the introduction of new projection techniques, such as cinemascope.

Extended series reduce revolutions to particular instances of diffusion. They mirror the dependence of colonies on mother states or of "minor" on "major" arts. In South America, both the organization and the dominant styles of architecture long reflected the conventions prevailing in metropolitan Spain during the years of the conquest of the New World. In more general terms, insofar as every major artistic center exports its innovations to a broad hinterland, it is not surprising to observe time lags in the emergence of the same art forms at the core and the periphery of the same cultural system. This diffusion, however, is selective and innovations tend to diffuse from the core toward the periphery rather than in the reverse direction. The work of the "peripheral" Malevitch, for instance, has been eclipsed by the discoveries of the "core" Mondrian. The patterns of diffusion that characterize extended series in a geographic space apply to functional or social spaces as well. Thus, the successful novels that are located at the core of contemporary literature are often adapted to the "peripheral" arts, such as the cinema or the theater. Similarly, certain canvases that represent the peak of "high" culture may later be exiled as décors for the model homes of a "low" culture.

"True" revolutions are the trademarks of simultaneous series that characterize the periods subjected to violent tensions between traditions and innovations, between exhausted formulas and novelties. During such periods, certain ideas, themes, or techniques are borrowed from a more or less distant past and may therefore be described as teleguided. In contrast, others represent deliberate rejections of established traditions and are therefore self-guided. Thus, simultaneous series imply the exposure of individual artists to competing forces. Many contemporary arts offer examples. Boundaries between avant-gardism and retrospectivism have become increasingly blurred precisely because the extreme form of avant-gardism involves a rehabilitation of specific stylistic patterns that is based on their very obsolescence. Thus, to state with so many contemporary writers, actors, or painters that "nostalgia is no longer what it used to be" sums up the ambiguities of simulta-

neous series, since the "no longer" suggests a regrettable discontinuity in the experiences of successive cohorts of artists, while nostalgia refers to the fascination of a past deemed to be invariant.

The Natural History of Artistic Revolutions

To establish a taxonomy of artistic series and to treat them as social constructs that enable observers to achieve a better understanding of the discontinuities that characterize revolutions is to keep the analysis at an aggregate level. As such, this approach does not seek to document the variety of processes that mark the shift from one paradigm to the next. Insofar as artistic revolutions imply the fall of a paradigm and the rise of its successor, their study as generic phenomena also requires the identification of the successive phases that mark the life cycle of paradigms. For this reason, I am suggesting here that there may be analogies between the processes characterizing the evolutions of little science into big science and of little art into big art.[32] Indeed, the patterns underlying the birth, growth, and death of a particular stream of values, ideas, and techniques should be similar across various modes of cultural production.

Like their scientific counterparts, artistic revolutions rarely take place randomly at various points of the logistic growth of one paradigm. This logistic growth, which refers to the amount of time necessary for a paradigm to reach a visibility twice as large as the one it had at the time of its emergence, can be measured in terms of changes in the numbers of (a) artists committed to its dominant traits, (b) the works of art of these artists entered in the public domain, (c) the references made to these works in catalogues, books, articles, exhibitions or even in other works, and (d) the size of the audiences attracted to these works. As an illustration, we may use these various measures to determine whether such paradigms as impressionism and abstract expressionism have required the same amount of time to reach a visibility twice as large as the one they had when these two terms became part of the public discourse. When we do so, we search for the limits of the validity of a sociological time, that is, a time made of equal, reversible, and re-

producible units, as we ask whether the life cycle of paradigms is independent of historical accidents.[33]

This concept of logistic growth therefore links revolutions to simultaneous series—that is, to the even competition of distinct paradigms. The mid-nineteenth century, for example, can be characterized by a simultaneous series in the case of the visual arts, as the prevailing paradigm of academism was threatened by the still-burgeoning impressionist school. After the latter's triumph, its logistic growth was affected by floor effects, by which I mean the various forces that accelerate the natural growth of cultural phenomena. In the case of impressionism, the thrust of the movement was accelerated not only by factors such as the invention of paint tubes or the increase in the number of galleries which facilitated the diffusion of any alternative aesthetic style, but also by the cultural crisis of the period that amplified the shortcomings imputed to any official orthodoxy. For all these reasons the initial rate of diffusion of aesthetic objects, styles, techniques, and materials typical of impressionism among all artistic communities and various segments of the public was much greater than the concept of logistic growth above would have led one to believe. In turn, this accelerated growth reduced the likelihood of another paradigmatic shift following soon after. Artistic revolutions therefore seem unlikely to occur as long as the growth of a particular strain of new ideas or techniques responds to the dramatic thrust of floor effects and accelerates the dominance of a specific paradigm over the entire artistic scene.

However, as in science, the logistic growth of artistic paradigms should vary across disciplines, because of contrasts in the relative scarcity of the resources they need and in the optimal size of their respective audiences. For example, the lower constraints exerted on the production and publication of visual as opposed to musical statements should be associated with a faster growth of paradigms in the first than in the second case. Furthermore, these growth rates are also shaped by the history of each field and of the society in which it is embedded. Thus, insofar as there is a historical acceleration in the logistic growth of successive paradigms, the life of abstract expressionism should have been shorter than that of impressionism. Similarly, in the case of the cinema, it should have taken less time for the French *nouvelle vague* to reach its peak than it took for German expressionism to reach a similar peak. This should be the case not only because of significant changes in the

composition of the corresponding communities but also because of changes in communication techniques, continual erosions of boundaries between national markets, and transformations of the links between patterns of social and cultural stratification. In short, the power of floor effects is historically relative.

But if the concept of logistic growth specifies when threats to existing paradigms are minimal, it also specifies how ceiling effects and, more specifically, the pressures associated with saturation expose paradigms to various types of revolutions. These pressures may come from the inside, and Seurat anticipated the observations of Derek De Solla Price in this regard when he wrote to Paul Signac, "The novelties brought about by the techniques of the point will wear out and a new cohort of painters will be anxious to explore new frontiers."[34] These pressures may also come from the outside, as the new art form has reached the boundaries of the market it may control under the conditions set by the social system in which this art form is embedded.

Responses to the pressures of ceiling effects are threefold. Practitioners may consider that the problems inherent to the object or the technique with which they are concerned have been solved, and so the paradigm dies purely and simply. The history of pointillism offers a case in point. The cubist and fauvist "revolutions" took place simply because pointillist artists had exhausted their vocabulary after having systematically varied the size, color, and shape of the points they used.

In other instances, ceiling effects may lead to the formation of convergent oscillations, that is, to an accelerated succession of peaks and troughs in the salience of the paradigm under attack. This response is possibly characteristic of the history of French tragedies in the seventeenth and eighteenth centuries, when they experienced an accelerated succession of short-lived revivals before being replaced by dramas.[35] This type of response to ceiling effects suggests once more the importance of simultaneous series as indicators of revolutionary situations. More specifically, oscillations suggest that the demise of a paradigm and the growth of its successor do not always follow linear patterns.

Finally, ceiling effects may lead to the formation of divergent oscillations, in which case time intervals separating the various revivals of a particular art form increase over time. This particular response further obscures the visibility of revolutions. Not only does this blurring reflect the long-term coexistence of competing

paradigms, but it also reflects the difficulty of establishing clear-cut distinctions between innovations, renaissances, and renascences on the one hand and revolutions on the other.

Conclusions

Each artistic discipline is characterized by recurrent tensions between normal and revolutionary practices. Normal practices involve the resolution of puzzles shaped by the rules shared by all the practitioners who adhere to the same paradigm. Revolutionary practices imply either the introduction of new aesthetic objects, styles, and modes of communication with the public, or the reinterpretation and reformation of any one of these components that already belong to the eminent domain.

My purpose in this chapter has been to underline the ambiguities inherent in the structures of artistic revolutions. Like their scientific counterparts, artistic revolutions seek to break boundaries between creativity and nature. To be sure, the processes by which the two systems of cultural production strive to break such boundaries differ. Thus, modern artists have tried to assert that all sounds, shapes, colors, and rhythms are equal and form an acoustic or visual democracy.[36] Yet their revolutions—which are labeled "isms" in order to suggest that they claim to forge ideologies without ideas—are necessarily relative. This is because any object dubbed to be a work of art necessarily acquires a selective meaning that depends on the distinct codes used by artists and audiences. There is a revolution whenever the selective meaning assigned to such a work ceases to be acceptable because of changes either in the codes used by artistic communities or in the composition of these communities and of their public. Thus all artistic revolutions are partial as they do not lead to a full reshuffling of the ideas adopted by a discipline and of the rank ordering of its practitioners. They are also partial insofar as their occurrences are not similarly distributed across fields. Furthermore, both because of and despite their logical and social relativity, artistic revolutions are often assessed in terms of the progression or regression they are deemed to foster. To the extent that revolutions are tainted with ideologies, their champions are eager to extol their successes, while

their detractors seek to minimize their visibility and to decry their consequences. Finally, though it might be tempting to undertake a systematic taxonomy of revolutions, the task appears to be impossible in view of the relativity of the positions occupied by the observers themselves. The first objective of an analysis of the structure of artistic revolutions can only be modest. It simply consists of determining how the form of each revolution *might* vary with the responses of artists and audiences alike to the saturation of a particular paradigm.

Up to this point, my analysis has focused on the structures of artistic communities and of their normal as opposed to revolutionary practices. Insofar as ideas, forms, and communities are social constructs whose existence is contingent on individual consciousness, the next step of this analysis is to examine how the various phases of the life cycle of individual artists might explain who engages in revolutions and when they engage in them. More specifically, insofar as revolutions require actors, my purpose will be to explore patterns of interaction between the profiles of individual careers and the tensions that distinguish normal art from artistic revolutions.

4

The Natural History of Artistic Careers

Creativity is located at the junction of three dialectical processes. Embedded in both physical and human nature, it strives to tame these two natures. Conditioned by the tensions that separate normal from revolutionary practices, it feeds and transforms such tensions. Finally, influenced by and influencing the internal organization of each artistic community, creativity is also shaped by the patterns of stratification of the society at large, whose image it contributes nevertheless to modify.

Clearly, revolutions are the making of individuals. But in what sense? As one could argue that any artistic statement is revolutionary because it constitutes a specific resolution of the tension between nature and culture, the first part of this chapter is devoted to a critical evaluation of that proposition. Artistic creations can be seen as resulting from a combination of cognitive, emotional, and moral processes, all embedded in nature as well as culture. As individual birthdates, sibling rank, and patterns of cognitive, emotional, and moral maturation or decay constitute unconscious events over which individuals have no control, all these factors remind us that creativity *is* a history. But the definitions of creativity and of their determinants are necessarily social and, therefore, historically dated. As such, they affect the artistic choices made by individuals. Correspondingly, these definitions remind us that creativity *has* a history. To adopt the first view is to underline the

94

unconscious and illusory character of creativity and revolution. To adopt the second one is not only to emphasize the conscious and voluntary property of creativity and revolution, but also to stress the fact that the meaning of these two concepts is historically relative.

However, individual contributions to artistic revolutions are only relative. Indeed, one could assert that such revolutions are contextual and depend upon the history and social profile of the discipline to which individuals belong. Thus, the second part of this chapter focuses on the interaction between the life cycles of individual artists and the paradigms to which they adhere.

As the unfolding of individual life cycles contributes to influence whether men or women choose to become artists, the specific discipline they select, and the style they embrace, it contributes to determining *who* is involved in normal and revolutionary practices; *when* men and women are most likely to foment or resist revolutions; and *how* they implement the choices they have made in this regard. Reciprocally, however, it is equally clear that the outcome of the decisions made by artists during the various phases of their lives depends on the extent and the form of the tensions between tradition and change in the particular field they have entered.

But the fact remains that artists are also social creatures. In the third part of the chapter, I suggest that the ways in which artists join specific communities and resist or implement revolutions cannot be independent of the patterns of social stratification operating in their societies, and hence of the circumstances from which artists originate.

The Dialectic Between Nature and Culture in the Creative Process

Creativity is often described as the process of transforming previously accepted ideas and of linking patterns of thought that have become disconnected because they have become automatic and hence unconscious.[1] As such, the creative process involves recurrent and simultaneous tensions between trapping and liberating, containing and expanding.[2] Certain aspects of the creative process correspond to the principle of life. The mechanisms of internal-

ization and retention contribute to enrich and differentiate the internal vision of creators. Other aspects of the creative process correspond to the principle of death. Indeed, the mechanism of externalization and its consequences, notably the editing of perceptions and raw productions, imply a reduction of this internal differentiation.

Clearly, these multifaceted tensions inherent in creative work can be attributed to nature. In this context, whether scientific or artistic, revolutions are limited by the dialectic between mind and brain, or between software and hardware. Not only can the outcome of linking previously disconnected patterns of thought be construed as the mere replication of natural processes hidden by a variety of cultural inhibitions but also the material basis itself of such linking activities may be seen as being controlled by nature. For example, to observe that revolutionary artists are winter born, and their conservative counterparts summer born, may be simply to assert that the distinction between normal and revolutionary practices reproduces the rhythm of the seasons. If so, revolutions cannot be voluntary.[3] Hence Shaw's argument about the work of Ibsen: "The existence of a discoverable and perfectly defined thesis in a poet's work by no means depends on the completeness of his consciousness of it."[4]

Alternatively, the definitions of both linking activities and previously disconnected patterns of thought can also be seen as pure products of cultural factors. Perceptions of disconnection are relative, and Jasper Johns has reminded us that "old art offers just as good criticisms of new art as new art offers of old."[5] The evaluation of such connections, however, is never value free. Giotto, for example, was ignored both by the most ignorant segments of his own generation and by the most sophisticated intellectuals of the following period. Praised by his contemporary Giovanni Boccaccio for "having resurrected the art of painting which was suffering from a deep coma," Giotto's works were later condemned for the painter's supposed lack of sophistication regarding the laws of perspective.[6]

Because creativity can be seen as an ecologically well-adapted response to the cognitive, emotional, and social needs of individuals whose participation in cultural worlds would otherwise be nonexistent, the correlation assumed to exist between the distinction between convergent and divergent modes of adaptation on the one hand and science and art on the other may be relative.[7] The first

distinction posits that unlike convergers, divergers have a set of cognitive abilities that attract them to ambiguous problems whose solutions do not require the control of established authorities. Furthermore, the ego boundaries of such personalities are said to be naturally looser and established later in life than those of convergers. In the same way that the distinction between convergers and divergers presupposes the stability of individual psychological makeups, the distinction between the arts and the sciences is often presented as if the contrasts between the demands of artistic and scientific tasks are constant. Yet the attraction of divergers to artistic rather than scientific careers depends also on the evolving organization of each system of cultural production and more specifically on the tensions between tradition and innovation to which each of these systems is subjected.

Regardless of its artistic or scientific outcome, creativity is a double history of the dialectic between nature and culture. On the one hand, the elaboration of each creative work necessitates a "natural" succession of drafts whose evaluation varies nevertheless with the culture of their creators and their critics.[8] On the other hand, the overall creativity of these creators depends both on their "natural" abilities and aspirations (as these result from their biological make-up, sibling rank, gender) and on the culture-bound organization of the fields in which they participate.

The social effects of the distinction between convergent and divergent modes of adaptation are therefore not stable. In this sense, they have a history. In the past, such effects were less significant than those of the distinction between the crafts and engineering.[9] Crafts implied a direct and hazardous contact with empirical objects and hence a sum of concrete gestures learned through the imitation of already established masters. In contrast, as engineering sought to achieve a more indirect or abstract contact with these objects, the ambition of artists was to create machines or models able to eliminate the aleatory consequences of the direct intervention of the hand. Sculpture was belittled and seen as a mere craft because it entailed sweat as well as fatigue, because it could not be learned without the assistance of a master, and because its product was believed to be, at least in part, the result of uncontrolled natural forces. In contrast, painting was considered to be akin to engineering, because of its reliance on mathematics and hence on experiences acquired through reading technical books rather than observing practicing artists.[10] Today, divergent modes of adapta-

tion are less prevalent in the case of individuals attracted to ap-
plied rather than fundamental arts; at the Chicago Art Institute,
for example, there are significant differences in the perceptive and
cognitive outlooks of students preparing for applied and funda-
mental artistic careers.[11] Thus, contrasts between convergers and
divergers differentiate not only scientists from artists but also vari-
ous types of artists from one another.

As creativity is a cultural construct, its explanations are also
historically and culturally relative. During the high Middle Ages,
the correlations assumed to exist between the four seasons (spring,
summer, autumn, and winter), the four elements (air, fire, earth,
and water), the four temperaments (sanguine, melancholic, cho-
leric, and phlegmatic), and the four parts of the day (morning, mid-
day, dusk, and night) specified not only the modes of interaction
between all these natural orders but also the influence of these
modes on various forms of creativity. The corresponding correla-
tions accordingly shaped patterns of access to artistic careers.[12]
Following Aristotle's theories, the notion of the creative personal-
ity was closely linked to the notion of melancholy; it was only later,
when arts and crafts became analytically distinct activities, that
the relevant astrological signs shifted from Mercury to Saturn.[13]

In more general terms, the history of the concept of creativity
seems to parallel the history of the concept of nature as it applies
to the arts. For this reason, there are parallel revolutions in the his-
tories of the *outcome* of creativity and of its *prerequisites*. As an il-
lustration, although journeys are often seen as contributing to ar-
tistic work, their imputed contributions in this regard vary across
periods and cultures. Travels may constitute pilgrimages to the
sources of legitimacy. Many non-Italian painters went to Rome for
this very reason, which also accounts for many of the visits made
by American artists to Europe. Yet changes in the conceptions of
both nature and the arts have been associated with revolutions in
the conception of travel as a source of inspiration. Thus, exoticism
facilitated the discovery of the Orient by writers and painters dur-
ing the mid-nineteenth century and later on inspiration became
linked with the notion of exile, as exemplified by Gauguin's sojourn
in Tahiti.

To conclude, the social elaboration of the distinctions between
divergent and convergent modes of individual creativity follows
logically as well as chronologically the social elaboration of the
distinction between the orderly and random qualities imputed to

nature. More generally, insofar as creativity is and has a history, its explanations cannot but reflect the ambiguities of the interaction between the worlds of reality and of perception.[14] On the one hand, artistic events (whether they pertain to individual works or to entire careers) are both the by-products and the modifiers of individual actions, crafts, and cultural environments. On the other hand, the perceptions of such events are also both the by-products and the modifiers of individual psychological defenses, traditions, and ideologies.[15] Although these two worlds are analytically distinct, they constantly interact. Artists are never immune to self-fulfilling prophecies insofar as their works result from their evaluation of the chances that future events in their lives or in the endeavors of their competitors will happen in certain ways and at certain times. For this reason, the examination of revolutions requires a study not only of the life cycles of artists but also of their links with the tensions between normal and revolutionary forces within their professional communities. In this sense, biographies should be read not as mere accounts of individual lives but rather as accounts of the social networks formed by disciplines.

The Career Patterns of Artists

Artistic careers evolve within two distinct types of time: the time of the individual and the time of his or her surroundings. In the arts as in other human activities, aging modifies the structures of opportunities and constraints experienced by individuals, and hence the forms of their creativity.[16]

Regardless of their age, alternatives available to musicians, writers, painters, or sculptors depend also on period effects and hence on the development of their disciplines as well as the set of external constraints and opportunities faced by their communities. As an example, painters of the second half of this century have had to learn the lessons of impressionism, fauvism, cubism, and so forth. Similarly, the rules of the game and the mechanisms by which contemporary artists make their works public differ from the ones their nineteenth-century predecessors had to master.

Because aging does not take place in a historical vacuum, the professional life cycles of individual artists are often divided into

four phases of fifteen years each (preparation followed by early, middle, and late maturity) in order to capture changes both in the activities of individuals and in the organization of the practices and styles of their communities.[17] The justification for this particular way of dividing artistic life cycles is that the relative institutionalization of their preparatory phases, and hence of the relations between masters and apprentices, may differ for the members of two adjacent birth cohorts. In addition, the succeeding phases of their productive lives may be subjected to diverging historical forces.

There are, however, various types of cohort effects. The experiences shared by individuals born in the same year differ from those shared by individuals who simultaneously join the same paradigms. On the one hand, the risks incurred by an older Degas or Manet, as a result of their adoption of an impressionistic style, were not the same as those experienced by the younger Renoir. On the other hand, in contrast to impressionism which attracted painters of differing ages and experiences, surrealism grouped painters, photographers, and writers who tended to belong to the same age group. Correspondingly, the surrealist movement was, at least in part, a result of the marginal position occupied by its members in the structure of their communities, both because of their age and because of their predisposition to challenge the paradigms established by their elders.[18] As conflicts and cooperation between insiders and outsiders or among insiders themselves did not take the same form or the same intensity in the two cases, these two instances of revolutions should not have the same profiles.

The Effects of Family on Artistic Careers

The history of the arts clearly reveals the concentration of talents within certain families. In music, Karl Philip Emanuel and Johann Christian Bach succeeded their father, Johann Sebastian, and the Strauss family dominated the musical scene of Vienna from the mid-nineteenth century until the early twentieth. The painter Maurice Utrillo was the son of the painter Suzanne Valadon. In France, the Casadesus family has long dominated the performing arts, some of its members making their name in the theater or the cinema, others establishing their reputation in the musical domain. To observe that some families contribute more

than others to the production of artists is insufficient. Is it the result of genetic or environmental factors? Does it correspond to the effects of nature on history or to the influence of history on nature?

Regardless of this dilemma, we can differentiate various forms of environmental influence. First, artistic careers reflect the functions of social placement performed by familial groups. Artistic activities can be transmitted as hereditary social privileges. Such was the case for the master painter in the Middle Ages (the same holds true today for architects living in countries where the number of practitioners is limited and predetermined by the professional group).[19] Even when an artistic profession ceases to be treated as a social privilege, peculiarities in its modes of socialization may still narrow the pool of individuals entering the activity. The sharing of professional traditions (for instance the sharing of secrets concerning the making of stained glass windows) often induces children to continue the work of their fathers.[20] Children also may follow their parents' careers simply because they cannot gain access to more rewarding alternatives. In the past, children of actors and circus acrobats were forbidden, legally or informally, from entering other professions. The opportunities for artistic revolutions cannot be alike when children are forced into their parents' work and when they receive it as a social privilege.

Individual achievement is often said to reflect privileged emotional experiences related to early childhood. Thus, many creative individuals tend to be first-born, allegedly because this position in the family enhances the thirst for power and success.[21] In addition, creative individuals often seem to have been raised by goodhearted mothers and by fathers who stimulated their children's need for achievement. The childhoods of Brahms, Lewis Carroll, Goethe, and Proust all illustrate the type of family that appears to foster professional success.[22]

Nevertheless, do such experiences unconsciously shape individual motivations or are they simply self-fulfilling prophecies related to placement within a family group? For example, sibling rank may unconsciously affect an individual's cognitive and emotional relationships with other familial actors and therefore correspond to the influence of nature on history. But sibling rank may also be associated with a clearly patterned set of conscious parental expectations concerning the constraints and opportunities to which each child should be exposed. As such, it may reflect the influence of his-

tory on nature. Depending on the analytical path chosen, the meaning imputed to the participation of individual artists in revolutions will be different.

In addition, the distinctive characteristics of artistic careers are often said to reflect the games played by artists during childhood. The influence of family in this regard is twofold. First, familial groups shape boundaries between amateur and professional styles. Indeed, there are variations both in the mechanisms used to regulate playful activities and in the ages at which particular games or playful activities are considered permissible. Such variations dictate the intensity and length of the informal training acquired by children before their skills become the basis of a more formal artistic activity. For example, if a child begins studying a musical instrument at an early age, and if his or her parents evaluate performance with high standards, the child has a greater chance of becoming a successful professional musician.

Families also orient children toward and away from particular fields and artistic styles. The differential encouragement of verbal as opposed to physical games, and more generally the varying sets of norms regarding the use of the body during childhood, may account, at least in part, for the distribution of gifted adults in the literary as opposed to the performing arts. Similarly, the differential emphasis placed on competition, chance, imitation, and trances in children's play probably influences their relations with nature and others—and hence the kind of art they will practice later on, or the specific styles they will choose.[23] More pointedly, the distinction between, say, mimicry and vertigo or more specifically between the wearing of masks and the submission to trances precedes logically as well as chronologically the relative emphasis that adult artists attach to their roles as creators or as mere witnesses of the beauties of nature. Certain of these artists see the artistic realm as being exclusively composed of human artifacts. Others believe that the beauty of nature has pre-eminence over human beauty and see their role as uncovering the treasures hidden in the world of rocks, leaves, tree barks, or shells.[24]

Thus, familial contexts affect the distinctions between normal and revolutionary practices in two ways. As they shape contrasts between amateur and professional commitments to art, they shape the size and composition of artistic communities, and hence their stability. But as families encourage or discourage types of play for their children, they also influence both the ways in which adult

artists mediate the tension between nature and culture and the ways in which artists experience the underlying conflicts between tradition and innovation.

The Formal Training of Artists

Insofar as divergers tend to reject institutionalized learning, artists would be expected to have consistently negative attitudes toward formal schooling.[25] Yet distinctions between convergers and divergers in this regard vary over time and across fields. Contrasts in their attitudes depend on the mechanisms by which the artistic communities to which they belong regulate the two major scarcities with which individual practitioners are confronted, that is, the raw material they need to perform their art and the public they need to survive. For technical as well as social reasons, artists are often obliged to pool their resources. In addition, they must organize such activities in ways that maximize their access to an elusive public. As the grammar of literature is both less complex and more universally shared than the grammar of other artistic disciplines, the specific formal training of writers tends to be minimal. With the increase in literacy, writers have tended to learn their trade from an increasingly wide variety of sources. Some writers are autodidacts or have little higher education. Others use their experiences as medical doctors (e.g., Louis-Ferdinand Céline, Georges Duhamel, and Chekhov), as civil servants (Stendhal, Valéry) or as lawyers (Louis Auchincloss) in order to acquire a sense of the variety of human drama. Many literary figures, however, learn their skills from the active contacts with past writers that the teaching of literature requires. Further, as both reading and writing tend to be solitary activities, it is no wonder that literary paradigms are most fragile and that literary communities are most vulnerable to the processes of segmentation.

The effect of the pre-eminence of divergent over convergent modes of adaptation on the prevailing modes of learning in the visual arts is not a new phenomenon, either. As early as the Renaissance, there were debates as to whether artists should be rewarded according to the work produced or the degree of application and experience displayed. Some critics and philosophers preferred to reward creativity and its mysterious "diverging" alchemy; others thought that "convergent" craft, as measured by credentials, was a

more secure way to evaluate creativity.[26] Giorgio Vasari placed a higher value on divergent desinvoltura (or intuition) which he considered to be an inborn grace, than on convergent diligence, which he saw as the result of a strenuous labor learned in a formal context. In fact, many artists of the Renaissance based their claim to intellectual nobility on the notion that the fine arts could be learned without a teacher. Their stance parallels the comments of Renoir, who argued that he learned a great deal at school despite his teachers, or the comment of a contemporary painter: "I went to school chiefly to discuss God, tea, and art, but never to work."[27] At best, divergers and hence artists do not do well in school except in the matters they have decided to master.

Although painters seem to be consistent in their negative evaluation of the formal training they have experienced, the relative institutionalization of socialization processes in the visual arts seems to have followed a curvilinear pattern over the years. It increased from the Middle Ages to the first phase of industrialization before then beginning to decline. The regrouping of visual artists into guilds sought to limit the effects of competition not only by preventing "undesirable" artists from selling their work but also by generating a legitimate rank ordering of individual practitioners. Thus, guilds controlled modes of training, the amount of time that each apprentice spent with a master, and the conditions under which he would transfer from one workshop to the other.[28]

Although academies were created in order to liberate individuals from the obsolete social conventions of the guilds, their innovative functions did not last long. Indeed, they rapidly exerted a monopoly not only over the teaching of specific techniques but also over the access of individual painters to the market.[29] For example, the Grand Prix de Rome, an award for which all graduates of the Ecole des Beaux Arts competed, guaranteed not only easier access to the salons but also more frequent purchase of one's works by public museums.[30] Under such conditions, there was a systematic decline in the variability of the paths followed by individual artists. Thus, the proportion of professional painters who attended the Ecole des Beaux Arts increased from 12 percent among painters born between 1785 and 1794 to 26 percent among those born between 1835 and 1844.[31]

The subsequent decline in the role played by formal training in the careers of individual painters was produced by four distinct forces, which began to operate more or less simultaneously. First;

the invention of paint tubes relieved fine arts students from the obligation of working in the same locale and hence of being exposed to the orthodoxy of a single teacher or school. As the diffusion of these tubes fostered growth of new, privately owned schools, it liberated artists, newcomers and old hands, amateurs and professionals alike, from many institutionalized forms of social control and it enabled them to explore new techniques and new objects.[32]

Second, the individualization of artistic markets and the opening of new art galleries gave new opportunities to artists who had been unwilling or unable to attend official training institutions. Most important, it freed students from having to use teachers as formal sponsors.

Third, the decline of official art schools reflected drastic shifts in the ideology of creativity. The subjectivity of artists became more valuable than their faithfulness to reality, which resulted in a higher status for assimilation than accommodation as distinct modes of adaptation in the creative process. In other words, the translation of an artist's preexisting cognitive or emotional frameworks into artistic statements became a potentially greater source of reward than the ability to follow externally defined modes of nature. As faithfulness to nature lost its salience in the definition of the arts, learning began to be defined in informal and diffuse rather than formal and structured ways. Correspondingly, art schools have become increasingly suspected of perverting individual talents, with the claims made that instructors impose their own style and perceptions of the world—and therefore teach assimilation-oriented savoir-faire rather than an accommodation-oriented "*savoir être.*"[33] Furthermore, the rise of individualistic ideologies and of the status attached to originality has been socially selective.[34] As such ideologies originate from the upper-middle and upper rather than the lower classes, their influence on the social definition of the arts reflects the enhanced status accorded to painting as an occupation and the correspondingly higher social origin of individuals attracted by such careers.

Finally, the decline in the salience of formal training in painting results from a sharpened distinction between pure and applied forms of art. Not only does this sharpening correspond to accentuated contrasts between the respective marketplaces of the two activities but it also reflects growing differences in the populations they attract as well as in the modes of socialization to which these populations are exposed. Students seeking jobs in applied forms of

visual art need credentials; their counterparts aspiring to become painters can do without such credentials.

The histories of the performing arts differ in this regard. In classical music, formal training is directed toward the mastery of the syntax needed to perform an increasingly complex repertoire in a variety of settings. The weight of this requirement has been reinforced by the consequences of both technological innovations and the growing scarcity of the rewards made available to professional musicians.[35] The production of high-fidelity recordings and tapes has heightened the standards demanded of performers entering the highest strata of the musical community. The increased competition manifests itself in the number of awards that musicians must earn before joining respectable orchestras or being allowed to give recitals. The same holds true for dance and theater. In all cases, disjunctions between the growth of economic and social rewards attached to artistic success and the stability of the number of plays, films, concerts, ballets, or operas produced can only accentuate the dependence of young performers on teachers whose role is increasingly that of gatekeeper.

Thus, the influence of institutional forms of training on artistic revolutions is twofold. The frequency of revolutions should vary as a reverse function of the salience of institutional training and hence as a direct function of the scarcity of the raw materials needed by individual artists or of the most significant rewards to which they have access. Whenever the decline of this scarcity is accompanied by an accentuation of the hostility that students experience toward the social control that goes with any type of formal training, there should be an accelerated segmentation of existing paradigms and an increase in artistic revolutions. In the fields that stress institutional forms of learning, revolutions should involve the substitution of a new paradigm for the preceding ones and should be analogous in that sense to scientific revolutions. In the fields that minimize the importance of training, revolutions are more likely to imply a proliferation of paradigms and a segmentation of the corresponding communities.

The Variability of Individual Careers

The boundaries separating the various moments of an adult artistic career mark shifts not only in the social distance separating

successful individuals from their less successful counterparts but also in their respective artistic activities. These boundaries, however, vary across time and artistic fields, because of both actual and perceived variations in the relationships between aging and the structure of opportunities.

Aging and Success. Youth implies a propensity to make artistic revolutions, since it is associated with minimal commitment to the norms of the field. Correspondingly, the notion of prodigy evokes positive images in the case of many arts. Mozart composed many of his best pieces during his early and middle childhood. Rimbaud completed his work at the end of his adolescence, and the success of Raymond Radiguet's novels, caused in part by his early death, symbolized for Cocteau the victory of angels over death.

Nevertheless, both the fact of aging and its ideological representation evoke the acquisition of experience and wisdom. Many folk artists begin to produce late in their lives as a response to the new leisure time they enjoy, or sometimes as a response to a mystical experience. Furthermore, in ideological terms, all forms of creativity are subjected to the "Matthew effect" insofar as earlier accomplishments tend to be underestimated, later ones overestimated.[36] Correspondingly, the notion of *péché de jeunesse* offers a counterpoint to the image of prodigy. Not only does the excellence attributed to older artists give them easier access to the market, but it also can lead them to destroy earlier works that do not meet their current standards, as the painter Georges Rouault did. Indeed, prodigies encounter many difficulties in reaching a level of success in adulthood that matches their own hopes or the expectations of their sponsors.

In ideological terms, time also places many traps before those who want to examine their own evolution or to compare their youth with those of others. Leconte de Lisle, a French poet of the nineteenth century who was successful enough to be considered the leader of the symbolist school, complained about the "new pleasant young men who are nothing other than good students." In the same vein, many contemporary older painters assert that they were more innocent at the beginnings of their careers than the current newcomers.[37]

Regardless of these conflicting images of the effects of aging on creativity, the passage of time exacerbates differences in the success encountered by individual artists. These differences, however,

are not independent of historical variations in the functions assigned to various art forms. Andrew Egleski, the most successful dancer of his generation, could claim only a modest $175 per week at the peak of his career some twenty years ago; in 1978, Nureyev was paid $10,000 a performance. Similarly, the top fees demanded by the most popular opera singers quadrupled between 1951 and 1978 (from $1,000 to $4,000 a performance).[38] The same holds true for writers. In addition, although their average income remains modest, there is a wide range between the earnings of the most and least successful of them. As aging accentuates the differential success of individuals, it lowers the cohesiveness of their age cohort. Thus, aging should minimize their collective participation in the making of artistic revolutions.

Aging and the Differentiation of Styles. As individual artists grow older, the interaction between reality (the culture to which they belong, the craft of their profession, their psychological make-up) and perceptions (the ideologies or traditions of their various milieus and their own defense mechanisms) accentuates the specificity of both their statements and of the rhetoric they use to justify them. Thus, Manet learned to tame the contradictions between his admiration for the Spanish painters of an earlier period and his desire to translate what the modern world was about. Similarly, Walter Gropius, the architect, resolved the tensions between craftsmanship and engineering that he saw as being at the very root of modern architectural practice. And Mondrian learned how to overcome his unconscious fear of primitive animal instincts by liberating his painting from the influences of the past.[39] But as the passage of time therefore sharpens contrasts in the profiles of individual forms of creativity, it also sharpens differences in the roles that artists play in making or preventing revolutions. Thus, the distinctions that Kubler establishes among artistic styles should help identify the positive or negative contributions of various artists to the making of revolutions.[40]

Ruminative artists devote their lives to the resolution of a single problem. Lorrain, for example, wanted to improve the solutions suggested by Caracci to the problems of landscapes, and Cézanne was constantly trying to go beyond the techniques of Poussin. Similarly, Rouault's paintings may be seen as the result of his obsession with translating on canvas the tensions that oppose the colors of a

stained glass window to the darkness of its lead frame. Because these artists work within the confines of a single paradigm, they adopt extreme positions toward the idea of revolution.

Versatile artists shift easily from one problem or style to the next or move across disciplines. Early on, Leonardo invented and resolved various problems in both the visual arts and engineering. Michelangelo wrote poetry, painted, and sculpted. Thomas Jefferson was an architect and a scientist as well as a politician. More recently, Jean Cocteau not only worked in music, film, and theater but also wrote novels and poems and painted murals. In contrast to ruminative artists, versatile individuals are revolutionary insofar as they keep changing their styles and prevent the identification of any central tendency in their work. Yet their revolutions are lonely ventures and do not contribute to paradigmatic shifts.

Evangelistic artists tend to be "empire builders" and are, as such, rigorous teachers. The styles of Jacques Ange Gabriel or of Frank Lloyd Wright offer examples in architecture. In fact, Gropius complained that Wright invited imitation at the expense of the formation of truly independent artists.[41] In the theater, Stanislavski and Strasberg offer analogous illustrations. Because of their leadership, such artists play a key role in making or preventing revolutions.

Precursor artists mark the dawn of a new paradigm. Thus, in her *Princesse de Clèves*, Madame de La Fayette sketched the stylistic techniques that were to become the trademarks of psychological novels. In metalwork, Lorenzo Ghiberti pioneered the use of materials that became an integral part of the discipline. In painting, Courbet began to explore the use of color and shadow in ways that were later systematized by the impressionists. Picasso, in his *Still Life with Chair Caning*, invented the collage technique, which was to be elaborated some years later by Braque in *Le Jour* and Juan Gris in *Fantomas*. Similarly, Salvador Dali anticipated the realism of Andy Warhol and his use of "installations" as legitimate aesthetic innovations.

The work of *rebel* artists is closely related to the demise of a paradigm that has run its full course. The surrealist movement offers a case in point. Such were also the intentions of Rimbaud when he wrote poems criticizing the prevailing lyrical styles of his time. In the cinema, this characterizes the aspirations of the French *nouvelle vague* and notably of Jean Luc Godard. But the concept of

rebellion is relative. In painting, Henry Jackson, after having been a bonafide representative of the abstract expressionist school, has returned to figurative art and is currently engaged in monumental sculptures. His rebellion offers a striking contrast with Anton Prinner's. The aesthetic trajectories of these two artists are alike, as both have abandoned a style considered to be progress oriented. Yet, whereas Jackson's stylistic shifts have been successful because of his ability to find a new audience, Prinner has failed because of his marginality in the contemporary French art scene. His friendship with Picasso was insufficient to redeem his status as a political refugee and aesthetic nomad. In other words, the fate of rebel artists varies according to both the direction imputed to their rebellions and the reactions of society to their type of rebellion. Like precursors, rebels are also key actors in artistic revolutions, although their respective contributions in this regard are not necessarily immediately recognized.

Far from developing in a social vacuum, each one of these styles can only blossom in appropriate ecological niches. Precursors and rebels take significant risks in closed and small-scale societies, where innovations are often treated as deviance. Alternatively, only the richest and most stable centers of power can support versatile or evangelist artists. The salience of each one of these forms of creativity depends also on the evolution of economic arrangements. Dramatic increases in existing modes of division of labor lead simultaneously to a decline in the incidence of versatile individuals and to a rise in the number of rebels. In such contexts, versatility is a sign of amateurism or of conservatism imputed to decaying elites; conversely, rebelliousness becomes more acceptable and is viewed as a logical outgrowth of the increasing cultural segmentation at work in the society at large. Indeed, this segmentation facilitates the partial diffusion of an ideology of progress that prefers the prospective properties of an imaginary future to the tangible and perceptible character of past exemplars.

Thus, the differentiation of individual types of creativity and their differential distribution across distinct ecological niches affect not only the extent of the tensions between normal and revolutionary practices but also the substance of these tensions and their outcomes. The incidence and meaning of revolutions should therefore vary across disciplines. As these fields attract different personality types, the tensions to which they are subjected reflect not only

their own history but also the contradictions of the immediate environment.

Aging and Occupational Mobility. This mobility is twofold. First, it takes a lateral form, migrating across fields. For example, writers who began their careers as novelists may use their skills to write plays, screenplays, or even lyrics.[42] The history of authors such as Sartre or Capote offer cases in point. The same type of mobility characterizes painters who become involved in ceramics, tapestry, or stained glass, such as Matisse, Picasso, and Chagall. This form of mobility reflects both the differential rank ordering of the disciplines from which and to which artists migrate and the competition between practitioners within each of these fields. Thus, novelists are more likely to write screenplays than scenarists are likely to publish novels. This is because the screenplays written by the former are more likely to be praised than the novels written by the latter. Similarly, some painters may be tempted to design posters (Picasso designed the dove of the peace movement), but poster artists are less likely to move into painting. The fame of painters can be transferred to the design of posters; in contrast, the more limited reputation of poster designers prevents them from competing effectively in the painters' territory. Asymmetric patterns of mobility across fields may also result from the differential difficulties attached to the mastering of various techniques. For example, it is easier to shift from the clarinet to the saxophone than vice versa. The saxophone has an octave key that automatically raises low C to middle C or middle C to high C. One standardized fingering works in each of the instrument's ranges or registers. In contrast, clarinetists get a different note when they press the octave key and their fingering varies in function of the range in which they are playing.

Affected by the differential internal requirements of various disciplines, lateral mobility is also contingent on external political factors. For example, the Russian Revolution of 1917 induced certain avant-garde Russian painters to claim they should stop making patches of color on moth-eaten canvases and to capitalize on their skills to design posters or theater sets for revolutionary plays.

The second form of occupational mobility involves changes in the roles of individuals within their fields. Pianists and violinists may become conductors and actors may become directors. More important, there are variations in the extent to which teaching rep-

resents the apex of an artistic career. In fields such as film, theater, music, and architecture, teachers have highly coveted positions because they generally control access to the material that newcomers need to perform the activity. For instance, professional cameras are too expensive for most aspiring newcomers and their use as a learning device is accordingly restricted to formal institutions that can afford the expense. This enables highly established directors to select those of their "apprentices whom they feel to be sufficiently talented to acquire a direct experience of the camera.[43] A similar privilege is held by musicians who often control the circulation of the best instruments among their students.[44] In such cases, as well as in theater or architecture, market access depends on the recommendations of instructors, which is why the best musicians are often asked to teach at Julliard, why in France, teaching at the Conservatoire is the highest reward for an actor, and why Gropius ended his architectural career at Yale.[45]

In contrast, the status is lower for teachers in the literary or the visual arts. Recent declines in the rewards derived from teaching in these two disciplines explain, at least in part, why Sartre stopped teaching as soon as he reaped sufficient royalties from his works, and why Matisse is the last famous painter to have attempted to organize a school.[46] Such declines have occurred because the segmentation of the relevant markets increasingly prevents teachers from controlling their students' careers. In addition, the growing value attached to subjectivity tends to imply a growing ideological differentiation of the requirements of making and teaching art. The first role implies a universe of subjective forms and feelings; the second one, the subordination of one's own imagination to the needs and dreams of students. Correspondingly, these two roles are increasingly viewed as being mutually exclusive and as yielding unequal rewards. Making art represents the royal path open to talented artists; teaching art is seen as a dubious activity reserved for beginners or for professionals unable to succeed on the merits of their own talent.

Aging and the ensuing differentiation of individual trajectories tend to lessen the cohesiveness of communities that artists formed early in their careers. However, the effects of aging in this regard vary both across and within disciplines. They are less marked in music than in the visual arts because of the differing market structures of these two fields. In the visual arts, the negative effects that the differentiation of individual trajectories exerts on the cohesive-

ness of communities formed by artists at crucial moments of their careers are contingent on historical contexts. These effects could not be identical in the case of, say, the impressionists and the surrealists. As impressionist painters did not have the same age, nor, therefore, the same success expectancies when they were initially confronted with the stigmas imposed on them by outsiders, the community they formed was doomed to be short-lived. The positive effects of their collective success on their personal bonds were quickly overshadowed by the weight of interindividual differences and competition. Soon enough, Manet refused to participate in some impressionist exhibitions despite the pressure exerted on him by Pissarro. Similarly, Degas would not show his paintings with those of Pissarro and Gauguin because he argued that the first one was a Jew, the second a socialist, and that such an association would be detrimental to the sale of his own works.[47] Alternatively, although the initial cohesiveness of the surrealist movement was greater due to the youth uniformly shared by its members, it was progressively eroded not only by the differential success encountered by its various members over the years, but also because of the progressive institutionalization of the movement, followed by its split into hostile factions.[48] In other words, the demise of impressionism may be imputed both to the differential aging of its members and the essentially defensive functions of the movement. In contrast, the demise of surrealism reflects contradictions between the aggressive goals it pursued and the divisive effects of the differential careers of its members over the years.

In short, whereas the unfolding of individual careers is shaped by the tensions between the normal and the revolutionary practices of each discipline, the same unfolding influences reciprocally the life of the corresponding communities. As aging accentuates differences in the success or the specialization of individual artists, it reduces the cohesiveness of the communities they formed at the beginning of their careers, and these communities become more vulnerable to the revolutions sought by newcomers. Similarly, as aging affects patterns of mobility both within and across fields, it influences not only the size and composition of revolutionary groups (and the content of the paradigmatic shifts they seek to establish) but also the chances that the corresponding changes will be successful.

The Variability of Artistic Careers Across Social Categories

Thus far, I have suggested that artists' lives shape and are shaped by the history and organization of each discipline. In this sense, I have emphasized the internal determinants of the interaction between the structures of individual careers, paradigms, and revolutions. But individual careers are also conditioned by external factors and hence by ascriptive characteristics (gender, socioeconomic status, and cultural background). These external factors concern not only the resources made available to artists, or the values that they hold but also the reactions they provoke among their peers or within the public at large. Therefore, these factors affect not only the propensity of artists to engage in normal as opposed to revolutionary activities, but also the images generated by these activities.

Sex Roles and Artistic Careers

There are three possible reasons why so few female artists have been successful. Women may be less creative than men; they may enjoy fewer opportunities; or their achievements may be consistently ignored or subverted.

The sociopsychological profiles of female artists differ from those of male artists. A study at the Chicago Art Institute shows that while its female students discriminate among visual stimuli more easily than female non-art students, their abilities are lower than those of their male counterparts. The women in the study did not rely on their memory, perception, reasoning, and imagination in their problem-solving activities in the same way as men did. Furthermore, the success of female art students was more closely related to their perceptive skills, while their male counterparts' success was more closely related to their personalities.[49] Indeed, female art students appear to be convergent personalities more often than their male colleagues do.[50]

Although the differential psychological profiles of male and female artists might reflect, at least in part, the uneven distribution of particular traits among the two populations, it certainly generates or reinforces sexual stereotypes. The very notion of art evokes images of softness, warmth, and irresponsibility that are usually

associated with the stereotypic portraits of women. As some male artists take a dim view of such images, they belittle the significance of contributions made by women artists. Mondrian, for example, denigrated the terms *horizontal*, *static*, or *material*, which he imputed to the world of women.[51] In contrast, he associated the terms *vertical*, *kinetic*, and *spiritual* with an exalted idea of man.

These stereotypes have been used to justify the obstacles limiting women's participation in the arts and, more specifically, their restricted access to the established forms of education. For several centuries, reading and writing were privileges sparingly granted to those women with an aristocratic background or to those entering religious orders. The differential access of women and men to the world of literacy was paralleled by contrasts in the range of disciplines or particular styles they could adopt.[52] In literature, few women writers of the European preindustrial period have made a lasting impact on the field, and their contributions involve a narrow variety of genres.

Similarly, in painting, the few female painters of the pre-Renaissance period worked primarily on religious subjects or as illuminators of religious texts.[53] Later on, the restrictions regarding education and the ambiguous status accorded to all artists continued to limit the artistic opportunities available to women. For the most part, they could learn artistic skills only if they belonged to a family of artists. But, insofar as they worked in the shadow of their fathers, brothers, or husbands, their own contributions were ignored, destroyed, or wrongly attributed to the male members of their family. The same pattern holds true in the case of music: in the early nineteenth century, Fanny Mendelssohn found it necessary to "hide" some of her songs in opus 8 and 9 of her brother, Felix.[54] An exception to this trend concerns the painter Sofonisba Anguisciola, whose noble background enabled her to enjoy the same advantages as her male competitors and, notably, the same access both to the raw materials required and to the market.

The emergence of middle classes and the corresponding diffusion of liberal philosophies have exerted conflicting effects on the artistic opportunities for women. On the one hand, the spread of egalitarian ideologies and the greater diffusion of formal schooling have helped even the ratios between the sexes in literary communities.[55]

Although the diffusion of literacy and the ensuing recognition of the novel as an acceptable literary genre have increased the num-

ber of female authors and readers, the visibility achieved by female novelists remained initially culturally selective.[56] Perhaps because industrialization took place earlier in Great Britain than in France, the contradictions of the bourgeois ideology concerning the role of women were revealed earlier in Great Britain. Correspondingly, the history of female novelists is richer and runs deeper in Great Britain. The continuous succession of English authors ranging from Jane Austen, George Eliot, Fanny Burney, and the Brontë sisters to Katherine Mansfield and Virginia Woolf is without equivalent in the case of France, where many gaps exist between the contributions of George Sand and Colette.

Against the progress achieved by women in literature, the expansion of the middle class and the corresponding development of new stereotypes in the definition of female roles contributed to the creation of new obstacles to women's becoming successful professionals in other artistic fields. In general terms, new patterns of division of labor were associated with a differentiation of the social meaning imputed to the artistic activities of the two genders. Among men, artistic interests became tolerated as a form of professional commitment; among women, the same interests were acceptable only insofar as they enhanced a woman's attractiveness and hence specifically her status among eligible candidates for marriage. Although the daughters of well-educated families were often expected to play a musical instrument, to sing, to dance, to write, or to paint watercolors, they were still expected to be pleasing rather than astonishing and hence to behave as amateurs.

Social expectations concerning the role of women have not only narrowed the artistic careers that women could choose, but they have also limited the paths women could take in order to succeed and be treated as professionals. In painting, Elizabeth Simcoe (the wife of the governor of Upper Canada) was, or felt, only entitled to make an inventory of local landscapes, and her works have either remained private or have been exclusively entered in local historical collections. In music, certain instruments have been considered to be more suited to women than others.[57] As early as 1784, the Musikalischer Almanach discouraged women from "playing the flute because it was conducive to a burdening of their lips; from blowing the horn because it showed visceral support for their tone; or from playing the cello because it twisted their upper torsos and strained their necks in unnatural ways."[58] In contrast, the keyboard offered more opportunities because it did not violate the proper image

that a woman should offer to a male public. "The girl can finger her instrument, her feet demurely together, her well-groomed hands striking the keys with no unseemly vehemence as an outward symbol of her family's ability to pay for her education and, most important, her decorativeness." Because they were often used only as accompanists, female pianists were often expected to stop playing after the soloists' final phrase.[59] The dates at which women gained legitimate access to particular musical instruments still influence the "universalistic" or "particularistic" hurdles they must overcome. Even today, female pianists have a greater chance for success than female horn players. The former are evaluated primarily in terms of the qualities imputed to their performance. Before displaying their skills, the latter must initially overcome the prejudices of conductors.

In addition, expectations concerning the role of women have also reinforced the segregation of activities by gender, limiting the opportunities that women could enjoy in order to perform at a professional level. In painting, women were long forbidden from studying the nudes of either sex, or even from moving from one art school to another, since such experiences would allow them to establish uncontrolled contacts with men.[60] These interdictions obliged them to engage in specialities (pastels, watercolors, tapestries, embroidery) or substyles (still lifes, portraits) that were, by the same token, considered to be minor or trivial since they generally did not attract the most talented men.

In the theater, the differentiation between the two genders long contributed to the lower status of female actors and the limited opportunities for "honest" women. Originally, English pantomime involved only male performers. And in the Japanese Kabuki theater, female roles were held by men.[61] Taboos forbidding the public appearance of female actors dominated the stage of many European operas until the end of the eighteenth century. Indeed, female parts were sung by young boys or castrati. While the illusions provoked by this kind of arrangement have been evoked by Balzac in *Sarrazine* or, more recently, by Fernandez in *Porporino*, the revolution that the public appearance of professional female singers represented for the cause of feminism may explain why George Sand decided to draw a portrait of a diva in *Consuelo*. In effect, the influence that segregation has exerted on the differential theatrical opportunities enjoyed by men and women is also, albeit indirectly, suggested by the revival of the ballet during the early nineteenth

century. This revival was probably made possible by the virtual monopoly of women on dance.[62] Alternatively, women may benefit, albeit rarely, from the prejudices held against the presence of male adolescents on the stage. The role of Chérubin in *The Marriage of Figaro* is usually performed by a woman because it is believed that the ambiguities of the character would have a pernicious influence both on the morality of young male actors playing the part and on the public.

The same expectations concerning the role of women have been associated with a formal or informal limitation of the arenas in which the two sexes have been allowed to compete and hence of the arenas in which women could establish their superiority over men. As long as female musicians were forbidden from entering academies or musical colleges, they were institutionally eliminated from the market of performers.[63] In the same vein, the dearth of female architects in Europe or in America, suggests the enduring "impropriety" of allowing a woman to supervise draftsmen and craftsmen. It is probably for similar reasons that few women have become orchestra conductors. Social reactions toward competition between women and men are particularly marked when women choose a field in which their presence violates clearly existing taboos. The case of the sculptor Camille Claudel, whose brother was the French poet Paul Claudel, offers a dramatic case in point. In becoming the mistress of Auguste Rodin she transgressed the taboos forbidding relations between students and teachers. In exploring the symbolic translation of physical love in her work she challenged the aesthetic puritanism of the French bourgeoisie. Current evidence suggests that she was at least as talented as Rodin, but the scope of the revolutions she was trying to accomplish condemned her to fail. Abandoned by her family as well as by Rodin himself, she was declared insane and committed to a mental institution where she died of old age. In contrast to this bleak picture, the comparatively higher number of female directors in the cinema, while still small (Lina Wertmuller, Agnes Varda, Nelly Kaplan, Lilian Cavanti, Jeanne Moreau), is probably the result of the recent celebration of film as an art form. As such, the medium has fewer restrictions than the disciplines with richer historical legacies and hence more deeply rooted prejudices.[64]

Similarly, women have rarely been in a position to transmit their artistic skills and paradigms to students. In spite of her success, Rosalba Carriera, for instance, could not form a school.[65]

More recently, the musician Nadia Boulanger never taught at the Conservatoire, and her network of influence has been broader among foreign than French composers and performers. Indeed, the "exceptional" nature of her status in this regard results in part from her influence over strangers who could not threaten the local artistic order.[66] In this case, as in many others, the effects of two differing types of social marginality (as woman and alien) tend to cancel each other out. The fact that the stigma attached to the status of women and to the status of "alien" seems to have subtractive rather than additive properties may also explain why Marguerite Yourcenar, an American citizen, was the first woman ever elected to the French Academy.

In addition, the artistic and matrimonial roles of women have often been considered mutually exclusive. To be sure, there are cultural variations in the ideological constructs used to justify incompatibilities between such roles. In France, a professional woman is called "Madame," regardless of her matrimonial status, acknowledging that professional achievements might offer alternative routes to the supposedly highest possible female status, that of wife. Conversely, in English-speaking countries, a professional woman is called "Miss" regardless of her matrimonial status, and this labeling emphasizes contrasts in the status that a woman derives from her marriage and the status she achieves through her own achievements.

Regardless of these ideological variations, a woman with high artistic aspirations constantly faces dilemmas in conducting her life. In the past many women ceased their artistic activities when they married, either because they internalized the values assigned to the role of wife or because of social pressure. For example, Marie-Guilhelmine Benoit, a highly successful painter during the reign of Napoleon, was asked by her husband to stop participating in exhibitions after his entry in the French Conseil d'Etat, the highest administrative court.[67] Alternatively, many female artists who decided to focus on their careers were obliged either to assume an asexual or a masculine posture or to assert their sexual emancipation. As George Eliot chose her name to hide her gender, George Sand "made for herself a *redingote guerite* and smoked cigars in order to look like a man and to stop looking like a lady with all the limitations that went with such a role."[68]

Thus, the very conquest of artistic institutions by women is in itself a revolution, especially in view of the obstacles that they

must overcome. Women therefore often commit themselves to a particular field earlier in their lives than men do, and hence their careers are often more precocious.[69] Yet the sacrifices women make along these lines do not always guarantee their success. In the past, art dealers often allowed only initials and not full signatures to appear on the prints or paintings of women artists, and many patrons would not pay as much for a work if they knew the artist to be a woman.[70]

These factors all contribute to the disparities between the number of female artists throughout history and the number of their works that have been identified and preserved. These disparities should be taken into account when one intends to evaluate the contribution of women to artistic revolutions. What are the conditions under which the constraints associated with the number, the socioeconomic origin, and the age of women artists induce them to join already existing paradigms or alternatively to participate in the making of revolutions?

The Influence of Socioeconomic or Cultural Origins on Individual Artistic Careers

The lower number of artists from socioeconomic or cultural minorities can be attributed to several causes. The corresponding inequalities may result from the differential distribution of specific aesthetic abilities among various segments of the population at large. They may reflect differences in the access these social groups have to the material means to perform specific types of art. Finally, they may be caused by the uneven distribution of cultural power across social groups.

The first supposed cause is ambiguous. To be sure, as measured by tests, both general intelligence and general need for achievement are not similarly distributed along socioeconomic or cultural lines. However, this observation is not particularly illuminating, as it is based on self-fulfilling constructs aimed at justifying the existing distribution of recognized talents. More promising is the observation that socioeconomic or cultural contrasts appear in the modes of cognitive or emotional adaptation. As distinct social classes or cultural groups do not use the same techniques to express emotions, they are not evenly represented in the various artistic disci-

plines. Not only is the stereotypically inhibited emotional style of the Protestant middle class likely to discourage theatrical aspirations among its individuals, but also the ensuing underrepresentation of such individuals in theatrical companies raises the question of whether they may dominate existing paradigms and hence become high achievers or whether their status condemns them to engage in revolutions. Similarly, as differences between divergent and convergent modes of adaptation become both scientifically validated and politically legitimated, they cannot but systematize existing differences in the modes of access to the corresponding communities. To the extent that convergers and divergers are spread differentially across social categories, explanations of contrasts in their respective careers cannot be politically innocuous.

Variations in the participation of various social categories in such artistic communities reflect also the resources required by the practice of the relevant disciplines. Professional musicians, for example, must have access to high-quality instruments.[71] This makes it difficult for less affluent categories of the population to become professional performers, which is certainly one of the reasons why there are so few black classical soloists in American orchestras.[72] The same material reasons may also explain why there are fewer black painters than writers.[73] Furthermore, variations in the social composition of different artistic communities also reflect the differential timing and length of the training required by these disciplines. Indeed, artistic disciplines that require both an early and long apprenticeship (notably dance) are likely to be filled with individuals whose mothers are willing to accept the full-time role of coach and impresario. Alternatively, whenever access to means of production, socialization processes or market structures become more democratic, there is a parallel broadening in the social horizons from which individual artists originate. In France, changes in the role of the official academies (as agents of socialization and arbiters of market access) made it acceptable for artists to come from broader social origins; before 1794, 60 percent of French painters were born in Paris, and by 1844, that figure had dropped to 26 percent.[74]

Contrasts in the social composition of artistic communities depend also on the cultural power held by various social groups. Historical variations in the number of black actors or musicians, for example, depend on two sets of factors. On the one hand, they de-

pend on the intensity of the black population's search for its cultural identity and on the form that such a search takes. However extensive the black middle class may be, its members may be still unwilling or unable to support a variety of performing arts simultaneously. Correspondingly, variations in black support to black theater and music may be negatively correlated.[75]

On the other hand, variations in the number of black actors and musicians have also depended on the racial prejudices of the patrons of those artistic disciplines. In the theater, *Othello* usually stars a white actor. In addition, black actors are often prevented from playing roles whose characteristics are described as being universal. This type of discrimination follows even more complex patterns in other performing arts. In 1975, there were only seventy black performers in the ranks of some five thousand regular professional musicians attached to the fifty-six leading American orchestras. The New York Philharmonic never had more than one black soloist at a time. This underrepresentation is particularly striking in view of the differential visibility achieved by black male and female opera singers.[76] Although the names of Marian Anderson, Leontyne Price, Grace Bumbry, and Shirley Verret are well known among operagoers, their male counterparts are hardly recognized. Thus, it seems that being female defuses the discrimination against being black. In other words, it seems that the imposition of two negative stigmas on the same artist has subtractive rather than additive consequences, even though these consequences have nothing to do with whether performers are seen rather than exclusively heard.

The racial attitudes of the white cultural elite also explain the variable success encountered by Third World writers and directors. Because of the characteristics of the literary and film markets, the survival of Third World artists depends on the diffusion of anticolonialist ideologies among the arbiters of taste. The writings of Sartre have undoubtedly helped Third World poets, novelists, and filmmakers enter the circles of French high cultural forms.

In short, the patterns of stratification operating in the society at large influence the socioeconomic or ethnic composition of differing types of artistic communities. The multifaceted complementarities between the artistic rank ordering of various disciplines and the social rank ordering of the corresponding artists and their audiences affect the likelihood of artistic revolutions, the profile of their protagonists, and their orientations.

The Translation of the Artist's Social Marginality

To the extent that works of art question the existing definitions of natural and social relations and to the extent that these works simultaneously forge new illusions and demystify those already accepted by artistic communities, they are seen as threatening the existing social and aesthetic order.

Because of the lower status attached to their gender, socioeconomic origin, or cultural background, female, black, or Third World artists confront therefore specific challenges. They are condemned to march under two flags since they must decide whether their statements, born because of or despite their social disadvantages, should confirm, deny, or transcend the marginality of their social status.[77] Although these artists, like their mainstream counterparts, aspire to enter "the roll of recognized masters," they must ascertain whether their success will require them to elaborate particularistic or universalistic statements about the human condition and whether such elaborations will be perceived as normal art or as revolutionary artistic statements.

Marginal artists who seek to make universalistic statements tend to divorce themselves and their works from the social consequences of the ascriptive status imposed on them. Commenting on the 1977 exhibition entitled "Two Centuries of Black Painting," David Driskell accused most black painters of the past of having been unduly universalistic and of having ignored the conflicts experienced by their race, and having rarely dealt with the position of blacks within American society. Yet this charge ignores the relativity of the concept of universalism. Not only does it deny that blackness was hardly a recognized object of aesthetic research at the time but it also ignores the consequences of the peripheral position occupied by *all* American artists in the art world. To be recognized in America, an American painter had to go to Europe, to integrate the forms of the then dominant culture, and hence to reproduce the "normal" art forms of the period. Insofar as the style of black artists (and, for that matter, their white counterparts) reflected the conservatism of American collectors, the influence of external patterns of social stratification on the functioning of artistic paradigms and on their vulnerability to revolutions was twofold. To fault black painters for having been color blind presupposes that there was a market ready to absorb black art, whatever its specific definition would have been. In addition, for such an art

form to have taken hold in America, the European art world would have had to recognize it first—and its export to America would have required the implausible mediation of a significant white artist or collector. In situations characterized by dual systems of stratification (black versus white, central versus peripheral art worlds), the success of revolutions that aim to legitimate minorities as objects of aesthetic research often requires that the social status of its authors or sponsors be high.

The same patterns characterize the musical arts as well. Jazz was treated as a low art form as long as it was written by blacks for blacks. Its transformation into a high art form required two conditions. First, the status of jazz as a writing style was enhanced when it attracted white composers such as George Gershwin and when it began to be performed by largely white orchestras. Second, its acceptance was furthered when European elites hailed jazz as a new form of high art.

In addition, changes in the markets of the visual and the musical arts have been selective. American painters and composers are no longer obliged to acquire a touch of European "class" in order to be successful, though the same obligation continues to weigh on contemporary American musicians, regardless of their socioeconomic or ethnic origin. Thus, the style of American conductors is defined as universal only insofar as it has been labeled so in the musical capitals of Europe.[78]

The success of the revolutions prompted by artists with a low socioeconomic or ethnic status therefore depends not only on the patterns of social stratification operating in their own societies but also on the rank ordering of cultural elites themselves and hence on the significance of the distinction established between the core and the periphery of the corresponding artistic markets. Whenever minority artists ignore either one of these conditions, their endeavors seem doomed to fail. Revolutions fail, therefore, whenever such artists directly protest existing patterns of stratification and celebrate the particularities attached to the ascriptive components of their own status. In French literature, Alphonse Daudet and Frédéric Mistral tried to celebrate their own roots and to evoke Provençal habits and language; yet their works were relegated to the low-status category of regional novels. In this country, William Faulkner's work avoided such regional labeling only by being hailed by European critics as universal. Similarly, it is because authors such as Theodore Dreiser or Jules Vallès have sought (or have been

accused of seeking) to celebrate the particulars of working-class life that their works have been relegated to the minor genre of the populist novel.

Thus, artistic statements about the conditions of minorities present some common problems. First, the success of the revolutions that such statements represent depends on the ascriptive characteristics of both their authors and their audiences. Certain white authors (notably Eugene O'Neill in *Emperor Jones* and Jean Genet in *Les Nègres*) and musicians (notably Mezz Mezzrow and Dave Brubeck) have tried to overcome the aesthetic barriers of ethnic segregation, but their success usually depends on their acceptance by the black cultural elite and their attitude toward segregated art forms. In the same way that some black elites assert that white artists cannot legitimately cross racial boundaries in their artworks, some feminists argue that women's art should be segregated; Lucy Leppard, for instance, asserts that certain aspects of women's art are inaccessible to men, that certain forms of patterns are found exclusively in the work of women.[79] In this view, women artists are supposed to develop a vaginal imagery on which they claim to exert a legitimate monopoly. But if the imagery of women's art is vaginal, why is the imagery of male artists not limited to the penis? And why are some male artists obsessed with the vagina? When feminist artists or critics emphasize the thing, that is the sex, and assert that "pudenda should not be an object of shame but of glory," they risk confirming Hegel's proposition that contradictory terms such as shame and glory are structurally identical. In other words, their reduction of art to a liberation and, more specifically, to an isolation of sexual geography may doom their work to the low-status category of regional artifacts.

In addition, the success of the revolutions represented by such statements may depend on the extent to which they are translated into universal values. In English literature, many female writers of the early nineteenth century resolved this problem by using the then socially acceptable themes and symbols of the antislavery movement to elliptically denounce the repression to which all women were subjected. Similarly, George Sand introduced parallels between the miseries of her own sex and those endured by the peasants and working classes of her time.[80] More recently, French-speaking black writers and moviemakers have not only borrowed the universal French grammar and symbols to denounce the specific abuses of French colonialism but some of them, notably Med

Hondo and Ousmane Sembène, have also sought to show parallels and differences between the evils of social and cultural stratifications.

Finally, the success of these revolutionary statements cannot be independent of historical context. Nothing illustrates more graphically the equivocations between "high" and "low" art in this regard than the tensions to which folk arts are subjected. Whether folk artists are American Indians, Haitians, or Africans, their works and careers remain marginal as long as they are exclusively related to local functions and have no obvious meaning to outsiders. If their works acquire the status of objects d'art among certain segments of colonizing societies, however, their value varies over time with the degree to which their authors import more modern materials or sources of inspiration or retain and rediscover techniques and symbols deemed to be the epitome of "primitivism" by the patrons of high art.[81] Thus, although art may be a form of collective action, the structures of this collective action are still subject to changing processes of conflicts both within artistic communities and between such communities and the world at large.[82]

Conclusions

Artistic careers develop within various temporal frameworks. They are histories and correspond to the unconscious unfolding of specific processes systematically distributed over time, but they also have histories and correspond to the successive conceptions that individual practitioners, their communities, and the society to which they belong entertain about nature, culture, and artistic interrelations between them.[83] This double nature of creativity illuminates the relativity of artistic revolutions. It helps explain who will engage in normal practices and who will participate in artistic revolutions.

In addition, both the objective opportunities offered to various types of practitioners and their subjective evaluations of the risks they should take are not constant throughout their lives and careers. In other words, the effects of aging on careers cannot be alike when disciplines are experiencing normal practices and when they are in the process of undergoing artistic revolutions. Thus, in or-

der to explain when revolutions are likely to occur, it is necessary to examine the histories of individual artists and their artistic communities.

Finally, the influence of individual careers and aging on the making of revolution varies also according to the patterns of stratification at work in society. These patterns affect the distribution of cognitive, emotional, and normative orientations of the population at large. As such, they affect not only the origin and the outlook of artists but also the conditions under which their works will be praised or ignored. Most important, social stratification affects the ways in which artists negotiate the dilemma raised by the universalistic and particularistic functions imputed to their activities, and hence their definitions of the tensions between normal and revolutionary practices. Correspondingly, understanding patterns of stratification helps explain the object of revolutions.

5

Artistic Revolutions: Conflicts Over the Durable, the Transient, and the Rubbish

While works of art symbolize a particular mode of control over or of submission to nature, they also foster specific patterns of interaction between artists and audiences, as well as among audiences themselves. Thus, artistic revolutions cannot be studied exclusively from an internalist perspective. Artistic revolutions are also political, as they imply changes in the rank ordering of artists and audiences as well as in the organization of their relations.

Correspondingly, artworks must be defined not only in terms of their values of usage (as we have done so far) but also in terms of their values of exchange.[1] This chapter is devoted to an examination of these values.

The logic underlying the values of exchange conferred on works of art regulates the equivalences operating in art markets and hence their political economy.[2] In other words, it specifies the economic and social scarcities attached to the rewards that artists derive from their labor. It also regulates the ambivalences underlying modes of social interaction between artists and audiences. To be sure, the performance or the display of a work presupposes an agreement among various participants. Yet this agreement remains spatially, temporally, and functionally limited and does not prevent participants from experiencing conflicting feelings toward one another. Artists frequently complain about the philistine dispositions of their clients; patrons are rarely indulgent toward the eccentric lifestyle they impute to artists. Correspondingly, artists

128

and audiences constantly negotiate the symbolic scarcities attached to the social positions that they claim to occupy in relation to one another. Finally, artistic communications depend on a logic of differences; social groups use art to differentiate themselves from one another and to claim a status that places them above others. The rank ordering of the various arts, of the various genres within each field, and of the various works within these genres enables elites to legitimate their privileges and to justify their own social scarcity.

All societies tend to contrast individual works, genres, and disciplines in terms of their "durable," "transient," or "rubbish" properties.[3] When individual works of art, genres, and entire disciplines are entered in the "durable" category, they are deemed to symbolize the noblest, that is, the most universal and permanent qualities of human societies. When they are entered in the "transient" category, they are believed to constitute pragmatic responses to historically dated and spatially circumscribed situations or needs. Finally, the term "rubbish" suggests that the corresponding artifacts are considered to be outdated or to mirror the bad taste that plagues certain social or cultural groups. Because these categories are social constructs, the placement of individual works, genres, or entire disciplines in either one of these categories cannot be stable.

Societies differ from one another in terms of the degree to which they allow disciplines, genres, and works to move from one category to another. In some cases, disciplines, genres, or individual works are prevented from moving across these three socially constructed categories. The distinctions between what belongs to durable, to transient, or to rubbish categories helps distinguish castes from one another. To the fixed hierarchy of disciplines, genres, and works corresponds the fixed hierarchy of social groups. Despite the fact that in other societies, disciplines, genres, and works move across the boundaries separating durable from transient or rubbish categories, these moves do not necessarily entail an equal and homogeneous distribution of power and prestige across social groups. Whenever or wherever the social control exerted on these moves is rigid, the social distributions of power and prestige are independent. Those patrons and artists considered most prestigious treat artistic disciplines, genres, and works as indicators of purity rather than as sources of power. In other words, they claim that aesthetic and social hierarchies are independent and, more specifically, that there are universal masterpieces or noble fields whose merit can be recognized by all individuals. Conversely, whenever

or wherever the social control exerted on the move of artistic ob-
jects across categories is loose, power and prestige remain aligned
but the continuous erosion of status and prestige differentials leads
ultimately to a flattening out of patterns of social and aesthetic
stratification and to the disappearance of the durable category.

Thus, artistic revolutions do not only involve changes in the
mobility undergone by artistic objects across the categories of du-
rable, transient, and rubbish and in the ensuing changes of status
experienced by individual artists or patrons. Indeed, revolutions
require changes in the rules that make such a mobility possible,
and they correspond to shifts in the codes that regulate relations
between artists and patrons or among patrons themselves.

Because these categories of durable, transient, and rubbish are
not defined similarly across artistic fields and over time, this chap-
ter will evaluate these categories by field and assess how the shifts
from one category to another correspond to the making of particu-
lar forms of artistic revolutions.

Changes in the Distinction Between Durable, Transient, and Rubbish in the Visual Arts

Against the conventional wisdom that arbitrarily assumes that
objects derive their qualities from inherent physical properties, I
agree with the notion that these qualities result from a social pro-
cess of endowment.[4] The same forces that confer these qualities can
withdraw them in changed social circumstances. Distinctions be-
tween "high" (durable) and "low" (transient or rubbish) forms in
the plastic arts reflect discontinuities in the status that artists, pa-
trons, and their go-betweens occupy in the society at large, and
hence in the intensity and the form of the tensions that develop be-
tween them.

Quantitative Definitions of Durable, Transient, and Rubbish Objets d'Art

It is initially tempting to reduce the qualities attributed to a
canvas, sculpture, or piece of pottery to quantitative terms, and

hence to relate such qualities to mere numbers. In this perspective, the value attached to prints is a reverse function of the number of copies produced.[5] Conversely, the high quality imputed to a collection varies as a direct function of the number of items that few patrons are able to acquire. Similarly, the quality of collections also tends to be evaluated in terms of the ability of their initial owners to convince museums or galleries to acquire the whole lot rather than a selection.[6] Of course, the simplest translation of the value of an artifact into quantitative terms consists in setting a dollar value for it. The purchase of Andy Warhol's *Soup Can* for $60,000 in the 1970s supposedly secured the buyer a safe investment.

However, to reduce distinctions among artistic categories to quantitative terms unduly minimizes potential contradictions inherent in the economic functions served by the arts. To be sure, these distinctions justify the development of collections as tax shelters and as hedges against inflation and other economic uncertainties. But such functions paradoxically foster an increase in the volume of durable art markets. For example, auction prices for Picasso prints more than doubled between 1960 and 1969, and the total sale of prints at the famous auction house Sotheby, Parke and Bernet climbed from $150,000 to about $2 million between 1967 and 1969.[7]

Because of these economic functions, participants in durable art markets seek maximal stability in the definition of what constitutes high art. As suggested by the famous forger Elmyr de Hory, collectors, art dealers, and museum curators are not necessarily eager to identify the authors of fakes; the search for forgers would add further uncertainty to an already risky market.[8] Prompted by similar motivations, collectors may buy artifacts directly from artists or through private dealers, but when they want to sell their acquisitions, they often use the services of auction houses in order to confirm the legitimacy of their investments. Furthermore, it is not unusual for collectors to impose a floor price on the items they want to sell. Should the floor price exceed the highest bid obtained at the time of the auction, auctioneers may be obliged to "buy in" at the seller's price and return the object to the owner. This procedure is intended to limit the range within which the values of durable art forms can vary. For example, a public auction recently enabled art specialists to claim that a Giacometti bronze should be sold at about $230,000.[9]

Yet the participants in a durable art market do not only seek to

minimize their economic risk. They also have social motivations, to distinguish themselves from the rest of the population. Investments in the art world constitute a significant mechanism of social discrimination. Thus, the recent *Guide to the Collection and Care of the Original Prints* warns readers against the perversions of collecting with an eye to profit.[10]

As soon as one emphasizes the symbolic properties of art collections, however, one challenges the impermeable nature of the boundaries separating the durable, transient, and rubbish categories. In fact, there are marked variations in the motivations of individual collectors. Even during the Renaissance, when the definitions of "durable" art and of what was worth collecting were supposedly more universal, some Italian patrons were known for their obsession with the cruel or the grotesque, in contrast to their German counterparts, who were seen as disproportionately attracted to nudes.[11] Similarly, at a time when historical paintings and evocations of antique ruins were highly fashionable, the British consul in Venice was collecting landscapes and views.

Today, accentuated contrasts in the biographies of art collectors sharpen even further the differences in the criteria they use to build their collections. Some of them subscribe to an ideology of specialization and prefer to acquire the representative works of a particular school. Justin Tannhauser acquired his reputation as a specialist of turn-of-the-century cultural life and donated to the Guggenheim Museum various major works produced by Cézanne, van Gogh, and Manet.[12] Other collectors remain faithful to the imagery of a general education that goes along with the notion of a patron of the arts and are more eclectic in their choices. Thus, Van Hirsch's collection ranges from medieval paintings (judiciously acquired at the auctions liquidating the treasures of the Hermitage and of the Hohenzollern Sigmaringen family) to the works of Modigliani.[13]

In contrast to individuals who owe their reputation to their intimate knowledge of various art worlds, however, the choices of other collectors remain suspect. This is usually because their taste does not fit the criteria of accepted specialists. William Clark, a nineteenth-century American copper king, is still accused of having preferred ownership to connoisseurship. "He is a perfect barometer of what money was drawn to, in his generation, when it was left unguided by superior knowledge or serious ideas."[14]

Yet money alone cannot explain patrons' tastes and choices. Although some art dealers speculated that the affluence of petrodollars would boost their business, a Kuwaiti exhibition of Thomas Gainsborough and other English painters of the same period sold hardly any paintings. In the recent past, wealthy Middle Easterners (primarily Iranians and Egyptians) strove either to bring back to their countries objets d'art that had been exported to Europe during earlier periods or to purchase paintings or sculptures evoking historical figures who had a strong appeal in their countries. In short, collections reflect qualitative choices that vary over time and across cultures.[15]

Qualitative Definitions of Durable, Transient, and Rubbish Works of Art

Defining the qualitative boundaries separating categories assigned to works of art involves two distinct types of criteria. The first set of criteria pertains to an evaluation of the work itself, the second to an evaluation of the surroundings within which it has been created.

The Characteristics of Artifacts. The category to which artifacts are assigned depends on both the materials used to create the work and the function it is intended to perform. During the Renaissance, an Italian painter was renowned for using brushes that varied with the social status of his clientele. He used gold for nobility, silver for private citizens, and copper for the populace.[16] The accentuation of patterns of social stratification has rendered elusive the qualities imputed to the raw materials of an art work. Opulence can mean either luxury or decadence. Visual spareness may be a symbol of simplicity and asceticism but it may suggest plainness and poverty.

In addition, as already noted by Thorstein Veblen, an artwork derives its quality from its uselessness.[17] Initially, paintings and sculptures had a higher status than tapestries and ceramics because the latter served more obvious utilitarian functions, were produced in series, and were treated as transient. However, that distinction has progressively lost its significance. Utilitarian objects, such as tools, may become durable and may be shown in such temples of high art as the Metropolitan Museum of Art. Such

objects generally make the transition to the durable category when
they become antiques (that is, scarce) or lose their initial useful-
ness.[18] Furthermore, many contemporary artists seek to erode the
distinction between pure and applied art by transforming utilitar-
ian objects into poetic images. This holds true of Robert Arneson's
ceramic typewriter with red fingernail keys or of Jim Melchert's
three-foot-high letter *a* in steel.[19]

However, the status of paintings themselves is problematic.
Thus, the value of landscapes remains low as long as they are merely
documentary and as such are easily accessible to the general popu-
lace. Panoramas offer a case in point: exhibitions of panoramas of
the Mississippi River were accompanied by popular music. As
these panoramas were the precursors of early movie houses, their
status was that of transient forms of art. At the same time, useless-
ness has never been the sole condition for a painting to enter the
durable category. Scenes of daily life (*bambocciante*) were long
considered a durable art form only insofar as they were sufficiently
idealized and only as long as economic conditions enabled collec-
tors to acquire them without sacrificing more classical works.[20]
Similarly, the status ascribed to portraits has followed a curvi-
linear trajectory over the years. During the nineteenth century,
their value declined with the growing democratization of the sit-
ters (Ingres complained about the debasing chore of drawing the
portraits of bourgeois clients) before enjoying a selective recovery,
contingent on the age of each work, as it became fashionable to ac-
quire portraits because of their imputed aesthetic value rather
than because of their roles as symbols of a genealogy.[21]

In short, a visual artifact enters the durable category because
its owners acquire the power to control the irrationality of space,
not only through their appropriation of the materials utilized but
also through depriving the artifact of its usefulness.

The Characteristics of Artists. The entry of a canvas, print, sculp-
ture or other visual artifact into the durable as opposed to the tran-
sient or rubbish category depends on viewers being able to identify
without a shadow of a doubt the signature of its author. The impor-
tance of such a signature has increased with the growing individu-
alization of all social roles and with the concomitant superiority
assigned to genius over skill.[22] As a result, the development of in-
creasingly sophisticated techniques of attribution, based, inter
alia, on scientific devices such as x-rays, has reduced the number of

"official" Rembrandts from six hundred to about three hundred fifty; the number of Vermeers present in the National Gallery of London has similarly decreased from six to three, and two British experts recently attributed eleven paintings of John Constable to his son Lionel.[23]

The importance attached to the signature as a symbol of a work's originality has affected art markets in various ways. Because of the emphasis placed on the unique, copies tend now to enter the rubbish category, regardless of the identity of their authors. This emphasis has also been accompanied by a growing fascination with painters whose lives and styles remain mysterious, such as the Le Nain brothers.[24] Finally, as noted, such an emphasis has stimulated the importance of forgeries, which renders more problematic the definition of boundaries between the rubbish and durable categories. To be sure, forgery is not a new phenomenon. Fernand Léger, for instance, has been suspected of creating a number of Corots, and Maurice Vlamynck, a number of Cézannes.[25] Yet increases in the demand for modern art may prompt an increase in the number of fakes for two reasons. As suggested by Elmyr, forgery requires an intimate familiarity with the lifestyle of the "victim." Therefore, forgers are likely to be contemporaries if not close associates of their victims. Furthermore, the possibility of forgery is also increased by the current rhetoric that minimizes the distinction between the "transient" world of machines and the "durable" world of artistic and individualized creation. As sculptors such as Claes Oldenburg and Louise Nevelson use industrial plants in order to realize their works, how can the finished product be attributed to one artist when it involves so many hands and so many machines?[26]

The Characteristics of the Artist's Environment. The entry of an artifact in the durable category is also contingent on the status assigned to the culture to which it belongs. Variations in this status reflect variations in the control that competing social groups claim to exert on space. Durable art forms are considered cosmopolitan; their rubbish counterparts are considered provincial. However, the cosmopolitan quality of durable art is only superficial, because it reflects the domination of particular elites who claim to have a universal vocation. During past centuries, durable art implied a commensurate submission to the tastes of the French upper classes. Such tastes dictated whether Spanish works of art or black masks and sculptures were admissible to the temples of high art. In Ameri-

can circles, this lopsided definition of cosmopolitanism implied
the superiority of European artists and therefore obliged American
painters to establish their credentials in European capitals before
being accepted by American patrons.[27]

In the United States, distinctions between the cosmopolitan
and provincial character of art forms on the one hand and their du-
rable, transient, or rubbish qualities on the other have ceased to be
linked, for several reasons. Because of the vagaries of established
art markets, certain American collectors have become more active
in collecting primitive art, challenging the long-standing notion
that only eighteenth- and nineteenth-century folk art was worthy of
the serious collectors' interest.[28] As a result, many primitive paint-
ers have been able to move from outdoor art shows to more estab-
lished galleries and to raise their prices from less than $100 to con-
siderably more than $1,000. Furthermore, the doubts increasingly
nourished by American collectors toward European artists have
been reinforced by the growing intervention of museum specialists
in favor of local rather than foreign artists. Finally, American crit-
ics and artists have been able to win their long-standing battle
against the supposed evils of a European cultural colonialism.
After having compared the effects of large-scale importing of Euro-
pean art by industrial magnates to the "invasion of Ellis Island by
alien hordes," critics have successfully celebrated the authentically
American nature of abstract expressionist painters such as Mark
Rothko, Robert Motherwell, Jackson Pollock, and Willem de Koo-
ning.[29] But now that New York has replaced Paris as the official
capital of the avant-garde, a show there has become a requirement
for European artists seeking to make their names.[30] The place that
used to be at the periphery of the art world system has become its
core. Moreover, the success of contemporary American painters
has spread to the art of their predecessors, many of whom have
been rehabilitated. For example, the paintings of George Caleb
Bingham, which had fallen into virtual oblivion, have recently
been heralded as those of "the Rembrandt of the Midwest," and one
of his canvases was sold for close to $1 million at a recent auction.[31]
In short, the transfer of specific works of art from rubbish or tran-
sient to durable corresponds to shifts in the relative power and sta-
tus of various social classes and of various nation states.

Finally, distinctions between the durable, transient, and rub-
bish categories depend on the characteristics assigned to the era
during which the work was produced, and hence on the control

that various social groups exert over time. The form and extent of this control vary with the differential availability of various schools or styles on the market, the modes of interaction between public and private collectors, and the current techniques of reproduction. As this control depends also on the prevailing ideology of the larger society and on the relative preeminence of elites, there are recurrent tensions between the glorification of the past and its condemnation as a symbol of obsolescence. As a result, the status of a particular artist or of a particular genre does not evolve in a cumulative way. For example, all Raphael's paintings were among the most valued at the end of the eighteenth century, but his early work was not even considered worth copying a century later.[32] As another example, the values ascribed to Joseph Turner's paintings were initially as high as those ascribed to the paintings of his contemporary Thomas Gainsborough; yet the price asked for Turner's canvases remained stable or even decreased until that artist was hailed as a precursor of the impressionist movement. For a last example, the proportion of historical paintings sold in French public auctions between 1750 and 1850 declined from 52 to 30 percent, whereas the share of "timeless" landscapes in such sales increased from 27 to 42 percent.[33] As already noted, the acceleration of social mobility and of the diffusion of upper-class status symbols induced a parallel acceleration of changes in the resolution of the tensions between a positive (or *arrière-gardist*) and a negative (or avant-gardist) evaluation of past works.[34]

Thus, variations in the qualities imputed to artworks or forms suggest that objects have no real intrinsic properties.[35] Whether they are initially entered into the durable category (in which case their value should increase over time), into the transient category (in which case their value should decrease over time), or into the rubbish category (in which case their values should remain uniformly low), their fate is not sealed. As suggested, revolutions correspond to changes in the categories in which artworks are entered.

Interactions Between the Status of Artworks and the Relationships Between Artists and Patrons

The greater the mobility of artworks across categories, the greater the differentiation not only of collectors and of artists but also of their modes of interaction with one another.

Many observers of the New York art scene have contrasted the flashy style of major purchasers during the sixties with the more discreet and intellectual approach of their successors in the seventies.[36] The earlier group is said to have traveled more easily the cocktail party circuit, and to have been keen to be seen in public with the "blue chip" artists they were sponsoring. The collectors of the seventies more often came from a lower socioeconomic environment and tended to share a larger part of their private lives with the artists they sponsored. As they claimed to build their collections for such artists rather than for the public, their collections are said to have been more stable than those of their predecessors. Thus, there are variations in the styles of interaction that collectors adopt not only toward one another and their artists but also toward their possessions.

In addition, the blurring of the boundaries between aesthetic categories modifies the range of prices that artists are able to obtain for their works. After the boom experienced by abstract expressionist paintings in the late fifties, the new respect won by American art quickly rubbed off on pop artists, whose works began to command high prices during the late sixties. However, such increases in scale of the economics of taste have been paralleled by greater variations not only in the values assigned to different painters of the same school but also in the earnings that individuals may expect during their careers. Although collectors are the primary beneficiaries of this increase in scale, the fees that artists can charge still tend to rise with the official quotes of their canvases. For instance, it is believed that Andrew Wyeth received no less than $250,000 per painting at the height of his active life, and the substantial earnings of Picasso are undoubtedly mirrored by the richness of his estate.[37]

Finally, the differentiation of collectors and artists entails as well a differentiation of their professional encounters. During the Renaissance, exhibitions were often held on a saint's day in order to embellish the churches where they were held and to validate the merits attributed to the canvases of old masters rather than to help current painters sell their works.[38] Toward the end of the seventeenth century, the functions and forms of these exhibitions began to vary with the profiles of the countries in which they were held. In France, both the selection of painters, sculptors, and architects entitled to receive government commissions and the sale of their art to royal households contributed to the shaping of public taste.

In contrast, the exhibitions of the Royal Academy in Great Britain were held in order to secure its independence from the English monarchy through the sale of convases and catalogues, and hence to maintain private aesthetic standards. Organized later in German cities, exhibitions were intended to help artists identify themes of inspiration more serious than those in vogue and to lift the taste of collectors, critics, and the public at large.[39]

With the passage of time and, more specifically, with the institutionalization of art history, there has been a further differentiation of the educational and economic functions served by exhibitions. While the development of individualism has been accompanied by an increase in the number of one-artist shows, the growth of an ideology emphasizing the pedagogical value of the arts has stimulated the growth of shows that regroup paintings in terms of a particular theme (art about art, the object as a poet, the gardens of Paris) or of the common ideology of their authors (surrealists, école de Barbizon, etc.).[40]

To this differentiation of the functions performed by exhibitions corresponds a parallel differentiation of their organizational patterns. Until the end of the eighteenth century, official competitions enabled individual patrons to institutionalize their own preferences in order to screen applicants more easily. Today, such competitions are almost exclusively initiated by the public sector.[41] The relative importance of direct contacts between artists and collectors has declined over time as a result of the rising number of art dealers and of the resulting commercialization of high art. The increase in scale of the economy of tastes has also been associated with the growth of multinational companies whose structures are adapted to the specific features of the artistic market. Thus, the famous New York dealer Leo Castelli has not only developed a highly efficient network of art galleries to which he assigns exclusive rights on the new works of specific artists, but in addition, he also ranks his secondary galleries in terms of the status of their respective patrons.[42] Moreover, Castelli uses European collectors as models to guide the more inexperienced American buyers building "durable" collections.

This multifaceted differentiation of dealers and patrons creates tensions in the functioning of art worlds. As long as artistic markets consisted of a limited group of people who originated from the same sociocultural environments and operated within close knit networks, the motto "What you see is what I say" which they used

in their professional transactions did not present significant political or social problems. Yet as more people have joined the trade, there have been greater variations in their tastes, educational or professional experiences, and financial resources. With the corresponding erosion of traditional modes of social control, the art world has become unable to validate information concerning the price of canvases sold, their authenticity, and the history of their ownership.[43] Correspondingly, the forger Elmyr claims that few reputable dealers take back from their clients works of art that are later demonstrated to be inauthentic.[44] Furthermore, patrons do not necessarily want their naiveness to be publicly exposed, and the same holds true for the experts who make mistakes in identifying works. Some curators have been instrumental, for instance, in judging an Elmyr to be a Dufy of the highest quality.

The increased erosion of the boundaries separating the qualities ascribed to objects and the accentuated differentiation of patrons, artists, and their encounters tend to reflect as well as create an "anomic" situation.[45] Indeed, disjunctions between the organizational and cultural structures of art worlds foster contradictions not only in the definitions that participants give of success and its indicators but also in the definitions they offer of the legitimate means for achieving success.

The growth of such contradictions affects the likelihood and the form of artistic revolutions in various ways. Increases in the number of forgeries create revolutions, as they modify the number of recognized masterpieces. The recognition of such forgeries drastically alters existing hierarchies in the communities of collectors, museum curators, and artists themselves.

In addition, as the commercialization of art obliges artists to be directly involved in the sale of their products and to push their works as well as their images, it erodes existing boundaries between durable, transient, and rubbish forms of art. Some of the most famous American painters spend most of their professional lives traveling, making personal appearances in the appropriate circuits, and generally promoting revolutions or counterrevolutions, in order to increase sales of their works. Regardless of the rhetoric artists use to that effect, all these changes are revolutionary because they alter the meaning of the distinction between "art for art's sake" and commercial art.[46]

As a consequence, artistic revolutions may also concern shifts in the definition of the rights that artists hold over their produc-

tion. For example, in 1978 the painter Georgia O'Keeffe was threatened with a lawsuit by her former agent, who claimed that the "artist had eliminated her from her will in a cruel and wrong way."[47] In this sense, the rights of successful painters seem to become more problematic. This situation induces a growing number of artists to challenge the limits traditionally imposed on their rights. In contrast to the royalties of writers and musicians, whose value increases with the number of times their works are reproduced, the value attributed to a painter's work traditionally has been defined in terms of its uniqueness and originality. In other words, painters dispose only once of the source of profit inherent in their work. Artists did not necessarily challenge this arrangement as long as their creativity was a source of sufficiently large symbolic rewards. Nevertheless, their stance in this regard changed with the growing ambiguities underlying relations between the visual arts and the processes of mass production. Thus, the painter Robert Indiana, who painted the word *Love* on a canvas in 1964, saw his motif used by various manufacturers without receiving any compensation.[48] To be sure, both the use of copyright symbols on the canvas and the development of licensing rights, authorizing a manufacturer to utilize an artist's motive under close supervision, may prevent painters from feeling cheated. But to resort to either of these strategies is to risk eroding further the premises on which the myth of durable art has been based. Indeed, the same erosion may also be produced by the laws that seek to guarantee a royalty to an artist each time his or her work is resold.[49]

Furthermore, revolutions may involve a redefinition of the symbolic rights of ownership that an artist might claim concerning his or her work. In contrast to many modern artists who have been unable to prevent the "editing" of their works, Rothko refused to deliver canvases already sold to the Seagram Company when it became clear that they would not be hung as initially agreed.[50] Similarly, Jean Dubuffet recently sued Renault for destroying his *Salon d'Eté*, a major work the automobile manufacturer had commissioned.

Finally, revolutions may involve a transformation of the traditional mechanisms by which works are presented to the public. Thus, the conception of art as a performance emphasizes the emphemeral nature of aesthetic communications and prevents the "freeze" to which they are subjected in the context of traditional exhibitions. Similarly, earthworks or various forms of street art

prevent their appropriation by privileged segments of the public and hence their privatization. "The moment you try to move my creations, to take them away for your private enjoyment, you destroy them," claimed Charles Simonds, a New York artist specializing in the creation of intentionally transient art objects.[51]

In short, the growing segmentation affecting the worlds of art dealers, collectors, and painters changes the form and the intensity of the tensions opposing artists to the public. Thus, artistic revolutions concern the resolution of conflicts between the rights to private ownership that a buyer of a work of art believes to have acquired with the public rights that artists believe they retain over a work because of their public status.[52] These tensions are mirrored in the equivocations surrounding the word *frame*. While it evokes the last step before a canvas enters the public domain, the word evokes also the economic or social traps into which artists, dealers, and collectors alike are likely to fall as a result of this entry. In other words, while the word *frame* refers to the materials used for enclosing a picture, it also refers to the scheming behaviors for which all these actors tend to reproach one another. Artistic revolutions also concern the implications of framing.

Artistic Revolutions and Museums

Tensions in the definitions of the qualities assigned to artworks also affect the social definitions of museums. Indeed, the role of museums has been challenged since the first days of their institutionalization. The hoarding of disparate objects has been and continues to be believed to make them lose their original meaning. In 1792, a visitor to the Dépôt des Petits Augustins, where revolutionary authorities had regrouped the various artworks removed from churches and castles, complained that the works looked like a collection of disarticulated and lifeless manikins.[53] Similarly, philosophers and painters have often complained about the unavoidable conflicts between the ceremonial functions that a painting or a sculpture serves for its creator or for the person who commissioned it and its ostentatious role when it is on display in a museum. In fact, the same visitor to the Dépôt des Petits Augustins complained that it was most inappropriate to show the statues of the church Saint Sulpice up close since they had been created to be viewed

from a distance. Thus, museums have often been suspected of distorting the meaning of works of art.

Such a suspicion reflects the tensions that oppose the forces of exclusion and inclusion at work in legitimating processes. As museums necessarily serve political purposes, government attitudes toward them are highly variable. Some theoreticians of the French Revolution saw museums as an opportunity to show French citizens the bounties that the new regime had extracted from aristocratic mansions, castles, monasteries, and churches or from less fortunate countries. Napoleon was later able to reach a similar objective by bringing back art treasures from Egypt and Spain. During modern times, the Nazis were famous for pilfering the museums of the countries they vanquished.

In contrast, certain governments consider that the public display of artifacts that symbolize inimical cultures may jeopardize the purity of their own ideological views. The Soviet government, for instance, closed the Hermitage collection in Leningrad for years, since the museum had exhibited paintings by supposedly decadent artists for the enjoyment of supposedly decadent social groups. The Soviet government also sold to the private collectors of Western Europe the paintings and antiques of the czar and of the Russian nobility.

In the same vein, museums may serve two opposite social functions. They may offer to the public the collections of cultural elites as exemplars of high taste or they may, conversely, protect such collections from the unhealthy curiosity of the masses. The political centralization of French museums is believed to enable every citizen to equally participate in the appreciation of works of art, thereby legitimating the dominance of the taste of cultural elites. Against this cultural imperialism of French museums, the majority of American museums remain private institutions that are sponsored by a few individuals and that cater to a narrow segment of the population. As, at least initially, the trustees or the board members of the Chicago Art Institute and of the local Museum of Modern Art did not originate from the same segments of the socioeconomic cultural elites, the two museums differed in their acquisitions policies or in the ways in which they organized their respective shows.[54] The point is that the decentralization of American cultural institutions and the contrasted profile of their sponsors reflects and fosters a parallel fragmentation of tastes.

Tensions between the forces of inclusion and exclusion at work in legitimating processes reflect and generate parallel conflicts in the importance attached to quantity as opposed to quality. On the one hand, the role of museums is analogous to that of archives in that their wealth is defined in terms of the number of items accumulated or displayed. During the nineteenth century, for example, the walls of European museums were cluttered with canvases of various authors, sizes, and types. On the other hand, a museum's value may be defined in terms of the ideological choices that underlie its presentation of collections. As early as 1793, it was suggested that "the content of exhibitions should be enlightened and embellished by the *method* with which objets d'art are displayed."[55]

But far from being monolithic, this method itself betrays opposite time orientations. During the French Revolution, museums were often seen as appropriate places for sheltering masterpieces of the past and for asserting the existence of real or imaginary continuities between their stance and an idealized vision of days gone by. The emphasis placed on the value of past artworks and artists remains nonetheless equivocal, because of the contrasted meaning assigned to the past. Conservation may be restrictive and involve strictly the upkeep of past artifacts in their current state. Yet conservation may also involve a reinterpretation, if not a downright reconstruction of the past. During the middle part of the nineteenth century, Eugène Viollet-le-Duc was often criticized for imposing an inappropriately romantic vision on his restoration of medieval castles and churches. Closer to us, certain New York painters recently protested the cleaning of Tintoretto's unfinished *Alvenigo Mecenigo Presented to the Redeemer*, objecting to the revelation of new figures on the canvas "that had been obviously painted out by the artist himself."[56] Yet, to paraphrase here the nostalgic complaint of Le Corbusier, how can one identify the days when cathedrals "used to be white" and identify the boundary between conservation and restoration? Against this view which, despite its ambiguities, assigns a privileged status to the past, artistic elites and museum curators take seriously the objections of the French critic Charles Delescluze who complained that "museums were necessarily the hospitals if not the cemeteries of the arts."[57] They maintain that such institutions should be innovative and support all forms of current artistic expression. Thus, some modern museums have added photographs to their collections and have recently sought to erode the traditional boundaries erected between

painting and sculpture, the visual and the performing arts, and even between the arts and the sciences. Yet this type of innovation also creates controversies; take, for example, the criticism levied against the Tate Gallery in London for buying from the minimalist sculptor Carl André "a mere pile of bricks."[58]

The method to which I have alluded also betrays opposite conceptions of the social functions to be performed by museums. On the one hand, museums are expected to provide formal as well as informal educational experiences, and art schools are often attached to museums, which in addition frequently offer programs and facilities to students of primary or secondary institutions. In 1966–1967, for example, the Art Institute of Chicago was visited by 75,000 children, brought by their schools or school-based cultural groups.[59] On the other hand, museums are also seen as businesses that must use all the marketing devices available to attract the most visitors. Obviously, these educational and marketing aspects create tensions.[60] Those who stress the functions of museums as sanctuaries of the purity of art complain that museums have become flooded with counterfeit art; those who emphasize the role of relevance in this regard deplore the inhibiting atmosphere of many museums and notably the repressive behaviors they adopt toward children.

Thus, artistic revolutions also concern the activities of museums, their organization, and their functions. Shifts in the definitions of artistic categories and hence in the patterns of interaction between artists and patrons (as well as among patrons themselves) imply parallel shifts in the openness, centralization, and architecture of museums. The recent bureaucratization of American museums and the increased sensitivity of a certain segment of the American cultural elite to art history have culminated in the construction of the new wing of the National Gallery in Washington, the design of which seeks to reconcile a public and monumental space (evident in the exterior and the halls) with the private and individualized relations that art viewers are expected to build with carefully selected works of art in small, intimate rooms. In contrast, the ideology of mobility prevailing in France during the 1960s was conducive to the construction of the Centre Beaubourg, a cultural supermarket where boundaries between public and private spaces have been obliterated, symbolizing the need to erode boundaries between durable and other art forms, as well as between past- and present-oriented cultures.[61]

Artistic Revolutions as Conflicts Between Upper and Lower
Social or Cultural Groups

Insofar as the distinction between durable and other cultural
forms or between the noble and popular functions of museums
is not intrinsic but depends on the relations that various social
groups entertain with one another, it is necessary to examine the
artistic behaviors and attitudes of these groups. In fact, such be-
haviors and attitudes are used as symbols to justify or challenge
inequities in the distribution of power and prestige in the society
at large.

In the United States, rates of attendance at museums vary ac-
cording to income and education.[62] In 1975 the number of Ameri-
cans who visited a museum ranged between 20 percent (for those
earning less than $5,000 a year) and 59 percent (for those whose
annual income exceeded $15,000). For respondents who had not
finished high school, only one-fifth had ever visited a museum,
compared with more than three-quarters of those who had gradu-
ated from college. To the extent that the amount of education is
therefore a better predictor of exposure to museums than income,
cultural rather than purely economic capital seems to be the sig-
nificant determinant of these rates.

Yet the various components of such cultural capital may have
differing effects in this regard. Visits to museums vary with the
type of study undertaken and are more frequent among those who
have followed a general rather than a narrow curriculum. Further-
more, far from being absolute, the influence of educational experi-
ence is contingent on the socioeconomic background of the popula-
tion examined. Among French university students, only 21 percent
of those originating from lower classes reported having visited mu-
seums and art galleries in 1964, compared with 39 percent from
the upper classes.[63] For the first group, such visits were more often
the result of initiatives taken by teachers and other educational au-
thorities; for the second one, such visits tended to begin earlier and
to reflect the influence of their familial community. In other words,
the first population usually learned new skills; the second one gen-
erally consolidated the fruits of a cultural legacy.

These differences in the modes of acquisition of cultural capital
were accompanied by parallel contrasts in individual behaviors
and attitudes toward the visual arts. For the first population, going
to a museum often remained a part of school experiences; for the

second, it was often an integral part of leisure activity. University students originating from the upper classes were more likely to use travel and vacations to visit museums. Furthermore, there are significant social or cultural distinctions regarding taste. While Picasso complained that "nowadays, the nonartists who visit the Louvre are the people who admire whatever makes paintings into good likenesses," preferences for "good likenesses" are more characteristic of children than of adults, of individuals with lower levels of education, or even of laymen rather than of experts.[64] Among the university students to whom I alluded, the proportion of individuals who are familiar with modern nonfigurative art rose from 15 percent in the case of those with lower-class backgrounds to 30 percent among those from the upper classes. In fact, the latter were also more likely to appreciate such a style than the former.[65]

There are two possible reasons for this contrast. Insofar as individual differences in aesthetic taste reflect the distinct cognitive styles prevailing in the familial environments within which respondents have grown up, one may argue that the "elaborated syntactic code" of middle- and upper-class families probably facilitates a greater familiarity with and appreciation of the abstractions and syntax used by contemporary painters.[66] However, this line of reasoning tends to be ahistorical and unduly emphasizes the "objective" meaning of the arts. One may therefore prefer to argue that upper-class individuals are attracted to modern abstract painting because of the processes by which they exert their dominance. Indeed, such elites keep changing the definitions of taste in order to differentiate themselves from the cultural aspirations of groups with lower positions in the social hierarchy. Far from being static, relationships between patterns of social and cultural stratification change, therefore, with historical conditions.[67] Correspondingly, the concept of cultural reproduction cannot evoke only the image of a wheel turning on itself. To the extent that the wheel turns on a changing terrain, discontinuities exist in the symbols used by dominant classes to assert their supremacy and to take advantage of their privileges.[68] In short, artistic revolutions also concern shifts in the correlations among the distributions of status, power, and resources in the population at large. Correspondingly, there are two types of revolution. In one case, artistic revolutions and the ensuing shifts of individual works or genres from transient or rubbish into durable categories are spurious insofar as they simply facilitate the perpetuation of the existing cultural elite's dominance.

The blossoming of kitsch and the beautification by such elites of the vulgar or the ugly to which the term "kitsch" corresponds offer a case in point. In the second case, revolutions result from changes in patterns of stratification and from the emergence of new elites that are able to impose their own standards.

Changes in the Distinction Between Durable, Transient, and Rubbish in Music

As is the case in the visual arts, musical productions have no intrinsic qualities. The qualities bestowed on them reflect the differential time orientations of various social groups. Past works or styles may be celebrated as precedents and as sources of inspiration for current composers, performers, and audiences alike, but they may also be condemned as symbols of decadence, if not of obsolescence. Thus, musical objects can also be categorized as durable, transient, or rubbish. Their movement among categories is subject to the same types of problems that the visual arts encounter.

However, unlike the visual statements whose productions are generally made once and for all, musical statements are mediated by performers. Correspondingly, the consequences of the moves of musical works from one category to another depend on the interaction between the musical syntaxes chosen and the economic or technological constraints regulating communication among composers, performers, and audiences.

Differentiation of Musical Syntaxes and Their Status as Musical Forms

In the second chapter, I argued that musical styles differ from one another in terms of their positions on two distinctive continua. Styles differ in terms of the number of organizational principles (such as melody, harmony, and pitch) that they specify and regulate. But they also differ in terms of the autonomy or the integration of these organizational principles. For example, a jazz soloist is faced with a multitude of melodic and rhythmic choices, whereas the performers of serial music are constrained by an overarching

structure that dictates the notes, rhythms, pitches, and themes that they must play.

Contrasts in these styles imply differences in the form of the shifts they may undergo. Thus, a style based on a limited number of organizational principles operating independently of one another (for example, popular music and its varieties) leads to the succession of large-scale, internally homogeneous, but discontinuous series. A style characterized by a large number of organizational principles operating independently of one another, as in jazz, evolves by successive distortions of the original structure. Accelerations of rhythm or additions of chords offer many examples of how this particular style has switched from, say, rag to swing. While classical music evolves through a slow metamorphosis of each component or of their interaction, the extensive and highly integrated syntax used in atonal or serial music makes its changes revolutionary and leads to the formation of entirely new paradigms.

Conflicts Between Musical Notation and Expression. Contrasts between musical styles and their histories affect how distinctions develop among musical forms and how tensions evolve among the various participants in the musical world. Thus, changes that have characterized classical music have induced conflicts between languages of notation and languages of expression or between composers and performers.[69] Indeed, such conflicts have increased in intensity and frequency since the mid-nineteenth century. In order to assert their supremacy over performers, composers have begun making increasingly complex notations to specify how their pieces should be performed. Furthermore, they have also sought to enhance their own status in the cultural community as a whole by embellishing the titles of their pieces with increasingly elaborate references—romantic in the case of Schumann, baroque in the case of Debussy, and self-mocking in the case of Satie. However, the composers' quest for a higher social status has also fostered conflicts in their relations with performers. As certain composers find the role of performer debasing, few show directly how their works should be performed. Stravinski is one of the few modern composers to have recorded his own works and hence to have provided players and audiences with a clear translation of his creative intentions.[70] Conversely, performers such as Paganini have sought to impose an immanent meaning on the score and make it subservient to the personality of the player. Liszt, for instance, said, "The con-

cert is myself." Thus, musical revolutions involve changes in the positions that composers and performers claim to occupy vis-à-vis one another.[71]

Revolutions as Conflicts Within Languages of Musical Notations.
Distinctions between durable and other musical forms are associated with accentuated tensions in the language of notation itself. Since, as in the case of the visual arts, a work's value depends on the authenticity of its author's signature, some composers may be tempted to engage in forgeries. In this regard, some doubts have been raised concerning the authenticity of Albinoni's *Adagio* and of Mozart's *Adelaide* concerto. Such frauds may affect the economic status of the relevant scores as written documents, but they do not necessarily lead to the displacement of such scores from the "durable" to the "rubbish" category. There are several reasons for the stability of their status. Musical forgers are often motivated by their desire to enlarge the repertoire they are keen to perform or by their desire to acquire a reputation as discoverers of lost manuscripts. Because of the specific legal structures of musical royalties, the only social problems raised by musical forgeries are necessarily limited: contemporary composers may accuse one another of plagiarisms.

Although the specific properties of musical ownership rights prevent signature from influencing the distinctions among musical styles, such distinctions are still contingent on the competition that divides composers regarding what constitutes the most appropriate writing styles. Certain modern composers denigrate the artisanal work of their competitors, which they contrast with the need to elaborate a total philosophy or a total architecture that they see as characteristic of their own style.[72] For example, many avant-garde composers despise the music of Carl Orff, whose emphasis on tonal melodies and simple rhythmic chants in *Carmina Burana* won him a place in the standard repertoire of many orchestras.

Thus, the claim that musical forms are high or durable reflects the hidden messages present in the score and hence the body of general knowledge required of their listeners. Indeed, the abstraction of high musical forms may be such that the burden of proof lies entirely in the ears of audiences. For example, as John Cage seeks to emphasize randomness in the production of rhythms and sounds, listeners increasingly complain that they must wait for reviews before deciding what their reactions to his pieces (or works

like them) should be. In this sense, musical revolutions concern shifts in the rank ordering of the scores that composers intend to impose on audiences.

Revolutions Concerning Languages of Musical Expression. The growing division of musical roles and the increased differentiation of musical styles have also heightened tensions in the language of expression itself. These tensions concern the choice of instruments. For a long time, the flute had a low status and many composers were reluctant to write a piece for the instrument.[73] The same still holds true for the accordion. In addition, the status of instruments is relative to the scores being performed. After World War II, because of the large pool of talented harpsichordists such as Wanda Landowska or Clifford Kilpatrick, the performance of Bach's or Vivaldi's music on grand pianos rather than harpsichords was considered to be a low rather than a high musical form.[74]

Distinctions among musical forms also concern the use of particular performing styles. Since Mozart's father referred derogatorily to vibrato as a performing style, many violinists and critics of today tend to unduly believe that the use of vibrato in Mozart constitutes an anachronism and falls, as such, into the category of a low art form. This example offers another illustration of the social, and hence relative, nature of the definitions of aesthetic categories. Today, the use of vibrato in playing eighteenth-century music may be considered to be "rubbish," either because it is deemed, albeit improperly, that this style constitutes an anachronism, or because its dramatic properties sound as inappropriate to high-class "ears" as to the older Mozart's.

Distinctions among musical forms also concern the profile of performing groups. Recitals and chamber music performances occupy a stable position in the pantheon of high musical forms because of their private and hence exclusive character, but variations in the size of orchestras are more equivocal. The number of players may be a direct indicator of wealth and hence of high status, as exemplified by the intentions of Berlioz with regard to some of his scores. In contrast, a very large orchestra may at times be considered symbolic of excessive opulence and hence of bad taste.

Finally, distinctions among musical forms concern the choice of the editions retained for the performance. In contrast to the use of the transcriptions of Bach's music by Tausig, Liszt, Busoni, or Respighi—which has been considered alternatively to be a sign of

high or low culture—Leopold Stokowski's orchestral arrangement of Satie's *Gymnopédie* tends consistently to be treated as a low musical form that corrupts the canons of high taste.[75]

Increased variations and hence ambiguities in the definitions of "high" performing styles have been conducive to a systematic rise in the status accorded to conductors. In the French opera of the nineteenth century, the popularity enjoyed by certain famous soloists entitled them to criticize their partners on stage during the performance.[76] Since then, the visibility of competition among individual artists has been increasingly superseded by the conflicts between these artists and their conductors. Indeed, the star status of conductors threatens the established reputations of individual performers, who may feel obliged to adjust to a style that they do not approve of. Zubin Mehta's move from Los Angeles to the New York Philharmonic created various tensions not only because of the high professional status enjoyed by the New York performers but also because of the new demands they anticipated would be made by the new conductor.[77]

Thus, musical revolutions concern shifts in the status imputed to each instrument's performing style and to the status of each category of performer. Such shifts occur, for example, when ballet music enters the most prestigious concert halls or when accompanists, those artisans of applied music, cease to remove themselves from the stage.[78]

Revolutions as Shifts in the Economic Organization of Music

The evolution of the effects that distinctions between high (durable) and low (other) musical forms have on the relations between musicians and their public depends on two factors. First, these effects depend on the institutionalization of musical roles and on the consequences of this institutionalization regarding the status of composers and performers. Second, they vary with the influence that economic and technological factors exert on the public as opposed to private nature of musical performance.

In the past, musicians (who began as wanderers) depended on festivals for two different reasons.[79] Their economic survival was a function of the calendar of local celebrations. But they were also obliged to avoid the consequences of their constant challenge to the established order. Physically excluded from the community

and socially rejected at the very bottom of the social hierarchy, they were nevertheless treated as superhuman because of their envied contact with the dangerous and the forbidden. Because their journeys circulated common aesthetic symbols throughout a world that was still barely ordered hierarchically, they contributed to a marked, albeit ephemeral, integration of both the subgroups that made up each community and the communities themselves. The diffusion of these symbols was the instrument of the domestication of musicians. Indeed, the greater power of the church and the nobility enabled prelates and princes to appropriate for their own benefit the symbolic properties of musical work. During the seventeenth century, the musician Joachim Quantz was hired by the orchestras attached to the courts of various German princes and, ultimately, by the king of Prussia, for whom he acted as official flutist.[80] On the whole, this domestication implied diffuse modes of social control. For example, Bach was criticized by his sponsors in Arnstadt both for having spent too much time in Lübeck, a city he had visited in the hope of improving his skills, and for having learned new melodies and techniques that were judged as incompatible with the proper functioning of the Arnstadt chorale. Furthermore, Bach was expected not only to maintain the organ of the Arnstadt church in working condition but also to avoid contact with those elements of the local population suspected of tarnishing the church's good name. Similarly, the contract that Prince Esterházy had with Haydn stipulated that the musician had obligations not only as a composer and performer but also as an administrator and that, as such, he was responsible for the debts contracted by his predecessor. Such a domestication often induced musicians to view their work as dependent on the privileged relations they could establish with their sponsors. Thus, Jean Baptiste Lully dedicated his *Persée* to Louis XIV in these terms: "This opus is dedicated to you alone who will shape its fate."

With the progressive professionalization of the musical world and the ensuing lengthening and institutionalization of the studies providing access to musical careers, both composers and performers experienced a notable rise in social status. As these careers began to attract individuals from higher social strata, the corresponding revolution involved a shift in the relations between musicians and audiences.

Musical revolutions have also concerned the organization of musical performances. This organization is subject to various spe-

cific spatio-temporal constraints. Unlike the organization of exhibitions, the performance of a concert or an opera involves the successive rather than the simultaneous presentation of artifacts to the public. In addition, concerts, like operas, are offered to limited audiences, who gather in a specific room at a specific time.

Revolutions reflect shifts in such constraints, as they modify the attribution of distinct musical qualities to various types of concerts or operas or alter the differential status accorded to live performances as opposed to recordings.

Initially, concerts were considered a high musical form, insofar as their scheduling facilitated the exclusion of supposedly undesirable segments of the population. This status has been somewhat threatened by the rising costs attached to the star qualities of soloists or conductors. Indeed, such costs have necessitated an increase in the size of orchestra halls, in order to ensure the financial feasibility of musical ventures.[81] But, as this increase makes audiences more democratic and hence less socially homogeneous, and as orchestras and operas are obliged accordingly to retain conservative repertoires, the status of musical innovations is equivocal. For example, the Chicago Symphony Orchestra rarely devotes more than half its program to music composed since 1900. In fact, the same orchestra is known as a "German" orchestra in view of its preference for German or Austrian music. A similar pattern can be observed concerning the Metropolitan Opera's choice of works. Its repertoire betrays a marked selectivity of periods as well as authors.[82]

Under such conditions, distinguishing the internal from the external components of musical revolutions is a tenuous enterprise. External revolutions involve changing the décor of concert or opera halls, moving performances to museums and other public places, or allowing audiences to enjoy a greater sense of freedom and to wander freely from room to room or to relax on sofas.

Internal revolutions consist of choosing unusual works that have been excluded from the repertoire. In this sense, musical works that were condemned to the category of rubbish may later be seen as durable. The conductor Jens Niegaard, for example, recently offered a program including four Mozart sonatas to which Edvard Grieg later added second parts.[83] Internal revolutions also concern the production of musical premières. Such premières are however less frequent than in the visual arts. As the commissioning of new musical works does not usually offer any financial ad-

vantage, new works are unlikely to be sponsored by upper-class patrons. Further, these sponsors are unlikely to gain prestige from the backing of pieces whose evaluation is considered to be the task of specialists rather than of the public at large. For the same reason conductors often take numerous precautions in such productions.[84] Composers and soloists must have their names already established in the marketplace. Similarly, conductors often give preference to native composers or make such performances contingent on such extraneous events as the inauguration of a hall or monument. All these factors make this type of internal musical revolution relatively rare. In 1964, for example, premières did not constitute more than 20 percent of the program offered by the Chicago Symphony. In fact, the proportion is even lower if one considers only the production of contemporary new pieces.[85] Thus, the weight of external factors not only limits the production of premières but also prevents them from being automatically acclaimed as high or durable musical forms. As already noted, in order to be durable, a cultural form must appear to be both socially and economically motivated and symbolic of as many universalistic as particularistic orientations.

In addition, similar socioeconomic constraints foster critical ambiguities in the status assigned to recordings. Indeed, this status is definitely more equivocal than that assigned to visual reproductions. On the positive side, the status of records has probably been enhanced as a result of initial skews in the distribution of gramophones and record players.[86] Only the upper classes could privately own such equipment, while the lower classes could only listen in public places. Records have, therefore, gained some of the qualities that record-playing instruments derived from their roles as markers of social stratification. The status of records was probably also enhanced by the agreements that Stokowski, then conductor of the prestigious Philadelphia Orchestra, signed with RCA, or Eugene Ormandy later concluded with Columbia, as the high social status of performers and composers was probably transferred to the object itself. For this reason, the value imputed to a record does not necessarily decline with its age. Furthermore, at the very peak of stylistic innovation, prestigious records also tend to include the recordings of earlier artists, whose merits are enhanced by both the passage of time and their entry into the musical pantheon.[87] More recently, as the development of tape cassettes renders traveling (a symbol of the upper class) with music less cum-

bersome than before, it prevents the mass production of music from being necessarily a sign of "rubbish." In this sense, the status of a score depends on whether it is heard in public or private places.

On the negative side, recording can exert an ambiguous influence on the careers of musicians. Although certain famed performers such as Glenn Gould retired from live performances as soon as they could, many musicians experience difficulty assessing the mix of live and recorded performances that might most benefit their careers.[88] Contradictions in the effects that musicians impute to recording endow the record itself with an ambiguous status.

These ambiguities are also related to the organization of the recording industry.[89] Because the risks faced by the industry are more closely related to the uncertainties of the public's taste and to the variability of the media's selection of what is worth covering rather than to technological difficulties, its organization is not bureaucratic. For this reason there are sharp variations in the profile of successful performers and of the musical directors of the companies that sponsor them; more important, however, their respective "turnover" is high.[90] Periods of concentration in the recording industry are associated with convergences in the repertoire and with the dominance of established stars at the expense of newcomers or falling artists. Alternatively, short-lived periods of enhanced competition among recording companies usually imply both an expansion in the number of scores reproduced and an increase in the experimentation with new performers. As this competition generates quick successions of convergences and divergences in the repertoires offered to the public, high (or durable) musical forms cannot be clearly defined in terms of past or future orientation. Nor can the boundaries separating them from their lower counterparts be clearly established. In brief, economic constraints tend to accentuate the cyclical properties of musical revolutions. As such, they blur these revolutions even further.

Musical Revolutions as Conflicts Between Social Groups

Distinctions concerning the objective properties of musical styles have specific psychological implications. Although appreciation of music increases with the frequency with which it is heard, the corresponding increase varies according to the conventionality

of its style (and more specifically of its relative use of a central key, of a tone row, and of the articulation of its movements on steps rather than leaps). The repetition of the same highly conventional piece does not modify individual differences in its appreciation. The repetition of semiconventional scores, such as those composed by Bartók, tends to uniformly enhance positive reactions. More important, however, the positive effects that repetitions of the same unconventional score have on its being liked are selective and vary with the psychological make-up of the individuals examined. Whereas "open minds" (those who score low on a conformity scale) react more favorably toward innovative music such as Arnold Schönberg's, when they are exposed to it more than once, the repetition of such music increases the dislike of their "closed mind" counterparts (those who score high on the same scale). The results of this socio-psychological experiment raise two questions. Can these results be generalized to other art forms and can we expect that the contrasted responses of open and closed minds would be as marked in the case of the visual arts? More important, what is the extent and the direction of the correlation between the distribution of open and closed minds on the one hand, wealth, power and status on the other, in society at large? Indeed, this second question is not academic, as the distinction between closed and open minds may be used to justify the placement of musical scores and their authors in the durable, the transient, or the rubbish category.[91]

As in the visual arts, the attitudes and behaviors of various social groups toward musical forms are both a by-product and a producer of inequalities in prestige and power within the society. Similarly, rates of attendance at symphonic, operatic, or ballet performances vary more by educational than occupational categories. In effect, multivariate analyses of such rates suggest that levels of formal schooling and occupational status are better predictors of who attends the performing arts than income.[92]

But if exposure to higher musical forms depends primarily on the amount of cultural capital acquired by individuals and used by them in the context of their occupational lives, it also depends on how such capital is acquired. Among French university students, one-third of those who originate from an upper-class background have attended a concert of classical music compared with only one-fifth of those who have more modest origins. In the first case,

direct musical experiences are generally acquired in the context of the familial environment; in the second, they are generally learned as a by-product of school life.[93]

Differences in the modes of formation of cultural capital imply parallel contrasts in the knowledge of modern musical forms. Among French university students, the knowledge of modern composers ranges between 68 percent for those with a privileged socio-economic background and 41 percent for those with a poorer background. Thus, as in the case of the visual arts, musical tastes acquired within the formal context of educational institutions are generally more conservative than those stimulated by the familial environment and then confirmed at school.

Clearly, there are cultural parallels regarding visual and musical tastes. But what accounts for such parallels? Positive orientation toward revolutionary visual arts seem to precede and act as a necessary condition for positive orientation toward revolutionary music. But does this mean that a more direct and compelling relationship exists between individual imaginations and the collective symbols used in the visual arts? To be sure, the grammar of visual arts may be less sophisticated than the grammar of music. However, the effects of contrasts between these two grammars are probably reinforced by the less frequent offering of courses in the history of music than in art history, or of courses in music than in art by primary and secondary schools. In other words, as the diffusion of supposedly high-class tastes in the visual arts may follow more structured and systematic channels than the diffusion of such tastes in music, innovative and even revolutionary statements are more likely to be accepted today in the first field than in the second. However, the resistance of the public to musical revolutions or innovations is a relatively recent phenomenon. Until the middle part of the nineteenth century, the learning of musical grammar by intellectual elites was sufficiently developed to enable them to nourish similar reactions to innovations in music and to innovations in painting or in sculpture. Diderot or Rousseau, for example, were as much engaged in a critical evaluation of the composers of their period as they were involved in passing judgments on the merits of the eighteenth century's painters.

Yet the relationship between the hierarchies of musical forms and of social groups is far from being rigid. The cosmopolitan orientations of the upper classes enable them to transform low musical forms into higher art forms. In France, for example, exposure to

jazz increases with socioeconomic status, and the revival of its earlier forms has always been controlled by higher social groups.[94] The same social groups have also played a significant role in enhancing the status of singers such as Edith Piaf or Yvette Guilbert, whose repertoires and audiences were considered initially to be popular and not durable. Alternatively, an initially prestigious piece of music may diffuse to all sections of the population as a result of its use by the mass media. Vivaldi's *The Four Seasons*, Albinoni's *Adagio*, and the Pachelbel Canon offer illustrations of this process and tend, ultimately, to be rejected for that reason as parts of "musak," that is, rubbish.

In short, in music as in the visual arts, revolutions involve shifts in the alignment of social and cultural hierarchies. The significance of these shifts depends on the time lags characterizing the diffusion of certain standards or styles among various social groups, and on their reversibility. Their meaning cannot be the same when they result from the diffusion of popular cultural forms into loftier cultural groups and from the diffusion of higher cultural forms into lower cultural categories. In the first case, revolutions are unobtrusive, as they do not prevent existing elites from maintaining their dominance. The influence of the second type of diffusion on musical revolutions is more problematic. Such a diffusion may prevent revolutions, insofar as it fosters the notion of "masterpieces," whose function is to hide conflicts between social or cultural groups. Such a diffusion may be derisive also, as is the case when "durable" scores become treated as elements of the world of "musak." Finally, such a diffusion may foreshadow revolutionary changes in existing patterns of social stratification.

Changes in the Distinction Between Durable and Other Literary Forms

As in the visual and musical arts, the distinction among literary categories depends on the notion of scarcity. Until the mid-nineteenth century, this scarcity characterized not only the distribution of literacy but also the production processes of reading materials. Changes in this scarcity have altered the symbolic and material properties of the books entered into the "durable" category.

From a symbolic perspective, the status of a text is a function of its imputed intrinsic qualities. Obviously, durable books present a full rather than an abbreviated or expurgated version of the original document. In this sense, selections and digests are necessarily parts of a lower culture. In addition, the status of a text is a function of the generality of the themes it treats. For this reason, regional, populist, feminist, or science fiction novels tend to remain marginal; if they graduate to higher literary planes, it is, more often than not, because their supposed provincialism is counterbalanced by the positive influence of their age. For example, the stigma imposed on Zola's socialism has disappeared as a result of the historical, hence obsolescent, nature of his stance.

Furthermore, the status of a text is also a function of the status assigned to the period or the culture to which the author belongs. Thus, the fame of past authors tends to go through peaks and troughs analogous to the changing popularity of past painters or musicians. Similarly, writers of "durable" (understand powerful) nations are more likely to enter the domain of durable literary forms than their counterparts from rubbish (understand marginal) nations. In France, for example, English, German, Russian, Italian, and Spanish writers have been placed on the shelves of the "classics" more often than their Scandinavian, Portuguese, or Turkish counterparts. For the same reason, American writers who visited the shores of European culture (Edgar Allan Poe, Henry James, F. Scott Fitzgerald) have generally been treated with more respect than their counterparts who remained at home.

The status of a text is also enhanced whenever it includes a critical and historical account of the conditions under which it was created and whenever it presents the variants introduced by the author both before and after the entry of the work in the public domain. Indeed, the texts of privately owned copies are ultimately compared with the texts of those copies acquired and maintained by libraries. Correspondingly, durable literature derives its status from the positive judgments passed by literary critics. Yet the role played by such critics differs from that observed in other fields. Because the history of durable literary forms is sufficiently cumulative and consistent, the judgments passed by past critics tend to belong to the literary eminent domain and to be taught in regular literary courses at the secondary or university level. As a result, the qualities imputed to literary critics are less distant from the self-

images that literary elites develop of themselves than those imputed to other cultural specialists.[95] Like literary critics, literary elites claim to have a general education and feel entitled to belittle the role of technique and specialization in the perpetuation or transformation of current literary orders. For these reasons, the definitions of the distinctions between durable and other categories are more democratic in literary than in artistic fields.

While the status of a book depends primarily on its content, it is also a function of its physical appearance, and hence of its binding or of the quality of its paper. In other words, a durable book owes its status to its quality as an objet d'art. Correspondingly, this status varies with the number of copies available, their age, and, more specifically, the time lag between the initial entry of the book into the public domain and the date of each copy's actual printing. As a matter of fact, the last factor has long contributed to the determination of a book's status. During the seventeenth century, the nobility accorded a higher status to the medieval copies of a text than to printed and more recent versions of the same document.

Against this backdrop, literary revolutions involve changes not only in the organization of publishing activities or in the modes of diffusion of printed materials but also the ensuing changes in the rank-ordering of books and of their authors. Before the French Revolution, the distinction between high and low literary forms in France reflected the differential organizational profile of various publishing houses. As political authorities were primarily concerned with the writings of a few intellectuals able to diffuse their ideas within narrow social circles, they sought primarily to limit the privilege of printing and publishing to a few carefully selected artisans who enjoyed a monopoly over the profits derived from the reproduction and the sale of the corresponding works.[96] In contrast to this centralized organization of high literary forms, the creation and diffusion of popular literature were highly decentralized. In France, the major publishing houses were located in Troyes, Toulouse, and Quimper. The works published by these houses were sold by peddlers who offered a great variety of goods besides books. It is only during the nineteenth century that the organizational infrastructures of high and popular literary activities have converged and that, for example, authors have organized themselves, regardless of their status, to obtain their share of the income generated by the publication of their works. In this sense, literary revo-

lutions, like their counterparts in the performing or the visual arts, concern the protection of practitioners from the greed of their competitors, their sponsors, or of the public at large.

Reading "high" literary materials has always been considered a private and solitary adventure involving the reader's direct and silent communication with the author. In contrast, reading popular literature was initially a collective and public experience. This type of reading took place during the evening, when the men of different familial groups gathered in one room, their womenfolk in another, in order to undertake collective tasks such as weaving. The reader was a priest, a soldier, an itinerant teacher, or a trader who commented on the materials he read and acted as a group discussion leader. Correspondingly, reading durable material has always tended to reinforce the cultural skills already acquired by individuals. In contrast at least initially, popular reading resulted in only a superficial diffusion of such skills; literary revolutions have involved the merging of those styles.

Similarly, there were initially marked contrasts between the content of high and popular literary forms. Durable literature involved an elaborate rank ordering of styles, at the bottom of which were novels and fairy tales. In contrast, popular literature was more egalitarian. Focused on mythology, pseudosciences, religion, or medieval plays, it often reproduced themes that were selected from medieval conceptions of the world. Often unsigned and rewritten by publishers, these documents were progress-oriented insofar as they often complained about the vices of the contemporary upper classes. But they were also conservative, for they perpetuated traditional ideas, not only regarding scientific matters but also concerning human passion and religious salvation. The boundaries between the two forms of literature were quite rigid. During the seventeenth century, Corneille, La Fontaine, and, to a certain extent, Perrault were the only writers of the period whose works were incorporated into French popular literary forms.[97] Finally, high culture was more likely to equate newer and better, but its popular counterpart remained faithful to the equation between older and better.

The literary revolutions that marked the nineteenth century blurred the boundaries between high and low literary forms. Industrialization, urbanization, and educational development all contributed to the rapid expansion of novels as a literary genre and

to their diffusion through books, newspapers, and magazines.[98] More specifically, the invention of the iron frame press sharply increased the impressions that could be made per hour.[99] At the same time, the size of the market soared with increases in schooling and literacy. Correspondingly, the differentiation between high and low literary genres became more subtle. Respectable authors such as Balzac and Flaubert have borrowed themes from popular culture. Alternatively, popular culture became more sensitive to current events and current heroes, to deal, for example, with the accomplishments of scientists and colonial explorers.

This blurring has heightened political restrictions concerning the production and diffusion of all printed documents. In contrast to their predecessors who were only concerned with the diffusion of printed documents among the sole established elites, the political and religious authorities of industrializing societies of the nineteenth and even twentieth centuries became eager to limit the circulation of all "subversive" ideas among the lower classes. Thus, literary revolutions also concern shifts in the control exerted over books.

Recent technological innovations in printing have enabled publishers to create a mass market, contributing to the further erosion of the boundaries between high and low literary forms.[100] Thus, the introduction of paperbacks in France markedly increased the sale of previously scarce literary novels. François Mauriac's novel *Thérèse Desqueyroux* sold 79,000 copies when it appeared in 1938, but the number climbed to more than 500,000 when it came out in paperback. Although the novels of Zola never reached the literary market because of their socialist and realist orientations, their commercial purgatory ceased when the books appeared in paperback, which enabled the author to enter the literary pantheon from which he had been excluded.

Thus, literary revolutions also pertain to the patterns of diffusion of books. At first, scholarly bookstores were not eager to sell paperbacks, and when they did, such books usually were relegated to remote parts of the store. In this sense, as in the visual arts, there is a correspondence between the hierarchy of objects and the hierarchy of the places where they are exchanged.[101] However, the status of libraries tends to be lower than that of museums. While museums derive their prestige from the uniqueness of their statues, vases, or canvases, most of the books acquired by libraries are

available elsewhere. Correspondingly, libraries cannot claim that the cultural assets they offer to the public are scarce. Since, in addition, they serve a more differentiated clientele than museums, libraries are generally the instruments of popular rather than high culture. As such, they are less instrumental in the making of artistic revolutions.

Conclusions

All aesthetic communications involve several logics that seek to maximize the scarcities that artists and audiences claim to symbolize vis-à-vis one another. To be sure, these scarcities always refer to qualities imputed to the work itself. But the fact remains that these imputations represent the triumph of one class of artists over another, of one class of society over another, and of producers of art over consumers of art (or vice versa).

In all cases, the resulting definition of "high" art involves, therefore, successful manipulations of the spatial and temporal frameworks underlying aesthetic communications. In all cases, this definition evokes a private world. Indeed, while the term *private* evokes above all the distinguished or splendid isolation of particular social groups, it also suggests, implicitly at least, the deprivations suffered by their unsuccessful competitors.[102] In this sense, high and low art forms can never totally merge. As soon as higher social groups feel that specific lower art forms are worth redeeming, those forms are expropriated and no longer belong to their original producers or admirers.[103]

The spatial aspects of a "high" aesthetic communication emphasize the "scarce" understanding of the tasks that need to be accomplished or that have been accomplished. In other words, the appreciation of high culture is necessarily a source of invidious comparisons among social groups. Stereotypically, representatives or champions of high culture are chided for being snobbish and effeminate, but representatives and champions of low culture are criticized for being vulgar or for advocating degenerate, pathological, or gross art forms.[104] To be sure, tastes can be more objectively differentiated in terms of the differential commitment they repre-

sent toward mood rather than substance or to the validation of existing practices and orientations rather than to experimentation. Yet such judgments are never value free, and the processes of admiration or of rejection to which they correspond reflect the patterns of interaction binding socioeconomic and cultural hierarchies to one another.

These patterns differ as between societies characterized by an ideology of mobility based on contest (and hence on innovations) and societies characterized by an ideology based on sponsorship (and hence on replication). In other words, high artistic forms are more likely to be future oriented or at least to be defined independently of traditions and of precedents in the first than the second context. These patterns also vary across disciplines. During the same period, a specific artistic milieu may extol the pre-eminence of mood over substance as a symbol of high art, whereas another milieu may take the opposite stance.

The spatial aspects of the distinctions between high (durable) and low (transient or rubbish) art forms also concern the exclusive traits of the physical environment in which aesthetic communications take place. Thus, the claims of the cinema to a higher status succeeded when the field legitimated the institutionalization of *cinémathèques* (film repertory theaters), where a privileged segment of the audience could appreciate the exclusive characteristics of an actor (e.g., a Bogart retrospective), a director (e.g., a John Ford series), or a particular film movement (e.g., an Italian neorealism series).[105] Like the collections of museums and the repertoires of concert halls, the status of films shown by repertory theaters or movie theaters is a function of the exclusive properties assigned to their clienteles.

The spatial aspects of the definition of high or durable art pertain also to modes of production. Thus, the salience of high or durable depends on the relative patterns of segregation between pure and applied forms, processes, or artifacts. This is because pure forms evolve in a significantly more exclusive environment than applied forms. A canvas derives its uniqueness not only from the fact that it stands by itself but also from the singularity of its author and its owners; in contrast, a utilitarian object is granted a lower status because of the number of copies involved, the lack of attention paid to the signature of the artisan, or the lack of distinction among the groups owning or using it. A parallel tension exists

between regular and ballet orchestras. Because ballet music is considered an applied form, its musicians are often expected to be heard rather than seen and thereby lose a part of their individuality.

Finally, it appears that most forms of communication acquire a high status when artists are able to form independent communities, write the history of their own field, and use it as a benchmark against which to evaluate current productions. The cinema was able to claim the status of high art as soon as it borrowed not only themes or techniques from disciplines already recognized as high art forms but also performers who had already made their names in such disciplines (Louis Jouvet in France, Laurence Olivier in Great Britain).

As for the temporal scarcity of "high" aesthetic communications, it is twofold. It reflects the differential calendars or schedules of various social groups. Not only can upper-class patrons impose their festivals on distinct classes of artists but in doing so they can also exclude those segments of the population for whom "time is money" and who are accordingly unable or unwilling to use time as a consumption good rather than as an investment.[106]

In addition, the scarcity to which these temporal aspects of artistic communications correspond concerns the differential evaluation of the past and the future. In some instances, the scarcity lies in the monopoly that cultural elites are able to establish over the past and hence in the exclusive use they can make of precedents to justify their tastes. But in other instances, such a scarcity lies in the monopoly that elites exert on the definition of what the future holds for a particular discipline and hence in their exclusive use of the notion of avant-garde. By excluding certain components of the temporal continuum, high art simultaneously excludes social groups with the "wrong" orientations. Criteria for such exclusion are never fixed: Time-lags are also elements of the private nature of a high status, since what distinguishes upper and lower social groups is the amount of time necessary for the former to change "the rules of the game" and to keep abreast of competitors.

As the production of the arts depends more on the public at large than the production of science does, artistic revolutions present more external components than their scientific counterparts do. In all the artistic disciplines, revolutions involve shifts in the boundaries between pure and commercial (or between the durable, transient, and rubbish) qualities imputed to artistic works. In addition, artistic revolutions involve shifts in the rights that art-

ists and patrons claim to exert on such works. Finally, in all artistic disciplines, revolutions involve shifts in the material organization of the public display of individual works and hence in the definition of audiences.

Contrasts in the relative size and segmentation of the communities of producers on the one hand and consumers on the other explain not only why the frequency and the visibility of revolutions differ across disciplines at a single moment and within the same discipline over historical time but also why such revolutions do not present the same properties. Indeed, such contrasts make it possible to distinguish pseudorevolutions (which lead to changes in the durable, transient, or rubbish status assigned to individual works or to entire genres without altering the relative rank ordering of the various segments of the populations of producers or audiences) from those revolutions that involve changes in the rank ordering of individual works or entire genres because of changes in the social stratification of producers and patrons.

In addition, these types of revolutions do not share the same direction.[107] Revolutions to the left involve a blurring of distinctions between durable, transient, and rubbish categories and a corresponding emphasis on the relevance of works or genres to the needs of individual artists, listeners, viewers, or readers. In other words, as such revolutions emphasize the triumph of an ideology that celebrates both equality and individualism, they lead to the development of styles such as kitsch. In contrast, revolutions to the right seek not only to change who should define the categories of durable, transient, and rubbish but also to reaffirm the exclusiveness (and the boundaries) of these categories. Even though the changes resulting from revolutions to the right are relative and involve changes in the exemplars that typify each aesthetic category, they always emphasize the triumph of artistic purity and, more specifically, the need to reassert definite hierarchies of individual works or genres, and hence the rank ordering of artists and audiences.

Clearly, these types of revolutions rarely occur simultaneously in all fields. Indeed, variations in the size of the communities of producers, their cohesiveness, the extent of the competition among them, the social as well as cognitive distance separating them from their audiences, and, finally, the properties of these audiences themselves introduce as many differences in the form, severity, and orientation of the crises encountered by each field. But whereas these

crises correspond both to internal and external forces, the revolutions they may generate result from their dramatization.

Because of the complex dialectic between the internal and external components of artistic revolutions, the concept of dramatization raises two major questions. First, do paradigmatic shifts have distinct properties when they pertain to policies in the arts and for the arts? Second, are these shifts gradual and smooth or sudden and discontinuous?

6

Artistic Revolutions as Dramatic Social Problems

Artistic revolutions are obscene for three reasons.[1] First, they unveil the ambiguities of the established order and, as such, force readers, viewers, or listeners to see that the emperor has no clothes, or, on a more abstract level, that the socially recognized inadequacy between symbols and what they stand for is challenged. In other words, revolutions mark the collapse of the distinctions between simulations and stimulations. Second, revolutions unmask the double dialectic of the interaction between individual and social bodies. On the one hand, they abolish the tension present in the duality of the individual body as a source of pleasure and glory and as a source of shame and guilt. On the other hand, they abolish as well the duality of the individual and the social body as both performers and viewers. In this regard, it is not accidental that the eye symbolizes both female sexual organs and our understanding of the world. Third, we should not forget that in etymological terms, obscenity refers to ominous signs that announce a future full of threat and uncertainty. In ancient Rome, these signs belonged to the left side of the universe, and it is not fortuitous that the left side is called sinister. In short, revolutions are obscene because they jeopardize the precarious balance that characterizes not only relations within artistic communities but also systems of interaction between such communities and the society at large.

To the extent that revolutions are obscene, the works that epito-

169

mize either the established order or the revolutionary challenge become the objects of aggression. When Dali and more recent painters have added moustaches to the Mona Lisa, the very archetype of high art, their purpose has been to shock their more conservative peers.[2] The public or artist hostile to the established aesthetic order may even destroy or mutilate the canvases or statues they consider to be symbolic of that order. Conversely, the first performances of Victor Hugo's *Hernani* and Stravinski's *The Rite of Spring* offered many opportunities for the champions and the adversaries of change to battle.

But insofar as revolutions are obscene, aggressive behaviors are directed not only toward artifacts but also toward the individuals suspected of either maintaining or challenging the established order. The exiles of Hugo, D. H. Lawrence, and Dimitri Shostakovich, the imprisonment of Oscar Wilde, and van Gogh's stay in a mental institution are often invoked as examples of the kinds of punishments to which revolutionary artists are exposed. These punishments are not only symbolic but instrumental as well. When Pierre Boulez and Maurice Béjart exiled themselves from Paris, it was because the French music and dance communities were unwilling to accept or even tolerate the paradigmatic shifts championed by these two artists.

Whether the controversies provoked by revolutionary endeavors focus on policies for the arts (and hence reflect the differing views that various subgroups hold about artistic communications or about relations between artistic communities and their publics) or on policies in the arts (and hence result from conflicts concerning the paradigmatic definitions of artistic production or appreciation), they become social problems when they reach a sufficiently high level of dramatic intensity.[3]

The primary object of this chapter is thus to identify the processes by which revolutionary endeavors fail or triumph. In so doing, I will suggest that the "natural histories" of the social controversies caused by revolutionary endeavors involve a wider range of variables than is usually acknowledged. After a brief reassessment of the classical sociological theories of social problems, I will show that the transformation of such revolutionary endeavors into social problems depends on the dialectical interaction between the dramatic potential of the controveries generated and their translation into dramatic terms. The dramatic potential of controversies

reflects the substantive uncertainties from which they arise, the procedures available to introduce them in a formal agenda, and the range of labels that opponents use to describe their respective positions. This dramatic potential acts as a necessary but insufficient condition for the emergence of a full-fledged social problem. Depending on the cultural and historical settings in which they take place, the actions of individuals or groups who are directly or indirectly involved in the controversy do or do not develop its potential to a dramatic intensity. As a result of such actions, the controversy itself is elevated or not elevated into a social problem.

The study of artistic revolutions—and hence the unfolding of controversies generated either by artistic innovation or by resistance to change—necessitates an analysis of the dialectic between the macrohistory of the cultural environments in which the dramatic potential of a controvery is embedded and the microhistory of the relevant groups or individuals who, acting in a specific setting, seek to enhance or lower the intensity of such a potential.

To establish that the transformation of the social controversies generated by revolutionary endeavors into social problems depends on the dialectic between these two factors nevertheless is insufficient. Controversies generated by policies in and for the arts differ from one another because of contrasts in the sociocultural characteristics and the relative power of the actors involved. Accordingly, there should also be differences both in the processes by which the two types of controversies become social problems and in their respective outcomes.

The Relevance of Traditional Sociological Approaches to the Study of Social Problems in and for the Arts

The first cohort of sociologists involved in the study of social problems assumed that the social condition that is deemed reprehensible or problematic is unquestionably real and raises genuine challenges to the society at large.[4] Few in number, social scientists interested in analyzing the social problem that subversive or immoral art constitutes have followed this assumption and defined their task as profiling moral, political, or aesthetic "polluters" and

examining the responses of various populations to such forms of "pollution." They have, for example, suggested that men react sexually to the mere presentation of genitalia, while women's arousal more typically requires a romantic context but is beclouded with feelings of guilt or anxiety.[5] When involved in the study of subversive art, social scientists have also identified the determinants of authoritarianism, its incidence among various social groups, and its influence on public behavior, notably with regard to the arts.[6] Most important, these researchers have sought to differentiate the sociopsychological backgrounds of categories of deviants, victims, and the population at large. Implicitly, their explanations rely on the concept of natural history to describe how people's personalities evolve.

More recently, other sociologists have challenged the assumptions made about the reality of the condition deemed reprehensible. Based on the notion that scandals lie in the eyes of beholders rather than in the actions of individuals suspected of wrongdoing, their explanations of social problems involve identifying the successive stages through which social controversies evolve—from the initial negative value judgment to eventual resolutions, in whatever form, of the resulting conflict.[7] Because this second approach attempts to account for the differential careers of social problems, it refers more explicitly to the notion of natural history.

However, both conceptions of natural history—implicit and explicit—are incomplete. In seeking to identify the dynamics of social problems, many authors fail to distinguish the macroevolution of the concept involved (e.g., in the present case, abstract art, pornography, obscenity, incitation to disturb public order) from the microevolution of concrete claims against certain individuals in specific settings. Yet the social definition of such generic terms as pornography or political subversion can only be inferred from the symbolic properties imputed to specific publications, plays, paintings, or movies. For example, it is the diffusion of the lowbrow *Hustler* rather than the comparatively highbrow *Playboy* in a given region and at a given time that has been the source of recent social controversies, not the abstract concepts of "girlie magazine" or of pornography in general. Correspondingly, it is necessary to distinguish the genotypical and phenotypical aspects of the relevant classes of phenomena.[8]

In fact, both the social definition of pornography, obscenity, or subversion and the emotions they stir differ according to the char-

acteristics of the critics, producers, and consumers of the corre-
sponding art forms and of the fate of the analogous cases that have
already been adjudicated. Thus, the growing acceptance of *Playboy*
among social elites has necessarily modified the informal bound-
aries separating the "artistic" nude from "prurient and lewd" pho-
tography. Similarly, nudity or the display of sexual intercourse on
film necessarily ceased to be prurient as soon as the film *Last Tango
in Paris* was hailed as a work of art and did not entail any signifi-
cant legal controversy in the major capitals of the Western world.
Alternatively, variations in the substance of the formal charges lev-
eled against immoral novels reflect the differential effectiveness of
the legal actions taken against such books as *Madame Bovary*, *Ulys-
ses*, and *Lady Chatterley's Lover*.

Because the definitions of what constitutes reprehensible art
are constructs whose social properties can only be inferred from
the claims made about specific books, paintings, or movies, any
analysis of the relevant classes of social problems (e.g., pornogra-
phy, subversion, etc.) requires the natural histories of concrete
claims to be distinguished from the evolution of the generic con-
cepts on which these claims are based.

In addition, most social scientists fail to recognize the range of
actors involved in social problems. Typically, their analyses re-
main unduly focused on relations between initial claimants and
the institutional agencies expected to adjudicate the case and,
more specifically, on the strategies successively adopted by these
actors.[9] Yet the differential natural histories of complaints made
against *Hustler* and *Playboy* also reflect the power either imputed
to or actually exerted by their publishers and their readership, and
hence their ability to manipulate the case against them. Similarly,
contrasts between the relative success experienced by Flaubert
against his detractors, the condemnation of Baudelaire by formal
courts, or the administrative troubles faced by Lawrence can cer-
tainly be attributed to the different social status that these three
writers enjoyed in their respective literary communities and in the
society at large. Because the stages through which controversies
evolve present variable properties, an analysis of these stages
should be simultaneously focused on the status and actions of
claimants, judges, and suspects. In other words, it should involve
an examination of triadic rather than dyadic relations.[10]

A Reformulation of the Natural Histories of Artistic Social Problems

Contrary to what many sociologists would like us to believe, social problems are *social* not because of the objective challenges facing currently prevailing policies, but because the ensuing controversy is gauged as sufficiently dramatic by a significant number or class of spectators.[11] In other words, the adjective *social* in the expression social problems implies only that current policies have been challenged and that the challenge has reached a critical intensity. Thus, the use of the thoroughly social metaphor of drama helps avoid the dangers of the misplaced concreteness inherent in the mechanical, organic, or evolutionary metaphors attached to the notion of natural history. As such, it helps ascertain with greater accuracy the processes underlying the development of social problems, the direction of their effects, and the range of these effects.[12]

The relative dramatization of social controversies generated by artistic revolutions is a function of the challenges generated by two types of uncertainty. The first uncertainty lies in evaluating the risks attached to either innovation or the perpetuation of well-established principles or policies. Artistic communities face recurrent tensions between the need to maintain well-established truths and the need to denounce them as illegitimate or obsolete myths.[13] In music, the use of dissonance is equated with treason and harmonic modulation with sedition. Similarly, the detractors of Stravinski condemned *The Rite of Spring* as obscene, but the surrealists used the same term to denounce the conservatism of the bourgeois aesthetic style of the post–World War I period. Challenges concerning this substantive uncertainty may be more specific and may only concern the limits within which the general public may gain access to the problematic statement. In contrast to a so-called elitist conception of the arts (which stresses the social need to differentiate high from low art forms, art from pornography, or art from propaganda), libertarians tend to view any such attempt as constituting some form of political or economic censorship, which they maintain is inimical to the growth and progress not only of the arts but also of democracy.[14] Indeed, to seek to overcome ambiguities may be either liberating or repressive. The substantive uncertainties underlying artistic social problems therefore concern both policies in the arts and public policies for the arts.

The second uncertainty concerns how the participants expect the controversy to be resolved. These participants weigh the risks attached to the stances they intend to take. Depending on the gains and losses they anticipate that their discourse will bring to their cause or status, they choose dramatizing or dedramatizing strategies in order to most effectively manipulate the conflict's resolution. Yet their expectations in this regard may be invalid. For example, the publishers of *Madame Bovary*, fearful of an open confrontation with the judges appointed by Napoleon III, asked Flaubert to delete certain details in the original manuscript. But when these deletions failed to prevent the state attorney from bringing charges against *Madame Bovary*, Flaubert initially chose dedramatizing strategies and maneuvered behind the scenes in the hope of quashing the charges.[15] He visited the minister of education and tried in vain to convince him of the negative impact that the prosecution of a provincial bourgeois like himself would have on the government's future at a time of impending elections. When that did not succeed, Flaubert had no recourse but to directly confront his opponents during the trial itself with a partly defensive and partly offensive strategy. Indeed, he argued at some points in the trial that he was innocent of the charges leveled against him, and he denounced at other points the oppressive nature of the ideology underlying these charges. Lawrence was also not entirely successful in his choice of dramatizing strategies. When he published *Lady Chatterley's Lover* in Europe rather than in Great Britain in order to illustrate the sexual oppression of the English society, his opponents simply retaliated administratively by making it very difficult for readers to obtain copies of the book. As these measures offered dramatic resolutions of the dilemma posed by the consumption rather than the production of statements concerning the relation between art and sex, Lawrence failed to impose his own battlefield.[16]

Thus, the extent to which a controversy becomes a social problem depends both on the dramatic potential of the substantive uncertainty at stake and on the effectiveness of the strategies adopted by all people involved. A study of the natural histories of social problems caused by works of art requires therefore an examination of these two factors and their interaction.

Cultural and Historical Variations in the Dramatic Potential of Artistic Social Problems

The dramatic potential of such social problems involves the combination of (a) the substantive basis of the uncertainty, (b) the procedures by which the controversy might be placed on some official agenda for resolution, and (c) the stigma that various participants wish to impose on the offending actors. Such a dramatic potential is necessarily rooted in distinct historical and cultural environments.

The Substantive Basis of the Uncertainty

As already suggested, we must distinguish the uncertainties generated by the production of art from those accompanying aesthetic communications—in other words, the uncertainties pertaining to policies in the arts from those pertaining to policies for the arts. As far as policies in the arts are concerned, the emergence of a new technique, material, aesthetic object, or style of communication with the public threatens to modify the definition of the aesthetic problems that practitioners have agreed to consider essential. As revolutionary endeavors threaten the solutions previously adopted, they also threaten to transform the organization of these communities. With regard to policies for the arts, the uncertainty and the conflict it engenders concern the optimal form of communications to be established between artists and publics. Despite the relativity of the distinction between internalist and externalist approaches, the first type of uncertainty is closer to the internalist end of the continuum, the second closer to its externalist counterpart.[17]

Regardless of such a distinction, the bases of these uncertainties are threefold. They pertain to (a) the fundamental properties and functions of aesthetic research, (b) the allocation of resources necessary for the performance and the publication of such research, and (c) the boundaries between high and low art forms or between upper and lower social categories.

Challenges to the Substantive Properties of the Arts. The introductions of new literary, musical, theatrical, or visual styles constitute examples of the uncertainties underlying policies in the arts, and hence the definitions of the relation between the arts and nature.

The difficulties encountered by the eighteenth-century French en-
cyclopedists, the turmoil that accompanied the first performance
of *Hernani* (Hugo's exemplar of Romantic theatrical theory), and
the scandals provoked by Salvador Dali all remind us that chal-
lenges to the definition of what art should concern invariably pro-
voke controversies within artistic communities. Reactions to the
film *The Deer Hunter* and its aesthetic translation of the turmoil
generated by the Vietnam war highlight the dimensions of such
controversies. Responding to public criticism, the president of Uni-
versal Pictures (the film's distributor) argued that "films—like all
forms of art—use metaphors," while the critic of the *Los Angeles
Times* asserted that "the central metaphor of the movie is a bloody
lie." While other critics called the film "a criminal violation of the
truth," Edward Kaufman, professor of cinema at the University of
Southern California, protested that "all artists lie and manipulate
history, if not nature itself." [18] The significance of the controversies
generated by the use of such events as aesthetic objects is nega-
tively confirmed by the long silence observed by German film-
makers toward the Nazi period. To use the contradictions of that
period as aesthetic objects would have been a crime against the fa-
thers. It is only recently that German artists have dared to treat
this theme. [19]

Similarly, uncertainties concerning the social functions to be
performed by works of art also lead to competing definitions of
policies for the arts. The central controversies relate to the prob-
lem of defining pornography, subversion, and immorality. [20] Until
the eighteenth century, the evils imputed to an immoral art were
diffuse. In France, to offend God or the state, to write overt or co-
vert glorifications of illicit sexual relations, or to perform such
illicit sexual activities were often considered a single generic cate-
gory (called libertinage). Correspondingly, any crumbling of exist-
ing social arrangements revealed immediately the fragility of the
assumptions underlying prevailing intellectual and moral life-
styles. As an example, since the social upheaval which shook French
society at the turn of the seventeenth century was accompanied by
a parallel psychological revolution, it engendered a wave of posses-
sions and devil worshiping, during which individuals accused of
libertinage were suspected of preaching heretic philosophies and
engaging in sexual perversions. As Urbain Grandier, the bishop of
Loudun, challenged both the existing theology of the church and
the authority of his ecclesiastic superiors, he was, by the same

token, accused of exerting a deplorable influence on the sexual behavior of local nuns and was burned at the stake.[21] Little by little, as a result of the increasing secularization of society and of the emerging rationalization of social relations, the categorization of evils imputed to an immoral art or culture became more differentiated. Thus, a decision by the Cours du Parlement de Paris dated January 1759 states that "by religious corruption, it is meant that variety of libertinage and notably of men with women. It is recognized that this kind of corruption is without doubt criminal since it offends God, but that it is not necessarily incompatible with the happiness of a nation." From that period onward, evils imputed to political and sexual deviances began to be treated as distinct categories. Further, the distinction introduced between actual behaviors and their artistic translation entailed a parallel differentiation of the charges brought against the depiction of sexual activities and those leveled against "illicit" sexual activities themselves. Both the procedures and the penalties involved in these two cases were entered in separate legal texts.

But the evils imputed to art also pertain to the symbols used. The fact that the Port Royal French Grammar of 1660 offered a normative rather than a descriptive profile of French language suggests an extension of existing modes of social control onto literary symbols.[22] This new form of social control endowed slang with a revolutionary power that it did not necessarily have earlier. Thus, during the French Revolution, the French publisher Jacques Hébert filled the articles of his newspaper with words such as *foutre* (*fuck*) as symbolic protests against the existing political order. For analogous reasons, authors such as Henry Miller and D. H. Lawrence later used similar vocabularies, which made their works perfect exemplars of potential social problems. "It is the words which placed her Ladyship in the dock," wrote one of the lawyers during the obscenity trial of *Lady Chatterley's Lover*.[23]

Similar historical and cultural variations appear regarding the use of nudity in the visual arts. During the Middle Ages, theologians distinguished *nuditas naturalis* (humility), *nuditas temporalis* (poverty or asceticism), and *nuditas criminalis* (lust or envy).[24] During the Renaissance, nudity symbolized the inherent beauty of truth and matrimonial unity. Artists of that period often distinguished the double nature of Venus, depicting her nude as the goddess of eternal happiness and fully clothed as the goddess of temporal pleasures.

It was not before the nineteenth century that nudity became an unequivocal symbol of sensuality and sexuality and as such became likely to generate social problems. Yet the evil imputed to nudity has remained relative and continues to vary both with the salience of the distinction between value of use and value of exchange and with the sex of the model.[25] Thus, a large concentration of nude bodies on a canvas is often deemed to be more offensive than the presence of a single body, because it implies promiscuity and hence a compromise of the requirements of quality to the benefit of quantity—a sin against the demands of high art, which is ideologically rooted in the value of use rather than in the value of exchange. Similarly, manifestations of sexuality are usually believed to be more vulgar in the case of male than of female models because the woman's nudity is perceived as more discreet and hence less embarrassing. As a result, the strategies that painters or photographers have used in order to avoid suspicions of evil intentions differ in the two cases. Artists are more likely to cover male genitalia with fig leaves, and, more generally, to obliterate obvious marks of male sexuality. In contrast, the potential scandal provoked by the female genitalia is often eliminated when an artist beheads the model and hence masks her identity.

Challenges to the Organization of Artistic Activities. The second category of uncertainties concerns the allocation of appropriate resources to artists. These uncertainties reflect the optimal power of artistic communities and, more specifically, competing definitions of policies in the arts. For example, the award of the 1949 Bollingen Prize for poetry to Ezra Pound was highly dramatic, because it revealed diverging views within the literary community as to the importance of the poetical rather than political merits of an individual.[26] Furthermore, it also revealed significant cleavages in the attitudes held by various poets toward the literary establishment and notably toward T. S. Eliot and his associates, who were accused of engaging in dictatorial practices and in "coup d'arts." Similarly, the coexistence of competing musical paradigms in France has generated bitter struggles between the followers of a classical dodecaphonic style and the followers of less orthodox modern styles over coveted teaching positions available in the Conservatoire National de Musique.[27] Clearly, these struggles affect the survival of competing paradigms: the official teaching of a particular style enhances the likelihood of its perpetuation.

Controversies within artistic communities concern competing definitions not only of their evaluation of individual statements or of their modes of socialization but also of the limits that they may impose on the production of artistic works. For example, during the first phase of the 1917 Russian Revolution, some artists claimed that because a still life was the very image of private property, socialist governments should encourage the graphic representation only of things that could not be owned—that is, nonfigurative styles.

The history of nudes in painting offers another case in point. As previously noted, learning anatomy by using live models could only take place in pre–nineteenth-century Europe in academies from which women and individuals with a marginal status were excluded.[28] During that period, the painting of nudes did not present significant social problems. The social distance between artists and models was clearly defined, and "women could show themselves déshabillé in front of painters because the latter did not count."[29] In addition, nudity was only a background designed to enhance the beautiful and delicate arrangements of clothes and draperies. As a result, in the eighteenth century the actress Melle Lacy could appear with exposed breasts in the role of Amour in l'Eglé without creating a scandal: "the costumer had simply no draperie he wanted, to put under the lace garland to be placed across the actress's chest."[30] If later on the process underlying the production of nudes became as controversial as its outcome, it is because changes in the socially acceptable definition of relations between men and women, or between artists and their audiences, have altered the boundaries between public and private worlds and correspondingly have transformed the symbolic properties of the human body. Because of these changes, female models have sought to avoid scandals by being more selective in the poses they accept and limiting the contact they have with painters and students before and after work sessions.[31] In nineteenth-century America, the mix of egalitarianism and puritanism made the production of nudes particularly problematic. Thomas Eakins, the famous Philadelphia artist and teacher, encountered serious political difficulties when he decided to use male and female nude models in mixed classes. He had to take numerous photographs of models in order to reduce the length and frequency of their poses, and his models had to wear masks in order to make their identification impossible.[32]

Of course, the uncertainties underlying the appropriate alloca-

tion by public authorities of resources for the publication of art-works illustrate even more brutally the uncertainties underlying policies for the arts. In the film *The Third Man*, Orson Welles's character remarks that, unlike Italy of the Renaissance—which, though ravaged by rapes, murders, poisonings, and other crimes, also supported the genius of Dante, Leonardo, and Michelangelo—Switzerland, which was busy building democratic institutions, had offered only the cuckoo clock to the cultural history of the Western world. The point that the arts do not necessarily blossom under a liberal political regime was also implicitly made by Alexis de Tocqueville, who noted that the American brand of liberal pragmatism and egalitarianism restricted the development of aesthetic orientations.[33]

The ideological debate about the optimal social control to be imposed on artists is paralleled by sharp cultural variations in the ties between individual artists and artistic authorities as well as the society at large. Many governmental authorities have seen painters and poets as potential enemies and have sought accordingly to restrict the resources allocated to the arts. During the Renaissance, Paolo Veronese was severely criticized by the Inquisition for having described the real world in a sacred painting and as a result risked losing many commissions.[34] During the Nazi regime, many German artists were prevented from exhibiting their work because of the "deviant" nature of their political or aesthetic commitments. Similarly, in the Soviet Union, artists whose work is not considered compatible with the official aesthetic orientation may lose access to publishing houses or to official art galleries.[35] In the case of music, the French pianist Alfred Cortot was ostracized after 1945 because he had played during the war for the benefit of German audiences. More strikingly, Shostakovich's music was simultaneously condemned in Russia for failing to meet the standards of Marxist-Leninist aesthetics and praised in the West for the same reason.[36]

Nevertheless, many authorities may wish their administrations to embody the platonic ideal of the true, the beautiful, and the good. This was particularly true in the Italian courts of the Renaissance, and the tradition was perpetuated by such famous friendships as those between Descartes and Queen Christina of Sweden, Voltaire and Frederick of Prussia, Diderot and Catherine the Great of Russia. It was in such a tradition that President Kennedy invited Robert Frost to recite a poem at his inauguration.[37]

These opposite policies (which some governments may adopt simultaneously) generate two problematic types of political intervention in the realm of the arts. The funds earmarked for the arts may be challenged. But the government may also give preferential support to one discipline, genre, or particular style and be challenged for its choice. Federal grants in the United States generate controversies insofar as they favor high rather than low art forms, already legitimated practitioners rather than newcomers, and professionals rather than amateurs.

Challenges to the Distinction Between High and Low Forms of Art. The final category of substantive uncertainties generated by the production of art forms or works reflects the equivocations underlying the boundaries between high and low artifacts or between the aesthetic behaviors and attitudes of upper and lower social categories. As far as policies in the arts are concerned, the relevant controversies are born from debates about the validity of the role played by artists or critics as definers of such distinctions. When Jean Noverre, one of the leading theoreticians of the ballet, wrote at the end of the eighteenth century that "Imitation is the very basis of the ballet, which is essentially a political art," he was asserting not only the pre-eminence of nature as the only model for artists to emulate but also the pre-eminence of an aristocratic over a vulgar aesthetic style. More pointedly, he added, "Only men of condition present a sufficient number of facets and express their passions in many thousand distinct ways that are full of fire as well as of nobility."[38] In other words, in pleading for a rank ordering not only of feelings but also of those individuals entitled to translate them in aesthetic terms, Noverre merely sought to confirm the gains that artists (and not only dancers) had already derived from an imitation of the patterns of social stratification at work in the society at large. In other words, the most successful dancers of the time already sought to promote a system of cultural and social reproduction.

More recently, Sir Joseph Duveen, a famous British art dealer, provoked a crisis in the art world by writing in 1920 that a painting owned by Andrée Hahn "was a copy, hundreds of which had already been made. The real *La Belle Ferronière* is in the Louvre." When he asserted that "if a large number of masterpieces that the public is expected to learn to admire in order to improve and cultivate its esthetic sense are outright forgeries, of dubious ancestry, or

of slight artistic value, then the public has the right to know it," he thereby challenged the differential influence that critics, dealers, and painters of the time exerted over the definition of high art.[39] As such, his actions generated a full-fledged social problem within artistic communities.

Similar difficulties are behind the dilemmas experienced by the Trockadero Ballet, a company of transvestite dancers, in their attempt to see their activities recognized as a high art form.[40] Using historical precedents, the company also amplified its claim to a high art status by rejecting the patronage of gays and turning down offers from institutions specializing in mass entertainment, such as the casinos of Las Vegas. Yet the success of this claim has been and still is dependent on the sponsorship of the critics and elites entitled to pass judgment on the high qualities of this particular art form.

Finally, these difficulties are illustrated in the trial of *Lady Chatterley's Lover*, which sought to determine whether the book was available only in Charing Cross, "a street specialized in smut," as claimed by the prosecution, or "in respectable neighborhoods as well," as claimed by the defense.[41] The prosecution's case, if successful, would prove the book to be rubbish or trash; if unsuccessful on that score, the prosecution would have had to find other criteria by which to condemn the book.

With regard to policies for the arts, the dramatic potential of works of art reflects the difficulties of limiting their availability to social categories supposedly entitled to enjoy them. In this regard, sculptures usually have a low dramatic potential, not only because of the noble qualities imputed to the materials and objects used, but also because of their usually exclusive location, which automatically filters the number of viewers. The dramatic potential of books or movies is much higher, because their audience is more amorphous socially. Thus, the social problem generated by *Lady Chatterley's Lover* did not result so much from the aristocratic heroine's adultery with her gamekeeper as from the availability of such a story to a heterogeneous audience.[42] Similarly, the varying popularity of certain operas reveals apparently parallel changes in the real or imagined composition of the operagoing public. Mozart's *Cosi Fan Tutte* and Monteverdi's *Incoronazione di Poppea* fell into virtual oblivion until recently, not so much because of their style as because their themes were considered to offend the morality of audiences.[43] In other words, past audiences were believed both to be

more attentive to the plot of operas than to their style and to be unable to distance themselves from a plot whose morality they were suspected of taking at its face value.

The fear caused by the consequences attached to an appropriate mixing of social categories is still evident in the United States today. "Urban degradation is the price of pornography and I think it more than dubious that Gay Talese [a writer for the *New York Times*] and his daughters would welcome a marquee advertising live sex acts on stage, next to their apartment house."[44]

However, the decision to exclude certain social categories from access to problematic works of art reflects diverging ideologies. There is the fear that the reading or viewing of such works will enable lower social groups to challenge the existing power structure. Minorities (women, young people, lower classes) have been imagined to fall prey easily to the lures of an immoral art. Such was the stance of the state attorney in the trial of *Madame Bovary*: "Who is likely to read the novel? Is it men who are primarily concerned with political economy? No, the light pages of *Madame Bovary* are most likely to fall in lighter hands, in the hands of single females and sometimes of married women."[45] *Lady Chatterley*'s prosecutor echoed his remarks: "What are the reactions of the people buying *Lady Chatterley* for 3 shillings and 6 pence? Would you approve of your young sons and your young daughters—for daughters can read, too—reading this book? Do you think that the young girls working in factories are going to read it as something sacred?"[46] Among these social groups deemed to be inferior, some are considered more vulnerable than others. Thus, when a member of the House of Lords was asked whether he objected to his daughter reading *Lady Chatterley's Lover*, he replied that he had none, but that he would mind very much his own gamekeeper reading the book, suggesting thereby that the emancipated sexuality of men or of the lower classes causes social evils that are worse than those resulting from the sexual liberation of women and of upper classes.[47] The fear caused by possible reversals in the hierarchy of tastes, and thus, in the patterns of cultural and social stratification is still plaguing modern societies. The legal controversies surrounding the magazine *Hustler* during the 1970s reflect the difficulties of ascertaining the limits within which "the erotic tastes of bus boys, farmers and other truck drivers might be legitimately allowed to diffuse back to the literary establishment."[48]

The fear that certain publications threaten the existing order

may explain why the charge of obscenity has also been leveled against scientific efforts to educate the public about sexual reproduction and more specifically about birth control.[49] Indeed, regardless of whether the message is scientific or artistic, its diffusion is problematic whenever it jeopardizes existing patterns of social hierarchy and modes of social domination.

But the ideology used to justify the restrictions imposed on artistic activities also emphasizes the need for the state to guarantee the right to dignity of specific social groups. Legislators during the French Revolution claimed to be sufficiently concerned with the ideals of liberty and equality to pass laws prosecuting the authors of books, posters, and prints likely to offend the "natural modesty" of women.[50] A similar preoccupation induced the curators of early American museums to set aside a day for enabling "ladies" to view one of the first indigenous nude paintings, *Danae and the Show of Gold*, an ancestor of the playmate of the month.[51] Such examples may reveal more about the attitudes that male-oriented elites hold toward the dignity of women than about this dignity itself. Yet the meaning of crusades against pornography remains equivocal, as some of the leaders of the current women's movement protest increasingly loudly against pornographic materials, which they consider to be inimical to their interest as a group.[52]

In fact, this type of self-defense is used not only by women. Certain interest groups sought to block the distribution of the movie *The Night Porter*, claiming that it offered a distorted and debasing image of the relations between all the guards of German concentration camps and all the inmates of such camps—despite the director's assertion that she was exploring only one of the many psychological (rather than social) responses to such an experience. The same mechanisms of self-defense characterize the musical world. In 1981, for instance, Israeli musicians and audiences have protested the performance of Wagner's music by Zubin Mehta as a conscious or unconscious homage to their Nazi oppressors.[53]

The likelihood that the three categories of uncertainty discussed here (i.e., the moral or aesthetic meaning imputed to artistic symbols and their referents, the allocation of resources to individual practitioners or disciplines, and the access of various social groups to specific art forms) will generate social controversies susceptible to becoming full-fledged social problems varies across historical settings. The first category of uncertainty concerns the optimal subordination of artistic paradigms to aesthetic, moral, or politi-

cal values deemed to be more fundamental. The second one concerns the optimal boundaries between public and private spheres of activity as well as between discrete social categories. Finally, the third category reflects contradictions between the liberalizing tendencies of a laissez-faire ideology generated by a consumption-oriented type of capitalism and the repressive properties of the reproductive processes inherent in the modes of social stratification created by the same capitalism.[54]

The relative salience of the ideologies concerning these uncertainties reflects specific structural conditions. Thus, ideologies concerning the first uncertainty prevail in societies dominated by strong aesthetic, religious, or political commitments. Ideologies corresponding to the second type require the organizational patterns of artistic and other societal institutions to become sufficiently centralized. Finally, the ideologies associated with the third type of uncertainty presuppose a critical opening of art worlds to economic forces. In all cases, then, the dramatic potential of these various issues resides in the various forms taken by conflicts between old and new ways of looking at the world and, more concretely, between established elites and individuals or groups seeking to upset the status quo.

The Placement of the Controversy on Institutional Agendas

Societies differ according to the procedures that their various subgroups may follow to participate in agenda-building processes. The initiatives taken toward entering a social controversy in a formal agenda have three distinctive origins.[55]

Outside Initiatives. Groups located outside the formal structure of artistic communities or political institutions may articulate a grievance, try to spread sufficient interest in such a grievance among as many groups as possible in order to gain a place for it on the public agenda, and hence force decision makers to take a public stand.[56] In Great Britain, the Public Morality Council was created in 1889 in order to oblige governmental authorities to maintain acceptable standards of decency within the literary field. In 1934, the council claimed to have sent no fewer than 22 books and deputations on

allegedly obscene books to the home secretary in order to obtain support and publicity from critical segments of the press.[57] In fact, the actions taken by the council were ominous enough that publishers and authors applied their own pressure on the government in order to limit the scope of obscenity charges and to shorten the statute of limitations regarding obscenity. After the promulgation of the more liberal Obscene Publications Act in 1959, Conservatives took another outside initiative; they formed the Moral Defense Association (which included forty members of Parliament in its membership) to immediately attempt to find loopholes in the new legislation in order to restore the Towns' Police Clause Act of 1847 and to prevent the national application of more liberal standards.[58]

Outside initiatives have also been influential in the United States, as evidenced by the Society for the Suppression of Vice and its successive leaders, Anthony Comstock and John Sumner. Comstock became famous for attacking Shaw's *Mrs. Warren's Profession*. (His maneuvers generated the expression "comstockery," which connoted an exaggerated sense of prudishness.) His successor, Sumner, was at least as vigilant in his defense of public virtue and was famous for having brought Taylor Caldwell's *God's Little Acre* to the attention of the courts.

Inside Initiatives. In contrast to the first situation, this second procedure describes a pattern of agenda building that attempts to exclude the public's participation. French authorities, for example, have exerted a priori controls on publishers and authors since 1537, and on poster designers since 1689, thereby minimizing any public confrontation of their views on the arts.[59] Their power in this regard was enhanced by the obligation for all printers to take an oath upon taking public office and hence to be exposed to the recurrent risk of losing the right to exert their activities, should they be condemned for violating the terms of their charges.[60] The preference of the French government for inside initiatives is equally highlighted by the characteristics of the courts entitled to hear charges against literary or visual documents. Louis XVIII, Louis Philippe, and the Second Republic reluctantly accepted to assign the relevant cases to *Cours d'Assises* manned by a jury, that is, by "representatives of the people," a solution which dramatized the intentions of the government, but whose outcome was problematic, due to the limited control exerted by public authorities on individual jurors. Conversely, Charles X, Napoleon I, Napoleon III,

and the Third Republic assigned such cases to the lower *Tribunaux Correctionnels*, staffed with judges appointed by the government and likely to render the verdict expected by public authorities.[61]

Similar initiatives have intermittently characterized the American scene. Before 1930, the Customs administration could without trial confiscate materials deemed to be obscene or politically dangerous, and its officials forbade the importing of books by such authors as Aristophanes, Rabelais, and Balzac. In fact, the introduction of more liberal guidelines in the Tariff Act of 1930 did not prevent custom officials from seizing reproductions of Sistine Chapel frescoes made before Danièle Da Voltera had, at the command of Pope Paul IV, painted loincloths on Michelangelo's figures.

Mobilization. The last procedure describes the process of agenda building by which public authorities initiate a policy that identifies unacceptable aesthetic expressions but that requires public support for its implementation. The 1970s controversies concerning *Screw* and its publisher, Al Goldstein, and against Harry Reemes, the star of *Deep Throat*, a supposedly high-class hard core pornographic movie produced in the 1970s, are cases in point.[62] In 1973 the United States Supreme Court held that obscene material was to be protected by the First Amendment, unless the work as a whole was found to exceed the community standards of candor in the representation of sexual matters. Since the Court did not specify whether "community" referred to the judiciary districts from which jurors were to be selected and in which a trial would be held or to a more abstract concept that would reflect more accurately the views held by the average American, federal prosecutors decided to choose the first interpretation. More specifically, they sought to obtain convictions by "venue shopping" and by selecting districts in which U.S. attorneys had already achieved notoriety in their actions against obscenity and in which juries would be conservative and hence prone to follow the prosecutor's recommendations.

The distribution of the three procedures by which the substantive issues raised by artistic activities can reach a public forum varies according to cultural or historical setting. The first procedure tends to prevail in decentralized societies with an egalitarian and populist ideology. The second one tends to characterize highly centralized social systems or societies within which links between various governmental "layers" are weak and ill defined.[63] The third and final procedure requires a critical distance between political

leaders and followers and hence an easy manipulation of the latter. While each procedure corresponds to a particular type of society, their geographic distributions overlap and their relative preeminence tends to decline with the growing complexity of existing economic and political structures.

The examples discussed for the most part concern policies for the arts—that is, policies regarding the interaction between artistic communities and the world at large. As far as policies in the arts are concerned, the type of initiatives taken in order to place a controversy on the public agenda depends on whether the conflict opposes different subcultures or members of the same subculture. In the first instance, outside initiatives tend to prevail, insofar as their purpose is to challenge the support that both the state and the public at large are suspected to offer to the competing paradigm. The battles of *Hernani* and *The Rite of Spring*, or the scandal that the surrealists provoked during the first performance of Cocteau's *La Voix Humaine* at the Comédie Française were all intended to test the relative power of factions competing to gain total control over the entire artistic community. In the case of individual conflicts within the same community, the distribution of these initiatives varies with the cohesiveness of the community examined. The more cohesive the community is, the more likely it is that its leaders will rely on inside initiatives or on mobilization. The history of the surrealist movement offers many examples of this trend, as its leader, André Breton, used these two strategies to retain the ideology's initial purity.

These various procedures color differentially the dramatic potential of controversies generated by revolutionary endeavors insofar as they imply contrasts in the amount and type of evidence required in order to adjudicate the issue. Not surprisingly, inside initiatives enable public authorities to remain highly secretive about their actions. For example, it is still impossible to identify the origin of the suit against *Madame Bovary*.[64] Although the formal decision was clearly made by a magistrate attached to the Ministry of Justice, his decision was motivated by political pressures. Four theories have been suggested regarding the source of these pressures. The initiative may have been prompted by a religious member of the court who was shocked by Emma Bovary's death scene. The prosecution may have been engineered by the Empress Eugénie in order to help the novelist Octave Feuillet, who envied Flaubert's rising popularity. In addition, Flaubert may have

been the indirect victim of attacks directed either against his friend Maxime Du Camp or against Du Camp's magazine, which had received an administrative warning and was threatened with a general suppression. Last, the trial may have been triggered by the circulation of an article by Flaubert, who protested that he had been subjected to higher standards than other writers in editing the manuscript. In contrast to the secrecy underlying inside initiatives, it is much easier to document the origin of outside initiatives or of mobilization. Thus, one can identify the sources as well as the rationales of the scandals provoked by *Lady Chatterley's Lover* and *Deep Throat*.

In short, variations in the procedures available to actors are also associated with parallel contrasts in the thrust of their arguments and hence in the direction of the dramatic potentials of the controversy they seek to develop. Whether they concern policies in or for the arts, inside initiatives or mobilization techniques usually seek to maintain the status quo or to foster counterrevolutions. The claims pressed by outside initiatives are likely to be conservative as frequently as they are innovative.[65]

The Stigma Involved

The dramatic potential of the controversies provoked by revolutionary endeavors depends on the range of the penalties that claimants, potential suspects, and agencies adjudicating the case would like the public to impose on the participants, if convicted. This range is defined by authorities according to the potential threats they attribute to deviations from existing models or practices.

Sin. This potential is maximal when courts may condemn the problematic behavior or belief as sinful.[66] Thus, the Spanish Inquisition condemned heretic writers to be burned alive with their writings. The emotions provoked by this type of "sin" still run deep. The anticultural slogan of the Nazis ("When I see an idea, I draw my gun") parallels the society in Ray Bradbury's novel *Fahrenheit 451*, in which all cultural artifacts are banned or burned. As already suggested, the definition of a sinful art is highly diffuse. Encompassing both "problematic" beliefs and actual behaviors, it concerns supposed offenses against God, political authority, and the established code of sexual morality.

The condemnation of a work as sinful generally requires the theatrical undoing of the dominance claimed by the culprits over their victims and the symbolic reintegration of the latter into the official social system.[67] The sinful work is thought to generate sinful behaviors and beliefs among those individuals who have been exposed to it. Treated as victims rather than accomplices, these individuals must submit themselves to cleansing rituals (exorcisms, public confessions, etc.) in order to be reintegrated in the community at large. But as the sins initially imputed to problematic works of art and to their authors constitute a critical challenge to existing practices, the corresponding charges are necessarily directed against those segments of already established elites who seek to alter the status quo. The social distribution of such charges is therefore skewed. Before the French Revolution, the writings or the paintings of high-class artists could be suspected of libertinage, that is, of being politically or sexually offensive, but, despite their subversive ideas or vocabulary, the blue books (called "blue" because of the color of their covers) and other materials of popular culture could circulate freely. This was not only because the mobility of this type of material (which was sold by peddlers) limited its vulnerability to an institutionalized form of control, but also because the spontaneous "ribaldry" or political rebelliousness of the masses did not threaten the existing social or natural orders.[68] In brief, sin is the risk which accompanies the privilege of power.

Crime. The dramatic potential of a controversy provoked by revolutionary artistic endeavors is moderate when the worst possible stigma imposed on the losing party corresponds to the notion of crime. The shift from a sinful to a criminal view of certain artworks entails a differentiation of the concrete charges brought against their creators and more specifically the entry of political, religious, professional, and sexual offenses into distinct legal categories. Yet this shift does not necessarily take into consideration the author's intentions. For example, the American authorities who condemned Theophile Gauthier's novel *Mademoiselle de Maupin* stated clearly that "if the things said . . . were said openly, frankly, in the language of the street, there would be no doubt in the mind of anybody, I take it, that the work would be lewd, vicious and indecent."[69] In other words, the judgment attributed objective properties to Gauthier's book, independent of the symbols chosen by the author.

Because the notion of crime is associated with a secularization and a differentiation of pre-existing modes of social control, the definition and vindication of the relevant charges require the services of an increased number of experts. As early as the eighteenth century, the Parliament of Paris decided that the book *Encyclopedia or Reasoned Dictionary of the Sciences, the Arts and the Industries* should be examined by a lieutenant governor (a representative of the central government), two professors of philosophy (representing the intellectual community), two doctors of theology (representing the religious community), three former lawyers of the Court (representing the legal profession) and one member of the Academy (a representative of cultural elites). This decision reflected the effects of the developing segmentation of knowledge and cultural practices and of the parallel differentiation of elites. It constitutes a preface to the ever-increasing diversity of the numerous commissions and committees asked in so many Western countries to evaluate the circulation of allegedly subversive, violence-inducing, or pornographic material. At the same time, as the notion of crime still implies the state's intervention in the controversy, it can end in the destruction of the work and the imprisonment of the culprits, along with any reparations they may be asked to make to their victims.

Error. The dramatic potential of a controversy provoked by a revolutionary endeavor is minimal when the worst possible stigma imposed on the losing party pertains to the notion of error. Error can take various forms. It may result from the illegitimate borrowing of certain ideas or symbols from a competitor, or from the conditions under which the work has been made accessible. In other words, it is not the substance of the material that is suspect but rather the lack of precautions taken in defining its value or limiting its accessibility. In the search for errors, it becomes essential for claimants as well as counterclaimants to ascertain the economic and social conditions under which the statement in question has entered the public domain—that is, its price as well as where it is displayed or acquired. The sanctions taken against art forms or works deemed to be erroneous are more varied than in the two previous categories. In the cinema, films may be entered in commercially limited categories (such as *R* or *X*) or edited in ways that make them less offensive to some and less appealing to others. In literature, books may be expurgated or subjected to advertising re-

strictions. In all disciplines, the correction of errors can also imply adding new elements to the original version (credits if the offense is economic, a happy ending if the offense is political or social).

To conclude, charges of sin and to a lesser degree of crime tend to prevail in environments in which the effects of highly centralized artistic or political structures are reinforced by a strong commitment toward a religious, political, and aesthetic orthodoxy. Charges of error are more frequent in the context of societies torn between the forces of stratification, which stress the significance of scarcity in the allocation of rewards and pleasures, and the forces of mobility, which emphasize the principle of affluence in such an allocation. To the extent that the shift from sin to crime to error is not unilinear, the stigma imposed on deviants can evolve back and forth between these two extremes, in response to specific historical accidents. Furthermore, these stigmas differ across fields; while pornographic or subversive books and canvases may be castigated as errors, pornographic or subversive films may be simultaneously labeled as crimes or sins.

Variations in the stakes that actors confront are accompanied by parallel contrasts in three factors. The first concerns the processes underlying the case's adjudication. Thus, the direct intervention of public authorities lessens as one moves from a sinful to an erroneous social definition of a problematic art. Second, there are variations in the evidence deemed necessary to adjudicate the case. The evidence legally required to support the charge against a controversial artwork becomes more specific and narrowly defined as it evolves from sin to error. There are contrasts in the sanctions that accompany the adjudication of the case. As already noted, these sanctions can range from the destruction of the work (and possibly its author) to the obligation to introduce economic or technical changes in the artwork itself or in its distribution.

Once more, although the distinctions established in the previous pages generally concern policies for the arts, they apply also to policies in the arts. The more cohesive an artistic paradigm, the more likely it is to impose the label of sinful or criminal on the deviant behaviors of some of its members. To again use surrealism as an example, Breton did not hesitate to consider as sinful or criminal certain members of the group. Thus, the poet Robert Desnos wrote that "to be a friend of Breton is one of the moral horrors of the time. Many who have fallen into an irremediable disgrace give no further excuse than the fact that they were for only one day his

friends." Thus, Philippe Soupault, one of the early members of the movement, incurred Breton's rancor when he began to write novels, a literary form for which Breton felt nothing but contempt. Correspondingly, in the subsequent issue of *Literature*, the magazine of the surrealists, Soupault's name was followed by blank pages. Such a rewriting of history, and more specifically the elimination of Soupault from the historical accounts of surrealism, is the punishment imposed on sinful or criminal behaviors.

Specific Variations in the Dramatization of Artistic Controversies

The object of a social controversy generated by a specific art form or artwork, the procedures by which the controversy enters any kind of forum, and the stigma attached to the problematic statement or behavior, all affect the form and intensity of the dramatic potential of the controversy. Insofar as the controversy tests the limits of the consensus concerning the social condition initially found reprehensible, all the actors involved face various risks and uncertainties.[70] These actors belong to a variety of classes that include claimants, counterclaimants, the agency entitled or expected to resolve the case, and the structured or unstructured groups of spectators whose function is both to legitimate the decisions of the agency and to gauge the dramatic intensity of the conflict. As far as policies in the arts are concerned, these spectators usually belong to the periphery of existing paradigms. As far as policies for the arts are concerned, these spectators belong to social categories that are not the direct targets of the decisions designed to strengthen or lower the restrictions imposed on artistic communications.

These participants all adopt specific dramatizing or dedramatizing strategies that reflect their assessment of the risks taken and, hence, of what they expect to gain or lose from their stance.[71] These strategies pertain to an appropriate manipulation of the "action," that is, of the issue at stake and of the space as well as the time within which it takes place.

Unity of Action. As suggested by Aristotle, the dramatization of an issue requires it to be intensely focused. Conversely, a play which involves several subplots that are not integrated and articulated around a central dilemma lacks sufficient dramatic appeal. Spec-

tators cannot identify themselves with too many heroes and condemn too many villains. The same holds true for the social construction of controversies. Unless actors (claimants, suspects, the "court," and the public at large) are willing to view claims and counterclaims as parts of a single issue, there can be no social problem.[72] But if there is no social problem, there is no drama either. For example, during his trial, Flaubert tried to dedramatize the charges leveled against him by suggesting that the examples of lasciviousness imputed to *Madame Bovary* were innocuous in comparison with some descriptions of romantic attachments included in a novel by Prosper Mérimée, a popular French novelist of the time whose book was published without incident. In other words, in showing that instances of lasciviousness were more numerous than claimed by the prosecution, Flaubert intended to demonstrate that the whole issue was too diffuse and lacked the dramatic properties necessary for building a social problem. In addition, Flaubert also engaged in dramatic countercharges, such as attending the trial with a secretary in order to record the proceedings of the trial, a practice that was forbidden in that type of case.[73] He was thereby trying to shift the debate to the more dramatic ground of the problems raised by the infringement to the liberty of the press that his trial symbolized. The president of the tribunal himself dedramatized the consequences of his decision by blaming Flaubert for having forgotten "that the primary mission of literature is to elevate intelligence and morality" and "that there are limits which no artist is allowed to exceed," while asserting simultaneously that "it was not established that the author intended to celebrate vice." Despite his criticism of the book and its author, he dismissed the case.

The mix of dramatizing and dedramatizing strategies in the controversies surrounding *Lady Chatterley's Lover* and Lawrence's previous works is different. As the controversy resulted from outside initiatives, the original claimants were necessarily obliged to accentuate the dramatic qualities of their stance in order to convince both the prosecution and the public at large of the significance of the case they intended to build. This is evidenced by witness reviews that appeared in *John Bull* in 1927 and 1928. "This is the sort of book which in the hands of a boy in his teens might pave the way to unspeakable moral disaster," or "There is no law at present under which D. H. Lawrence may be ostracized completely

and for a good stiff spell."[74] Against such stances, Lawrence took an equally dramatic position when he published the wish "to see men and women to be able to think sex fully, completely, honestly and cleanly" and stated that "between the stale grey puritan who is likely to fall into sexual indecency, the smart jazzy person of the young world who says we can do anything and then the low uncultured person who looks for dirt, sex has hardly any place of its own."[75] But Lawrence also used dedramatizing strategies by publishing a private edition of *Lady Chatterley's Lover* abroad, which thus modified the terms of the controversy from the problems raised by the publication of a controversial work to the problems raised by its import by private persons.

Dramatizing and dedramatizing strategies can be used by actors other than claimants, suspects, or courts. Thus, the prosecution of *Hustler* and of its publisher Larry Flynt during the 1970s provoked a split among the cultural elite who were directly or indirectly involved in publishing enterprises. As some of them held the liberty of information or publication to be indivisible, the government's action was seen as a step toward a totalitarian regime. For others who viewed the circulation of pornography as nothing but the circulation of yet another form of goods and services, Flynt was not a dissident, but rather the very pillar of a mass-consumption society. As such, he did not deserve First Amendment support.[76]

The diffuseness and the number of arguments used serve different emotional purposes for claimants, courts, and suspects. For the claimants and the courts, diffuse or multiple arguments facilitate a routinization of the suspect's condemnation and hence a dedramatization of the underlying controversy. When the case is presented as a mere illustration of a well-established issue, suspects must identify specific exceptions to the charges they face, and their "acting" consists in convincing the audience of the dramatic nature of these exceptions. Conversely, whenever suspects develop a diffuse system of arguments, it is in order to dedramatize the evil imputed to their work. Thus, by allowing the defense to prove that "even if the totality, rather than some parts, of a book is obscene, its publication is in the interest of science, literature, art, learning or other objects of general concern," the 1959 Obscene Act of Great Britain gave to the lawyers of Lawrence's publishers the opportunity to dedramatize the very term *obscenity*. Alternatively, when the CIA tried in 1979 to ban a book's publication because of sixteen "litigious" words that the CIA maintained could jeopardize na-

tional security, it sought to emphasize the dramatic properties of specific words.

Manipulation of the Space. The dramatic intensity of a social controversy is related to the visibility, unity, and clarity of the social space within which it takes place. Actors intentionally seek to lower or raise the visibility of their opponents within that space. At one extreme, suspects or courts may choose to ignore the identity of claimants, denying thereby the existence of a social problem. At another extreme, claimants, suspects, or courts may arbitrarily elevate the status of one or more of the protagonists in order to enhance the drama and to facilitate the full development of a social problem.

In the arts, however, this manipulation has equivocal effects. On the one hand, as already noted, awarding the Bollingen Prize to Ezra Pound in 1949, right after World War II, was intended to dramatize the enduring uncertainty raised by the relationships between artistic and political commitments. The execution of the French poet Robert Brasillach for "political" crimes after World War II intended to make the same point. In contrast, Picasso's drafting of the peace dove was certainly intended to dedramatize the charges of communism against the peace movement, under the assumption that a famous painter could not be a dedicated communist.

Embattled artists resort to the same dramatization techniques by an appropriate manipulation of their own status. In the Soviet Union, Boris Pasternak and Aleksandr Solzhenitsyn used their fame to dramatize the conflicts between them and the artistic and political commitments of the Communist party. Conversely, Anais Nin dedramatized successfully the stigma of erotica by publishing *The Delta of Venus* after having achieved sufficient notoriety. Correspondingly her erotica have been reviewed in terms of high art. In contrast, the bad reputation acquired by Henry Miller because of the "premature" publication of *The Tropic of Cancer* and *The Tropic of Capricorn* still prevents many cultural elites from being aware of his *Colossus of Maroussia*, which has no erotic flavor whatsoever. It may be because the outcome of status manipulation is always uncertain that the author of *The Story of O* has apparently preferred to remain hidden under the mask of a nom de plume.

Similarly, Diane Keaton refused to disrobe when she performed in *Hair* because she was afraid of the consequences it might have

on her professional status, but Marie-Thérèse Barrault invoked both her achievement as an actress in highbrow films such as *My Night at Maud's* and her status as the wife of a producer to dismiss as inconsequential her disrobing in *Cousin, Cousine* and hence to minimize the drama of using nudity in the cinema. Similarly, Judy Collins certainly relied on her previous success to dismiss the same dramatic nature imputed to her posing nude for the sleeve of her 1979 album, *Hard Times for Lovers*.

In contrast, while Marlon Brando may have considered that the nudity demanded in *Last Tango in Paris* could jeopardize his reputation as an actor, Reemes has used it in *Deep Throat* as a dramatic symbol of the economic failure resulting from his "regular acting" and, for example, from his participation in a touring Shakespeare repertoire company. "Reemes won the recognition of stars in playing himself in the Harry Reemes story and elevated as a result his rating from an *X*- to a general audience."[77]

The dramatic intensity of a controversy also depends on the unity of the social definition of both the places where the controversial artworks are made public and of the forums in which the ensuing controversy is to be heard. On the whole, the homogeneity of the public lowers the dramatic intensity of controversial statements. Thus, innovations in sculpture are less dramatic and less revolutionary than innovations in painting because the public is more homogeneous in the first than in the second case. In the theater, the use of nudity in plays such as *Hair* or *Oh! Calcutta* had a low dramatic intensity in New York, because of the relative homogeneity of the audiences filling the theater. In contrast, these shows became loaded with dramatic intensity in other cities because of the greater variability of local publics and hence of the more indeterminate nature of the functions expected from local theaters.

In contrast, the fragmentation of appropriate legal forums lowers the dramatic appeal of the case to be adjudicated since its outcome has no nationwide implications. Thus, the Supreme Court dedramatized the social controversies generated by pornographic art when it returned such cases to local jurisdictions, legitimating variations in the aesthetic and moral standards of each community. In fact, the Court went further in its dedramatizing strategies when it defined community standards in broad terms and excluded from its consideration the special status attached to certain categories of the local population, such as children.[78]

The dramatic intensity of a controversy also depends on the unity of the discourse within which arguments are developed. However, the effects of this rhetorical unity are not alike when it is used by claimants and by suspects. While the diffuseness of the arguments invoked by claimants tends to weaken their case, the use of multiple lines of reasoning by the defense introduces beneficial doubts in the mind of the public. Thus, the claims against *Lady Chatterley's Lover* lost their dramatic intensity once the defense produced some thirty religious, psychiatric, and literary experts to challenge the prosecution. The variety of premises on which they built their arguments and the absence of counterexperts produced by the prosecution could only underline the diffuse character of the charges and hence their fragility.[79] Alternatively, Duveen's assertions against the authenticity of *La Belle Ferronnière* lost their dramatic appeal because of the multiplicity of ideological frameworks used by the experts he called to testify on his behalf. Indeed, such inconsistencies helped both the lawyer of the plaintiff and the court to dramatize their own stances; "You have been privileged to sit in one of the most interesting cases ever heard in any court," said the judge in his instructions to the jury.[80]

The Manipulation of the Timing of the Case. In all social systems, the dramatic intensity of a controversy is related to the date at which the controversy begins, its timing, and the developmental pattern of its resolution. Regardless of the issues involved, tabling a motion or sending it back to a committee and hence delaying the outcome of the case can often be considered as an attempt to dedramatize the conflict and hence to perpetuate the status quo. These two tactics seek to wear down the resistance of potential opponents and to exploit the likelihood that audiences will get bored.

The effects of speeding a controversy's resolution are more equivocal. On the one hand, establishing a firm deadline for a solution can emphasize the urgency of the problem. Pierre Mendès-France, for example, deliberately imposed a deadline for the peace negotiations with Vietnam and stated publicly that he would resign within his first ninety days of office if he was unsuccessful. On the other hand, the acceleration of a case can also be used as a dedramatizing strategy, such as when it prevents protagonists from organizing their resistance and prevents audiences from appreciating both the goals and the processes of the controversy.

Similarly, the dramatic manipulation of time evolves choosing the most propitious moment to publicize the issue. Although the contradictions of the Vietnam war may have been evoked more strongly in *Apocalypse Now* than in *The Deer Hunter*, the fact that the second of these movies won the Academy Award was used to start a controversy that not only concerned the merits of that war, but also the artistic world views of scenarists or directors and, more generally, the Hollywood film industry. Indeed, both Jane Fonda and Vanessa Redgrave have used the same forum and the same ocasion to make statements about the "dubious nature of the relations binding political and artistic establishments to one another."[81]

Once more, a comparison between the controversies generated by *Madame Bovary* and *Lady Chatterley's Lover* offers numerous illustrations of the manipulations of time to which judges, claimants, or suspects may resort. Flaubert tried in vain to delay his trial by visiting various officials, asking them to quash the government's charges. The government itself sought to routinize its treatment of the charges brought against Flaubert, first by accelerating the case (which was resolved in a few months) and second by allowing public debate about *Madame Bovary* only after the trial. When its case was lost, the French government sought to sustain the dramatic appeal of the issues raised by "immoral" literature by prosecuting such authors as Baudelaire.[82]

Regarding *Lady Chatterley's Lover*, the quick succession of negative reviews published by the conservative press was intended to force the English government to take dramatic action against the author. Similarly, the prosecution of the Penguin edition publishers in 1961 apparently stemmed from references made to the book in a similar case adjudicated some time before. But the 1961 case was primarily conceived by the police, the publishing industry, and the voluntary associations concerned with freedom of the press or the protection of public morality as a dramatic test of the newly adopted Obscene Act. Furthermore, to judge Lawrence's book after the author's death and after his entry in the eminent domain of literature was also a test of the literary community's ability to impose a legal ratification of its own standards.

To sum up, the transformation of the social controversy generated by a problematic artwork into a social problem requires the empirical testing of the underlying substantive uncertainty, the consent of some legitimate court or agency to judge the test, and

the consent of the parties to subject their competing views to such a test. Variations in the strategies that all these actors adopt—whether to clarify or obscure the dimensions of such a test, to enhance or lower its visibility, or to accelerate or slow down its proceedings—account, therefore, for the greatly diverse careers of concrete claims made about particular art forms or artworks. Indeed, such strategies often account for the triumph or failure of the corresponding revolutionary endeavors.

The Interaction Between the Dramatic Potential and the Dramatization of Artistic Social Controversies

To distinguish the dramatic potential attached to the social definition of a behavior deemed problematic and of its subsequent treatment from the outcome of the strategies of the actors involved in the case is a heuristic and hence arbitrary device. These two factors are dialectically related. Neither the general conditions nor the specific actions we have examined here can, alone, determine the evolution of a social problem. To emphasize the pre-eminence of dramatic potentials is to risk falling prey to the fallacies of structuralism and to unduly see the dramatic properties of the issue as being independent of the actors. Alternatively, to evaluate the dramatic properties of the actions taken by various classes of actors would be to risk the ahistorical fallacies of a symbolic interactionist approach that unduly describes the movements of actors on stage, independent of the larger plot in which they participate consciously or unconsciously.[83]

In short, these two types of factors constantly interact. Changes in the characteristics of the population involved in the arts, in the structures of art worlds, and in the society at large affect not only the scope and binding properties of existing paradigms but also the motivation of various actors to push for shifts in such paradigms or to resist the relevant changes. By the same token, these changes also shape the dramatizing and dedramatizing strategies that protagonists use to cope with the situation. Alternatively, the natural histories or careers of concrete controversies change not only the strategies chosen by the participants in the cases to come but also the boundaries separating socially acceptable from illegit-

imate practices—and hence the social definition of artistic deviance. The relevant sets of interaction take three major forms.

Cultural drift. In all cultural systems, there is a slow but cumulative change in the norms and values underlying policies in the arts and policies for the arts. As far as policies in the arts are concerned, the dramatic properties of aesthetic revolutions may be only momentary. Insofar as the reconstruction of artistic events by art historians is made within a linear framework, the public tends to believe that as a new paradigm is integrated in the aesthetic repertoire, the practices it generates have always been normal.[84] Although the "battle" of *Hernani* represented the theatrical translation of the struggle between the political forms of liberalism and conservatism prevailing at the time, both the victory of the Romantic aesthetic and the Revolution of 1830 are now seen as having normalized this particular conception of the theater. Similarly, the battle of *The Rite of Spring* is believed to have fostered the progressive acceptance of new musical styles. In painting, the scandal created by the exhibitions of the first group of impressionist paintings is believed to have rapidly lost its emotional power and to have accelerated the segmentation of visual paradigms.

As far as policies for the arts are concerned, the same cultural drift affects the system of sanctions and rewards to which artists are exposed. Changes in the economy of publishing industries have slowly modified the audiences and meanings of an erotic or subversive literature. The refusal of the courts to condemn James Joyce's *Ulysses* also contributed to extend the limits of what was considered acceptable. In the cinema, the antiwar statement of *The Deer Hunter* renewed the dramatic properties of the yet even stronger statements of *Apocalypse Now*. Similarly, the relatively uncontroversial frontal nudity in *Last Tango in Paris* introduced a new variability in the definition of X-rated movies and correspondingly fostered an erosion of the boundaries used to distinguish this type of movie from more conventional films. In turn, the dedramatization of nudity in the cinema modified the symbolic use of nudity in photography. The success of an exhibition representing Dallas residents in the nude induced its author to generalize the same "paradigm" to New York and to hope seriously that his future exhibition ("New York in the Nude") would include as sitters members of the literary, political, and social elites.[85]

But while cultural drift affects the definition of problematic aes-

thetic styles and the sanctions to which they are exposed, it also influences the system of rewards to which artists aspire. The awarding of the Nobel Prize to Boris Pasternak set a precedent that allowed the prize in later years to be awarded for reasons that were not devoid of political considerations.

The notion of cultural drift therefore amplifies the notion of jurisprudence. Whether an innovation affects policies in the arts or for the arts and whether it results from changes in the composition or the organization of artistic communities and their audiences, its adoption sets up a dynamic process that dedramatizes not only the new definitions of the objects of aesthetic research (and their symbolic treatment), but also the new strategies used by individuals or groups holding opposite aesthetic views, and the new procedures by which their conflicts are effectively resolved.

Successful Innovations in the Limits of Existing Opportunities.
Such innovations entail the creative exploitation of generally recognized possibilities that have remained untapped but are not outside normative standards. Insofar as they do not directly contradict existing norms but rather maximize established values in novel ways, they gain immediate acceptance. As such, they minimize the visibility of paradigmatic shifts.

The diffusion of nudity from one medium to another illustrates this process. What was initially problematic was the shift of artistic nudity from a low to a high status. Considered vulgar in the cinema as long as movies were deemed to be a mass entertainment and as long as the status of actresses was equivocal, nudity became acceptable when the cinema in general achieved legitimacy as a high art form. This legitimacy having been established, the high status granted to films such as *Ecstasy* and later *Last Tango in Paris* contributed to facilitating the diffusion of the use of nudity to the theater, as exemplified first by *Hair, Oh! Calcutta*, and afterwards in more classical plays (e.g., plays by Marivaux and Chekhov). Nudity encountered even less difficulty entering the world of ballet, as exemplified by the *Triumph of Death* performed by the Danish Royal Ballet, even though its schedule of performances suggested the limits of this liberalization.[86] However, the legitimation of nudity has not yet diffused to the world of music, and there was indeed a scandal when a female cellist performed in the nude on a New York stage during the sixties.

The references to the diffusion of the use of nudity as an illustra-

tion of "innovations in the limits of existing opportunities" reveals the boundaries within which diffusion occurs across arts. Clearly, the notion of existing opportunities highlights the increased dominance of economic forces within the art world. Nevertheless, this dominance manifests itself only within the limits of existing patterns of social stratification. The transfer of an art form from a low to a high status shows that only those who are able to do the most can do the least. *Le bourgeois peut s'encanailler* (middle-class people can pretend to be bums), and upper-class people can choose which "low" artistic styles they intend to legitimate. In contrast, lower socioeconomic classes or groups identified with lower aesthetic styles encounter far more difficulty in their efforts to be admitted to the temples of high art or to be allowed to import "high" artistic forms without lowering the initial qualities of such forms. Time lags in the respective gentrification of "low" art forms or aesthetic symbols (such as nudity) in the cinema, the theater, and the ballet result also from the differential symbolic properties of the spaces within which these three media evolve. As the physical and the social distance between performers and the public decline from the first to the third of these media, the threat that nudity raises to the status of each corresponding class of participants increases.

Organizational Competition and Selection. Individual variations in ideological preferences lead to the decision of whether to join ideologically competing voluntary associations. This process has two significant consequences. First, wherever there is widespread discontent with existing institutions—because of a lack of fit between social norms and individual motives—there is a proliferation of associations offering diverse remedies. This proliferation represents an adaptive response to the breakdown of the existing mechanisms facilitating compromises. The multiplicity of ideologies designed to attract membership or endorsement enlarges the scope of competition among paradigms, which adds a new complexity to the processes by which these paradigms filter from one generation to the next or from one subculture to another. In short, organizational competition and selection facilitate both an increase in the number of aesthetic forms and in the number of social controversies that the development of such forms might generate. Second, even when selective processes lead both one type of art and one type of social controversy to prevail, some of the less successful variants still remain in existence. These variants are stored

not only as cultural memories but also as dormant organizations, ready to expand and to be revived when social conditions are more propitious.

These selective processes generate sporadic reactivations of both specific problems and the controversies they provoke. Thus, the analogous tensions experienced by French society during the mid-nineteenth century and those experienced by the British social system in the early twentieth century have been conducive not only to the production of novels such as *Madame Bovary* and *Lady Chatterley's Lover* but also to the development of the controversies that have accompanied the publication of such novels.

Yet these revivals involve a reinterpretation rather than a mechanical repetition of original modes of social adaptation. Although allusions to *Madame Bovary* were made during the trial of *Lady Chatterley's Lover*, the problems raised by the publication of Lawrence's book could not have the same meaning as in Flaubert's case. The evolution of the issues of pornography and immoral art offers a more telling example. Initially developed by priests, such issues were focused on the metaphysical problems of the corresponding sets of beliefs or practices (libertinage), but their successive revivals have obviously involved differing actors and modes of reasoning. The first revival involved middle-class, Victorian men who feared that pornography would turn loose the erotic energy of women and lead them to sexual rebellion. The second and latest revival casts feminists as claimants who assert that pornography—or, for that matter, any erotic literature—is a "means of perpetuating the oppression of women because it associates sex and power and thus reinforces the exercise of the patriarchal dominance that men intend everywhere to impose upon women."[87]

The Resolution of Revolutions Seen as Social Problems

This journey through the dramatic potential of artistic statements and the dramatizing strategies used by the actors in artistic controversies should help us understand why artistic ideologies can be entered in two categories.[88] The first is conservative, and involves the continuous specialization of practitioners and audiences who are expected to know more and more about less and less. In

such a perspective, competition among individuals is based on the rule of purity, and its form is contained by the hierarchical rank ordering of artists and audiences, as well as by the visibility of those in charge. The second type of artistic ideology seeks to erode boundaries between specialties or even between disciplines. Authority within the discipline is constantly challenged through questioning the relevance of the components of specialities or disciplines to the tasks that artists and audiences have carved for themselves. In this perspective, there is no institutional limit to competition, as the prevailing ideology is one of equality.

Although either one of these ideologies may simultaneously prevail in different disciplines and although their dominance varies over time, to distinguish them may help us achieve a better understanding of whether the paradigmatic shifts that constitute the core of artistic revolutions are gradual or discontinuous and whether the shifts toward and away from these two ideologies present symmetrical properties.

The distinction established between these two ideologies reflects two forces. Their visibility varies directly with the degree to which their formulation is consonant with the prevailing orientations of both the professional community and the most significant elements of the audience. But their visibility varies also as a reverse function of the frequency with which they are publicly formulated despite such orientations. Either one of these ideologies remains stable whenever the rate at which "deviant" statements or tastes are incorporated into the mainstream approximates the rate at which they are produced. This occurs either by lowering the standards of purity or by increasing the significance attached to relevance and by adding new components to the term. But such a balance is unlikely. Indeed, as the number of artists or statements deviating from existing norms continues to increase, deviants begin to feel closer to one another than to practitioners who represent the paradigm's mainstream. As the solidarity of these deviants increases, they begin to feel that it is the mainstream that must make any necessary adjustment. Conversely, those individuals who represent the mainstream begin to see that their earlier tolerance of deviation threatens the legitimacy of what they stand for, and that the best way to maintain boundaries is to strengthen them. Hence, a polarization results, setting the "insiders" (who want to re-emphasize the ideology to which they subscribe) against all "outsiders" (who are regrouped in the opposition without always

being aware of the nature of their common ideological commitment). But as insiders decrease and outsiders increase in number, the polarization that was originally a marginal phenomenon invades the whole landscape of artistic communities and their audiences. The revolution that insiders dread comes about because of the prophylactic measures they have taken. In short, existing boundaries suddenly collapse.

But are there similarities in the structures of revolutions toward greater purity and toward greater relevance? The sudden collapse of the boundaries limiting the paradigms dedicated to purity exhilarates those who consider any artistic institutionalization repulsive. This exhilaration characterizes many revolutions, from surrealism to the French experiences of May 1968. Yet, these "revolutions to the left" are usually associated with a decline in individual projects, both because of the purge of individuals or groups committed to an ideology of purity and because of the elimination of works seen as representative of a dreaded past. Meanwhile, disagreements about the definition of relevance keep increasing, while the attraction of doing "relevant" work diminishes. As an end result, manipulators and opportunists tend to move in, proposing to artists and audiences alike a new ideology of purity—with its concomitant emphasis on order, discipline, and status.

Thus, in contrast to revolutions from purity to relevance (revolutions to the left), which ultimately involve some type of catastrophe—that is, a sudden and marked discontinuity—revolutions from relevance to purity (revolutions to the right) appear to be a gradual reconstruction of a hierarchical system, because of both internal and external forces. Paradigmatic shifts and the social problems they entail are revolutionary in the first case but evolutionary in the second one.

Conclusions

The purpose of this chapter has been to identify the multiplicity of the natural histories of the social problems that artistic statements generate. Not only does the dramatic potential of such statements vary but also the same variations characterize the processes and outcomes of the controversies they generate.

Clearly, distinctions between revolutions and evolutions or be-
tween revolutions to the left and evolutions to the right vary across
disciplines. This is because of the specificity of the media they use
and, more generally, because of their differing symbolic properties.
The cognitive and emotional power of written words, painted im-
ages, recorded sounds, films, photographs, or of live shows differs
markedly. The audiences of various disciplines accordingly vary
both synchronically and diachronically. This is also because of the
specificity of the historical times at which these disciplines have
developed and hence of their ability to generate controversial works
or statements. Indeed, the historical specificity of the paradigms
prevailing in each discipline affects not only their respective pub-
lics but also the precedents used to justify or attack particular
works. The objects and strategies that characterize controversies
generated by films, for example, may rely on precedents drawn
from already established performing arts such as the theater or
the circus, but controversies generated by exhibitions can only be
built around precedents that are rooted in the same world of the
visual arts.

Furthermore, there are significant differences in the dynamics
of controversies generated by policies in and for the arts. In order
to become social problems, controversies require the participation
of a critical number of significant others. If controversies in musi-
cal, theatrical, or cinematic policies are more likely to become dra-
mas or full-fledged social problems than controversies in the liter-
ary or the visual arts, this is not only because of the differential
symbols used by these disciplines but also because of their differ-
ential ability to mobilize their audiences. To the extent that an ar-
tistic revolution is a social problem and hence a drama, the trans-
formation of the underlying controversy into a social problem
requires audiences to be sensitive to the issues presented as well as
to their consequences. Literary quarrels are increasingly viewed as
quarrels of specialists who should be left alone to their own de-
vices, in contrast to quarrels about competing performing styles in
the cinema or in the theater, which are more often deemed to con-
cern the modern version of the "honest man" of the seventeenth
century—that is, the average man. In effect, the differences ob-
served between these disciplines in this regard also result from
contrasts both in the size and the geographic concentration of their
respective audiences. Not only does the number of readers decline,
but reading is more and more a solitary activity.

Controversies concerning policies for the arts take two opposite forms that are common to all disciplines. First, they are generated by the use of negative reinforcements and hence by censorship in its various political or economic forms. Correspondingly, controversies for the arts have often resulted from the tensions between the need to protect freedom of expression and the need to maintain order. Yet there seems to be an increased demobilization of individuals and groups most likely to take a stand against measures aimed at inhibiting such a liberty. Individuals and groups increasingly view such a liberty as a formal pretext designed to cover up the transformation of art into a depersonalized merchandise, preventing audiences from participating in an authentic liberation of their own consciousness.[89]

Second, controversies generated by policies for the arts are also the result of positive reinforcement and hence of the selective assistance that governments extend to various art forms and artists. Recurrent debates about whether political authorities are obligated to close the gap between "high" and "low" cultural forms, artists, and audiences offer cases in point. Such policies are controversial because of the ever-changing boundaries between high and low art forms. For example, does the democratization of culture require that more individuals (from varying social groups) have access to high art forms or does it simply imply the vulgarization of such forms? Concretely, then, does democratization imply an increase in the number of novels, poems, or plays published in paperback, or does it imply a simplification of texts and their publication in abbreviated forms? Similarly, does this democratization imply a less expensive high-quality recording of Satie's *Gymnopédie* performed at the piano (following the intentions of the composer), or does it involve the recording of Stokowski's orchestral arrangement, which exaggerates the piece's dramatic impact and makes it more accessible? Furthermore, is the dilemma between these two routes toward democratization universal or does it vary across media? It is useful in this regard to remember that quarrels about the relative merits of cinematic and theatrical adaptations of a novel rarely reach the same intensity.

Most important, closing the gap between high and low cultural worlds does not necessarily involve the same risks or difficulties in centralized and decentralized countries. The institutionalization of French academies or the state-controlled development of folk arts in the Soviet Union and Eastern European countries should re-

mind us that this type of public support enables a particular class of artists to enjoy a higher standard of living, but also tends to freeze the prevailing styles into new forms of high culture, which thereby lose their initial spontaneity.

Alternatively, the segmentation of competing artistic communities or competing audiences in decentralized countries often prevents relevant political choices from being democratically informed. Thus, in the United States, the theme of democratization of the arts is fraught with ambiguities and, more specifically, with the equivocations resulting from the competition between subgroups of artists and cultural elites. Some artists may use federal support to accentuate their dominance in the field and to gain easier access to markets from which they were previously excluded.[90] Connoisseurs may also take advantage of governmental decisions to confirm their pre-eminent position or to accentuate the profits they derive already from the segmentation operating in various art markets. In all cases, decentralization tends therefore to enable those groups with the most political clout and the easiest access to the core of the political system to replicate or reinforce existing arrangements. In other words, while decentralization is ideologically extolled as an instrument enhancing participation, it is used frequently to cover up initial inequities in political power.[91] In this sense, there is a recurrent subversion of the official rationales on which public support of the arts is based. To make things worse, the effects of this apparent but fictitious decentralization are often aggravated by the differential organizations and histories of the various artistic disciplines. Decentralization cannot have the same implications in the visual arts (which are characterized by a low division of labor) as in the performing arts (which are characterized by a high segmentation of individual roles).

Last, whenever controversies concerning policies for or in the arts involve issues that are perceived as abstract or esoteric, they tend to be confined within the limits of "executive chambers." The multiplicity of audiences involved and the multiplicity of ideologies to which they may be sensitive impede their mobilization and enable competing pressure groups to adopt secret forms of competition that have little dramatic appeal. In short, once more, there emerges a fundamental distinction between revolutions to the right and revolutions to the left. Regardless of the relativity of the meanings imputed to right and left, revolutions to the right tend to have less drama than revolutions to the left.[92]

7

Dreams, Deeds, and Misdeeds of a Sociology of the Arts

The concept of revolution stirs strong and conflicting feelings. Its champions would like us to believe that revolutions constitute sharp discontinuities in the distribution of values and power and that, as such, they correspond to the abolition of the established order. Nevertheless, Stravinski reminds us that in mathematics, revolutions refer to the orbit followed by a point or body around a particular axis, and that, as the corresponding movement of these points or bodies returns them to their point of departure, revolutions may be illusory. Archibald MacLeish went one step further when he noted at the eve of World War II: "Revolutionists are rarely rebuilders of the world they have brought down, and the continuity of the pretense of revolution beyond the victory of revolution brings about a peculiar frustration and sterility with which we, in our time, are only too familiar."[1] Indeed, against the self-inflating rhetoric surrounding revolutions it is increasingly evident that they may be more partial and may have occurred later than the actors would like us to believe.[2]

Yet the concept of revolution and the emotional responses it provokes also vary across systems of cultural production. In the sciences, revolutions are perhaps acknowledged as such, but they are often considered sources of progress and become increasingly invisible, as innovations swallow past achievements. In the arts, the word *revolution* is frequently used for self-serving reasons. As

211

the appeal of innovation wears thin and as it becomes increasingly difficult to distinguish the "caviar" (or authentic) from the "meatball" (or illusory) quality of the works presented as innovations (to paraphrase here Russell Baker, the editorialist of the *New York Times*), artists and audiences alike are tempted to awake a faltering enthusiasm or indignation.[3] "Innovation [or revolution] is a delightful criterion of accomplishment: it relieves the artist of all other duties."[4]

To the extent that the arts and sciences constitute two distinct albeit both opposed and complementary cultural systems, my purpose here has been to transpose Kuhn's arguments concerning scientific revolutions into an artistic key. Thus, the first goal of this book has been to assess the extent to which the properties assigned to scientific revolutions characterize their artistic counterparts. But to stop there would have accorded an absolute value to Kuhn's ideas concerning scientific revolutions and their relativity. Thus the second purpose of the book has been to debunk some of Kuhn's ideas and to suggest how an examination of artistic revolutions demonstrates the limits of his conception of the scientific world. Further, an evaluation of similarities and contrasts between the structures of the revolutions affecting the two cultural systems cannot but demystify the very concept of revolution and chase the evil or benevolent ghosts that are associated with the term.

In the arts as in the sciences, revolutions result from individual initiatives. In both systems, it is necessary to contrast those practitioners who maintain the status quo and those who depart from established rules. In both systems, the first class of practitioners may replicate the work of others or their own previous works in order to confirm the boundaries of the puzzle on which they are working. When we can recognize the style of a particular painter, writer, musician, or film director, we may suspect that he is remaining within the limits of the paradigm he has chosen and that he or she is not particularly innovative. When we see a Buffet or a Rothko, when we hear a Pergolese or a Cimarosa, we are usually able to recognize their peculiarities easily and to identify correctly their other works when we see or hear them. Such artists are often considered minor for that very reason. Conversely, we may be fooled by the identity of artists who are always moving from one paradigm to the next. If a person saw only a Picasso from the "blue period" (and knew nothing of the progression of his style), that viewer would probably not be able to identify Picasso's later works. In-

deed, one could see in Picasso's succession of works a succession of revolutions as long as one were not familiar with the history of Derain, Braque, Juan Gris, and Matisse and as long as one did not have access to the evidence that would distinguish revolutions from diffusions.

But although individual innovation is perhaps a necessary condition for the making of a revolution, it is far from being a sufficient one.[5] To be labeled revolutionary, producers of culture must make that impression on their professional community. Correspondingly, scientific or artistic revolutions are concepts which pertain to the life of the corresponding communities. In the arts as in the sciences, a revolution constitutes a dramatic paradigmatic shift, that is, a dramatic change in the set of symbolic generalizations, models, and exemplars used by practitioners in the field. In both systems, the shift owes its dramatic properties to either the number or the visibility of the protagonists or to the salience of the controversies triggered by the new paradigm.

In both cases, revolutions are similarly partial for a variety of reasons. First, they represent dramatic, albeit relative, shifts in the permanent tensions that works of art symbolize between subject and object, and thus between history and nature. To forget the relative character of these shifts is to distort the meaning of revolutions in two opposite ways. To follow Francis Bacon's steps and to claim unduly that one can triumph over nature only by subjecting oneself to its power, is to render revolutions either futile or conservative. Indeed the works of Gödel in mathematics, of Escher in painting or etching, and of Bach in music should not be conceived as merely consisting of underscoring the ambiguities of "strange loops" present in nature. Conversely to go in the opposite direction, and to claim the pre-eminence of subjectivity and of history is to exaggerate the importance of revolutions, as such a stance dissolves knowledge as well as power and reifies the tensions between tradition and change.[6] Indeed, total revolutions would entail the dissolution of existing communities with no tradition against which to rebel. In the sciences, as I noted earlier, Einstein's revolution was rooted in certain enduring Newtonian principles. Similarly in the arts, the impressionist revolution did not immediately imply a shift in the established definition of aesthetic objects.

Furthermore, scientific and artistic revolutions are partial whenever they involve primarily the diffusion across fields of symbolic generalizations, models, and exemplars that were initially

problematic in one field. In the sciences, the use of photographs as evidence was highly problematic when Einstein's theories were being tested but became accepted later, when it diffused to other fields. In the arts, the use of flashbacks was more revolutionary in the cinema (where it was first introduced) than in the theater.

In addition, revolutions are partial in both systems insofar as they require particular sets of characters. Kuhn argues that scientific revolutions tend primarily to involve practitioners who are minimally committed to their field because of their marginal position. The same holds true for some of the arts. Nevertheless, it is important to distinguish here between the effects of an internal and external marginality. By internal marginality, I refer to individuals who work in the periphery of existing paradigms. Although revolutionary practitioners frequently owe their effectiveness to the solidarity that results from the peripheral nature of their position, the passage of time leads them to experience different levels of success and recognition and to follow distinct trajectories. Over the years, a cohort of revolutionary newcomers loses its tight-knit profile; as these newcomers get older and more seasoned, their involvement in revolutions often becomes passive or proactive rather than direct. But marginality has external components as well. Modes of access to systems of cultural production affect the participation of women, lower classes, and religious or ethnic minorities, as well as their status in the corresponding communities. Thus, to evoke the possible contributions of external marginality to revolutions is to raise the need to ascertain the conditions under which minorities seek to enter specific disciplines, to maintain the normal practices of their fields, or to engage in revolutions—and if they participate in revolutions, to determine how their marginality affects the content of the revolutions they seek.

Yet there are also significant differences in the structures of scientific and artistic revolutions and in their relativity. Whereas in the sciences, revolutions concerning the tools of analysis and the phenomena studied are closely intertwined, this is not necessarily the case in the arts. To accept Einstein's theory of relativity, observers also had to accept the validity of the photographic evidence from the solar eclipse of 1919. In contrast, artistic revolutions pertain simultaneously to the choice of aesthetic objects and of the symbolic translations of such objects, only as long as artists seek to develop and institutionalize a holistic conception of their work. At other times, the same artistic disciplines may share the same defi-

nition of the means for transposing aesthetic objects yet disagree about the choice of these objects—or vice versa. Thus, because the idea of nature is a relatively invariant imperative for the sciences, the profile of the challenges that generate scientific revolutions tends to remain relatively constant throughout history. In contrast, because the idea of nature imposes a more variable influence on the arts, there is greater historical variation in the profile of the challenges that produce and accompany artistic revolutions.

Contrasts in the relative importance of nature in the definitions of scientific and artistic disciplines have other implications. A scientific revolution is immediately subjected to a natural validation, to determine whether the new paradigm in fact explains a larger part of the phenomenon under study. The arts generally do not require natural validation. To be sure, an architectural paradigm is revolutionary only insofar as the buildings it generates endure. To be sure, a new paradigm in sculpture or in ceramics can be revolutionary only if the works that result do not disintegrate immediately. Similarly, a musical revolution requires performers to be able to perform its scores. Yet the constraints of the idea of nature are looser in literature and painting. Even in painting, however, the notion of ephemeral revolution is currently under attack, as the curators of museums of modern art are showing signs of disenchantment about the idea of acquiring works that cannot be maintained.

In more general terms, scientific and artistic revolutions are different because of the contrasted meaning of the term *experiment* in the two contexts. In the sciences, experiments imply replications and introduction of constants in order to test the limits of the generalization proposed. In the arts, experiments involve innovations, and hence the removal of existing constraints on the treatment or publication of the aesthetic object.[7] In the scientific context, experiments involve a constant re-evaluation of the principle of "more or less" that underlies statements and propositions and hence successive approximations of the upper and lower limits within which the relationships deemed to exist between two phenomena are actually verified and can be acted on. Conversely, artistic experiments are governed by the law of "all or nothing," insofar as they are either successful because accepted or failing because rejected. In this sense, their logic is more global. Further, while scientific experiments are based on the neutralization of time and allow the replication of work already done, this possibility is forbidden to artists. In the first case, time can be reduced to

its cumulative and reversible properties. In the second one, replication is impossible, because artistic works are located in the irreversible and discontinuous flow of historical time.[8] Hence the difficulty for painters, musicians, writers, and audiences to distinguish the concepts of imitating, copying, and adapting.

In the sciences, revolutions tend to be evaluated exclusively by practitioners themselves. In contrast, artistic revolutions derive some of their properties from the reactions of the public at large. Thus, whereas scientific revolutions are essentially dependent on the internal functioning of the various disciplines, artistic revolutions have stronger external components. Their success is almost always a function of the rules which govern the communication between artist and audiences. If I have emphasized the significance of shifts in the property rights accorded to individual artists, it is because such shifts significantly modify the definition of the tasks that these artists and their communities set for themselves. The development of earthworks or of happenings in the visual arts are partially the result of the desire to drastically change the established modes of communication of painters with their public. The role played by improvisations in the performing arts are analogous, and their purpose is to emphasize the ephemeral quality of the communication established between performers and audiences. Similarly, if I have emphasized the changes in the organization of museums, concerts, or film societies, it is because changes in the organization of artistic archives are instrumental in bringing about significant shifts in the way artistic communities and the public at large evaluate innovations and traditions. Museums do not play a similar role in the sciences, because scientific progress and its ideology immediately incorporate revolutions within the framework of normal practices and thus render such revolutions invisible.

These various contrasts between artistic and scientific revolutions affect their respective timings, forms, outcomes, and universality. First, they differ in timing. While the curves of logistic growth of individual paradigms should follow parallel patterns in the case of distinct scientific fields, the same curves should differ more significantly in the arts. There, curves should be distinct because the rank ordering of disciplines reflects, at least in part, the rank ordering of audiences and more specifically the differential power and prestige these audiences enjoy.

Scientific and artistic revolutions also differ in their forms. In

contrast to scientific revolutions, which are necessarily associated with the idea of progress, their artistic counterparts should engender a wider range of reactions. The same artistic shift may be labeled progressive by some and regressive by others. In addition, contrasts between rapidly occurring revolutions to the left that imply a shift from the rule of purity to the rule of relevance and slowly evolving revolutions to the right that imply a return to the principles of purity from the rule of relevance are more marked in the case of the arts than of the sciences.

There are also contrasts in the outcomes of the two types of revolutions. As scientific revolutons are made progressively invisible, they tend to alter the profiles of entire disciplines. In the arts, revolutions lead more frequently to the fragmentation of existing fields and, more specifically, to the blossoming of competing paradigms, which tend to follow cyclical patterns. Further, the general history of scientific revolutions evolves from a reduction in the number of paradigms articulating the life of a single field to the succession of such paradigms. In contrast, the general history of artistic revolutions evolves from changes of paradigms to increases in the number of such paradigms.

The types of revolutions also differ regarding their universality. While scientific revolutions tend to have universal implications, the same does not hold true for their artistic counterparts. For example, members of the Canadian "group of seven" (Thomas Thompson, Alexander Jackson, Frederick Varley, Edward McDonald, Arthur Liesmer, Stewart Harris, and Francis Johnston) were revolutionary insofar as they tried to legitimate the local landscape, notably the Georgian Bay, and created a style like that of the French Nabis. Yet Canada's peripheral position in the world art scene relegated these artists to relative anonymity. As a consequence, the Georgian Bay never acquired the symbolic appeal of Provençe or Italy.

To summarize, the variability of the revolutions across systems of cultural production and hence across distinct artistic or scientific disciplines reflects both the differential uncertainty of their respective tasks as well as the differential need of their practitioners to coordinate their activities.[9] Furthermore, as both the uncertainties of the tasks to be accomplished and the need to coordinate individual activities vary over time, there are historical changes in the structures of revolutions within fields.

These variations within and between fields regarding the struc-

tures of revolutions can be attributed to various factors. First, they are affected by the number of practitioners, their family background, and the extent of the competition. Modes of social control prevailing in each community are influenced by the number of scientists or artists working in a field and hence by the intensity and frequency of face-to-face contacts. Furthermore, these modes are also influenced by the social origin of these practitioners and more specifically by the norms, values, and practices of the prevailing social groups to which they belong. Last, these modes of social control are affected by the intensity of individual competition and by the differential salience of competing paradigms. For all these reasons, the structures of revolutions vary across disciplines. For example, the limited number of sculptors and the homogeneity of their social origin (which is usually relatively high) limit the size of the field and hence the competition. Correspondingly, revolutions in sculpture are less visible and less frequent than revolutions in painting. For the same reasons, the structures of revolutions in painting cannot be alike when, on the one hand, access to painting careers is limited and when, on the other, there is a democratization of the field. Hence the purpose of chapter 6 was to assess the differential profile of normal and revolutionary artists and examine how the corresponding contrasts vary both across fields and over time. But the purpose of that chapter was also to suggest that if the effects of the distinction between normal and revolutionary practice on what people do and how they are treated depend on the stages of their careers, these effects are not absolute but differ also across disciplines and historical periods.

Another factor is the community's sensitivity to external as opposed to internal pressure. In chapters 2, 3, and 4, I established the dialectic between the internal and external spaces within which artistic revolutions occur. The analysis of internal space consists of showing how revolutions concern the specific relations that artistic communities maintain with nature, symbolized in the definition of the work of art to be achieved or in its appreciation once it is completed.

Regardless of the field, artistic modes of dealing with nature and the corresponding patterns of social interaction are dominated by the principle of scarcity. In the visual arts, the negotiations concerning appropriate definitions of aesthetic objects and of the methodology underlying their translation into symbolic terms help legitimate the particular form of scarcity that success represents.

Success can refer to the difficulty of conforming to established rules. Yet success can also be seen in terms of the difficulty engendered by a violation of such rules and by the imposition of a personal style or vision. The same tension characterizes the world of the performing arts. At one end of the continuum, the scarcity of success implies a rank ordering of performers in terms of their faithfulness to the original text. What is scarce is the chameleon-like quality of actors or musicians who can "alienate" themselves to the benefit of playwrights or composers. At the opposite end, the scarcity of success reflects the rank ordering of performers according to their ability to impose their own masks over the intentions of creators. What counts, then, is John Wayne playing John Wayne, regardless of the part he plays or Paganini performing Paganini regardless of the score he reads.[10] Thus, from an internalist perspective, revolutions correspond to the resolution of the tension between the scarcity assigned to key individuals or groups and the scarcity assigned to significant themes or symbols. When this resolution leans toward individuals or groups, revolutions to the left tend to prevail. Conversely, when this resolution leans toward themes or symbols, revolutions to the right tend to occur.

At the same time, the structure and functioning of each artistic community also depend on the larger context in which they are embedded. Thus, the relativity of artistic revolutions also reflects the distinction between policies in and for the arts.

The relative importance of revolutions caused by policies in the arts, as opposed to for the arts, varies across disciplines. Poetic revolutions are more often focused on policies in the arts than are musical revolutions. The public is both more limited and more professional in the first than the second case. Similarly the frequency and the significance of revolutions generated by policies in the musical arts have declined over the years. Innovations in the organizational patterns of concerts as well as recording industries have enhanced the importance of policies for the arts in this particular field.

A sociology of revolutions for the arts involves an explanation of the extent, form, and determinants of shifts in the relations that specific classes of audiences and artists develop toward artistic works entering the public domain. It also involves explanations of the extent, form, and determinants of the tension between the relations of generalization and of differentiation that various segments of the public entertain with one another in their respective appro-

priation of these works. Works that are labeled masterpieces and are claimed as such to stand as collective symbols of a universal human culture can be contrasted in this regard with works that are labeled as forms of "high" or "low" culture and symbolize the conflicts between upper and lower social or cultural groups.

Revolutions concerning policies in and for the arts are also conditioned by the relative centralization of political institutions. Variations in the extent and form of the control that such institutions exert on the organization and rhetoric of artistic disciplines are associated with parallel variations in the composition, socialization, and practices of the relevant classes of artists and audiences. For example, the relative centralization of societal institutions affects the relative importance of the roles played by public and private sectors in the functioning of art worlds. Contrasts in such roles are conducive to differences not only in the importance of positive (awards, commissions, etc.) or negative (boycotts, censorships) reinforcements to which artists are subjected but also in the procedures adopted in the distribution of such reinforcements. Under these conditions, variations in centralization imply variations in the risks that artists and audiences take when they engage in revolutions and hence the frequency as well as the form of such revolutions.[11]

Similarly, contrasts in the ideologies used to justify social mobility are associated with variations in the social definition of both artistic experiments and their evaluation.[12] As differences between the ideologies of sponsored and contest mobility imply variations in the boundaries between public and private spheres of interaction, artists living in either one of these two ideological contexts do not have the same access to the resources they need in order to innovate. Nor do they face the same sanctions when their innovations are treated as deviances. For example, insofar as the system of sponsored mobility characteristic of French society implies a tighter and broader control over cultural orthodoxy, French artistic innovations tend to be both fewer and more fundamentally rebellious than those of their American counterparts. Indeed, as a system of sponsored mobility enhances the public nature of artistic canons, recurrent battles are waged between innovating French artists and French cultural elites who are eager to act as models of taste and to expose their collections to the public at large.[13] The tension between innovating artists and cultural elites is more muted in the American world, since elites there generally derive their cultural status from their privacy and, more specifically, from

their ability to prevent lower social groups from gaining access to the canons of high taste.

Thus, revolutionary processes in the arts cannot be the same when they begin in centralized as opposed to decentralized or in sponsored as opposed to contest mobility social systems. But equally important, the relative effect of internal as opposed to external forces on revolutions differs across disciplines.

Another reason for variations among artistic revolutions is the differential dependence of disciplines on material resources. For example, because the material resources necessary for the production of literary statements are more limited than those required for making films, the number of participants in revolutions, the scope of the changes they intend to introduce, and the timing of their actions are necessarily different in the two cases. Similarly, the structure of revolutions in the visual arts cannot be the same when the materials needed to produce canvases are controlled by monopolistic instructions such as academies and when such materials are distributed more evenly among various classes of artists. Thus, chapter 2 has examined variations in the resources required by distinct disciplines at different times during their histories. This was done in order to ascertain the relative weight of external and internal forces on the making of revolutions in distinct disciplines.

Another factor is the scope of the problems that the discipline views as fundamental. During the same historical period, artistic disciplines can differ from one another in terms of the challenges they seek to overcome. For example, while the pointillist painters were concentrating their attention on the symbolic translation of objects, novelists at the time were challenging both the choices of the objects to be treated and the choices of the symbols most appropriate for dealing with such objects. As another example, the challenges confronting writers in the decades preceding the French Revolution were larger than those accepted by musicians. Those synchronic differences among the arts are matched as well by diachronic contrasts within the same artistic discipline. As an example, the surrealist painters were more overtly ambitious in their revolutionary aspirations than their pointillist predecessors. Indeed, the purpose of the surrealist movement was not only to alter drastically the symbolic language used by mainstream artists but also to change the political order of both artistic communities and the society at large. Thus, the purpose of chapter 3 has been to assess the relativity of revolutions and hence the variability of their structures.

Artistic revolutions also vary according to the paradigmatic organization of the discipline. In the arts as in the sciences, disciplines differ from one another in terms of their practitioners' commitment to the various components of the same paradigm. For example, contrasts between the revolutions that occurred in the cinema and in the visual or in the performing arts during the pre–World War II period can be, at least in part, explained not only by the differential history of these fields but also by their differential organization, and by the number and severity of the crises they were experiencing at the time or had experienced earlier. In short, the structures of revolutions in each artistic and scientific field are contingent on the combined effect of the uncertainties of the tasks to be mastered and of the need for coordination that the performance of these tasks is supposed to require. Thus, chapter 2 has been devoted to an analysis of the forms taken by such uncertainties and of their determinants in various fields and notably of the role played by the innovations in the techniques of communication, of production and in the markets' structures. Because of these uncertainties, the resolution of tensions between traditions and innovations requires—sometimes—the dramatization of the underlying dilemmas and of the conflicts they generate within communities or between such communities and the society at large. Thus chapter 6 has been devoted to an analysis of variations in the dramatic properties of the processes and outcomes of artistic revolutions.

Yet these remarks about the differential structures of revolutions across scientific or artistic fields tell us as much about the analytical tools used as about the phenomenon studied.[14] As travelers in discovering the world discover by the same token the opportunities and constraints offered by the vehicle they have chosen, the formulation and testing of hypotheses concerning artistic revolutions are necessarily evaluations of the tools of the sociological trade.

Sociology and Relativity

To say that the relativity of artistic revolutions may merely reflect the relativity of sociological tools of analysis raises two ques-

tions. First, are there sufficient similarities and convergences between the arts and sociology to legitimate the sociological study of musicians, painters, writers, actors, and audiences? Second, under what conditions is the validity of sociological analyses enhanced or lowered?

Relationships Between Aesthetic and Sociological Conceptions of the World

Historically, there have been striking similarities in the means and the values used by artists and sociologists to represent reality.[15] Novelists and painters have seen landscapes and portraits as appropriate metaphors of the human condition, long before sociologists realized the richness of such materials. The impersonal nature of the metropolis was evoked by the film director Fritz Lang or the novelist John Dos Passos before that term entered sociological discourse. Balzac, Dickens, Daumier, and Pissarro illustrated the simultaneously liberating and alienating effects of an urban lifestyle, long before Louis Wirth codified the social properties of urbanism. In *Lucien Leuwen*, Stendhal drew portraits of the bankers, bishops, governors, and other actors involved in electoral intrigues, long before political sociologists examined the conditions under which such machinations develop.

Borrowing from artists their metaphorical language, sociologists have also borrowed from them various preoccupations about the dynamic conflicts of individuals and their social milieus. Romantic poets, novelists, and painters have sought to conjure the multifaceted contradictions of human existence: the conflicts between individual freedom and social order, between the search for tradition and for innovation, and (perhaps most significantly) the januslike passage of time that marks progress and liberation as much as decay and obsolescence.[16] But whereas nineteenth-century artists acted as memorialists or prophets in this regard, social scientists sought to systematize artistic testimonies and prophecies. More pointedly, they sought to isolate explanations that could reconcile the recurrence or the universality of individual and collective experiences with their historical or cultural specificity.[17]

Yet social sciences and the arts share not only similar historical legacies but also similar difficulties in the pursuit of their respective goals. First, their paradigms tend to be local and short-lived.[18]

In both cases, schools compete with one another. Practitioners tend to recognize the limitations of their own world views by adding to the theories or methods they offer the suffix *ism*, which is symbolic of an ideological and hence restrictive commitment. The surrealism of visual or literary arts parallels in this regard the symbolic interactionism of sociology. Correspondingly, the teachings of artistic and sociological theories are often subjected to a significant process of cultural or temporal segmentation.[19] In other words, as these teachings ignore the existence of rival hypotheses or techniques, they disregard the problems raised by the growing divergences that mark the evolution of the disciplines.

In addition, both the arts and sociology tend to run counter to the notion of replication. Indeed, few sociological works seek to replicate already published analyses. Hence, the difficulties of evaluating these replications. Conflicts in Margaret Mead's and Derek Freeman's interpretations of the social organization of the South Sea islands or in Oscar Lewis's and Robert Redfield's conclusions regarding the consequences of social change in Mexico are as often imputed to differences in the talent or the personality of these various authors as to significant changes in the environments they studied.[20] Yet, as most artists intend to act as witnesses of their time, or as prophets of eras they dread or to which they aspire, they accept their immersion in the flow of history. In contrast, even though social sciences and history are intertwined, sociologists tend to dismiss as trivial the effects of time on their endeavors.[21]

The arts and sociology also share analogous amounts of self-reference in their languages and accordingly encounter parallel difficulties in the axiomization of their foundations.[22] This is because in both cases "human mind seeks to grasp human mind and the knowledge thereby produced exerts unavoidably a direct influence on a man's life." Nevertheless, the arts and social sciences display significant differences in this regard. Painters and writers often use a language dominated by self-reference. As they trust their public's sense of identification, they consciously invite that public to reflect on the human condition as it is revealed by and through their own minds.[23] In contrast, most social scientists use this type of language covertly. They tend to deny the influence of self-references and seek to build self-sufficient axiomatic systems in order to explain social reality. Their nostalgic quest for a full axiomization of their activities is illustrated in the dreams of George

Simmel, who wanted to build sociology "as a geometry of social relations."[24] In this sense, poets and sociologists work miles apart.[25]

The Relativity of Sociology

In the course of this analysis, I have suggested that the relativity of sociological studies of artistic revolutions is simultaneously methodological, theoretical, and ethical. Confronted with the dual limitations that space and time introduce in their work, sociologists constantly face the dangers resulting from excessive generalization, or alternatively from excessive differentiation. On the one hand, William Blake reminds us that "to generalize is to be an idiot," because any oversimplification of the relations that we develop with nature and with our fellow human beings turns out to be a reassuring but self-serving ideology.[26] In this instance, as in many others, panaceas turn out to be placebos. On the other hand, Aristotle warned us that there is no science of the unique and that an excessive attention to particular details of the specimens collected prevents us from identifying the category to which they belong and from making some sense of the universe in which we live.

Insofar as I recognize the dangers presented by these two extremes, my purpose has been to undertake a systematic analysis of the ambiguities underlying the tensions between differentiation and generalization in any study of revolutions. Both an insufficient and an excessive reduction of this phenomenon yield faulty results. Both artificially lower the extent of variations from which one may extract meaningful explanations.

Methodological Relativity of Sociology. To stress the relativity of sociological methods is to stress the uncertainty of the conclusions of any sociological work. I suggested in the introduction that the success of revolutions may be measured through the use of two sets of indicators. On the one hand, one can evaluate a new paradigm's success by assessing the number of books, articles, or exhibitions devoted to its exemplars and hence by evaluating the number of explicit references it elicits among the members of the relevant community. On the other hand, one can also evaluate the number of stylistic, formal, and substantive elements that diffuse from the new paradigm's core to its periphery, regardless of the hostile or

negative judgments that practitioners pass on such elements. In the first case, the analyst emphasizes the significance of conscious models in order to measure revolutions. In the second case, the analyst relies on unconscious models. But what is the relative validity of these two sets of indicators?

There is no easy answer to such a dilemma, because of the multiplicity of variations in both the objects and purposes of human actions and in the attitudes that accompany them. Thus, the preposition *of* in sociology of the arts, of medicine, or of the law reminds us that in order for their analysis to be valid, sociologists must acknowledge that the corresponding bodies of theories and practices as well as the institutional contexts in which they are embedded logically and chronologically precede the inquisitive glance of the sociologist.

The historical differentiation of the various aspects of nature with which these distinct cultures are concerned renders the relations between the corresponding communities and sociology more problematic. Indeed, it exacerbates the challenges attached to the distinction between internal and external components of such cultures. To collapse this distinction to the profit of internalist conceptions that these "cultures" have of their own tasks leads to their glorification and, ultimately, to the dismissal of sociology as a unified body of theoretical and methodological statements.

But to take the opposite route, as most sociologists are inclined to do, and to reduce the study of the arts, medicine, or law to their external components is a self-fulfilling prophecy as well as a form of self-serving imperialism. To deny the specificity of the "nature" with which these disciplines deal contributes to a further bureaucratic abstraction of the human conception of nature.[27] Even when sociologists leave to specialists the study of the technical problems raised by artistic, medical, or legal "natures," they still reduce the external forces of these fields to empty and standardized forms that prevent any understanding of the specificity of artistic, musical, literary, or theatrical revolutions. Furthermore, not only does the false dichotomy between the technical and social aspects of these disciplines contribute to a further segmentation of human knowledge, but it also conveniently exempts sociologists from exploring the technicalities of the worlds they intend to study. As a result, they claim unduly that their own discipline is the only framework that offers a sufficiently encompassing and coherent explanation of these fragmented natures conveniently reduced to ideologi-

cal constructs. The danger is that such a stance arbitrarily erodes the specificity of revolutions in any cultural system.

Against this self-serving imperialism, a methodological relativity acknowledges the ambiguities of the dialectic between nature and culture as it affects all cultural systems—including sociology itself. In the study of medicine, this leads to an examination not only of the variability of the relations between doctors and patients but also of the organized processes by which the uncertainties underlying the definition, identification, and treatment of diseases are reduced.[28] In the study of law, this means a parallel assessment not only of the relations between lawyers and claimants but also of the organized processes by which the uncertainties underlying the definition, the isolation, and the protection of individual or collective rights are tamed. Finally, in the arts, to emphasize the ambiguities of the distinction between nature and culture requires the analysis to focus equally on the relations between artists and audiences and on the organized processes by which the uncertainties underlying the definition of aesthetic objects and their symbolic translations are overcome. In short, the understanding of revolutions taking place in any cultural system demands an understanding of the components of the particular "nature" that the system is facing.[29]

Conflicts between the requirements of methodological relativity and the self-serving imperialism of sociology have two implications. First, methodological relativity presupposes a crucial symmetry in the relations between sociologists and the actors of the disciplines they intend to study. Because medical doctors, lawyers, and artists have always recognized the social foundations of their activities, they have always acted as "sociologists" in order to be technically and economically successful. By the same token, the success of sociological analyses depends not only on the explanatory power of the methods and theories used by researchers but also on their knowledge of the specific logical structures of the disciplines that they seek to understand. Simply put, the word *participant* in the expression "participant observation" is as important as the word *observation*. This importance is noteworthy because many contemporary students of drug cultures have no difficulty participating in such cultures but refuse to do so when they intend to study legal, medical, or artistic worlds. In contrast, I have emphasized the multiplicity of the relations between culture and nature in order to stress the need to identify the properties of the

internal spaces specific to each discipline, and to ascertain the so-
cial foundations of the cognitive processes by which each disci-
pline copes with a privileged segment of nature.

Second, methodological relativity also requires the recognition
of the ambiguities underlying the distinction between anomaly
and falsehood in the analyses of the differing natures with which
each one of these disciplines is dealing.[30] Correspondingly, rela-
tivity accords equal weight to regularities and inconsistencies as
sources of vitality, not only in each of the fields examined but also
in sociology itself. In other words, parallels can be drawn between
the contrasts opposing normal and revolutionary practices in the
arts, medicine, and law on the one hand and in sociology itself on
the other; therefore, to employ methodological relativity is to ac-
knowledge the limitations and discontinuities of any type of so-
ciological analysis.

Theoretical Relativity of Sociology. Theoretically, the notion of rel-
ativity implies the obligation for sociologists to explore the dialec-
tic between a definition of liberty that emphasizes our submission
to necessity and stands as a recognition of the "prisons" of life and
a definition of liberty that emphasizes our ability to forge a new
environment through the imagination, at long last liberated from
its biological and social inhibitions.[31]

The dangers of prematurely closing this dialectic are twofold.
One could perceive human beings as merely executing the decrees
of a natural order. This stance reduces the scope of all modes of cul-
tural production, including sociology itself. The only task of the so-
cial sciences would then be to achieve a better understanding of
the natural order to which all human societies are subjected. As
artists are expected to imitate nature, sociologists are expected to
elaborate an ultimate rationalization of such a natural order and to
translate in social terms all natural constraints and opportunities.
This stance corresponds to the temptations of all fundamentalisms
that mark human nostalgia for fixed points of departure and ar-
rival in the journey of life. In this perspective, either there is no
revolution or such revolutions are arbitrarily assigned a specific
and predetermined direction. Even when this view does not take
such a drastic form, it still overemphasizes the relativity of revolu-
tions and considers them as dealing only with the ambiguities in-
herent in the distinctions between figure and ground. Thus, musi-

cal revolutions should only involve manipulations of the contrasts between melody and accompaniment or between beat and offbeat. Similarly, in painting, revolutions would involve only the transformation of figures located in the ground into figures in their own right. But to take such a stance is to see revolutions as consisting only of "coming home" and thus underlining the natural elements of creativity that human history has blurred, eroded, or hidden.[32]

In contrast, one could also see men and women as the absolute subjects of the same natural order. To make revolutions is then to arbitrarily assert that culture always triumphs over nature and that the weight of the present moment always overshadows the constraints of the past. In other words, one disregards once and for all the possibility that the inhibitory messages of traditional moralizing might be biologically grounded. By excluding nature from culture and tradition from progress, this stance rejects without further examination the possibility that the networks of prescriptions and proscriptions inherent in social evolution might counter the selfish tendencies that biological evolution has selected cumulatively over the centuries because of genetic competition among co-operators.[33] In contrast to the first stance, which underestimates the accomplishments of Prometheus, the second stance unduly celebrates the virtues of an uncontrolled technology that claims to exert an omnipotent control over nature.[34] In this perspective, revolutions and liberations become unduly synonymous terms.

However, the French philosopher Pascal warned us more than two centuries ago that man is neither an animal nor an angel; our task, therefore, is to identify the dialectic between the realities and the social constructions of nature and culture. Indeed, to plead in favor of theoretical relativity is to emphasize the fact that analyses that treat these two terms as being mutually exclusive rather than reciprocal tend to yield similarly invalid results.

The second theoretical dilemma confronted by sociologists concerns the weight of history and time on the production of culture. On the one hand, men and women may be seen as mere by-products of historical forces. Whether these forces generate discontinuous cycles of events or foster cumulative results, individual aspirations and behaviors are treated as irrelevant and inconsequential epiphenomena that cannot alter the order of things. On the other hand, men and women may be seen as by-products of immediate socializing influences, in which case time and history are unduly

neutralized to the profit of a discontinuous present.[35] The first view, symbolized by eschatological conceptions of history, exaggerates the power resulting from a manipulation of social relations; the second one exaggerates the role played by socialization in these relations. In the first case, time is a tyrant, but in the second case, it is an important and innocent manikin. Although the first view minimizes individual responsibility, in contrast to the second one—which imputes any deviation to faulty socialization—their outcomes are identical. Innocent or guilty, people are not in charge of their own lives. Conversely, to plead in favor of theoretical relativity also is to plead in favor of a search for the relations of inclusion and exclusion that bind not only nature to culture but also culture to its own history.

An illustration of the challenges and pitfalls of such a search is of the fox and the wolf who were equally inclined to relish what they believed to be a piece of cheese at the bottom of a well.[36] After seeing the moon's reflection at the bottom of the well, the fox jumps in and realizes—too late—that the reflection is not the dreamed-of cheese. Stuck in the water, the fox convinces a wolf passing by that a piece of cheese is waiting at the center of the darkness of the well's pit. As the wolf gets into the pail to lower himself, the fox gets into the other pail and regains his freedom. As one animal rises and the other falls and as the movement of the winch reflects their hopes to fulfill their desires, the moon blindly follows its own course. It completes its revolution and accentuates the separation between objects and their appearances, before the beginning of a new cycle causes another fox and another wolf to fall prey to the same illusions.

The moral of this parable therefore concerns the consequences attached to the exchange of appearances and to the development of social relationships devoid of objects. The more we confuse nature or time with their social representations, the more intense are the struggles provoked by these two concepts and the more people suspect one another of forgeries. If we forget, as the wolf and the fox did, how far we are from controlling nature and time—these ultimate objects of our desires—these objects become dissolved into illusions, either because of the restrictions of our perceptions or because of the inter- and intraindividual conflicts fostered by the confusion between objects and illusions. Hence to plead in favor of theoretical relativity is to plead in favor of an approach that recon-

ciles phenomenology (the analysis of appearances) with dialectics (the analysis of the logical support of phenomenology).

Ethical Relativity of Sociology. Finally, relativity also has ethical dimensions. Because no society can live without a sense of the sacred, all producers of culture are condemned to the same ambiguous search for consensus.[37] Although it is tempting to argue that because of this ambiguity, there is a negative correlation between the symbolic weight of political power and the political weight of symbolic power, this negative correlation is neither total nor stable.[38] In their search for consensus, social scientists and artists may be convergers as well as divergers.

These convergences and divergences reflect the tensions between anchoring the self in institutions and anchoring the self in impulses.[39] To reduce the image of the true self to the requirements that accompany any position that an individual occupies in institutional structures risks reducing the person to a miniature of societal systems. This is the danger to which both functionalist and Marxist social scientists have often succumbed in their attempts to reconcile individual and collective progress. As these social scientists seek to harness individual creativity and make it work toward either the confirmation or destruction of the existing social order, they can only reduce arbitrarily the autonomy of artistic paradigms and revolutions. As a consequence, many artists feel obliged to stress the irreducible nature of the tensions between individuals and society and to plead accordingly in favor of the autonomy of artistic revolutions.

However, there may be questionable convergences in the current celebration of spontaneity by artists and social scientists and in their common desire to anchor the image of the true self in impulses. The common properties of their aspirations in this regard offer a reflection of rather than on the effects of a postindustrial division of labor. As contemporary patterns of division of labor isolate individuals from one another and from nature—and hence from the tasks to be achieved—the notion of role (and thus revolution) becomes meaningless. An increasing number of artists extol this meaninglessness and the underlying fragmentation of the world by claiming that "only an aggregate of fragments carries a meaning which is wholly ineffable and protected against self-doubts.[40] In a parallel manner, many social scientists use the word

convention in their analysis of rules and standards to suggest that they are dispensable and hence optional.[41] In this sense, far from working on current social arrangements, both artists and social scientists only mirror the contradictions of such arrangements. Yet, this mirroring has some serious implications. As Rieff writes, "the claim to express everything and to allow everything can only exacerbate the feeling of being nothing."[42] Paradoxically, whether in the arts or in the social sciences, the anchoring of the image of the "true self" in impulses introduces a pathetic twist to the old expression; "L'Etat, c'est moi."[43] The point is not only that this exaltation of the ego may just hide its poverty, but also that it may exacerbate the negative contributions of anarchy to the revolutionary quest for a new social order. Indeed, anarchy and revolutions are mutually exclusive.

This brief evocation of divergences and convergences in the ethical stances adopted by artists and social scientists illustrates the most fundamental property of relativity's moral aspects. In ethical terms, the term *relativity* refers primarily to the dynamic and constant conflicts between individual or collective behaviors and the ideals from which these behaviors originate. Existential philosophers have reminded us of the spatial and temporal relativity of our failings and achievements and hence of the relativity of the notion of progress.[44] They have also reminded us that the search for progress depends equally on individual faithfulness to the past and individual commitment to the future. This dual requirement implies that while we are condemned to constantly reinvent the wheel of our own inventions as well as of those of our ancestors, we should not forget that this wheel turns constantly on a changing terrain.[45] Thus, all cultural revolutions are both relatively moral and morally relative, because their effectiveness is bound by both culture and time.[46] But moral relativity also presupposes that "somewhere, there is a state of grace in which a truth can be reached that is not itself a purely political act."[47] It is in this sense that revolutions, whether in the arts or in sociology itself, are simultaneously driving as well as inhibiting forces, myths as well as mystifications.

NOTES

Notes for Chapter 1: An Invitation to a Sociology of the Arts

1. Anton Chekhov, *Selected Stories* (New York: Signet, 1960), pp. 275–87.
2. I use the word *diversion* as Pascal used the term. Diversions prevent us from remaining faithful to our metaphysical commitments. Thus, there are similarities between the results of these distractions and the "false consciousness" evoked by Marxist philosophies.
3. In other words, both the production of art and the exposure to artworks generate inter- and intrarole conflicts. The first type of conflict refers to the tensions that individuals experience within themselves because of the contradictory requirements that accompany their participation in differing social groups. The second type describes the tensions among individuals with the same position in the social structure. Thus, a performing composer may experience interrole conflicts to the extent that the requirements of performing and composing differ. Alternatively, two conductors may experience intrarole conflicts, as they do not necessarily share convergent stylistic commitments. For example, conductors who play the piano are deemed to differ from those with a more diversified training. See P. Hart, *Conductors: A New Generation* (New York: Charles Scribner's Sons, 1979). For a more general discussion of the distinction between inter- and intrarole conflicts, see R. Brown, *Social Psychology* (New York: Free Press, 1965), pp. 156–70.
4. T. Kuhn, *The Essential Tension* (Chicago: University of Chicago Press, 1977), chapters 7, 14.

5. J. Wolf, *The Social Production of Art* (New York: St. Martin's Press, 1981), p. 24.

6. For a review of similarities in the structures of artistic and scientific work, see E. Rothstein, "Mathematics and Music: One Deeper Link," *New York Times*, 29 August 1982. See also P. Pizon, *Le rationalisme dans la peinture* (Paris: Desain et Tolra, 1978), pp. 12–18.

7. Kuhn, *The Essential Tension*, chapter 14.

8. I am using a distinction that has become classical in the sociology of science. It is remarkable, however, that the same distinction has not reached the same level of salience in the study of the arts. In both cases, of course, the distinction is heuristic and it artificially treats the terms *internalist* and *externalist* as mutually exclusive. But as the distinction is also substantive, it may betray the limitations of the theories on which the terms are based. Thus, we must note the dialectic between internalist and externalist perspectives. For amplification, see Kuhn, *The Essential Tension*, pp. 118–22. See also R. McLeod, "Changing Perspectives in the Social History of Science," in *Science, Technology and Society*, ed. I. Spiegel Rosing and D. De Solla Price (Beverly Hills: Sage Publications, 1977), pp. 149–80.

9. Pensée 586, *Pensées* (Paris: Le Seuil, 1962).

10. E. Panofsky, *Architecture and Scholasticism* (London: Latrobe, 1916).

11. As quoted by G. Huaco, *Sociology of the Art Film* (New York: Basic Books, 1965), p. 104.

12. Wolf, *The Social Production of Art*, p. 86. Thus, at least for some art historians, boundaries between artistic innovations and revolutions are problematic.

13. Ibid., p. 76.

14. See Madame de Staël, *De la littérature considérée dans ses rapports avec les institutions sociales* (Paris: Charpentier, 1842), who tried also to show that differences between English and French writing styles reflected the political and religious contrasts between the two countries. See also H. Taine, *Philosophie des Beaux Arts* (Paris: Hachette, 1895), who tried to demonstrate that the social influence on the arts is twofold. First, social arrangements shape individual personalities and hence the feelings or conflicts people are likely to experience. Second, social institutions filter artistic products and retain only those works of art corresponding to prevailing ideological currents.

15. For a general discussion of this theme, see R. Bastide, *Art et société*, (Paris: Payot, 1977), p. 167. Yet to suggest the possibility that the arts may follow an evolution is to raise crucial questions concerning the direction of that evolution. Are the arts making progress or are they doomed to experience a certain decadence? Is the history of art cumulative or cyclical?

16. For a discussion of this theme and of its multifaceted implications, see

N. Pevsner, *Academies of Art: Past and Present* (Cambridge: Cambridge University Press, 1940), pp. 132–39.

17. L. Goldmann, *Le dieu caché: Etudes sur la vision tragique dans les Pensées de Pascal et le théâtre de Racine* (Paris: Gallimard, 1955), p. 34.

18. I use the word *tinkering* to remind the reader that the audacity of writers such as Diderot prevented them from entering the mainstream of a rationalist way of thinking and the pantheon of literary masters.

19. In a recent debate concerning the merits of a public support for the arts, a reader of the *New York Times* reminded us that the survival of Rubens was contingent on the profits resulting from a crass exploitation of Dutch colonies by the Netherlands. "More about arts vs. politics," *New York Times*, 8 May 1977. For a more systematic discussion of the processes by which macro- and microstructural conflicts are translated in specific works of art, see C. Schorske, *Fin de Siècle Vienna: Politics and Culture* (New York: Knopf, 1979).

20. Bastide, *Art et société*, p. 163. It is therefore relevant to determine the conditions under which the increased complexity of social structures leads to a parallel increased complexity of artistic styles, and to speculate as to whether such a relationship can be generalized to all forms of art.

21. V. Kavolis, *Artistic Expression: a Sociological Analysis* (Ithaca: Cornell University Press, 1968).

22. L. Goldmann, *Pour une sociologie du Roman* (Paris: Gallimard, 1964), chapter 1. See also Georg Lukács, *The Theory of the Novel: A Historico-Philosophical Essay on the Form of the Great Epic Literature* (Cambridge: MIT Press, 1971).

23. P. Legendre, *La passion d'être un autre* (Paris: Le Seuil, 1978), p. 299.

24. For an elaboration of this distinction as it applies to social or cultural phenomena, see R. Levine, *Culture, Behavior and Personality* (Chicago: Aldine, 1973), pp. 121–23. Clearly, the distinction is metaphorical and should not be borrowed mechanically from the field of biology. Most important, we must remember that one can apprehend social or cultural "genotypic traits" only through an examination of their phenotypic manifestations and, conversely, that the construction of a genotypic category helps us achieve a better understanding of phenotypes. This kind of distinction has, therefore, both theoretical and methodological implications.

25. This theme is derived from the William James lectures delivered in 1977 at Harvard University by D. T. Campbell. In this case, as in many others, the major task is to determine the dialectic binding variations between to variations within. To arbitrarily privilege either one of these sources of variations is to fall prey to the fallacy of reification.

26. Thus, it is important to distinguish the term *unconscious* as used by Freud and by Lévi-Strauss. For the second author, the term suggests

that the individuals or groups studied do not have any formal set of explicit rules to justify existing practices or that, should such rules exist, they do not make any sense in terms of the "statistical regularities" observed by social scientists.

27. The consequences of this fallacy on the worlds of writers have been evoked by authors such as J. Paulhan in *Les fleurs de Tarbes* (Paris: Gallimard, 1941) and B. Parain in *Recherches sur la nature et les fonctions du langage* (Paris: Gallimard, 1942).

28. For an example, see W. B. Key, "Did Rembrandt Paint It Blue?" *Holland Herald Newsviews* 9 (1974): 10–15. More generally, one should note that private jokes cannot be solitary jokes.

29. This line of interpretation also presupposes that Freudian unconscious forces are permanent and insensitive to historical change or cultural variation. This assumption is not necessarily justified. While the term *blue* seems to be associated with a transgression of sexual taboos in the history of the English language, this is not the case as far as the French are concerned. For a discussion of the symbolic properties of the word *blue*, see William Gass, *On Being Blue: A Philosophical Enquiry* (Boston: Godine, 1978).

30. For a systematic articulation of this view, see H. Becker, "Art as Collective Action," *American Sociological Review* 39 (1979): 767–76.

31. Wolf, *The Social Production of Art*, pp. 27–28.

32. Against the ahistorical stance of Becker in this regard, see the many concepts developed by historians and philosophers of science to account for the existence of scientific revolutions, and, notably, T. Kuhn, *The Structure of Scientific Revolutions* (Chicago: University of Chicago Press, 1970).

33. Goldmann, *Le dieu caché*, chapter 8.

34. For a criticism of the shortcomings of a symbolic interactionist approach in this regard and of the implicitly conservative political stance to which it corresponds, see R. Sennett, *The Fall of Public Man* (New York: Vintage Books, 1978), p. 36. The fallacy of symbolic interactionist thought illustrates quite graphically the process by which sociology might offer a reflection of rather than on the social arrangements it claims to explain. Indeed, if one of the dominant characteristics of contemporary American life is to emphasize the relative role of the "scene" at the expense of the "act" as determinants of meaning, symbolic interactionist writers have often contributed to justifying and rationalizing this phenomenon; it is in this sense that they can be described as conservative. For an elaboration of the terms *scene* and *act* as producers of meaning, see Kenneth Burke, *A Grammar of Motives* (Berkeley: University of California Press, 1969).

35. For a review of Parsons's views in this regard, see M. Albrecht, "Art as an Institution," *American Sociological Review* 33 (1968): 383–96. See

also R. Peterson, "Revitalizing the Concept of Culture," *Annual Review of Sociology* 5 (1979):137–66.

36. L. Meyer, "Concerning the Arts, the Sciences and the Humanities," *Critical Inquiry* 1 (1974): 163–79. This type of fallacy affects our understanding of other institutions as well. For example, to contrast artistic and scientific museums does not make any sense as long as we do not specify the characteristics of the various types of visitors likely to be attracted to such places.

37. For an example of this naiveté, see H. Becker and J. Walton, "Social Science in the Work of H. Haacke" in *Framing and Being Framed*, ed. H. Haacke (New York: New York University Press, 1976), pp. 145–52. Becker and Walton take the example of automobiles as an illustration of the cumulative effect of time on the value of objects—without realizing that the value of cars follows a curvilinear pattern over time, as they shift from the category "vehicle" into the category "collectible."

38. G. Reitlinger, *The Economics of Taste* (London: Barry and Rockcliff, 1961–70), p. 89.

39. R. Moulin, "Les intermittences économiques de l'art," *Traverses* 3 (1976):64–78.

40. For a general treatment of this theme and an analysis of variations in the number and characteristics of animals described in various cultural contexts, see P. Sorokin, *Social and Cultural Dynamics* (New York: American Books Co., 1937). For more modern, albeit more selective, references, see Legendre, *La passion d'être un autre*, p. 38.

41. For example, the paintings of Hogarth initially had a minimal value because of the ironical comments he made on social relations. See Reitlinger, *The Economics of Taste*, p. 66. The "rediscovery" of Honoré Daumier's cartoons can be partially imputed to the status he achieved as a painter, and the rediscovery of Jean-Louis Forain reflects the fact that his work is deemed to be representative of his period.

42. Wolf, *The Social Production of Art*, p. 108.

43. I am using here one of the leitmotifs of Kurt Vonnegut in *Slaughterhouse-Five*, a leitmotif renewed by P. Feieraband in his criticisms of a positivist philosophy of science in his *Against Methods* (Atlantic Highlands: Humanities Press, 1975).

44. Once more we can see the importance of the duality of the times present in the notion of nature. Indeed, one can use works of art as sources of documentation to determine whether nature is a history only as long as nature is deemed not to have history. For an illustration of the corresponding difficulties, see E. Leroy-Ladurie, *Histoire du climat depuis l'an 1000* (Paris: Flammarion, 1967).

45. If nature has a history, the same holds true *a fortiori* of human nature. For a development of this theme, see S. Moscovici, *Society Against Nature* (London: Harvester Press, 1972). Clearly, we could learn a great

deal about the external determinants of the arts if we could delineate the conditions under which changes in the salience of the taboos concerning certain patterns of social interaction are related to parallel changes in the artistic treatment of such patterns. Why is it, for example, that incestuous relations between siblings were described in dramatic terms by Jean Cocteau in *Les Enfants Terribles* before such relations between mothers and sons could be evoked humorously by Louis Malle in *Murmur of the Heart* and later in dramatic terms by Bernardo Bertolucci in *Luna*?

46. See F. Haskell, *Patrons and Painters* (New York: Knopf, 1963).

47. For a description of the precautions taken by Wagner in Bayreuth to prevent opera orchestras from being seen, see Sennett, *The Fall of Public Man*, p. 208. For an account of the competing views held in this regard since Wagner's days, see D. Henahan, "Opera Instrumentalists Should Be Heard and Not Seen," *New York Times*, 24 August 1975.

48. This entire section is derived from Legendre, *La passion d'être un autre*, chapter 1.

49. In addition, many sociologists have ceased to deal with alienation in terms of social relations, but define this concept as a psychological disease rooted within individuals. The resulting confusion is further enhanced by the fact that the term *reification* is used to describe both the reduction of persons into objects and the arbitrary coagulation of fleeting experiences into fixed entities. For a critical assessment of the deviations of sociology in this regard, see R. Jacoby, *Social Amnesia* (Boston: Beacon Press, 1975), pp. 8–9.

50. For an amplification of this theme, see R. Caillois, *Les jeux et les hommes* (Paris: Gallimard, 1958), pp. 43–48.

51. Marcel Proust as quoted by M. Polanyi, *Personal Knowledge* (Chicago: University of Chicago Press, 1958), p. 200. Of course, when I propose that art looms larger than reality, I want to make it clear that artistic models are both normative and descriptive.

52. For a systematic treatment of variations in the time orientations underlying various kinds of utopias, see K. Mannheim, *Ideology and Utopia* (New York: Harcourt, Brace, 1936), pp. 211–12.

53. G. de Nerval, *Oeuvres* (Paris: Bibliothèque de la Pleiade, 1956), p. 49.

54. Yet to stop the analysis at that very point, as many functionalist and symbolic interactionist writers tend to do, is misleading. We must, however, distinguish the shortcomings of functionalist and symbolic interactionist approaches in this regard. Insofar as the first sees social systems as characterized by an intrinsic state of equilibrium, its blindness to macrohistorical forces is internally consistent. It can only be challenged when one rejects the notion of balance as being anchored in ideological rather than empirical considerations. Conversely, the symbolic interactionist approach does not have any internal or external validity, since its ahistorical style contradicts its own premises. For

an amplification of this theme, see C. and B. Griffin, "Comments on Becker's Art as Collective Action," *American Sociological Review* 41 (1976):174–75.

55. I borrow this term from Kuhn, *The Structure of Scientific Revolutions*, and therefore refer not only to specific networks of practitioners rank ordered in terms of their contributions or of the date of their entry into the corresponding communities but also to the conceptions they share with regard to the purposes of their individual projects, to their choice of symbolic materials, or to the modes of socialization they tend to impose on newcomers.

56. Sennett, *The Fall of Public Man*, pp. 36–37.

57. E. Panofsky, *Renaissances and Renascences in Western Art* (Stockholm: Almquist and Wicksell, 1965), p. 84.

58. There should be in this regard many similarities in the life cycles of artistic and scientific paradigms. Thus, it should be worthwhile to compare the processes of adumbration described by Merton in *Sociology of Science* (Chicago: University of Chicago Press, 1972), p. 295, with the properties of formal sequence defined by G. Kubler in *The Shape of Time* (New Haven: Yale University Press, 1962), p. 35.

59. T. S. Eliot, "Tradition and the Individual Talent," *Selected Essays: 1917–32* (New York: Harcourt, Brace, 1932), p. 5.

60. For documentation, see W. Ivins, *Prints and Visual Communication* (Cambridge: MIT Press, 1969). See also E. Panofsky, *Renaissances and Renascences in Western Art*.

61. Certain French movie directors, such as A. Astruc or J. Rouch, have developed expressions such as "caméra stylo" or "cinéma vérité" to symbolize their sensitivity to the work done earlier along these lines by writers and philosophers.

62. In more general terms, I suggest therefore that in the modern world, the lower the division of labor operating in a particular artistic discipline, the more likely it is that its practitioners will adopt an individualistic ideology that minimizes the constraints of collective action.

63. As quoted by Wolf in *The Social Production of Art*, p. 88.

64. C. Lévi-Strauss, *Anthropologie structurale* (Paris: Plon, 1953).

65. R. Clignet, "The Variability of Paradigms in the Production of Culture," *American Sociological Review* 44 (1979):392–403.

66. E. Panofsky, *Renaissances and Renascences in Western Art*, p. 168.

67. For a systematic treatment of the patterns of interaction between painting and photography, see G. Freund, *Photographie et société* (Paris: Le Seuil, 1974) and S. Sontag, *On Photography* (New York: Farrar, Straus and Giroux, 1977).

68. A. Sharf, *Art and Photography* (London: Penguin, 1974).

69. Sontag, *On Photography*, pp. 31, 69.

70. A. Gouldner, *The Dialectics of Ideology and Technology* (New York: Seabury Press, 1976).

71. A. Cicourel, *Theory and Methods in a Study of Argentine Fertility* (New York: John Wiley and Sons, 1974), p. 197. Both the theoretical and methodological choices of sociologists vary not only in function of the training to which they have been exposed but also in function of their biographies. Hence, the importance for sociologists to question the meaning of their relations with the objects of their analysis. For an elaboration, see L. Hudson, *The Cult of the Fact* (New York: Harper & Row, 1972).

72. See J. Bonta, *Architecture and Its Interpretation* (New York: Rizzoli, 1979); see also Bonta, "American Architects and Architectural History" (University of Maryland, unpublished report, 1982).

73. As quoted by G. Leclerc in *L'Observation de l'homme: Histoire des enquêtes sociales* (Paris: Le Seuil, 1978), p. 13.

Notes for Chapter 2: The Structure of Artistic Paradigms

1. L. Meyer, *Music, the Arts, and Ideas* (Chicago: University of Chicago Press, 1967), p. 57.

2. Thus, the notion of the invisible college applies to the arts as well as to the sciences. See D. Crane, *Invisible Colleges* (Chicago: University of Chicago Press, 1972).

3. There are, in reality, various types of primitive or "naive" artists. Thus, it is necessary to ascertain the conditions under which such artists formalize the system within which they have operated before being discovered and, in more general terms, to identify the processes by which individuals move from one category to another. For an illustration of the sociological naiveté surrounding the problem raised by primitive art, see H. Becker, "Art Worlds and Social Types," *American Behavioral Scientist* 19 (1976):714.

4. The quote is derived from D. Hofstadter, *Gödel, Escher, Bach: An Eternal Golden Braid* (New York: Basic Books, 1979), p. 28.

5. T. Kuhn, *The Essential Tension* (Chicago: University of Chicago Press, 1977), p. 294.

6. R. Brown, *A Poetic for Sociology* (New York: Cambridge University Press, 1977), p. 26.

7. For a sketch of this chapter, see R. Clignet, "The Variability of Paradigms in the Production of Culture," *American Sociological Review* 44 (1979):392–409. For a systematic treatment of the similarities and contrasts between artistic and scientific endeavors, see R. Arnheim, *Toward a Psychology of the Arts* (Berkeley: University of California Press, 1966), p. 163. See also H. Simon, *The Sciences of the Artificial*

(Cambridge: M.I.T. Press, 1969), and J. Barzun, *The Use and Abuse of Art* (Princeton: Princeton University Press, 1974).

8. As quoted by G. Pelles, *Art, Artists and Society* (Englewood Cliffs: Prentice-Hall, 1963), p. 58.

9. Kuhn, *The Essential Tension*, p. 348.

10. See S. Moscovici, *Essai sur l'histoire humaine de la nature* (Paris: Flammarion, 1968), p. 226.

11. As quoted by Pelles, *Art, Artists and Society*, p. 96.

12. Ibid., p. 76. Indeed, many artists of the nineteenth century were sensitive to a scientific ideology. Thus, Poe wrote, "The work has progressed toward its completion with the precision of a mathematical problem," as quoted by H. Perruchot, *La vie de Seurat* (Paris: Hachette, 1966), p. 35; Seurat himself suggested that "it was impossible to be a mathematician without being simultaneously a poet" (ibid., p. 94). Braque is famous for having suggested that to have his paintings hung on the walls of the Palais des Papes in Avignon would be their best verification. For a more general discussion of the bonds between artists and scientists of that period, see C. Grana, *Bohemian Versus Bourgeois* (New York: Basic Books, 1964). For a discussion of the unconscious aspects of such relations, see E. Haffner, "The New Reality in Art and Science," *Comparative Studies in Society and History* 11 (1969): 385–97. For a more general discussion of the relative validity of the diffusionist versus functionalist hypotheses, see R. Rands and C. Riley, "Diffusion and Discontinuous Distributions," *American Anthropologist* 60 (1958): 274–87.

13. R. Nisbet as quoted by Brown, *A Poetic for Sociology*, p. 34.

14. Ibid., p. 35. For a more general statement on the logic of ambiguity as it controls creativity in mathematics, the visual arts, and the musical arts, see Hofstadter, *Gödel, Escher, Bach*, introduction.

15. R. Caillois, *Méduse et compagnie* (Paris: Gallimard, 1960), pp. 54–68.

16. One will note the double meaning of the word *design*, which refers both to a specific intention and to the outcome of an aesthetic project. Interestingly enough, the two concepts are distinguished in French. The first meaning is conveyed through the word *dessein*, the second one through the word *dessin*.

17. Braque as quoted by Tom Wolfe in "The Painted Word," *Harper's* (April 1975): 57–92. Picasso as quoted by Brown, *A Poetic for Sociology*, p. 35.

18. Brown, *A Poetic for Sociology*, p. 34.

19. Ibid., p. 47.

20. Kuhn, *The Essential Tension*, p. 295.

21. Ibid.

22. For an illustration of these rules of correspondence as they affect the choice of artistic objects, see B. Novak, *Nature and Culture in American Landscapes* (New York: Oxford University Press, 1980), p. 7. See also C. Hussey, *The Picturesque* (Hamden, Conn.: Archon Books, 1967).

23. Rimbaud wrote: "A black, E white, I red, U green, O blue, I regulated the form and the movement of each consonant and with instinctive rhythms, I intended to invent a poetic discourse accessible to each one of our senses." See the edition of his *Oeuvres* (Paris: Club Francais du Livre, 1949), p. 83.

24. E. Panofsky, *Architecture and Scholasticism* (London: Latrobe, 1954), loc. cit.

25. See B. Herrnstein Smith, *Poetic Closure: A Study of How Poems End* (Chicago: University of Chicago Press, 1968).

26. Caillois, *Méduse et compagnie*, pp. 59–64.

27. S. Moscovici, *Essai sur l'histoire humaine de la nature*, p. 48.

28. The two quotes come respectively from M. Fowler, *The Embroidered Tent* (Toronto: Amansi, 1982), chapter 2, and from J. Renoir, *Renoir* (Paris: Hachette, 1960), p. 212. Renoir's quote offers a striking parallel with Gramsci's statement about electricity, which existed as an abstract force in nature only as long as its properties had not been defined as problematic and systematically explored. In this sense, the properties of scientific and artistic "nature" are necessarily historically contingent.

29. This section is inspired by Meyer, *Music, the Arts, and Ideas*, pp. 194–208.

30. J. Constable, *The Painter's Workshop* (New York: Dover, 1954), chapter 2.

31. M. Serrulaz, "Les techniques du dessin," *L'Estampille* 127 (November 1980): 18–26.

32. Paggi as quoted by R. and M. Wittkover, *Born Under Saturn* (New York: Norton, 1969), p. 11.

33. M. Segall, D. T. Campbell, and M. Herskovitz, *The Influence of Culture on Visual Perception* (Indianapolis: Bobbs Merrill, 1966).

34. For a discussion of this theme and concrete illustrations, see R. Bastide, *Art et société* (Paris: Payot, 1977), pp. 160–68.

35. J. Dunning, "When a Pianist's Fingers Fail to Obey," *New York Times*, 14 June 1981. The article is particularly interesting as it shows historical variations, both in the diagnosis and the treatment of injured pianists.

36. Serrulaz, "Les techniques du dessin."

37. M. Polanyi, *Personal Knowledge* (Chicago: University of Chicago Press, 1958), p. 200.

38. For description of the role performed by sound engineers, see A. Hennion and J. P. Vignolles, *Artisans et industriels du disque: Essai sur le mode de production de la musique* (Paris: Cedes Cordes, 1978), pp. 255–57. Despite the significance of the contributions of these engineers and despite their ensuing notoriety in the appropriate professional circles, they are not usually given credit for their accomplishments in the general market. They differ in this regard from the cameramen in the film industry who may ultimately be known as much by the public at large as by professionals.

39. For a historical analysis of the control exerted by guilds and academies on the organization of work in the visual arts, see N. Pevsner, *Academies of Art: Past and Present* (Cambridge: Cambridge University Press, 1940). See also J. Constable, *The Painter's Workshop* (New York: Dover, 1954), chapter 1. In more general terms, it is therefore necessary to determine the conditions under which the segmentation of individual roles within an artistic field enhances the control exerted by the community as a whole on their allocation. In the modern world, it seems that the protection and control of individual practitioners are greater in the case of fields characterized by a high division of labor (e.g., music, cinema) than in the case of those in which division of labor has decreased (e.g., the visual arts).

40. For a vivid account of the distinction that musicians establish in this regard, see M. Mezzrow and B. Wolfe, *Really the Blues* (New York: Random House, 1946). See also J. Buerkle and D. Barker, *Bourbon Street Black: The New Orleans Jazzmen* (New York: Oxford University Press, 1973).

41. Pevsner, *Academies of Art*, p. 94.

42. I am using here the title of a book by R. Ellman (New York: Oxford University Press, 1967). The expression is apt on two counts. Literally speaking, this term refers to the rights that the community may claim to exert on private land; in French law, it also refers to the rights of such a community over the land of the shoreline covered by the highest tides. Symbolically, the term evokes therefore the incessant processes of selection and retention that mark the construction of paradigms.

43. J. Gusfield, "The Literary Rhetorics of Science: Comedy and Pathos in Drinking Drivers' Research," *American Sociological Review* 41 (1976): 16–33. But if scientists use rhetorical artifacts in order to narrow the expectations of their readers, artists do the same. This holds true not only of playwrights as I suggest here but also of scenarists in the case of the cinema. For instance, a remake enables audiences to pay more attention to the aesthetic choices of the new director and new actors.

44. R. Copeland, "When Films Quote Film, They Create a New Mythology," *New York Times*, 25 September 1977. Against the stance adopted by filmmakers in this regard, it is fruitful to look at the philosophy of many contemporary painters, as described by Wolfe, "The Painted Word," pp. 57–92.

45. Pevsner, *Academies of Art*, p. 231. See also W. Gerdts, *The Great American Nude: A Study in the History of Art* (New York: Praeger, 1974).

46. For a more general discussion, see E. Arian, *Bach, Beethoven and Bureaucracy* (Oxford: University of Alabama Press, 1971), pp. 35–36.

47. The role is particularly difficult since conductors complain about the loudness of prompters who accuse performers of being too discreet. For some portraits and anecdotes, see R. Braun, "An Operatic Perfor-

mance Is Always One Beat Away from Chaos," *New York Times*, 31 August 1975.

48. J. Rockwell, "Why Are Ballet Orchestras Bad?," *New York Times*, 12 September 1976. The current situation differs from the first decade of the century when Diaghilev was able to attract the best musicians.

49. I make here the assumption that the norms described by Merton as regulating the functioning of scientific communities apply as well to art worlds. For a discussion of these norms, see Merton, *Sociology of Science* (Chicago: University of Chicago Press, 1972), pp. 222–35.

50. For a critical examination of the limitations of their application in the scientific field, see I. Mitroff, "Norms and Counternorms in a Selected Group of the Apollo Mission's Scientists," *American Sociological Review* 39 (1974): 579–95.

51. These rights depend on external factors and were not recognized by the Soviet Union, for example, until the recent past. They also depend on the internal organization of each field and, as I will demonstrate in chapter 5, they are contingent on the differential contribution of the notion of replication to the artistic value of a work of art.

52. As the champions of black or women's art often address themselves to blacks or women, the champions of certain literary movements (such as surrealism) often seek to convince the converts. Earlier, Stendhal dedicated *The Red and The Black* to the "happy few."

53. L. Goldmann, *Le dieu caché* (Paris: Gallimard, 1955), p. 30.

54. See Clignet, "The Variability of Paradigms in the Production of Culture." Yet the distinction between national and ideological commitments as foundations of paradigms varies across art forms, in function both of the involvement of the body in the practice (and hence of face-to-face communications in the processes of socialization of newcomers) and of the size of the relevant markets. In the twentieth century, the importance of national schools is therefore more important in the performing arts than in other fields. See, for example, A. Kisselgoff, "There Is Nothing National About Ballet Styles," *New York Times*, 12 December 1976, and E. Siegmeister, "A New Day Is Dawning for American Composers," *New York Times*, 23 January 1977.

55. For an exploration of the fascination that the visual arts exerted on European writers of the eighteenth and nineteenth centuries, see E. Gilmore Holt, *The Triumph of the Art for the Public* (New York: Doubleday, 1979). It remains necessary to explain not only why musical communities have been less sensitive to the influence of writers but also why the boundaries between "pure" and "applied" forms are less clear-cut in the former than the latter case. For an illustration of the cooperation among musicians engaged in various styles, see K. Terry, "Jazz and Classical Musicians Interact," *New York Times*, 23 July 1978.

56. See Clignet, "The Variability of Paradigms in the Production of Culture."

57. This section is derived from W. Ivins, *Prints and Visual Communications* (Cambridge: MIT Press, 1953).
58. For an elaboration, see G. Freund, *Photographie et société* (Paris: Le Seuil, 1974), pp. 33–58, 73–84.
59. Renoir, *Renoir*, p. 172. While his stance reflected a general decline in the status occupied by portraits in the hierarchy of pictorial genres, photography did not significantly affect the boundaries between professional and amateur paintings of landscapes. It should be added that the demise of the role played by upper-class women in the production (and thereby the evaluation) of portraits entailed a parallel change in the role of art galleries that ceased to lend portraits to such women and became totally devoted to the selling of this particular genre. See G. Bernier, *L'art et L'argent: Le marché de l'art au XXème siècle* (Paris: Robert Laffont, 1977), part 1.
60. As a result of progress in the techniques of reproduction and the correspondingly greater diffusion of reprints, there has been a decline both in the status assigned to museums as temples of high art and in their role as socialization agencies for professional painters.
61. For a general discussion, see S. Sontag, *On Photography* (New York: Farrar, Straus and Giroux, 1977). Although at first the relations between the two media were not easy, and although Baudelaire, for example, argued that photography would primarily attract painters suffering from a lack of talent, there were crossovers between the two fields. Nadar and Lartigue offer cases in point. In spite of the growing differentiation of the two fields, contacts between their respective practitioners have persisted, as exemplified by the privileged relations of Georgia O'Keeffe with Alfred Steiglitz.
62. This is particularly true of popular music, and notably of rock. See, for instance, S. Bennet, "Other People's Music" (Ph.D. diss., Northwestern University, 1972).
63. For a brief description of the differentiation of the careers based on recordings and of those based on live performances, see J. Rockwell, "Why Do They Still Give Debut Recitals?," *New York Times*, 27 May 1979.
64. The effects of technological innovations on the competition among performers are evoked by H. Drees Ruttencutter in "Onward and Upward with the Arts: A Pianist's Progress," *New Yorker*, 19 September 1977, pp. 42–107.
65. See, for example, W. White, "Videodance, It May be a Whole New Art Form," *New York Times*, 18 January 1976. Although the author discusses primarily the aesthetic problems raised by the translation of ballets on the small screen, the relationships of cooperation and competition that develop between television producers and choreographers seem to be parallel to those developed earlier between painters and engravers or painters and photographers.

66. M. Du Camp, *Souvenirs littéraires* (Paris: Hachette, 1892).
67. As exemplars of this form of criticism, see C. Abbott, introduction in *Poets at Work*, ed. R. Arnheim et al. (New York: Harcourt, Brace, 1948). In more general terms, I suggest, therefore, that changes in the technology of production of literary documents are associated with parallel changes in the tensions between externalist and internalist schools of literary criticism.
68. See J. Constable, *The Painter's Workshop*, chapter 2.
69. J. Benthall, *Science and Technology in Art Today* (New York: Praeger, 1972).
70. G. Huaco, *Sociology of Film Art* (New York: Basic Books, 1966), pp. 18–22.
71. For a systematic description of the changes that have affected the characteristics of pianos, see A. Loesser, *Men, Women and Pianos* (New York: Simon and Schuster, 1955). For a brief evocation of these changes, see H. Schonberg, "The Latest Fashions in Old Instruments," *New York Times*, 6 February 1977.
72. L. Kandell, "The Ins and Outs of Piano Duets," *New York Times*, 6 June 1982.
73. J. Attali, *Bruits* (Paris: Presses Universitaires de France, 1977).
74. Of course, the effects of technological innovations on the arts have always been divergent. It has become a cliché to observe that at certain points in the development of a discipline, these innovations are defined as instruments of emancipation whereas at others they are viewed as tools of repression and inhibition.
75. Indeed, the great danger confronting sociologists in their modes of analysis is falling prey to the consequences of reification and hence forgetting that the socioeconomic status and cultural status of artists and audiences are not independent of one another.
76. For a development of this theme in the visual arts, see F. Haskell, *Patrons and Painters* (New York: Knopf, 1963) or G. Reitlinger, *The Economics of Taste* (London: Barry and Rockliff, 1961–70). For an analysis of the same phenomenon in the musical world, see Attali, *Bruits*, pp. 31–36.
77. Haskell, *Patrons and Painters*, pp. 22–23.
78. Attali, *Bruits*, p. 101.
79. R. Sennett, *The Fall of Public Man* (New York: Vintage Books, 1977), pp. 205–7.
80. As Kuhn notes, the discomfort that the public experiences as a result of the segmentation of consciousness generated by division of labor varies between the arts and the sciences. See "Comments on the Relations of Science and Art," *Comparative Studies in Society and History* 11 (1969): 403–12. However, both the form and the intensity of this discomfort vary not only between the arts and the sciences but also within the various disciplines that constitute these two cultures.

81. On this point, see Pevsner, *Academies of Art*, pp. 132–39, and also F. Haskell, *Rediscoveries in Art* (Ithaca: Cornell University Press, 1976).

82. For a sociological description of the role played by critics in this regard, see L. Hirsch, "Processing Fads and Fashions," *American Journal of Sociology* 77 (1972): 640–57.

83. W. Kerr, "Vices and Virtues of the Preview System," *New York Times*, 24 August 1975. There are, of course, cultural variations in this regard; American critics, for example, are apparently individually as well as collectively more influential than their British counterparts. See B. Nightingale, "Why do Playwrights Thrive in Britain?," *New York Times*, 10 July 1977. Against these cultural variations there are also historical constants. For example, theater companies in Paris have often accused one another of hiring supporters and critics. See, for example, E. Burns, *Theatricality: A Study of Convention in the Theater and in Social Life* (London: Longmans, 1972), p. 189. See also J. Lough, *Paris Theater Audiences in the Seventeenth and Eighteenth Centuries* (New York: New York University Press, 1976), pp. 145–62.

84. Pevsner, *Academies of Art*, pp. 132–39.

85. V. Zolberg, "Displayed Art and Performed Music: Selected Innovations and the Structure of Artistic Media" (Purdue University, Department of Sociology, unpublished paper, 1977).

86. See R. Poggioli, *Theory of the Avant-Garde* (New York: Harper & Row, 1971).

87. For a full treatment of the contrasts in perceived quality between older and newer in the scientific realm, see P. Feierabend, *Against Methods* (Atlantic Highlands: Humanities Press, 1975).

88. This quote, derived from H. Becker and J. Walton, "Social Science in the Work of Hans Haacke," in *Framing and Being Framed*, ed. H. Haacke (New York: New York University Press, 1976), shows how it is easy for sociologists to fall prey to unwarranted generalizations that are influenced by ideological considerations. Even in the case of painting, only a limited segment of the "high art" circles ceases to question the veridicality of aesthetic statements, and their stance is not permanent. What is problematic from a sociological perspective is the coexistence of opposite time orientations in various paradigms, and their distribution among various categories of painters and patrons.

89. As quoted by Zolberg in "Displayed Art and Performed Music."

90. This section is derived from A. Hennion and J. P. Vignolles, *La production musicale: Les politiques des firmes discographiques* (Paris: Centre de Sociologie des Innovations, 1975).

91. Sennett, *The Fall of Public Man*, p. 201.

92. Huaco, *The Sociology of Film Art*, pp. 18–22.

93. Copeland, "When Films Quote Films."

94. Some authors have contrasted the role played by art and science museums along these lines. See, for example, Kuhn, *The Structure of Sci-*

entific Revolutions, p. 167. Yet this contrast is exaggerated on two counts. First, science museums play a socializing role with regard to access to folk science. The modesty of their role in this regard results from the ways in which scientists write the history of their discipline and, more specifically, from their tendency to donate to such museums the discarded tools of their practice. Second, the importance assigned to art museums as agencies of socialization to high art forms has been challenged since the end of the seventeenth century. For documentation of these challenges, see P. Gay, *Art and Act* (New York: Harper & Row, 1976) in the chapter, "Manet: The Primacy of Culture," pp. 33–110.

Notes for Chapter 3: The Structure of Artistic Revolutions

1. G. Kubler, *The Shape of Time* (New Haven: Yale University Press, 1962) p. 54.
2. Ibid., p. 70. See also S. Kern, *The Culture of Time and Space: 1880–1918* (Cambridge, Mass.: Harvard University Press, 1983), p. 185.
3. B. Mittman has shown in recent articles how French theatrical companies tried both to retain spectators on the stage and to isolate them from the play itself, notably through modifying the architecture of the balustrade. See her "Keeping Order on the Stage in Paris in the Seventeenth and Eighteenth Centuries," *Theatre Research International* 5 (1980):99–107, and "Les spectateurs sur la scène: Quelques chiffres tirés des registres du XVIIème siècle," *Revue d'Histoire du Théâtre* 32 (1980):199–215, or "Cinq documents portant sur l'enceinte de la balustrade de l'Ancienne Comédie," *Revue d'Histoire du Théâtre* 2 (1983): 174–88.
4. I have been inspired in this chapter both by T. Kuhn, *The Essential Tension* (Chicago: University of Chicago Press, 1977), pp. 30, 167, 177, 226–27, 230, 234, and by H. Brown, *Perception, Theory and Commitment* (Chicago: University of Chicago Press, 1977), chapters 8 and 9.
5. For a general description of this diffusion, see E. H. Gombrich, *Art and Illusion* (New York: Pantheon, 1960), and S. Moscovici, *Essai sur l'histoire humaine de la nature* (Paris: Flammarion, 1968).
6. See E. Haffner, "The New Reality in Arts and Sciences," *Comparative Studies in Society and History* 11 (1969):385–97.
7. Given my firm belief in the recurrent interaction between artistic and scientific worlds, I follow in the following paragraphs the same logic as that adopted by A. Whitehead in *Science and the Modern World* (New York: Free Press, 1953). Indeed, the history of artistic and scientific paradigms reflects changes in the definitions of the relationships be-

tween subjects and objects and, more specifically, successive elaborations of the concepts of space and time as the prerequisites to our understanding of the world. This logic has been used, at least in part, by S. Kern in *The Culture of Time and Space: 1880–1918*. The author shows how both the scientific discoveries and the political revolutions of that particular period induced a growing number of artists in various disciplines to stress the relativity of space and time. Kern's approach and mine differ from that used by B. Lamblin in *Peinture et temps* (Paris: Klinsieck, 1983), insofar as Lamblin falls prey to anachronism and considers time to be an aesthetic problem prior to the nineteenth century.

8. For a more systematic elaboration, see M. Foucault, *The Order of Things* (New York: Vintage, 1973), chapter 2.

9. See E. Auerbach, *Mimesis* (Paris: Gallimard, 1968), chapters 5, 6.

10. R. Caillois, *Méduse et compagnie* (Paris: Gallimard, 1960). See also E. Panovsky, *Architecture and Scholasticism* (London: Latrobe, 1954).

11. For a further elaboration, see P. Francastel, *Etudes de sociologie de l'art* (Paris: Denöel, 1970), pp. 139–45, 211.

12. See E. Burns, *Theatricality: A Study of Convention in the Theater and Social Life* (London: Longmans, 1972). See, also, J. Duvignaud, *Sociologie du théâtre* (Paris: Presses Universitaires de France, 1965), chapter 3.

13. Roland Barthes, *Le degré zéro de l'écriture* (Paris: Gonthier, 1964), p. 51.

14. For a more systematic development, see R. Sennett, *The Fall of Public Man* (New York: Vintage Books, 1978), chapter 4. The relativity of the distinction between public and private roles has been dramatically evoked by Rossellini in *La Prise de Pouvoir par Louis XIV* (1966).

15. H. Nicholson, *Newton Demands the Muses* (Princeton: Princeton University Press, 1946), pp. 11–13.

16. See L. Goldmann, *For a Sociology of the Novel* (London: Tavistock, 1975). See, also, Georg Lukács, *The Theory of the Novel* (Cambridge: MIT Press, 1971).

17. For an earlier and convincing historical analysis of the evolution of the forms taken by the novel, see R. Caillois, *Puissances du roman* (Marseilles: Le Sagittaire, 1942), in which the author examines, inter alia, the growing differentiation of detective stories.

18. Burns, *Theatricality*, p. 96.

19. In addition to the work of Francastel already mentioned, see M. Shapiro, *Modern Art: Nineteenth and Twentieth Centuries* (New York: Braziller, 1978).

20. In this sense, the evolutions of the arts and the sciences are parallel. For a discussion of the internal aspects of this convergence and its historical evolution, see P. Pizon, *Le rationalisme dans la peinture* (Paris: Dessain et Tolra, 1978). For a description of this convergence at the turn of the century, see Kern, *The Culture of Time and Space: 1880–*

1918, pp. 101–80. For a discussion of the external aspects of this "convergence," see E. Tiryakian, "L'école Durkheimienne à la recherche de la société perdue: La sociologie naissante et son milieu culturel," *Cahiers Internationaux de Sociologie* 56 (1979): 98–114.

21. One will consult with pleasure the text and the images that G. Pérec and C. White devote to the problem in *L'Oeil Ebloui* (Paris: Chêne/Hachette, 1981).

22. See Kuhn, *The Essential Tension*.

23. For an amplification of the distinction between normal and revolutionary practices, see H. Brown, *Perception, Theory and Commitment: The New Philosophy of Science* (Chicago: University of Chicago Press, 1979).

24. See P. Rieff, *The Triumph of the Therapeutic* (New York: Harper & Row, 1968), p. 9. Even more interesting is the recent change of heart of S. Gablik who seems to have adopted by now a negative stance toward modern art. See her *Has Modernism Failed?* (New York: Thames and Hudson, 1984).

25. For a full development of the argument, see S. Gablik, *Progress in Art* (London: Thames and Hudson, 1976).

26. For a definition of such terms, of their parallels and divergences, see J. Piaget, "Pensée égocentrique et pensée sociocentrique," *Cahiers Internationaux de Sociologie* 10 (1951): 34–49.

27. See R. Clignet, "Pour une analyse systématique des relations enseignants-enseignés," *Revue Française de Pedagogie* 43 (1978): 31–46. While I recognize the validity of Piaget's distinction between assimilation and accommodation as the opposite components of any mode of adaptation, I differ from him in two ways. First, I posit that the dialectical interaction between these two modes of adaptation varies in form across fields and that there are differences in the "discipline" demanded of the practitioners of various disciplines. In addition, I suggest that the discipline demanded of such individuals varies over time with changes in the definition of the tasks expected from them.

28. See Rieff, *The Triumph of the Therapeutic*, p. 22. From a theoretical perspective, the relationship between individuation and progress is highly problematic. To argue that any movement is good that helps to free art from the tyranny of a code of rules and definitions (a stance taken by Burns in *Theatricality*, p. 204) is to celebrate the virtues of anarchy. As I will suggest in my conclusion, the individuation of the arts in the last part of the twentieth century is related to narcissism and can hardly be seen as progress. Against the notion that abstraction means progress, see A. Arnheim's discussion in "Accident and the Necessity of Art," pp. 162–81 in *Toward a Psychology of the Arts* (Berkeley: University of California Press, 1966). For a description of the pathologies developed as a result of an extreme abstraction in the visual arts, see J. Rockwell,

"Today's Blank Art Explores the Space Behind the Obvious," *New York Times*, 17 July 1977. From a methodological viewpoint, my criticism of Gablik's perspective leads me to emphasize the significance of the studies of variances rather than of central tendencies in the analysis of cultural and other social phenomena. See Gablik, *Progress in Art*, p. 10.

29. Kuhn, *The Structure of Artistic Revolutions*, pp. 172–73.
30. The metaphor used here is derived from the William James lectures delivered by D. T. Campbell at Harvard University in 1977. To the extent that the metaphor suggests that revolutions are partial and concern more the condition of the vessel than its direction, it also suggests that revolutions tell us more about science than about nature. *Mutatis mutandis*; the same argument can be generalized to art worlds.
31. Kubler, *The Shape of Time*, pp. 112–21.
32. This part is inspired by D. De Solla Price, *Little Science, Big Science* (New Haven: Yale University Press, 1962).
33. Lévi-Strauss's distinction between sociological and historical time is particularly relevant here. See *Anthropologie structurale* (Paris: Plon, 1958), p. 314.
34. As quoted by H. Perruchot, *La vie de Seurat* (Paris: Hachette, 1968), p. 133.
35. The tragedies of Voltaire offer an appropriate illustration of the phenomenon.
36. See D. Hofstadter, *Gödel, Escher, Bach: An Eternal Golden Braid* (New York: Basic Books, 1979), pp. 698–99. See also Kern, *The Culture of Time and Space: 1880–1918*, pp. 11–35, 131–80.

Notes for Chapter 4: The Natural History of Artistic Careers

1. For a full development of this approach to creativity, see A. Ehrensweig, *The Hidden Order of Art* (Berkeley: University of California Press, 1971), and A. Koestler, *The Art of Creation* (London: Hutchinson, 1964).
2. While this particular duality is borrowed from Ehrensweig, *The Hidden Order of Art*, many psychologists have emphasized the same point. In *The Emerging Goddess*, A. Rothenberg shows how the "janusian" uses of opposites and "homospatial" mechanisms of fusion and integration represent successive, conflicting, yet complementary moments of the creative act.
3. L. Hudson, *Human Beings* (New York: Anchor Books, 1976), pp. 121–22. The author intended to show the difficulties of explaining certain statistical regularities in the distribution of creativity among various populations.

4. As quoted by P. Gay, *Art and Act* (New York: Harper & Row, 1974), pp. 211–13.

5. As quoted by Gay, *Art and Act*, p. 64.

6. E. Panofsky, *Renaissances and Renascences in Western Art* (Stockholm: Almquist and Wicksell, 1965), p. 13.

7. For a systematic treatment of the contrasts between convergent and divergent personalities and their effects on creativity, see the four spectacular books that Hudson has devoted to the topic: *The Cult of the Fact* (New York: Harper & Row, 1972); *Human Beings; Frames of Mind* (London: Methuen and Co., 1968); and *The Ecology of Human Intelligence* (London: Penguin, 1970). Hudson's contributions are noteworthy for their exploration of the distinction between myths and realities and for their poetical properties.

8. For an example of the difficulties encountered by poets in this regard, see C. Abott, introduction in *Poets at Work*, ed. R. Arnheim et al. (New York: Harcourt, Brace, 1948) and also R. Gibbons, *The Poet's Work* (Boston: Houghton and Mifflin, 1979). These analyses tend to view changes between first and last versions as moving toward greater purity, intensity, and unity. But such analysts presuppose that artists are necessarily aware of their initial mistakes, and that they necessarily progress from one version to the next.

9. For a full treatment of the shift in the boundaries between arts and crafts and the growing differentiation of arts and sciences, see S. Moscovici, *Essai sur l'histoire humaine de la nature* (Paris: Flammarion, 1968), chapter 2.

10. Paggi, as quoted by R. and M. Wittkover, *Born Under Saturn* (New York: Norton, 1969), p. 11. The significance of this quote is reinforced by statements of other artists of the same period. Pierro della Francesca, for example, insisted on the need to measure in painting, and da Vinci stressed the need to read appropriate books and to translate their recommendations into actual practices. See S. Moscovici, *Essai sur l'histoire humaine*, pp. 220–24.

11. For an illustration, see J. Getzels and M. Csikszentmihalyi, *The Creative Vision* (New York: John Wiley and Sons, 1976), p. 54.

12. For a historical account of the theories or ideologies concerning creativity, see E. Panofsky, *Studies in Iconology* (New York: Oxford University Press, 1959), p. 206. See also R. Caillois, *Méduse et compagnie* (Paris: Gallimard, 1960), p. 10. See also G. Becker, *The Mad Genius Controversy* (Beverly Hills: Sage Publications, 1978). For a review of the contemporary rhetoric on the problem, see Gibbons, *The Poet's Work*.

13. This point is particularly elaborated by R. and M. Wittkover in *Born Under Saturn*. In more general terms, it follows that there is a dialectical relationship between creativity per se and the theories developed

to explain it. For example, if the distinction that Hudson established between convergences and divergences reflects current contrasts between various forms of creativity, it is also a producer of such contrasts.

14. Moscovici, *Essai sur l'histoire humaine*, p. 45. As an illustration, if the contribution of the distinction between left and right hand or side to creativity *is* history, insofar as it corresponds to an evolutionary process, it *has* a history and is, indeed, associated with significant changes in the symbols it evokes among various disciplines, notably in music or in the theater. See Caillois, *Méduse et compagnie*, pp. 16–17.

15. Gay, *Art and Act*, pp. 8–17.

16. N. Ryder, "The Concept of Cohort in the Study of Social Change," *American Sociological Review* 30 (1965): 840–61. As I suggest, it is important in this regard to distinguish the sharing of the experiences associated with the fact of being born the same year and the fact of entering an institution (school, art paradigm, etc.) at the same time. Regardless of the distinction between birth cohorts and other types of cohorts, it is also necessary to examine intercohort differences from both a punctual and diachronic perspective. In other words, the word *cohort* should evoke images of both snapshots and films.

17. G. Kubler, *The Shape of Time* (New Haven: Yale University Press, 1962), pp. 102–6.

18. I am extending here to the art scene the argument developed by T. Kuhn with regard to the authors of scientific revolution. See T. Kuhn, *The Structure of Scientific Revolutions* (Chicago: University of Chicago Press, 1970).

19. See G. Pelles, *Art, Artists and Society* (Englewood Cliffs: Prentice-Hall, 1963). See, also, N. Pevsner, *Academies of Art: Past and Present* (Cambridge: Cambridge University Press, 1940), who reminds us that in Europe painting skills were often transmitted from father to son until the end of the eighteenth century. The Van Loos and the Coypels offer cases in point. This particular mode of cultural reproduction has persisted longer in the world of architecture. See, for instance, R. Moulin, *Les architectes* (Paris: Calman Levy, 1973), chapter 1.

20. This tradition is so alive that in Reims (France), for example, the role has been transmitted not only from father to daughter but also from both of them to the latter's husband, Charles Marq. Thus, Marq's contributions include the realization of stained windows designed by Chagall for public monuments in Jerusalem, Chicago, and for the Reims cathedral itself.

21. It is interesting in this regard to compare the conclusions of W. Altus, "Birth Order and Its Sequellae," in Hudson, *The Ecology of Human Intelligence*, pp. 210–14, and the observations of S. Fish in "The Psychology of Science," in *Science, Technology and Society*, ed. I. Speigel Rosing and D. De Solla Price (Beverly Hills: Sage Publications, 1977),

pp. 282–99. These conclusions raise, of course, additional questions on the writings that Adler devoted to the psychological profile of first-born children.

22. There are a number of convergent observations on this point. See, among others, D. McKinnon, "The Nature and Nurture of Creative Talent," *American Psychologist* 17 (1962):484–95; B. Rosenberg and N. Fliegel, *The Vanguard Artist* (Chicago: Quadrangle Press, 1967), p. 135; D. McClelland, "On the Psychodynamics of Creative Physical Scientists," in Hudson, *The Ecology of Human Intelligence*, pp. 54–68.

23. This part is inspired by R. Caillois, *Les jeux et les hommes* (Paris: Gallimard, 1958), pp. 124–27, and by J. Huizinga, *Homo Ludens: A Study of the Play Element in Culture* (Boston: Beacon Press, 1972), chapter 10.

24. Caillois, *Méduse et compagnie*, chapter 2.

25. See Hudson, *Frames of Mind*, p. 13, and also McKinnon, "The Nature and Nurture of Creative Talent."

26. For example, see the archbishop of Firenze's quote in R. and M. Wittkover, *Born Under Saturn*, p. 24.

27. J. Renoir, *Renoir* (Paris: Hachette, 1960), p. 102; Rosenberg and Fliegel, *The Vanguard Artist*, p. 121.

28. N. Pevsner, *Academies of Art: Past and Present* (Cambridge: Cambridge University Press, 1940), p. 83.

29. Ibid. Also see the introduction of E. Gilmore Holt, *The Triumph of the Art for the Public* (New York: Doubleday, 1979).

30. Ibid. Also see G. Pelles, *Art, Artists and Society* (Englewood Cliffs: Prentice-Hall, 1963), and H. and C. White, *Canvases and Careers* (New York: John Wiley and Sons, 1965), who systematically retrace the evolution of the role played by the Academie des Beaux Arts after the end of the eighteenth century.

31. Ibid., pp. 48–49, 108–110. The rise in the opportunities offered to painters at the beginning of the impressionist period was accompanied by a democratization of their origin. Yet the opportunities offered to painters in this regard vary with the organization of the profession, and the differences that characterize the French and the British scenes along these lines are paralleled by contrasts in the socioeconomic origin of the local artists. For a discussion of this, see Pelles, *Art, Artists and Society*, p. 41.

32. The creation of Academies Jullian or Suisse in Paris was also the product of the "deregulation" of official art markets. On this point, see H. and C. White, *Canvases and Careers*, pp. 28–32.

33. A. Strauss, "The Art School and Its Students," in *The Sociology of Art and Literature*, ed. M. Albrecht, C. Barnett, and J. M. Griff (New York: Praeger, 1970), p. 159. As I shall suggest in chapter 5, the diffusion of this view has been conducive to both a decline and a transformation of the role played by museums as socialization agencies. For an analysis of the evolution of the views held in this regard, see Gay's chapter on

Manet in *Art and Act*. Indeed, one can easily contrast the stance of the art students evoked by Strauss with the stance of J. Reynolds, who is quoted by Gay: "It is by imitation only that variety and even originality of inventions are produced" (p. 74).

34. Among college students, for example, the merits assigned to originality are higher for upper- than lower-class individuals and for Protestants than Catholics. See J. Davis, *Undergraduate Career Decision* (Chicago: Aldine, 1965), p. 220.

35. H. Drees Ruttencutter, "Onward and Upward with the Arts: A Pianist's Progress," *New Yorker*, 19 September 1977, pp. 42–107. For an evocation of the difficulties encountered along these lines by conductors, see J. Rockwell, "What Hope for the Young American Conductor?," *New York Times*, 20 January 1980.

36. The Matthew effect refers to the fact that in science, the importance imputed to the discoveries of researchers tends to increase with their seniority. See R. Merton, *Sociology of Science* (Chicago: University of Chicago Press, 1973), pp. 284, 439–59. There is no reason not to believe that the same phenomenon applies to the arts.

37. R. Pouton, "Programme esthétique et accumulation de capital symbolique," *Revue Française de Sociologie* 14 (1973):217–34. See also Rosenberg and Fliegel, *The Vanguard Artist*, p. 53. In short, differences in the successive stages of artistic life cycles are blurred and distorted by the effects of aging on the perceptions of the past.

38. For a detailed account of the increased opportunities offered to individual artists, see R. Tyler, "The Artist as Millionaire," *New York Times*, 8 January 1978.

39. As quoted by Gay, *Art and Act*, pp. 224–28.

40. This section is derived from G. Kubler, *The Shape of Time* (New Haven: Yale University Press, 1962), pp. 95 and ff. This typology has the merit of introducing mutually exclusive categories whose meanings vary with cultural or historical contingencies. It differs in this regard from the ahistorical distinctions suggested by H. Becker in "Art Worlds and Social Types," *American Behavioral Scientist* 19 (1976):703–18.

41. Gay, *Art and Act*, p. 135.

42. The argument presented here is based on the assumption that there is an analogy between the mobility experienced by artists and by scientists. Thus, R. Collins and J. Ben David explain the development of psychology as a discipline in terms of the hierarchical differences existing between its two "ancestors," philosophy and physiology, and the relative mobility they offered to their respective practitioners. See "Social Factors in the Origin of a New Science," *American Sociological Review* 31 (1966):659–65. Although I feel that their argument can be generalized to the arts, there are also exceptions. Thus, popular singers like Frank Sinatra or Yves Montand have been able to move "upward" into acting and to capitalize on the experiences they have ac-

quired in these two fields. Yet the mobility they have experienced in this respect may also result from the ambiguous status occupied by popular songs and the cinema in the hierarchy of artistic disciplines and, more specifically, from the overall mobility experienced by these two fields. The migration of musicians between classical music and jazz constitutes another exception to the pattern I evoke here. Benny Goodman, for example, has acquired as strong a reputation for his jazz recordings as for his recording of Mozart's quintet for clarinet. Indeed, the rank ordering of musical activities has been and remains loosely defined among performers who do not feel disgraced by the profession for performing supposedly lower forms of music. For an illustration, see H. Philipps, "When New York Musicians Take to the Streets," *New York Times*, 17 August 1975.

43. The reality of these constraints is often underestimated by those American scholars who confuse the appearances of the "crony" system with the realities of the "buddy" system. The first term which suggests particularistic forms of corruption, must be contrasted with the second word, which refers to the solidarity resulting from the experiences of sharing the same type of scarcity. A buddy (the French translation is *copain*) is the person with whom one shares bread in a foxhole; a crony is the individual to whom one owes illegitimate favors. The confusion of these two terms is quite revealing of the corruption existing in certain departments of social sciences, but less revealing of the constraints with which other disciplines must cope. For an illustration of the difficulties confronting film directors, for example, see J. Mackby, "The Frustrations of Being Independent," *New York Times*, 17 October 1976.

44. E. Zuckerman, "Rhapsodizing over Musical Instruments," *New York Times*, 12 August 1979.

45. D. Henahan, "Vocal Virtuosos Teach Stars of the Future," *New York Times*, 2 December 1976. See also R. Ericson, "With Skill and Fuss Rostropovitch Charms Class," *New York Times*, 5 November 1975, in which the author graphically illustrates the contacts of the artist with his students at the Julliard School. Interestingly enough, performers live longer than the population at large, perhaps because of their involvement with differing age groups: see "Musical Charms May Lengthen Life," *New York Times*, 5 December 1978.

46. For a detailed account of the ambivalent relations of writers with teaching, see J. Leonard, "Critic's Notebook: For Many, Writing is a Hungry Trade," *New York Times*, 10 February 1976. While many writers would like to stay close to literary work, many of them have chosen to be civil servants (Hawthorne, Valéry), lawyers (Auchincloss), or doctors (Chekhov, Céline, Mondor, William Carlos Williams) than teachers. The low status attached to teaching in the visual and the literary arts is probably related to the salience of the distinction between pure and applied art in these two fields. See Rosenberg and Fliegel, *The Vanguard Artist*, p. 154.

47. Renoir, *Renoir*, p. 254.
48. For a description of this process as it applies to the arts, see R. Poggioli, *Theory of the Avant-Garde* (New York: Harper & Row, 1971). For a more general discussion of the natural history of social movements, see H. Toch, *The Social Psychology of Social Movements* (Indianapolis: Bobbs Merrill, 1965).
49. See Getzels and Csikszentmihalyi, *The Creative Vision*, pp. 62–66, and also Rosenberg and Fliegel, *The Vanguard Artist*, chapter 8.
50. Hudson, *Frames of Mind*, p. 20. See also Rollo May, *Sex and Fantasy: Patterns of Male and Female Development* (New York: Norton, 1980).
51. As quoted by Gay, *Art and Act*, p. 223.
52. For a general evaluation of women writers, see E. Moers, *Literary Women* (New York: Doubleday, 1976). However, the author does not examine the influence exerted in this regard by the restrictions imposed on the formal education of women. Until the end of the eighteenth century, certain philosophers recommended teaching women how to read but not how to write, in order to enable them to receive messages but to prevent them from gaining the autonomy that accompanies the free emission of written communications. For an elaboration, see L. Versini, *Laclos: Essai sur les sources et la tradition des "Liaisons Dangereuses"* (Paris: Klinsieck, 1969).
53. M. Bogen, *The Women Troubadour* (London: Paddington Press, 1976); see also A. Harris-Sutherland and L. Nochlin, *Women Artists: 1550–1950* (New York: Alfred A. Knopf, 1976). For a dramatic description of the difficulties encountered by female painters, see *Actes d'un procès pour viol suivi des lettres d'Artemisia Gentileschi* (Paris: Edition des Femmes, 1984).
54. For a recent portrait of female composers, see D. Henahan, "Let's Hear It for Composer Persons," *New York Times*, 31 August 1975, who cites Fanny Mendelssohn, Clara Schumann, and, in the contemporary world, Peggy Glanville Hicks, Barbara Kolb, Thea Musgrave, and H. A. Beach.
55. The reformist writers of the period were prone to divide the concepts of liberty and equality; Rousseau, for instance, was quite restrictive in the educational principles he saw fit to impose on women.
56. In *Literary Women*, Moers alludes to this difference between the number of French and British women writers but does not examine its origin.
57. The implications of the following quote are developed by A. Loesser in *Men, Women and the Piano* (New York: Simon and Schuster, 1954). The same point is also sketched by P. Honigheim in *Music and Society* (New York: John Wiley and Sons, 1973), p. 23.
58. It is interesting to note in this regard that, despite the cumbersome nature of the harp, it is considered to be a woman's instrument. For a vignette of a woman harpist, see R. Ericson, "What It's Really Like to Be a Harpist?" *New York Times*, 9 September 1977. In contrast to this article, which implies that the properties assigned to the performance

of an instrument are essentially social, H. Schonberg indicates that there are identifiable differences in the performing styles of male and female pianists. See his "How Sex Plays a Role at the Piano," *New York Times*, 27 May 1979.

59. See H. Epstein, "Accompanists of the World, Take a Bow," *New York Times*, 2 March 1975. In more general terms, it would remain important to analyze the extent and the determinants of historical or cultural variations in the sex ratio of the professional populations performing various musical instruments.

60. For various historical accounts of the restrictions imposed on women painters, see Harris-Sutherland and Nochlin, *Women Artists*, and Pevsner, *Academies of Art*, p. 231. See also G. Greer, *The Obstacle Race: The Fortunes of Women Painters* (New York: Farrar, Straus, Giroux, 1979). For a lighter treatment of this problem, see F. Du Plessix Gray, "Women Writing About Women's Art," *New York Times Book Review*, 11 September 1977.

61. See J. Dunning, "Kabuki Drama of Japan," *New York Times*, 2 September 1977, for both a portrait of the transvestites who perform in the Kabuki and a brief analysis of the origin of this tradition.

62. It is on such a tradition that the Trockadero Ballet relies in order to claim the status of "high art." See T. Tobia, "Drag Ballet: Can Men Make It in a Women's World?," *New York Times*, 2 March 1975. The blurring of the boundaries between genders in the contemporary world also explains the revival of the opera *Platée of Rameau*, an opera that uses a bass disguised as a woman.

63. Loesser, *Men, Women and Pianos*, pp. 88–89. See, also, Harris-Sutherland and Nochlin, *Women Artists*.

64. To the extent that the same holds true for modern forms of popular music, notably the rock field in which entirely female groups (e.g., Deadly Nightshade) can survive, one wonders whether those opportunities offered to women reflect the fields' lack of tradition and hence of prejudices or the weight of two negative stigma. The negative stigma imposed on women and on certain art forms cancel each other out.

65. Harris-Sutherland and Nochlin, *Women Artists*, p. 161.

66. See V. Perlis, "Nadia Boulanger: 20th Century Music Was Born in Her Classroom," *New York Times*, 11 September 1977. Thus, women seem to be accepted more either when they live in a foreign land or when they interact with foreigners. In more general terms, competition is socially acceptable only when it confirms the pre-eminence of the most powerful group. See L. Kuper, "Structural Discontinuities in African Towns," *The City in Modern Africa*, ed. H. Miner (New York: Praeger, 1967), pp. 127–50.

67. Harris-Sutherland and Nochlin, *Women Artists*, pp. 36–37, 49–50.

68. As quoted by E. Moers, *Literary Women*, p. 9.

69. See Harris-Sutherland and Nochlin, *Women Artists*.

70. M. and H. Klein, *Kathe Kolwitz: Life in Art* (New York: Holt, Rinehart and Winston, 1972), p. 48.

71. For a vivid description of the problems raised by the maintenance of musical instruments, see E. Zuckerman, "Rhapsodizing over Musical Instruments."

72. D. Henahan, "Only Black in Philharmonic is Resigning After 15 Years," *New York Times*, 29 August 1977, and "Will Cultural Apartheid Poison the Arts in America?," *New York Times*, 28 August 1977.

73. Rosenberg and Fliegel, *The Vanguard Artist*, p. 288.

74. H. and C. White, *Canvases and Careers*.

75. For a more general discussion, see A. Paris, "Cruse and the Crisis of Black Culture: The Case of the Theater" (Paper delivered at the Annual Meeting of the American Sociological Association, Chicago, 1976).

76. Disparities between the relative opportunities offered to black male and female singers are not necessarily constant. Thus, in the 1930s, the opera *Aïda* was performed in New York by an all-black cast. See H. Schonberg, "Aïda—Louselle, Caruso and a Herd of Camels," *New York Times*, 15 February 1976. Similarly, Virgil Thompson and Gertrude Stein in their opera *Four Saints in Three Acts* initially used an all-black cast, arguing that since their music and words were a departure from existing operatic paradigms, "marginal" actors would best be able to deal with the corresponding innovations. (See Thompson's interview in the movie *When This You See, Remember Me.*)

77. See H. Rosenberg, "Being Outside," *The New Yorker*, 22 August 1977, pp. 83–86. See also B. Novak, *Nature and Culture: American Landscape and Painting* (New York: Oxford University Press, 1980), chapter 10.

78. The problem is illustrated by J. Rockwell in "Does the American Conductor Have a Future?," New York Times, 18 November 1979.

79. As quoted by G. Glueck, "The Woman as Artist," *New York Times Sunday Magazine*, 25 September 1977.

80. In contrast to P. Spackas, *The Female Imagination* (New York: Avon Books, 1976), who treats creativity in absolute and ahistorical terms, S. Gilbert and S. Gubar in *The Madwoman in the Attic: The Woman Writer and the Nineteenth-Century Literary Imagination* (New Haven: Yale University Press, 1979) remind us that many literary women have compared themselves to untamed shrews and have sought to create a literary language accessible to all groups traditionally considered to be underdogs.

81. See B. Jules-Rosette, "From Art to Manufacture: Some Aspects of Contemporary Art Production in Urban Africa" (Paper delivered at the Annual Meeting of the North-Eastern Anthropological Association, Buffalo, 1973). See also A. d'Azevedo, *The Traditional Artist in African Societies* (Bloomington: Indiana University Press, 1973), p. 7.

82. In contrast to the implicitly functionalist view of Becker, who unduly stresses the cooperative behaviors that division of labor engenders, see

C. and B. Griffin, "Comment on Becker's Art as Collective Action," *American Sociological Review* 41 (1976): 174–76.

83. It is noteworthy in this regard that biography has progressed from a minor to a major form. See M. Pachter, ed., *Telling Lives: The Biographers' Art* (Washington: New Republic Books, 1979). As the fascination with this particular genre may reflect the growing confusion between voyeurism and acting, it corresponds to a further spread of the narcissistic culture that threatens contemporary art. For an amplification of such a view, see Christopher Lasch, *The Culture of Narcissism* (New York: Norton, 1978).

Notes for Chapter 5: Artistic Revolutions: Conflicts Over the Durable, the Transient, and the Rubbish

1. The distinction between value of use and value of exchange is derived from the Marxist tradition. For an illustration of its relevance to the art world, see the introduction of L. Goldmann, *For a Sociology of the Novel* (London: Tavistock, 1975). Value of use refers to the intrinsic properties of the artistic task and to the satisfaction that the fulfillment of the relevant aspirations generates. Value of exchange refers to the economic and social alienations or rather reifications generated by artistic communications. It is not accidental, therefore, that artists often tend to be sensitive to the dangers that this reification (artists call it prostitution) represents.

2. For a fuller development of this point, see J. Baudrillard, *Pour une critique de l'économie politique du signe* (Paris: Gallimard, 1972), notably, his discussion of "L'enchère de l'oeuvre d'art."

3. All this section is derived from M. Thompson, *Rubbish Theory* (Oxford: Oxford University Press, 1979), chapter 6.

4. M. Thompson, "Rubbish Theory: The Creation and Destruction of Values," *Encounter* 52 (1979): 12–24. See also H. R. Jauss, *Toward an Aesthetic of Reception* (Minneapolis: University of Minnesota Press, 1982).

5. W. Robertson, "The Convertible Play in Prints," *Fortune*, November 1970, 177–80.

6. An increasing number of articles are devoted to such an analysis. See, for instance, W. Birmingham, "The Auction Crowd," *New York Times Sunday Magazine*, 6 March 1977; H. Maidenberg, "Tax Shelters in Original Art," *New York Times*, 28 October 1979; and R. Reiff, "The Frenzied Market for Major Art," *New York Times*, 18 November 1979.

7. Birmingham, "The Auction Crowd."

8. C. Irving, *Fake* (New York: McGraw-Hill, 1969).

9. Birmingham, "The Auction Crowd."

10. C. Zigrosser and C. Gaehde, *A Guide to the Collecting and Care of Original Prints* (New York: Crown, 1965).

11. F. Haskell, *Patrons and Painters* (New York: Knopf, 1963).

12. J. Russell, "The Tannhauser Collection: A Mini-Museum of Modern Art," *New York Times*, 24 December 1978.

13. J. M. Guilhaume, "La vente Von Hirsch: La collection d'un européen," *Le Monde*, 22 June 1978.

14. The quote is derived from Hilton Kramer, "When Money Not Taste Builds a Collection," *New York Times*, 4 June 1978. For other descriptions, see Kramer, "The Influence of Money on Taste," *New York Times*, 18 June 1978, and J. Taylor, *The Fine Arts in America* (Chicago: University of Chicago Press, 1979), pp. 14–47. For a detailed analysis of variations in the acquisition policies of American collectors in Russia after the revolution, see R. Williams, *Russian Art and American Money* (Cambridge: Harvard University Press, 1979). For a portrait of French collectors, see R. Moulin, *Le marché de la peinture en France* (Paris: Editions de Minuit, 1967), and the recent book of M. Rheims, *The Glorious Obsession* (New York: St. Martin's Press, 1980). See also G. Bernier, *L'Art et l'argent: Le marché de l'art au XX^ème siècle* (Paris: Robert Laffont, 1977).

15. C. Lawson, "Will Petrodollars Oil the Market?" *New York Times*, 4 May 1975.

16. Haskell, *Patrons and Painters*, p. 143.

17. While this point has been originally developed in Veblen, *The Theory of the Leisure Class*, it has been amplified by Baudrillard, *Pour une critique de l'économie politique du signe*.

18. This evolution is based on two additional criteria. First, obsolete tools derive their status from the quality of the materials with which they have been made. Thus, artisanal tools may be worth admiring for the quality of their wood in the same way that pots may be admired for the quality of their glaze. Second, tools derive their status from the obsolescence of the functions they performed initially. Posters, for example, may claim a higher status once it is clear that the advertising campaign for which they were designed is finished. As a matter of fact, there is an increasing number of books on the art of such poster designers as Paul Colin or Savignac. For a more theoretical treatment of the conditions under which an object may become recognized as an exemplar of a high art form, see the distinction of G. Kubler between self and adherent signal, *The Shape of Time* (New Haven: Yale University Press, 1962), pp. 24–25. See also M. Heidegger, "The Origin of the Work of Art," in *Basic Writings from Being and Time* (New York: Harper & Row, 1977). See also the distinction that Lévi-Strauss establishes between icons and instruments in *La pensée sauvage* (Paris: Plon, 1961), chapter 1.

19. See L. Hammel, "A Show Where Literary Forms Imbue Craft with Another Dimension," *New York Times*, 17 December 1976.

20. Haskell, *Patrons and Painters*, pp. 132–41. Another example is the paintings of Hogarth, which initially were not highly valued because of their humorous references, which were deemed to be associated with low forms of art. See G. Reitlinger, *The Economics of Taste* (London: Barry and Rochliff, 1961–70), p. 66.

21. G. Pelles, *Art, Artists and Society* (Englewood Cliffs: Prentice-Hall, 1963), p. 32. See also Reitlinger, *Economics of Taste*, p. 181. In more general terms, changes in the values attributed to portraits seem to result from changes in the boundaries between public and private images of the self. The portrait as a genre may indeed cease to be a document about the identity of the sitter but may still be valued for the aesthetic qualities it reveals as well as for the social symbols associated with the history of its successive owners.

22. For an analysis of the processes by which the development of an individualist ideology leads to the association of genius with madness and to a corresponding decline of the role imputed to skills, see G. Becker, *The Mad Genius Controversy* (Beverly Hills: Sage Publications, 1978).

23. See G. Glueck, "The Experts' Guide to the Experts," *Art News* 77 (1978): 52–57. See also P. Failing, "When a Constable Is Not a Constable," ibid., pp. 90–91, and C. Rhyne, "Lionel Constable's East Berlin Sketchbook," ibid., pp. 92–93.

24. For a brief exploration of the mysteries underlying the activities of the Le Nain brothers, see P. Schneider, "Shows Feed the Mystery of Le Nain," *New York Times*, 27 December 1978. The same preoccupation with the identity of painters leads to an analogous preoccupation with the works of Chardin and, to a certain extent, of Georges de La Tour.

25. As reported by Elmyr in Irving, *Fake*, p. 138. From a more general viewpoint, it is therefore noteworthy that the sociological interest in mulitple scientific inventions is without equivalent in the art world. There are no such things as multiple inventions in the case of impressionism or of baroque music.

26. L. Maitland, "Factory Brings Sculptors' Massive Dreams to Fruition," *New York Times*, 24 December 1976. Further, the evolution of these particular modes of artistic production prevents artists from retaining control over the number of legitimate copies. Indeed, "mobiles" or "stabiles" are easily reproduced without the knowledge of their creators.

27. H. Rosenberg, "Being Outside," *New Yorker*, 22 August 1977, pp. 83–86. Regardless of the artists' race or gender, the success of American painters, musicians and writers has long depended on their acceptance by European elites.

28. R. Blodgett, "Collectors Flock to Folk Art," *New York Times*, 12 September 1976; also see B. Garson, "Portrait of the Artist as an Aging Radical," *New Yorker*, 16 April 1979.

29. For a historical account of the rebellion of American painters against European dominance, see T. Wolfe, "The Painted Word," *Harper's Magazine*, April 1975, pp. 57–92.
30. John Rockwell, "New York as a Big Gamble for Foreign Artists," *New York Times*, 26 November 1976.
31. Kramer, "The Influence of Money on Taste."
32. Reitlinger, *The Economics of Taste*, p. 34.
33. H. and C. White, *Canvases and Careers* (New York; John Wiley and Sons, 1965), pp. 32–33.
34. R. Moulin, "Les intermittences économiques de l'art," *Traverses* 11 (1976): 34–38. Not only does the value of artworks tend to follow curvilinear patterns, but in addition the slope of the patterns changes constantly throughout time. For an illustration of the phenomenon, see H. Kramer, "Bonvin Restored to His Rightful Place," *New York Times*, 29 July 1979.
35. Thompson, "Rubbish Theory."
36. For documentation, see C. Ratcliff, "The Art Establishment," *New York Magazine*, 11 November 1978. Compare the portraits evoked in the article with the notations of J. Russell, "The Arts in the Seventies: New Tastemakers on Stage," *New York Times*, 23 January 1977, or of P. Fromm, "The Cultural Retreat of the Seventies," *New York Times*, 23 July 1978. In fact, the pessimism of certain reviewers about the economic survival of artists may be related to their selective perception. In other words, is there a universal decline in the turnover of galleries, or are there simply more fluctuations in their respective stocks?
37. R. Tyler, "The Artist as Millionaire," *New York Times*, 8 January 1978.
38. See Haskell, *Patrons and Painters*, and N. Pevsner, *Academies of Art: Past and Present* (Cambridge: Cambridge University Press, 1940).
39. For an account of historical and cultural variations on the themes of exhibitions during the late eighteenth and early nineteenth centuries, see E. Gilmore Holt, *The Triumph of Art for the Public* (New York: Doubleday, 1979). The richness of the material presented by the author should enable researchers to determine with greater accuracy systematic regularities in the relative number of one-artist shows, in the number of retrospectives, and in the themes systematically chosen as organizing principles of exhibitions.
40. Ibid.
41. For a description of the role played by commissions in the past, see Haskell, *Patrons and Painters*, p. 187. For an illustration of the ambiguities underlying the role of such commissions in the modern era, see R. McKinzie, *New Deal for Artists* (Princeton: Princeton University Press, 1973).
42. For a general portrait of art dealers, see J. Taylor and B. Brooke, *The Art Dealers* (New York: Charles Scribner's Sons, 1969). For a specific

portrait, see R. Blodgett, "Making the Buyer Beg and Other Tricks of the Art Trade," *New York Times*, 26 October 1975.

43. Glueck, "The Experts' Guide to Experts."

44. See C. Irving, *Fake*. Many of the details offered by Irving are confirmed in G. Bernier, *L'Art et l'argent: Le marché de l'art au XX^ème siècle* (Paris: Robert Laffont, 1977), pp. 246–80. In a humoristic vein, see G. Perec, *Un cabinet d'amateur* (Paris: Balland, 1979).

45. For a theoretical statement about the concept of anomie, see R. Merton, *Social Theory and Social Structure* (New York: Free Press, 1964), chapter 4. For a further elaboration of the term and its adaptation to the modern context, see W. Simon and J. Gagnon, "The Anomie of Affluence," *American Journal of Sociology* 82 (1976):356–76. It remains necessary to determine the role played simultaneously by anomie of scarcity and anomie of affluence in the functioning of contemporary art communities. On the one hand, the proliferation of paradigms may be a reflection of the equivocations generated by affluence and of the ensuing erosion of the markers traditionally used to rank individual works and artists. On the other hand, the increasingly high expectations of so many contemporary artists lead them to experience feelings of deprivation and to suffer from the consequences of anomie of scarcity.

46. Fromm, "The Cultural Retreat of the Seventies."

47. E. Evans Asbury, "Georgia O'Keeffe Is Involved in Two Suits Linked to Agent Fees on Her Paintings," *New York Times*, 28 September 1978.

48. G. Glueck, "For Artists: A Way to Stop Ripoffs," *New York Times*, 3 August 1977.

49. The increasing number of articles on the issue reveals the malaise experienced by artists in this regard. See W. Bates, "Royalties for Artists: California Becomes the Testing Ground," *New York Times*, 14 August 1977; see also R. Bongart, "Writers, Composers and Actors Collect Royalties: Why Not Artists?" *New York Times*, 2 February 1975. See also E. Jong's untitled piece about the withdrawal of some sculptors from a Whitney Museum exhibition because of disagreements over the conditions of the exhibition in Op.–Ed., *New York Times*, 29 April 1976.

50. H. Rosenberg, "Death and the Artist," *New Yorker*, March 24, 1976, 69–75.

51. "The Talk of the Town," *New Yorker*, 22 November 1976, p. 35.

52. For a discussion of the changes in the boundaries between public and private worlds in this regard, see R. Sennett, *The Fall of Public Man* (New York: Vintage Books, 1977). For a specific illustration, see F. Lewis, "An Outraged Artist Battles with Renault," *New York Times*, 6 May 1977, concerning Dubuffet's suit against the French auto company, whose director demolished the artist's work after Dubuffet had been paid. See also D. and S. Toumin, "Harris Bank Facelift Raises Legal

Questions," *New Art Examiner* 9 (October 1981) regarding the rights that a painter retains over his or her work.

53. J. Clair, "Le rite et le reste: Une petite introduction aux réserves des musées," *Traverses* 10 (1978): 100–116.

54. For a full documentation, see V. Zolberg, "The Art Institute of Chicago" (Ph.D. diss., University of Chicago, 1974). See also Zolberg, "Conflicting Visions in American Art Museums," *Theory and Society* 10 (1981): 103–25.

55. D. Poulot, "Le reste dans les musées," *Traverses* 10 (1978): 92–99, emphasis added.

56. G. Glueck, "Artists Protest Restorations at the Met," *New York Times*, 18 February 1976. See also Glueck, "The Great Conservation Debate," *Portfolio* 2 (1980): 44–51. Finally for contrasts between the terms *restorer* and *conservator*, see P. McCormick, "Modern Paintings Tax Conservators," *New York Times*, 28 August 1982.

57. As quoted by G. Pelles in *Art, Artists and Society*, op. cit., 33.

58. R. Semple, "Tate Gallery Buys Pile of Brick or Is It Art?" *New York Times*, 20 February 1976.

59. Zolberg, "The Art Institute of Chicago," pp. 130–39.

60. G. Glueck, "Impressionist Epoch at Met Sets Records for Attendance: More Blockbustings in the Offing," *New York Times*, 23 July 1976. See also Glueck, "The Met Succumbs to a Box Office Mentality," *New York Times*, 2 March 1975, and Glueck, "Museums Are Manipulating Their Public," *New York Times*, 6 July 1975. In contrast, see J. Leonard, "Private Lives," *New York Times*, 20 December 1978, in which he criticizes museums for being insensitive to the needs and aspirations of some visitors, notably children.

61. L. Huxtable, "Two Museums," *New York Times*, 18 June 1978. See also H. Kramer, "Ideology Versus Quality as the Collecting Criterion," *New York Times*, 10 July 1977. For a more theoretical analysis of the dilemmas confronting museums, see C. Grana, "The Private Lives of Public Museums," in *Fact and Symbol* (New York: Oxford University Press, 1971); S. Lee, *On Understanding Art Museums* (Englewood Cliffs: Prentice-Hall, 1977); and B. O'Dohorty, *Museums in Crisis* (New York: Braziller, 1972).

62. P. DiMaggio and M. Useem, "Social Class and Art Consumption," *Theory and Society* 5 (1978): 141–61.

63. P. Bourdieu and A. Darbel, *L'amour de l'art* (Paris: Editions de Minuit, 1966). Further data are also available in P. Bourdieu and J. C. Passeron, *Les héritiers: les étudiants et la culture* (Paris: Editions de Minuit, 1964). Bourdieu has also published the sum of his systematic observations on the topic in *La distinction* (Paris: Editions de Minuit, 1979).

64. For an elaboration of Picasso's views on the topic, see A. Malraux, "As

Picasso Said, Why Assume That to Look Is to See?" *New York Times Sunday Magazine,* November 2, 1975.

65. See R. Frances and H. Vuillaume, "Une composante du judgement pictorial: La fidèlité de la reproduction pictoriale," *Psychologie Française* 9 (1964):241–47. See also A. Alland, *The Artistic Animal* (Garden City: Anchor Press, 1977), pp. 46–48.

66. B. Bernstein, "Class and Pedagogies: Visible and Invisible," in *Power and Ideology in Education,* ed. J. Karabel and A. Halsey (New York: Oxford University Press, 1977), pp. 511–34.

67. Thus, the notion of "cultural reproduction," elaborated by Bourdieu and his students, may be limited by its apparent blindness to historical factors. Indeed, the conservatism of established elites may be more subtle than the expression would induce us to believe, and such elites may be prone to change the symbols that mark their preeminence either in order to maintain their supremacy or in response to the pressures of a changing environment.

68. W. Moore, "Predicting Discontinuities in Social Change," *American Sociological Review* 29 (1964):331–38.

69. For a more systematic treatment, see Sennett, *The Fall of Public Man,* p. 198.

70. P. Davis, "When Composers Perform Their Own Music," *New York Times,* 16 May 1976. Stravinski differs in this regard from Schönberg, who rarely gave public performances of his work and left a limited number of recordings of his work.

71. Sennett, *The Fall of Public Man,* p. 199.

72. J. Attali, *Bruits* (Paris: Presses Universitaires de France, 1977), p. 225. See also H. Schonberg, "Defining Music Is Not as Easy as You Think," *New York Times,* 23 January 1977, and D. Henahan, "How Time Alters Our View of Music," *New York Times,* 1 August 1982.

73. This reluctance, which was not universal, can be accounted for in terms of two factors. First, it persisted as long as the production of the instrument was not rationalized and as long as there were correspondingly many forms of flutes. Second, the instrument tended to have a low status as long as its possession was not costly and was shared by various social groups. In short, the status of the flute rose as soon as it became more clearly differentiated from the recorder. For a more systematic treatment of the flute's status, see P. Bate, *The Flute: A Study of Its History, Development and Construction* (New York: Norton, 1969), notably chapter 9.

74. H. Schonberg, "The Latest Fashion in Musical Instruments," *New York Times,* 6 February 1977.

75. Again, this shows the significance of scarcity as a determinant of the distinction between durable and other art forms. Indeed, many of these transcriptions are interpreted as seeking to facilitate the proper

understanding of the corresponding scores by a larger number of listeners.

76. H. Schonberg, "How Did They Sing *Puritani* in 1835?" *New York Times*, 22 February 1975.
77. M. Winn, "Zubin Comes to Town," *New York Times Sunday Magazine*, 19 November 1978.
78. See H. Epstein, "Accompanists of the World, Take a Bow," *New York Times*, 2 March 1975.
79. For a full treatment, see R. Caillois, *Man and the Sacred* (New York: The Free Press, 1959), pp. 99–127.
80. Attali, *Bruits*, pp. 33, 35, 97.
81. For a general review of these issues, see W. Baumol and W. Bowen, *Performing Arts: The Economic Dilemma* (Cambridge: MIT Press, 1968).
82. For illustrations of musical "conservatism" in this regard, see M. Salem, *Organizational Survival in the Performing Arts: The Making of the Seattle Opera* (New York: Praeger, 1976); K. Mueller, *Twenty-Seven Major American Symphonic Orchestras: A History and Analysis of Their Repertoires; Seasons 1842–43 through 1969–70* (Bloomington: Indiana University Press, 1973); and R. Martorella, "The Performing Artist as a Member of an Organization" (Ph.D. diss., New School for Social Research, 1974).
83. R. Ericson, "Two Conductors Plan Off-Beat Events," *New York Times*, 8 January 1978.
84. See W. Mayer, "Live Composers, Dead Audiences," *New York Times Sunday Magazine*, 2 February 1975.
85. V. Zolberg, "Why Contemporary Displayed Art is Innovative When Performing Music is Not" (Paper delivered at the Annual Meeting of the South Sociological Association, Atlanta, 1978).
86. Once more, the importance of the distinction between public and private spheres is clear in this regard. My hunch is that, for the same reason, watching television was initially an unequivocal marker of high status. While the upper classes were able to watch it in the privacy of their homes, the lower classes had to watch it in public places. In the same vein, the status of a photograph depended initially on the public or private nature of the studio in which it was taken.
87. The underlying process is, of course, rather complex. In the case of operas, for instance, the prestige accorded early on to the performances of the Glyndebourne Festival was conducive to the recordings of the major pieces placed on the festival program. As the records were played by prestigious radio stations, their prestige rose further. With an increase in such a prestige, the decision was taken to reproduce them.
88. For a discussion of this point, see J. Rockwell, "Why Do They Still

Give Debut Recitals?" *New York Times*, 27 May 1979; H. Philipps, "How Recordings Can Create Careers," *New York Times*, 24 April 1977; and G. Gould, "In Praise of Maestro Stokowski," *New York Times Sunday Magazine*, May 14, 1978.

89. P. Hirsch, "Processing Fads and Fashions: An Organization Set Analysis of Cultural Industry Systems," *American Journal of Sociology* 77 (1972):639–59.

90. R. Peterson and D. Berger, "Cycles in Symbol Production in the Case of Popular Music," *American Sociological Review* 40 (1975):158–73. For a parallel argument with regard to the publishing industry, see A. Burgess, "Here is How to Be Your Very Own Best Seller," *New York Times*, 18 November 1979.

91. B. Mikol, "The Enjoyment of New Musical Systems," *The Open and Closed Mind*, ed. M. Rokeach (New York: Basic Books, 1960), pp. 270–88.

92. P. DiMaggio and M. Useem, "Social Class and Art Consumption."

93. Bourdieu and Passeron, *Les héritiers*.

94. A. Hennion and J. P. Vignolles, "Artisans et industriels du disque (Paris: CEDES/CORDES, mimeographed, 1978).

95. For a portrait of the current champions of high literary arts, see C. Lasch, *The Culture of Narcissism* (New York: Norton, 1979), chapters 2, 3, and 4.

96. See G. Bollème, *La bible bleue* (Paris: Flammarion, 1975); R. Mandrou, *De la culture populaire au XVIIème et XVIIIème siècles* (Paris: Stock, 1964).

97. M. Soriano, *Les contes de Perrault: Culture savante et traditions populaires* (Paris: Gallimard, 1968).

98. In *Sociology of Literary Taste* (London: Kegan Paul, Trench, Trutner and Co., 1944), L. Schücking suggests how novels initially were intended to be published as serials in selected magazines and journals.

99. See L. James, *Print and the People: 1819–1851* (London: Allen Jane, 1976), p. 17.

100. See D. Lacy, "The Economics of Publishing," in *The Sociology of Art and Literature*, ed. M. Albrecht, J. Barnett, and M. Griff (New York: Praeger, 1970), pp. 407–27. For both a quantitative and qualitative analysis of the same phenomenon, see "Les livres de poche," *Les Temps Modernes* 227 (April 1965).

101. In this sense, there is a parallel between art galleries and bookstores. Thus, Blodgett's arguments about galleries in "Making the Buyer Beg" also apply to the bookstore scene.

102. I am extending here the argument that Sennett developed in general terms about the distinction between public and private spheres of interaction. See *The Fall of Public Man*. In other words, I am emphasizing the excluding properties of the word *private*.

103. For an elaboration, see R. Hughes, *The Shock of the New* (New York: Alfred A. Knopf, 1981), p. 341.
104. H. Gans, *Popular Culture and High Culture* (New York: Basic Books, 1975). See also Alland, *The Artistic Animal*, chapter 7.
105. Once more I am therefore stressing the importance of the past as a legitimating force and criticizing a particular brand of sociology for its blindness to history's contribution to the making of ideology.
106. E. Zerubavel, *Hidden Rhythms* (Chicago: University of Chicago Press, 1981).
107. See M. Thompson, *Rubbish Theory* (Oxford: Oxford University Press, 1979), chapter 8.

Notes for Chapter 6: Artistic Revolutions as Dramatic Social Problems

1. For a philosophical view of obscenity, see J.-T. Desanti, "L'obscène ou les malices du signifiant," *Traverses* 29 (1983): 128–34.
2. The destruction of high art forms has various origins. It results from aesthetic conflicts, but may also reflect political motives. Recent victims include Michelangelo's Pietà, the Night Watch of Rembrandt, and the Palace of Versailles.
3. In viewing social problems as dramas between the solutions that competing groups would like to impose on the ambiguities of social life, I am borrowing concepts from K. Burke, *A Grammar of Motives* (New York: Prentice-Hall, 1945), and from D. Brissett and C. Edgley, eds., *Life as Theater: A Dramaturgical Sourcebook* (Chicago: Aldine, 1974).
4. This approach is most characteristic of "functionalist" writers for whom the highly negative feelings that certain behaviors stir on the part of most individuals or groups render obvious their properties as deviances. Their assumption makes it then unnecessary to distinguish the realities of the behaviors that have been performed (and later criticized) from the realities of the judgments passed about them. The combined product of these two types of realities is then treated as a universal and ahistorical given whose existence must be explained. For an illustration of this position, see R. Merton and R. Nisbet, eds., *Social Problems: A Contemporary Approach* (New York: Harcourt Brace Jovanovich, 1971). However, it should be noted that functionalist writers and, for that matter, most social scientists pay little attention to the social problems generated by pornography. Their official liberalism induces them to treat the corresponding class of social phenomena as

nonreal and to forget conveniently that both in a literal and a figurative sense, such phenomena may be real for significant segments of society, today and yesterday.

5. For an illustration of the "objective" studies conducted on the effects of pornography, see L. Gould, "Pornography for Women?," *New York Times Magazine*, 2 March 1975. For a more general treatment, see A. Kaplan, "Obscenity as an Esthetic Category," *Law and Contemporary Problems* 20 (1955):587–607, and W. Lockart and R. McClure, "Obscenity in the Courts," ibid., pp. 544–79.

6. The variability of the behaviors adopted by Nazi officials in this respect offers an excellent field of study.

7. For a summary of this literature and an analysis of the number of stages identified by various sociologists, see M. Spector and J. Kitsuse, *Constructing Social Problems* (Menlo Park, Ca.: Cummings, 1977), chapter 7.

8. This set of concepts is borrowed from R. LeVine, *Culture, Personality and Behavior* (Chicago: Aldine, 1973), pp. 137–69. This distinction has both substantive and methodological consequences. Substantively, it is relative to the perennial debate about the relations between essence and existence. Methodologically, it seeks to remind us that social scientists can only derive the abstract properties of a social phenomenon from their analysis of the spatially and temporally discrete examples of such a phenomenon.

9. The very fact that Spector and Kitsuse implicitly hold the characteristics or suspects as "constants" in their model is quite revealing of the lack of power they impute to this type of actor. The point is that such an assumption may be more revealing of their own political biases than of external reality. Most important, their assumption exaggerates similarities in the formal properties of the social problems generated by complaints issued by claimants with differing social positions. Yet there are necessarily differences in the possible scenarios underlying the natural histories of claims emanating, for example, from black and white parents against school authorities. This is not only because of differences in the "absolute" status of these two ethnic groups but also because of contrasts in the power they hold in relation to that exerted by the school authorities. Even though "deviants do not differ from non-deviants except that they are members of classes or groups that serve best the interests of other groups by being incarcerated, labeled or stigmatized" (see W. Chambliss, *Problems of Industrial Society* [Boston: Addison Wesley, 1973], p. 5), correlations between charges of deviance and existing patterns of social stratification are problematic and depend inter alia on the conception that various social groups have of the state and its adjudicating functions. In its blindness to this problem, American sociology is more often a reflection of than on current American social arrangements. For an implicit counterexample of

this weakness, see L. Zurcher and R. Kirkpatrick, *Citizens for Decency* (Austin: University of Texas Press, 1976).

10. The fact that the explanatory power of triads is greater than that of dyads has been suggested by M. Freilich, "The Natural Triad in Kinship and Complex Systems," *American Sociological Review* 29 (1964): 529–40, and T. Caplow, *Two Against One: Coalitions in Triads* (Englewood Cliffs: Prentice-Hall, 1968).

11. In contrast to Spector and Kitsuse, who, at least implicitly emphasize the role played by sheer numbers in the careers of any social problems, it is clear that some actors count significantly more than others in the relevant processes. For a discussion of this point, see V. Kavolis, *Comparative Perspectives on Social Problems* (Boston: Little, Brown, 1969).

12. All the metaphors to which I have alluded share the same fallacy of misplaced concreteness insofar as they treat the notion of natural history as real when, in fact, the concept is social, since it has itself a history that corresponds to several competing world views, supported by individuals or groups who vie with one another to impose their own policies.

13. For a more systematic treatment of this theme, see M. Peckham, *Art and Pornography* (New York: Basic Books, 1969). A similar viewpoint is taken by A. Touraine in *La société invisible, Régards 1974–76* (Paris: Le Seuil, 1977), who argues that "pornography is the exploitation of organized resistance to change" (p. 82) and reviews all the equivocations attached to concepts such as exploitation and change. While these equivocations render an objective definition of pornography impossible, it is noteworthy that the term is used to exaggerate the shortcomings of the positions held by the speaker's opponent. In the cinema, for example, Bertolucci argues that taboos exist to be broken and that pornography consists not of showing a universe of eroticism but rather of showing a false image or failing to give a genuine emotion to the audience. In so doing, he provides us with an illustration of why obscenity may be defined in terms of the confusion developed between simulation and stimulation. See *New York Times*, 4 October 1979. In the political realm, it should be remembered that Henry Kissinger, former secretary of state, described William Shawcross's charges regarding his policies in Cambodia as obscene.

14. For a general treatment, see L. Strauss, *Persecution and the Art of Writing* (Glencoe: The Free Press, 1952). For a more contemporary approach, and for an analysis of social reactions provoked by pornography in the traditional sense of the word (for example, by *Hustler* or *Deep Throat*), see R. Neville, "Has the First Amendment Met Its Match?," *New York Times Magazine*, 6 March 1977, and T. Morgan, "United States Against the Princes of Porn," ibid. See also W. Goodman, "What Is a Civil Libertarian to Do When Pornography Becomes So Bold," *New York Times*, 21 November 1976. For the same debate as it

pertains to political obscenities, see A. Cohen, "In the Matter of *Mein Kampf*," *New York Times*, 4 October 1979. Finally, in the musical world, see E. Rothstein, "Musical Freedom and Why Dictators Fear It," *New York Times*, 23 August 1981.

15. For a general description of the specific controversies generated by the publication of *Madame Bovary*, see R. Dumesnil, *La publication de "Madame Bovary"* (Amiens: Malfere, 1928), and A. Thierry, *Le procès de "Madame Bovary"* (Amiens: Annales du Centre Régional de l'Académie d'Amiens, 1966).

16. For an account of the battle waged by British authorities against D. H. Lawrence, see A. Craig, *Banned Books of England and Other Countries* (London: Allen and Unwin, 1962). In this particular case, it is important to note that, whereas some sections of British society believed that Lawrence's writings produced pornography and its social problems, the author himself believed the same social problem to be generated by the puritanism of his opponents. For a development of the author's views on the problem, see his *A Propos Lady Chatterley* (London: Mandrake Press, 1930), and *Sex, Literature and Censorship* (New York: Twayne Publications, 1953).

17. For a discussion of the relativity of the boundaries between internal and external as it applies to the scientific scene, see T. Kuhn, *The Essential Tension* (Chicago: University of Chicago Press, 1979), pp. 125–32. As already noted, this distinction and the problems that accompany it can be applied to the various art worlds as well.

18. The fact that the film won the Oscar caused the daily box office grosses to jump $100,000 a day in the New York area alone but stirred up a strong protest on the part of Vietnam Veterans Against the War and the "Hell No We Won't Go Away" Committee, organizations that saw in the film a racist slandering of the goals pursued by the Vietnamese people. See *New York Times*, 26 April 1979. In more general terms, what is at stake in the controversies generated by artistic statements is not the manipulation of events or characters per se but rather the intent imputed to the manipulation.

19. T. Pipolo, "German Filmmakers Seldom Focus on the Legacy of Nazism," *New York Times*, 1 August 1982.

20. Despite the theoretical statements of authors such as M. Peckham, *Art and Pornography*, M. Ernst, *In Search of the Obscene* (New York: Macmillan, 1964), and H. Clor, *Obscenity and Public Morality* (Chicago: University of Chicago Press, 1969), it is clear that the behaviors and beliefs that can be labeled obscene or pornographic are culturally and historically relative. Given the admiration of many sociologists for the dictum of W. I. Thomas that "a situation is real when people see it as such," it is surprising to observe that there is a dearth of studies identifying the particular conditions under which significant classes or numbers of individuals become convinced not only that a particular

statement fits the label of obscene but also that something should be done about it.

21. For a description of the determinants and consequences of this particular incident, see M. De Certeau, *La possession de Loudun* (Paris: Julliard, 1970).

22. This point is derived from Roland Barthes, *Le degré zéro de l'écriture* (Paris: Gonthier, 1970).

23. See H. Rolph, *The Trial of Lady Chatterley* (London: Penguin, 1961).

24. See E. Panofsky, *Studies in Iconology* (New York: Oxford University Press, 1959), pp. 150–51.

25. I am extending here the use that L. Goldmann has made of the distinction between value of use and value of exchange in his analysis of novels. See his *Toward a Sociology of the Novel* (London: Tavistock, 1975). The extension of this distinction requires the analysis to specify how various participants in the art scene interpret not only the symbolism of nudity but also the gender of the sitters, their number, the focusing of the artists on the whole figure or on a variety of details, the background against which this nudity is depicted, the status imputed to the sitter, to the painter and to their interaction, etc. For a historical analysis of the evolution of the symbolic properties of the nude, see K. Clark, *The Nude: A Study of Ideal Forms* (New York: Doubleday, 1956). For a witty description of the blurring of the distinction between value of use and value of exchange at the expense of the former during the Victorian era, see J. Maas, "Victorian Nudes," in *The Saturday Book*, ed. J. Hadfield (New York: Clarkson Potter, 1971), pp. 183–200.

26. See R. Wilson, *Man Made Plain* (Cleveland: Howard Allen, 1958). The point is that controversies about a writer's poetical and political merits can take place only during times of high political uncertainty and hence just before or after events such as wars or revolutions that divide both intellectual communities and the society at large.

27. For more details, see J. Attali, *Bruits* (Paris: Presses Universitaires de France, 1977), and A. Hennion and J. P. Vignolles, "La production musicale: Les politiques des firmes discographiques (Paris: Centre de Sociologie des Innovations, mimeographed, 1975).

28. For details on the variety of taboos confronting women artists, see N. Pevsner, *Academies of Art: Past and Present* (Cambridge: Cambridge University Press, 1940), and A. Harris-Sutherland and L. Nochlin, *Women Artists: 1550–1950* (New York: Knopf, 1976).

29. See R. Sennett, *The Fall of Public Man* (New York: Vintage Books, 1978), chapter 4.

30. Sennett, ibid.

31. For details see Pevsner, *Academies of Art*; see also Maas, "Victorian Nudes," who suggests how William Etty found his models in the Life School, among members of the foreign colony in Soho, among shop

assistants needing pin money and occasional "paragons." In the United States, see N. Harris, *The Artist in American Society: The Formative Years* (New York: Clarion Books, 1970), pp. 227–28, and W. Gerdts, *The Great American Nude: A Study in the History of Arts* (New York: Praeger, 1974).

32. See Gerdts, *The Great American Nude*. At the same time that the production of nudes in painting was creating such serious social problems, some female American sculptors were allowed to use paintings of nudes in order to enhance the realism of their art.

33. For a general discussion of the relations between artists and politicians, see W. Goodman, "The Artist and the Politician: Natural Antagonists," *New York Times*, 24 April 1977. See also Clor, *Obscenity and Public Morality*, chapter 7.

34. While the risks encountered by both dissident artists and patrons are high not only in financial but also in political terms, some artists and patrons do not hesitate to use the weapon of humor against the imperialism of bureaucrats. For example, V. Komar and A. Melamid have twisted Louis XIV's rallying cry, "L'état, c'est moi," to celebrate the independence and autonomy of the personality from the infringement of the powers of darkness. See G. Glueck, "Dissidence as a Way of Art," *New York Times Magazine*, 8 May 1977.

35. In all of these instances, it is not certain whether the intentions of the mighty are ideological or whether they aim more simply to neutralize potential sources of opposition.

36. D. Henahan, "How Time Alters Our Views of Music," *New York Times*, 1 August 1982.

37. For an elaboration of this debate, see W. Goodman, "Should We Subsidize Popular Art?" *New York Times*, 9 February 1975. In a debate organized by the author, the conservative philosopher Van Den Haag argued that it is impossible to prove that Mozart is a greater musician than Irving Berlin and hence that the financing of artistic enterprises is necessarily an arbitrary political decision. In contrast, the more liberal sociologist Herbert Gans argued that the role of public authorities should be to reduce the gaps existing between noble and popular arts. The problem, however, remains to determine whether the support of public authorities should be focused on the production or the consumption of the arts. Does democratization of cultural life mean an acceleration of the diffusion of "high art" across the various segments of society or does it mean that the state should subsidize those artists condemned to remain marginal because of insufficient material means?

38. As quoted by P. Legendre, *La passion d'être un autre* (Paris: Le Seuil, 1978), p. 116.

39. See H. Hann, *The Rape of La Belle* (Kansas City: Glenn Publisher, 1946), p. 3.

40. For a description of the efforts undertaken by the company, see T. To-

bia, "Drag Ballet: Can Men Make It in a Women's World?" *New York Times*, 2 March 1975, and C. Lawson, "Trockadero Catches On: Martins Isn't Deserting (for now)," *New York Times*, 12 December 1976. As noted by R. Caillois in *Méduse et compagnie* (Paris: Gallimard, 1960), male and female forms of transvestism do not evoke similar reactions on the part of audiences. It is interesting to note that simultaneous to the efforts of the Trockadero Ballet, there has been a revival of Rameau's opera *Platée*, which uses a male actor to impersonate a female character. The infrequency with which that opera had been performed is probably related to the lack of appropriate male singers. But this lack itself may be the result of formal and informal sanctions against artistic transgressions of the "legitimate" boundaries between the two genders.

41. At the time of the trial, the office of the prosecutor therefore refused to accept the copy of the book sent by the publisher and made a point of purchasing another copy in a bookstore in Charing Cross. Once more, this example illustrates the symbolic meaning attached to places as a determinant of the status to be assigned to a work of art.

42. These fears were particularly developed by conservative reviewers, notably in *John Bull* or the *Sunday Chronicle*.

43. Henahan, "How Time Alters Our Views of Music."

44. See "The Pornography Debate Goes on," *New York Times*, 12 December 1976.

45. See *Madame Bovary*, edition de E. Maynial (Paris: Garnier, 1961), p. 344.

46. See Rolph, *The Trial of Lady Chatterley*, p. 214.

47. As quoted by Ernst, *In Search of the Obscene*, p. 132. To be sure, the remark was probably made tongue-in-cheek, but, as usual, humor may tell us more than we would like to see.

48. See Neville, "Has the First Amendment Met Its Match?"

49. For example, charges of obscenity were brought against the British publishing house Boriswood for having facilitated the diffusion of the scientifically oriented *The Sex Impulse* in 1934. The same charges of immorality were brought in the United States against Margaret Sanger and such journals as *Marriage Hygiene*. In all cases, the "suspects" were accused of harboring leftist or revolutionary feelings. It remains necessary, however, to examine how changes in patterns of social stratification in the society at large are associated with changes in the definition of the social groups deemed to be easily misled by "questionable" artistic or scientific statements.

50. See J. Bécourt, *Livres condamnés, livres interdits* (Paris: Cercle de la Librairie, 1972).

51. See Gerdts, *The Great American Nude*.

52. For a theoretical statement of feminists views on pornography, see A. Carter, *The Sadeian Woman* (New York: Pantheon Books, 1979), who

argues that at both a macro- and a microlevel, pornography perpetuates the oppression of women. This stance has induced women such as Gloria Steinem to refrain from supporting the defense fund of Larry Flynt, the publisher of *Hustler*.

53. For the first example, see L. Cavani, "Entretiens avec Claire Clouzot," *Ecran* 25 (1974). For the second, see M. Brilliant, "Playing of Wagner in Israel Provokes Disturbances," *New York Times*, 17 October 1981.

54. The ambiguities of the consequences resulting from the coexistence of various stages of capitalistic development have been analyzed by H. Marcuse in *The One Dimensional Man* (Boston: Beacon Press, 1964).

55. This section is derived from R. Cobb, J. Ross, and M. Ross, "Agenda Building as a Comparative Political Process," *American Political Science Review* 52 (1976): 126–38.

56. Once more, however, we should emphasize the importance of distinguishing between the numbers and the classes of the people involved in the process. In certain political contexts, pure numbers are a sufficient source of pressure; in others, the outcome of initial claims depends more on the responses it elicits on the part of crucial actors, regardless of their numbers.

57. See Craig, *Banned Books of England and Other Countries*, pp. 95–97.

58. Indeed, decentralization enables many local communities to be more restrictive than central authorities. For an illustration of how communities may develop appropriate strategies in this regard, see H. Hummings, *Film Censors and the Law* (London: Allen and Unwin, 1967), p. 385.

59. See J. Bécourt, *Livres condamnés, livres interdits*.

60. Legislation regulating the activities of printers caused the printer of *Madame Bovary* to be a codefendant of Flaubert's.

61. Of course, it should be noted that, whereas the government controls more efficiently the outcome of the legal actions it presents to the Tribunaux Correctionnels, the penalties it might extract from such courts are more limited than those handed out by the Cours d'Assises.

62. See Morgan, "United States Against the Princes of Porn."

63. For a theoretical statement about the determinants and consequences of the relationships between the various layers constituting a political space, see A. Etzioni, *The Active Society* (New York: The Free Press, 1968).

64. See Dumesnil, *La publication de "Madame Bovary."*

65. Hence, the difficulty of defining in universal terms the substance of any social problem. In the first two instances, "substantive" issues are likely to be masked by unavoidable and more basic conflicts concerning the legitimacy of the extent of the social control exerted by public authorities.

66. The distinction between sin, crime, error, and competition is derived

from J. Pitts, "Personality and the Social System," in *Theories of Society*, ed. T. Parsons et al. (Glencoe: The Free Press, 1954), pp. 701–2.

67. For a description of such rituals, see De Certeau *La possession de Loudun*.

68. For a more complete documentation of the differential treatment to which "high" and "low" literary works were subjected at the time, see G. Bollème, *La bible bleue* (Paris: Flammarion, 1975), pp. 1–15. For a more pointed description of the ribaldry of such books and various forms of folk art, see G. Legman, *The Hornbook: Studies in Erotic Folklore* (New York: New York University Press, 1964).

69. See E. de Grazia, *Censorship Landmarks*: "Raymond Halsey, Respondent, Versus The New York Society for the Suppression of Vice" (New York: Bowker, 1969), pp. 71–74.

70. It is appropriate at this point to distinguish among (a) *strategies* that correspond to the intentions of the actors involved, (b) *actions* that represent the behavioral traces of these intentions, and (c) their respective *effects* as they are reconstructed by observers. Once more, such distinctions remind social scientists of the need to pay attention to the various temporal frameworks underlying the analysis of social scenes.

71. As already noted by Aristotle, dramatization consists in successfully stressing the unity of space, time, and action inherent in the confrontation of two opposite conceptions of the world.

72. See R. Cobb and M. Ross, "Limiting the Political Agenda: Some Hypotheses About Strategies Used to Prevent Consideration of New Issues," unpublished manuscript.

73. See *Madame Bovary*, edition E. Maynial. It was also forbidden to write a public review of a book subjected to public prosecution before the disposition of the case, another indication of the dominance of inside initiatives in the institutional mechanisms of agenda building used by centralized and authoritarian governments. Thus, the power of such initiatives is deemed to vary as a reverse function of their publicity.

74. The case of Lawrence is particularly interesting insofar as it illustrates the difficulties of identifying the boundaries of a controversy. These difficulties are twofold. As the conflict generated by *Lady Chatterley* was a by-product of earlier tensions between the aesthetics or the ethics of Lawrence and his opponents, it is difficult to determine which particular book or which author constituted a potential social problem. Furthermore, it is equally difficult to determine whether the social problems generated by the "obscenity" of Lawrence and the puritanism of his accusers are the opposite sides of the same social problem.

75. See *A Propos Lady Chatterley*, pp. 15–26.

76. See Morgan, "United States Against the Princes of Porn."

77. Ibid.

78. In 1978 the Supreme Court reversed a decision convicting a California resident of mailing obscene materials on the ground that the judge had unduly instructed the jury to consider "young and old, men, women and children" in deciding what was offensive by community standards. See *New York Times*, 24 May 1978. Such a decision, which emphasized the holistic character of the concept of community and challenged the judge's reference to children, was important on three counts. It sidestepped the issue of determining whether overall reactions to a questionable statement reflect adequately community standards. The underlying problem was to identify the relationships between the statistical distribution of a social response behavior and its social definition as a deviance. In addition the decision rendered the notion of community more problematic, as it stressed its situational components. Indeed, to relate the concept of community to the circulation of materials through the mail is to eliminate partially if not totally the problems raised by the exposure of children to questionable statements. Last, such a decision also sidestepped the question of determining how children are legal participants in a community.

79. For an evaluation of the status of the witnesses produced, see Rolph, *The Trial of Lady Chatterley*. In general terms, it becomes important to determine the conditions under which asymmetries in the use and the characteristics of witnesses used by claimants and suspects dramatize or dedramatize the issue. While the prosecutors of *Madame Bovary* and *Lady Chatterley* did not produce counterwitnesses, the behaviors of these prosecutors have different legal meanings. In the first case, the prosecution based its decision on the Roman principle "Reus excipiendo fit actor," and more specifically on the notion that the burden of the proof moved from the prosecutor to Flaubert and his codefendants. In the second case, the prosecution seemed to be testing the limits of the new Obscenity Act, which had just been promulgated in order to introduce some coherence in the administration of justice. The case of *Lady Chatterley* was brought to the attention of authorities when a judge admitted the book as evidence in a previous obscenity case. In other words, the prosecution of *Lady Chatterley* in 1961 was primarily dictated by external considerations, and in this sense, it had a low level of dramatic appeal.

80. Hann, *The Rape of La Belle*, p. 5.

81. The first actress made some statements about the injustices of the Vietnam war; the second, about the injustices of the Israeli position toward the Palestinians. In both cases, however, the timing of their public statements—at the Academy Awards ceremony—heightened the dramatic appeal of the issues.

82. The prosecution of Baudelaire (and, for that matter, other authors) directly after Flaubert's acquittal, shows the significance of the model sketched by Cobb, Ross, and Ross to which I alluded in note 72. In-

deed, a prosecutor's track record determines at least in part the legitimacy of his or her stance. Thus, after having lost a case, a prosecutor may dedramatize the underlying substantive issue of the next case to be adjudicated and either cease to prosecute, merely prosecute pro forma, or negotiate informal compromises with potential suspects. Alternatively, a prosecutor may seek to force the issue in the adjudication of the next cases to be examined in order to reassert the failing legitimacy of his or her concerns.

83. In their most extreme forms, these two positions illustrate the opposite fallacies to which sociology is exposed. In the first case, the abstract nature of the historical scene exonerates all individual actors from any responsibility and justifies the corresponding status quo. In the second case, the arbitrary emphasis placed on any pattern of socialization unduly eliminates a sense of history and the responsibilities that individuals face with regard to the transmission of their "estate," regardless of whether this estate is defined in economic or cultural terms. Hence, the importance of adopting a dialectical method. For a further discussion of this problem, see Sennett, *The Fall of Public Man*. See also N. Di-Tomaso, "Sociological Reductionism from Persons to Althusser: Linking Action and Structure in Social Theory," *American Sociological Review* 47 (1982): 14–45.

84. To be sure, the "linear" rewriting of history differs between the sciences and the arts. In the case of science, current practices constitute a fixed pole around which past theories and procedures are articulated. In the case of the arts, boundaries between competing styles are made more clear-cut than they were during the struggle.

85. See Judy Klemesrud, "Gunny Sacks to Book Racks; Texas Photographer Odyssey," *New York Times*, 10 August 1979. C. Collum's plan to photograph nude New Yorkers, including a few celebrities (such as Andy Warhol, Reggie Jackson, and Beverly Sills) constitutes another indication of the erosion of the boundaries between public and private domains at the expense of the latter.

86. See E. Mörke, "Nudity is Natural for the Royal Danish Ballet," *New York Times*, 16 May 1976. For a justification of the use of nudity in dance, see C. Barnes, "Oh Copenhagen," *New York Times*, 7 March 1976. The fact that there was no matinee representation of nude ballets reminds us, first, that pornography and art are differentially located during the hours of the day (the former has a long-established tradition as the province of idle afternoons of dirty old men), and second, that the composition of ballet audiences during evening performances is more homogeneous.

87. Thus, it remains necessary to write a history of sexual politics and to show how the revivals of sexual behavior as a social problem correspond to changes in existing patterns of social stratification. Changes in the particular sexual behaviors that are deemed to be controversial

should be paralleled by changes in the distribution of political and cultural powers. Thus, it could be interesting to trace in recent times the factors that have induced various women to write erotica while their peers denounced the enterprise as sexist. In the same vein, it could be interesting to examine how certain male authors continue to see the violation of sexual taboos as a liberation from political oppression, whereas others denounce the political evils resulting from the same phenomenon. See, for example, W. Reich, *The Functions of the Orgasm: Sex Economic Problems of Biological Energy* (New York: Farrar, Straus and Giroux, 1973), H. Lefebvre, *Sociologie de la vie quotidienne* (Paris: Gallimard, 1967), and Marcuse, *The One Dimensional Man*.

88. This section is inspired by Thompson, *Rubbish Theory*, chapter 8.

89. This suggests that the effects of division of labor are not cumulative. Although the segmentation of social groups and of their consciousnesses may foster inter- and intrapersonal conflicts, it may also accelerate shifts in alliances and prevent political participation.

90. Thus, Trotski's argument that "The arts require some support," in *Littérature et révolution* (Paris: Julliard, 1964), p. 22, is insufficient. Indeed, the results of this support depend on the pre-existing informal rank-ordering of artistic disciplines and artists. For a concrete illustration of the dilemma, see J. Friedman, "A Shift in the Federal Support of Popular Culture," *New York Times*, 13 May 1979, and, more important, the debate between E. Van der Haag and H. Gans, "Should We Subsidize Popular Arts?" *New York Times*, 9 February 1975.

91. While centralization is clearly a source of potential repression, the ideology underlying decentralization often corresponds to a gross mystification. In the United States, the decentralization of educational institutions enhances the obscurities of the educational game and enables dominant classes to maintain (through the use of particularistic mechanisms), if not to reinforce, their power. Intellectual "liberals" denounce the variability of grading processes as evidence of the capriciousness of educators, but this does not prevent them from rejecting any centralization of grading as inimical of the country's "democratic" ideology. For an illustration, see H. Becker et al., *Making the Grade* (New York: John Wiley and Sons, 1968). The stance of such intellectuals has two consequences. First, it leads centralized testing procedures to be paradoxically controlled by the private sector. Second, it leads administrators influenced by the pseudoliberal stance of these intellectuals to make a "discretionary use" of the data collected under the auspices of private testing firms and hence to reinforce their own power.

92. This entire chapter is an extension of two articles written earlier. See R. Clignet, " 'Madame Bovary' and 'Lady Chatterley's Lover' as Social Problems: The Natural History of Immoral Novels" *Social Problems* 28

(1981): 290–307. See also R. Clignet and D. Moyer, "Social Problems in Science and for Science," *Knowledge* 2 (1980): 93–116.

Notes for Chapter 7: Dreams, Deeds, and Misdeeds of a Sociology of the Arts

1. See A. MacLeish, *A Time to Speak* (Boston: Houghton Mifflin, 1940), p. 7.
2. For example, Manet's *Olympia* was not put on display at the Louvre before 1907—despite the success of impressionism. Similarly, while the movement was victorious as far as painting was concerned, architecture was still dominated by the renaissance of neoclassical styles. For illustrations and a theoretical discussion of the relativity of the concept of revolution, see A. Mayer, *La persistance de l'Ancien Régime* (Paris: Flammarion, 1983).
3. R. Baker, "Meatball vs. Caviar," *New York Times*, 18 April 1978.
4. MacLeish, *A Time to Speak*, p. 7.
5. In other words it is not sufficient to accept the argument developed by the French critic Charles Estienne "that any worthwhile artist is in a state of permanent rebellion against his or her own style." Such an argument is insufficient because it does not make clear whether the objective of this rebellion is to overcome the effects of nature or alternatively of culture. It is also insufficient because the stress placed upon the notion of individual rebellion minimizes the role of collective forces.
6. See J. Baudrillard, *Les stratégies fatales* (Paris: Grasset, 1982).
7. In more general terms it can be argued that as the arts are dominated by mechanical models, they are not subjected to full-fledged experimentation. In contrast, as the sciences are dominated by statistical models, their development is contingent on systematic experiments. For an elaboration, see C. Lévi-Strauss, *Anthropologie structurale* (Paris: Plon, 1958), pp. 311–15. The only artistic experiment that approaches scientific research concerns the work that some architects have done on the concept of minimal structures. The purpose of this type of research is to allow the future residents of housing projects to choose the shape and texture of the surroundings in which they will live. But the problem is to determine the minimal structural threshold below which this choice becomes impossible. Even in such a case, however, there is a significant difference with classical scientific experiments, insofar as the results are irreversible. For a general discussion

on this point, see J. Valadez, "Habitat as Experiment: Theory as Practice," *Urban Ecology* 7 (1982/83): 281–305.

8. For an elaboration of the distinction between sociological and historical time, see Lévi-Strauss, *Anthropologie structurale*.

9. The following section is derived from R. Collins, *Conflict Sociology* (New York: Academic Press, 1972). Although Collins's arguments concern scientific life, I suggest here how they can be easily extended to an analysis of artistic landscapes.

10. Sennett, *The Fall of Public Man*, pp. 200–201.

11. It is noteworthy in this regard that many sociologists are ambivalent about the concept of innovation. For example, Merton describes innovations as behaviors that reflect a proper internalization of socially valued goals but do not take into account the problems of using legitimate means. Indeed, he illustrates the concept with reference to the Mafia.

12. R. Turner, "Sponsored and Contest Mobility Systems," *American Sociological Review* 25 (1960): 855–67.

13. For an illustration of the French artistic establishment's resistance to innovation, see J. Laurent, *Arts et pouvoirs* (Saint-Etienne: Université de Saint-Etienne, Centre Interdisciplinaire d'Etudes et de Recherches sur l'Expression Contemporaine Travaux 34, 1983).

14. Hence the need for a reflexive sociology—that is, a sociology of sociology. In this regard, see A. Gouldner, *Dialectics of Ideology and Technology* (New York: Seabury Press, 1976).

15. See R. Nisbet, *Sociology as an Art Form* (New York: Oxford University Press, 1976).

16. Ibid., p. 38.

17. Ibid., p. 7. An excellent example of the contrasts and complementarities offered by the arts and the social sciences can be drawn from the works of the late R. Winch. While both Ibsen and Thurber drew psychological portraits of specific individuals, Winch sought to identify the sociopsychological conditions under which the observations of these two artists can be seen among married couples. See his *Mate Selection* (New York: Harper & Row, 1958).

18. L. Hudson, *The Cult of the Fact* (New York: Harper & Row, 1972), p. 137.

19. See T. Kuhn, *The Structure of Scientific Revolutions* (Chicago: University of Chicago Press, 1970), p. 167. While I subscribe to Kuhn's views regarding the teaching of science, I feel that he tends to confuse the teaching of literary or artistic criticism with the teaching of writing or of painting, which tend increasingly to accentuate the current segmentation of cultural life. As a case in point, teachers and students of ceramics often reject today the importance of "throwing," which still constitutes the core of the discipline. For a criticism of the segmentation prevailing in contemporary cultural life, see Q. Anderson, *The Imperial Self* (New York: Knopf, 1971), pp. 58–62.

20. The frequency of the first interpretation among American intellectuals confirms the ahistoricity of many of their positions.
21. Of course, there are exceptions to this pattern and the works of Norman Ryder, Norval Glenn, and Wilbert Moore, among others, show considerable sensitivity to the problems of historical time.
22. J. Bronowski, "The Logic of the Mind," *American Scientist* 54 (1966): 1–14. See also O. Werner, "On the Limits of Social Science Theory," in *Linguistics and Anthropology*, ed. M. Kinkade, K. Hale, and O. Werner (Liesse: The Peter de Ridder Press, 1975), pp. 677–90.
23. Werner, "On the Limits of Social Science Theory."
24. G. Simmel, *On Individuality and Social Forms* (Chicago: University of Chicago Press, 1971).
25. A Borenstein, *Redeeming the Sin: Social Science and Literature* (New York: Columbia University Press, 1978).
26. As quoted by Nisbet, *Sociology as an Art Form*, p. 20.
27. For a criticism of abstractions and of their effects in economics, see the conclusions of Alfred North Whitehead, *Science in the Modern World* (New York: Macmillan, 1925). See also the introduction of D. Hofstadter in *Gödel, Escher, Bach: An Eternal Golden Braid* (New York: Basic Books, 1979). As an illustration of this abstraction, one might contrast the abstract properties of the studies of R. Berk and S. Berk-Fenstermacher on housework (*Labor and Leisure at Home*, Beverly Hills: Sage Publications, 1979), with the inspiring concreteness of filmmakers such as Joseph Losey in *The Servant*, or playwrights such as Tina Howe in *The Art of Dining* or Jean Genet in *Les Bonnes*.
28. Marshall Shumsky, "Medical Diagnosis: The Heart of Clinical Medicine," *Sociological Symposium* 19 (1977): 37–61.
29. See T. Kuhn, *The Essential Tension* (Chicago: University of Chicago Press, 1977), pp. 125–32.
30. Ibid. See also Hudson, *The Cult of the Facts*, p. 128.
31. This theme is fully developed in D. T. Campbell, "On the Conflicts Between Biological and Sociological Evolution and Between Psychology and Moral Tradition," *American Psychologist* 30 (1975): 1103–26. For having taken such a view, the author has been stigmatized as a conservative. But the question remains whether the author is conservative when he notes that the concept of natural interest is praised both by capitalism and by the normative individualism of recent American schools of psychology and sociology.
32. For a review of the epistemological problems raised by the concept of revolution, see Hofstadter, *Gödel, Escher, Bach*. Indeed, the expression "coming home" is ambiguous. Empowered with a strong religious appeal, the phrase also evokes the possibility that revolutions are doomed to be conservative. It is probably because of these ambiguous properties that George McGovern chose this expression as the motto of his 1972 presidential campaign.

33. See Campbell, "On the Conflicts."
34. For a full treatment, see L. Winner, *Autonomous Technology* (Cambridge: MIT Press, 1977). See also A. Zidjerveld, *The Abstract Society* (Garden City: Doubleday, 1970).
35. N. DiTomaso, "Sociological Reductionism," *American Sociological Review* 47 (1982): 14–28.
36. M. Serres, *Le parasite* (Paris: Grasset, 1980), pp. 101–3.
37. P. Rieff, *The Triumph of the Therapeutic* (New York: Harper & Row, 1968). See also P. Bury, *L'art à bicyclette et la révolution à cheval* (Paris: Gallimard, 1972).
38. R. Debray, *Le scribe* (Paris: Grasset, 1980).
39. R. Turner, "The Real Self from Institution to Impulse," *American Journal of Sociology* 81 (1976): 989–1016.
40. M. Polanyi, *Personal Knowledge* (New York: Harper & Row, 1964), p. 20.
41. Hudson, *The Cult of the Fact*, p. 122. H. Becker's preference for the word *convention* is quite revealing in this regard insofar as the author arbitrarily chooses to emphasize thereby the arbitrary and disposable properties of the frameworks within which artists operate. One can contrast his use of the word *convention* with J. Wolf's emphasis on the concept of code to account for artistic life in her *The Social Production of Art* (New York: St. Martin's Press, 1981). Indeed, the word *code* has syntactic connotations and refers as such to the body of cognitive principles on which all communications are based. But it also refers to a dialectic of inclusion and exclusion, as all codes must be learned in order to be mastered. Finally, like the word *rule* or the word *convention*, the term *code* has a legal connotation that reminds us that communities bind their members to one another.
42. P. Rieff, "The Impossible Culture," *Encounter* 35 (1970): 33–44.
43. Created by Louis XIV, the expression recently has been twisted by two Soviet dissidents who interpret it literally to imply that there are as many individuals uttering these words as there are sovereign states. While the twist of these two authors represents a legitimate protest against the excessive centralization of the Soviet regime, the same twist also summarizes the culture of narcissism that prevails in the Western world.
44. Hence the controversy that opposed Sartre to Pierre Naville after World War II. Against Naville, who argued that the wisdom accumulated by the social sciences should have enabled Sartre to give a student the advice he was seeking, Sartre countered that there is no truth as long as wisdom remains a sum of external recipes toward which individuals remain indifferent. See *L'existentialisme est-il un humanisme?* (Paris: Denoel, 1974). In the same vein, see R. Nisbet, *History of the Idea of Progress* (New York: Basic Books, 1980), in which the author imputes the emergence of narcissism to the divorce of the notions of tradition and progress. As soon as we separate what we transmit to our

heirs from what we have acquired as heirs ourselves, the concept of progress becomes lost in the mirages of an egocentric self-satisfaction. Although Sartre owes at least part of his fame to his struggle against the fallacies of an abstract universalism, blind to historical dimensions, it is noteworthy that he has been faulted recently for having committed the very sin he had been denouncing. See P. Bruckner, *Le sanglot de l'homme blanc* (Paris: Le Seuil, 1983).

45. W. Moore, "Predicting Discontinuities in Social Change," *American Sociological Review* 29 (1964): 331–38.
46. F. Fanon, *Les damnés de la terre* (Paris: Maspero, 1960).
47. Hudson, *The Cult of the Fact*, p. 169.

BIBLIOGRAPHY

Abbott, C. "Introduction." In *Poets at Work*, edited by R. Arnheim et al. New York: Harcourt, Brace, 1948.

Albrecht, M. "Art as an Institution." *American Sociological Review* 33 (1968): 383–96.

Alland, A. *The Artistic Animal: An Inquiry into the Biological Roots of Art*. Garden City: Anchor Books, 1977.

Althus, W. "Birth Order and its Sequellae." In *The Ecology of Human Intelligence*, edited by L. Hudson. London: Penguin, 1970, pp. 210–14.

Anderson, Q. *The Imperial Self*. New York: Knopf, 1971.

Arian, E. *Bach, Beethoven and Bureaucracy*. Oxford: University of Alabama Press, 1971.

Arnheim, R. *Toward a Psychology of the Arts*. Berkeley: University of California Press, 1966.

Attali, J. *Bruits*. Paris: Presses Universitaires de France, 1977.

Auerbach, E. *Mimesis*. Paris: Gallimard, 1968.

Azevedo (D'), A. *The Traditional Artist in African Societies*. Bloomington: Indiana University Press, 1972.

Barnes, C. "Oh Copenhagen." *New York Times*, 7 March 1976.

Barthes, R. *Le degré zéro de l'écriture*. Paris: Gonthier, 1964.

Barzun, J. *The Use and Abuse of Art*. Princeton: Princeton University Press, 1974.

Bastide, R. *Art et société*. Paris: Payot, 1977.

Bate, P. *The Flute: A Study of Its History, Development and Construction*. New York: Norton, 1969.

287

Bates, W. "Royalties for Artists: California Becomes the Testing Ground." *New York Times*, 14 August 1977.

Baudrillard, J. *Pour une critique de l'économie politique du signe*. Paris: Gallimard, 1972.

———. *Les stratégies fatales*. Paris: Grasset, 1982.

Baumol, W., and Brown, W. *Performing Arts: The Economic Dilemma*. Cambridge: MIT Press, 1968.

Becker, G. *The Mad Genius Controversy*. Beverly Hills: Sage Publications, 1979.

Becker, H. "Art as Collective Action." *American Sociological Review* 39 (1975):767–76.

———. "Art Worlds and Social Types." *American Behavioral Scientist* 19 (1976):703–16.

———. *Art Worlds*. Berkeley: University of California Press, 1982.

———, et al. *Making the Grade*. New York: John Wiley and Sons, 1968.

———, and Walton, J. "Social Sciences in the Work of Hans Haacke." In *Framing and Being Framed*, edited by H. Haacke. New York: New York University Press, 1976, pp. 145–52.

Bécourt, J. *Livres condamnés, livres interdits*. Paris: Cercle de la Librairie, 1972.

Bennett, S. "Other Peoples' Music." Ph.D. dissertation, Northwestern University, 1972.

Benthall, J. *Science and Technology in Art Today*. New York: Praeger, 1972.

Berk, R. and Berk-Fenstermacher, S. *Labor and Leisure at Home*. Beverly Hills: Sage Publications, 1979.

Bernier, G. *L'Art et l'argent: Le marché de l'art au XXeme siècle*. Paris: Robert Laffont, 1977.

Bernstein, B. "Class and Pedagogies: Visible and Invisible." In *Power and Ideology in Education*, edited by A. Halsey and J. Karabel. New York: Oxford University Press, 1977, pp. 511–34.

Birmingham, W. "The Auction Crowd." *New York Times Sunday Magazine*, 6 March 1977.

Blodgett, R. "Collectors Flock to Folk Art." *New York Times*, 12 September 1973.

———. "Making the Buyer Beg and Other Tricks of the Art Trade." *New York Times*, 26 October 1975.

Bollème, G. *La bible bleue*. Paris: Flammarion, 1975.

Bongarts, R. "Writers, Composers and Actors Collect Royalties: Why Not Artists?" *New York Times*, 2 February 1975.

Bonta, J. *Architecture and Its Interpretation*. New York: Rizzoli, 1979.

———. *American Architects and Architectural History*. University of Maryland, Department of Housing and Interior Design, unpublished manuscript, 1982.

Borenstein, A. *Redeeming the Sin: Social Sciences and Literature*. New York: Columbia University Press, 1978.

Bourdieu, P. *La distinction*. Paris: Editions de Minuit, 1979.

————, and Darbel, A. *L'amour de l'art*. Paris: Editions de Minuit, 1966.

————, and Passeron, J.C. *Les héritiers: les étudiants et la culture*. Paris: Editions de Minuit, 1964.

Braun, R. "An Operatic Performance Is Always One Beat Away from Chaos." *New York Times*, 31 August 1975.

Brilliant, M. "Playing of Wagner in Israel Provokes Disturbances." *New York Times*, 17 October 1981.

Brisset, D. and Edgley, C., eds. *Life as Theater: A Dramatic Sourcebook*. Chicago: Aldine, 1974.

Bronowski, J. "The Logic of the Mind." *American Scientist* 54 (1966): 1–14.

Brown, H. *Perception, Theory and Commitment: The New Philosophy of Science*. Chicago: University of Chicago Press, 1977.

Brown, Richard. *A Poetic for Sociology*. Cambridge: Cambridge University Press, 1977.

Brown, Roger. *Social Psychology*. New York: The Free Press, 1965.

Bruckner, P. *Le sanglot de l'homme blanc*. Paris: Le Seuil, 1983.

Buerkle, J. and Barber, D. *Bourbon Street Black: The New Orleans Jazzmen*. New York: Oxford University Press, 1973.

Burgess, A. "Here Is How to Be Your Very Own Best Seller." *New York Times*, 18 November 1979.

Burke, K. *A Grammar of Motives*. Berkeley: University of California Press, 1969.

Burns, E. *Theatricality: A Study of Convention in the Theater and in Social Life*. London: Longmans, 1972.

Bury, P. "*L'art à bicyclette et la révolution à cheval*." Paris: Gallimard, 1972.

Caillois, R. *Puissances du roman*. Marseilles: Le Sagittaire, 1942.

————. *Les jeux et les hommes*. Paris: Gallimard, 1958.

————. *Man and the Sacred*. New York: The Free Press, 1959.

————. *Méduse et compagnie*. Paris: Gallimard, 1960.

Campbell, D.T. William James lectures delivered, Harvard University, 1977.

————. "On the Conflicts Between Biological and Sociological Evolution and Between Psychology and Moral Tradition." *American Psychologist* 30 (1975): 1103–26.

Caplow, T. *Two Against One: Coalitions in Triads*. Englewood Cliffs: Prentice-Hall, 1968.

Carter, A. *The Sadeian Woman*. New York: Pantheon Books, 1979.

Cavani, L. "Entretiens avec C. Clouzot." *Ecran* 25 (1974).

de Certeau, M. *La possession de Loudun*. Paris: Julliard, 1970.

Chambliss, W. *Problems of Industrial Society*. Boston: Addison Wesley, 1973.

Chekhov, A. *Selected Stories*. New York: Signet Classics, 1960.

Cicourel, A. *Theory and Methods in a Study of Argentine Fertility*. New York: John Wiley and Sons, 1974.

Clair, J. "Le rite et le reste: Une petite introduction aux réserves des musées." *Traverses* 10 (1978): 100–116.

Clarke, K. *The Nude: A Study of Ideal Forms*. New York: Doubleday, 1956.

Clignet, R. "Pour une analyse systématique des relations enseignants-enseignés." *Revue Française de Pédagogie* 43 (1978): 31–46.

———. "The Variability of Paradigms in the Production of Culture. *American Sociological Review* 44 (1979): 392–403.

———. "Madame Bovary and Lady Chatterley's lover as Social Problems: The Natural History of Immoral Novels." *Social Problems* 28 (1981): 290–307.

———, and Moyer, D. "Social Problems in Science and for Science." *Knowledge* 2 (1980): 93–116.

Clor, H. *Obscenity and Public Morality*. Chicago: University of Chicago Press, 1969.

Cobb R., Ross, J., and Ross, M. "Agenda Building as a Comparative Political Process." *American Political Science Review* 52 (1976): 126–38.

Cobb, R. and Ross, M. "Limiting the Political Agenda: Some Hypotheses About Strategies Used to Prevent Consideration of New Issue." Unpublished manuscript.

Cohen, A. "In the Matter of *Mein Kampf*." *New York Times*, 4 October 1979.

Collins, R. *Conflict Sociology*. New York: Academic Press, 1972.

———, and Benn David, J. "Social Factors in the Origin of a New Science." *American Sociological Review* 31 (1966): 659–65.

Constable, J. *The Painter's Workshop*. New York: Dover, 1954.

Copeland, R. "When Films Quote Films, They Create a New Mythology." *New York Times*, 25 September 1977.

Craig, A. *Banned Books of England and Other Countries*. London: Allen and Unwin, 1962.

Crane, D. *Invisible Colleges*. Chicago: University of Chicago Press, 1972.

Davis, J. *Undergraduate Career Decisions*. Chicago: Aldine, 1965.

Davis, P. "When Composers Perform Their Own Music." *New York Times*, 16 May 1976.

Debray, R. *Le scribe*. Paris: Grasset, 1980.

De Grazia, E. *Censorship Landmarks*. New York: Bowker, 1964.

Desanti, J. T. "L' obscène ou les malices du signifiant." *Traverses* 29 (1983): 128–34.

Di Maggio, P. and Useem, M. "Social Class and Art Consumption." *Theory and Society* 5 (1978): 141–61.

Di Tomaso, N. "Sociological Reductionism from Parsons to Althusser: Linking Action and Structure in Social Theory." *American Sociological Review* 47 (1982): 14–25.

Drees Ruttencutter, H. "Onward and Upward with the Arts: A Pianist's Progress." *New Yorker*, 13 September 1977.

Du Camp, M. *Souvenirs littéraires*. Paris: Hachette, 1892.

Dumesnil, R. *La publication de "Madame Bovary."* Amiens: Malfère, 1928.

Dunning, J. "Kabuki Drama of Japan." *New York Times*, 2 September 1977.
———. "When a Pianist's Finger Fails to Obey." *New York Times*, 14 June 1981.
Du Plessix Gray, F. "Women Writing About Women's Art." *New York Times Book Review*, 11 September 1977.
Duvignaud, J. *Sociologie du théâtre*. Paris: Presses Universitaires de France, 1965.
Ehrensweig, A. *The Hidden Order of Art*. Berkeley: University of California Press, 1971.
Eliot, T. S. *Tradition and the Individual Talent: Selected Essays: 1917–32*. New York: Harcourt, Brace, 1932.
Ellman, R. *The Eminent Domain*. New York: Oxford University Press, 1967.
Epstein, H. "Accompanists of the World, Take a Bow." *New York Times*, 2 March 1975.
Ericson, R. "With Skill and Fuss Rostropovich Charms Class." *New York Times*, 5 November 1975.
———. "What It's Really Like to Be a Harpist?" *New York Times*, 9 September 1977.
———. "Musical Charms May Lengthen Life." *New York Times*, 5 December 1978.
———. "Two Conductors Plan Off-Beat Events." *New York Times*, 8 January 1978.
Ernst, M. *In Search of the Obscene*. New York: Macmillan, 1964.
Etzioni, A. *The Active Society*. New York: The Free Press, 1968.
Evans Asbury, E. "Georgia O'Keeffe Is Involved in Two Suits Linked to Agents' Fees on Her Paintings." *New York Times*, 28 September 1978.
Failing, P. "When a Constable Is Not a Constable." *Art News* 77 (1978): 90–91.
Fanon, F. *Les damnés de la terre*. Paris: Maspero, 1960.
Feierabend, P. *Against Methods*. Atlantic Highlands: Humanities Press, 1975.
Fish, S. "The Psychology of Science." In *Science Technology and Society*, edited by Spiegel-Rossi, S., and De Solla Price, D. Beverly Hills: Sage Publications, 1977, pp. 282–99.
Foucault, M. *The Order of Things*. New York: Vintage, 1973.
Fowler, M. *The Embroidered Tent*. Toronto: Amansi, 1982.
Francastel, P. *Etudes de sociologie de l'art*. Paris: Denoel, 1970.
Frances, R., and Vuillaume, H. "Une composante du judgment esthetique: La fidélité de la reproduction picturiale." *Psychologie Française* 9 (1964): 241–45.
Freilich, M. "The Natural Triad in Kinship and Complex Systems." *American Sociological Review* 24 (1964): 529–40.
Freund, G. *Photographie et société*. Paris: Le Seuil, 1974.
Friedman, A. "A Shift in the Federal Support of Popular Culture." *New York Times*, 13 May 1979.

Fromm, P. "The Cultural Retreat of the Seventies." *New York Times*, 23 July 1978.

Gablik, S. *Progress in Art*. London: Thames and Hudson, 1976.

———. *Has Modernism Failed?* New York: Thames and Hudson, 1984.

Gans, H. *Popular Culture and High Culture*. New York: Basic Books, 1975.

Garson, B. "Portrait of the Artist as an Aging Radical." *New Yorker*, 16 April 1979.

Gass W. *On Being Blue: A Philosophical Enquiry*. Boston: Godine, 1978.

Gay, P. *Art and Act*. New York: Harper & Row, 1976.

Gerdts, W. *The Great American Nude: A Study in the History of Arts*. New York: Praeger, 1974.

Getzels, J., and Csikszentmihalyi, M. *The Creative Vision*. New York: John Wiley and Sons, 1976.

Gibbons, R. *The Poet's Work*. Boston: Houghton, Mifflin, 1979.

Gilbert, S., and Gubar, S. *The Madwoman in the Attic: The Woman Writer and the Nineteenth-Century Literary Imagination*. New Haven: Yale University Press, 1979.

Gilmore Holt, E. *The Triumph of the Art for the Public*. New York: Doubleday, 1979.

Glueck, G. "The Met Succumbs to a Box Office Mentality." *New York Times*, 2 March 1975.

———. "Museums Are Manipulating Their Public." *New York Times*, 6 July 1975.

———. "Artists Protest Restorations at the Met." *New York Times*, 18 February 1976.

———. "Impressionist Epoch at Met Sets Records for Attendance: More Block Busting in the Offing." *New York Times*, 23 July 1976.

———. "Dissidence as a Way of Art." *New York Times Sunday Magazine*, 8 May 1977.

———. "For Artists, a Way to Stop Ripoffs." *New York Times*, 3 August 1977.

———. "The Woman as Artist." *New York Times Sunday Magazine*, 27 September 1977.

———. "The Expert's Guide to the Experts." *Arts News* 7 (1978): 52–7.

———. "The Great Conservation Debate." *Portfolio* 2 (1980): 44–51.

Goldmann, L. *Le dieu caché: Etude sur la vision tragique dans les "Pensées" de Pascal et le théâtre de Racine*. Paris: Gallimard, 1955.

———. *Pour une sociologie du roman*. Paris: Gallimard, 1964.

Gombrich, E. H. *Art and Illusion*. New York: Pantheon, 1960.

Goodman, W. "Should We Subsidize Popular Art?" (a debate between E. Van de Haage and H. Gans). *New York Times*, 9 February 1975.

———. "What a Civil Libertarian Should Do When Pornography Becomes So Bold." *New York Times*, 22 November 1976.

———. "The Artist and the Politician: Natural Antagonists." *New York Times*, 24 April 1977.

Gould, G. "In Praise of Maestro Stokowski." *New York Times Sunday Magazine*, 14 May 1978.

Gould, L. "Pornography for Women." *New York Times Sunday Magazine*, 2 March 1975.

Gouldner, A. *The Dialectics of Ideology and Technology*. New York: Seabury Press, 1976.

Grana, C. *Bohemians Versus Bourgeois*, New York: Basic Books, 1964.

―――. *Fact and Symbol*. New York: Oxford University Press, 1971.

Greer, G. *The Obstacle Race: The Fortunes of Women Painters*. New York: Farrar Straus and Giroux, 1979.

Griffin, C., and Griffin, B. "Comments on Becker's Art as Collective Action." *American Sociological Review* 41 (1976): 174–75.

Guilhaume, J. M. "La vente Von Hirsch: La collection d'un Européen." *Le Monde*, 22 June 1977.

Gusfield, J. "The Literary Rhetorics of Science: Comedy and Pathos in Drinking Drivers' Research." *American Sociological Review* 41 (1976): 16–33.

Haffner, E. "The New Reality in Arts and Sciences." *Comparative Studies in History and Society* 11 (1969): 385–97.

Hammel, L. "A Show Where Literary Forms Imbue Craft with Another Dimension." *New York Times*, 17 December 1976.

Hann, H. *The Rape of La Belle*. Kansas City: Glenn Publisher, 1946.

Harris, N. *The Artist in American Society: The Formative Years*. New York: Clarion Books, 1970.

Hart, P. *Conductors: A New Generation*. New York: Charles Scribner's Sons, 1979.

Harris-Sutherland, A., and Nochlin, L. *Women Artists, 1550–1950*. New York: Random House, 1976.

Haskell, F. *Patrons and Painters*. New York: Knopf, 1963.

―――. *Rediscoveries in Art*. Ithaca: Cornell University Press, 1976.

Heidegger, M. *Basic Writings from Being and Time*. New York: Harper & Row, 1977.

Henahan, D. "Opera Instrumentalists Should Be Heard and Not Seen." *New York Times*, 24 August 1975.

―――. "Let's Hear It for Composer Persons." *New York Times*, 31 August 1975.

―――. "Vocal Virtuosos Teach Stars of the Future." *New York Times*, 2 December 1976.

―――. "Will Cultural Apartheid Poison the Arts in America?" *New York Times*, 28 August 1977.

―――. "Only Black in Philharmonic Is Resigning after 15 Years." *New York Times*, 29 August 1977.

―――. "How Time Alters Our View of Music." *New York Times*, 1 August 1982.

Hennion, A., and Vignolles, J. P. "La production musicale: les politiques des firmes discographiques." Mimeographed. Paris: Centre de Sociologie des Innovations, 1975.

———. "Artisans et industriels du disque." Mimeographed. Paris: Cedes. Cordes, July 1978.

Herrnstein Smith, B. *Poetic Closure: A Study of How Poems End.* Chicago: University of Chicago Press, 1968.

Hirsch, P. "Processing Fads and Fashions." *American Journal of Sociology* 77 (1972): 639–59.

Hofstadter, D. *Gödel, Escher, Bach: An Eternal Golden Braid.* New York: Basic Books, 1979.

Honigheim, P. *Music and Society.* New York: John Wiley and Sons, 1973.

Huaco, G. *Sociology of the Art Film.* New York: Basic Books, 1965.

Hudson, L. *Frames of Mind.* London: Methuen and Cie, 1968.

———. *The Ecology of Human Intelligence.* London: Penguin, 1970.

———. *The Cult of the Fact.* New York: Harper & Row, 1972.

———. *Human Beings.* New York: Anchor Books, 1976.

Hughes, R. *The Shock of the New.* New York: Knopf, 1981.

Huizinga, J. *Homo Ludens: A Study of the Play Element in Culture.* Boston: Beacon Press, 1972.

Hummings, H. *Film Censors and the Law.* London: Allen and Unwin, 1967.

Hussey, C. *The Picturesque.* Hamden, Conn.: Archon Books, 1967.

Huxtable, A. "Two Museums." *New York Times,* 18 June 1978.

Irving, C. *Fake.* New York: MacGraw-Hill, 1969.

Ivins, W. *Prints and Visual Communication.* Cambridge: MIT Press, 1969.

Jacoby, R. *Social Amnesia.* Boston: Beacon Press, 1975.

James, L. *Print and the People: 1819–1851.* London: Allen Jane, 1976.

Jauss, H. R. *Toward an Esthetic of Reception.* Minneapolis: University of Minnesota Press, 1982.

Jong, E. Untitled. *New York Times,* 29 April 1976 (op-ed page).

Jules Rosette, B. "From Art to Manufacture: Some Aspects of Contemporary Art Production in Urban Africa." Annual Meetings of the Northeastern Anthropological Association, Buffalo, 1973.

Kandall, L. "The Ins and Outs of Piano Duets." *New York Times,* 6 January 1982.

Kaplan, A. "Obscenity as an Esthetic Category." *Law and Contemporary Problems* 20 (1955): 587–607.

Kavolis, V. *Artistic Expression: A Sociological Analysis.* Ithaca: Cornell University Press, 1968.

———. *Comparative Perspectives on Social Problems.* Boston: Little, Brown, 1969.

Kern, S. *The Culture of Time and Space: 1880–1918.* Cambridge: Harvard University Press, 1983.

Kerr, W. "Vices and Virtues of the Preview System." *New York Times,* 24 August 1975.

Key, W. B. "Did Rembrandt Paint It Blue?" *Holland Herald Newsviews* (1974):9, 10–15.

Kisselgoff, A. "There Is Nothing National About Ballet Styles." *New York Times*, 12 December 1976.

Klein, M., and Klein, H. *Kathe Kolwitz: Life in Art*. New York: Holt Rinehart and Winston, 1972.

Klemesrud, J. "Gunny Sacks to Book Racks: Texas Photographer's Odyssey." *New York Times*, 10 August 1979.

Koestler, A. *The Art of Creation*. London: Hutchinson, 1964.

Kramer, H. "When Money Not Taste Builds a Collection." *New York Times*, 4 June 1976.

———. "Ideology versus Quality as the Collecting Criterion." *New York Times*, 10 July 1977.

———. "The Influence of Money on Taste." *New York Times*, 18 January 1978.

———. "Bonvin Restored to His Rightful Place." *New York Times*, 29 July 1979.

Kubler, G. *The Shape of Time*. New Haven: Yale University Press, 1962.

Kuhn, T. "Comments on the Relations of Science and Art." *Comparative Studies in Society and History* 11 (1969): 403–12.

———. *The Structure of Scientific Revolutions*. Chicago: University of Chicago Press, 1970.

———. *The Essential Tension*. Chicago: University of Chicago Press, 1977.

Kuper, L. "Structural Discontinuities in African Towns." In *The City in Modern Africa*, edited by H. Miner. New York: Praeger, 1967, pp. 127–50.

Lacy, D. "The Economics of Publishing." In *The Sociology of Art and Literature*, edited by M. Albrecht, J. Barnett, and M. Griff. New York: Praeger, 1970, pp. 407–27.

Lamblin, B. *Peinture et temps*. Paris: Klinsieck, 1983.

Lasch, C. *The Culture of Narcissism*. New York: Norton, 1978.

Laurent, J. *Arts et pouvoirs*. Saint-Etienne (France): Université de Saint-Etienne, Centre Interdisciplinaire d'Etudes et de Recherches sur l'Expression Contemporaine, Travaux 34, 1983.

Lawrence, D. H. *A Propos Lady Chatterley*. London: Mandrake Press, 1930.

———. *Sex, Literature and Censorship*. New York: Twayne Publications, 1953.

Lawson, C. "Will Petrodollars Oil the Market?" *New York Times*, 4 May 1975.

———. "Trockadero Catches On: Martins Is Not Deserting (for now)." *New York Times*, 12 December 1976.

Leclerc, G. *L'observation de l'homme: Histoire des enquêtes sociales*. Paris: Le Seuil, 1977.

Lee, S. *On Understanding Art Museums*. Englewoods Cliffs: Prentice-Hall, 1977.

Lefebvre, H. *Sociologie de la vie quotidienne*. Paris: Gallimard, 1967.

Legendre, P. *La passion d'être un autre*. Paris: Le Seuil, 1978.

Legman, G. *The Hornbook: Studies in Erotic Folklore*. New York: New York University Press, 1964.

Leonard, J. "Critics's Notebook: For Many, Writing Is a Hungry Trade." *New York Times*, 10 February 1976.

———. "Private Lives." *New York Times*, 20 December 1978.

Leroy-Ladurie, E. *Histoire du climat depuis l'an 1000*. Paris: Flammarion, 1967.

LeVine, R. *Culture, Personality and Behavior*. Chicago: Aldine, 1973.

Lévi-Strauss, C. *Anthropologie structurale*. Paris: Plon, 1958.

———. *La pensée sauvage*. Paris: Plon, 1961.

Lewis, F. "An Outraged Artist Battles with Renault." *New York Times*, 6 May 1977.

Lockart, W., and McClure, R. "Obscenity in the Courts." *Law and Contemporary Problems* 20 (1955): 544–79.

Loesser, A. *Men, Women and Pianos: A Social History*. New York: Simon and Schuster, 1955.

Lough, J. *Paris Theater Audiences in the Seventeenth and Eighteenth Centuries*. New York: New York University Press, 1976.

Lukács, G. *The History of the Novel: A Historico-Philosophical Essay on the Form of the Great Epic Literature*. Cambridge: MIT Press, 1971.

Maas, J. "Victorian Nudes." In *The Saturday Book*, edited by J. Hadfield. New York: Clarkson Potter, 1971, pp. 183–200.

McCormick, P. "Modern Paintings Tax Conservators." *New York Times*, 29 August 1982.

Mackby, J. "The Frustrations of Being Independent." *New York Times*, 17 October 1976.

McKinnon, D. "The Nature and Nurture of Creative Talent." *American Psychologist* 17 (1962): 484–95.

McKinsie, R. *New Deal for Artists*. Princeton: Princeton University Press, 1973.

MacLeish, A. *A Time to Speak*. Boston: Houghton Mifflin, 1940.

McLeod, R. "Changing Perspectives in the Social History of Science." In *Science, Technology and Society*, edited by I. Spiegel Rosing and D. De Solla Price. Beverly Hills: Sage Publications, 1977, pp. 149–80.

Maidenberg, H. "Tax Shelters in Original Art." *New York Times*, 28 October 1977.

Maitland, L. "Factory Brings Sculptors' Massive Dreams to Fruition." *New York Times*, 24 December 1976.

Malraux, A. "As Picasso Said, Why Assume That to Look Is to See?" *New York Times Sunday Magazine*, 2 November 1975.

Mandrou, R. *De la culture populaire au XVIIème et XVIIIème siècles*. Paris: Stock, 1964.

Manneheim, K. *Ideology and Utopia*. New York: Harcourt, Brace, 1936.

Marcuse, H. *The One Dimensional Man*. Boston: Beacon Press, 1964.

Martorella, R. "The Performing Artist as a Member of an Organization." Ph.D. dissertation, New School for Social Research, 1974.

May, R. *Sex and Fantasy: Patterns of Male and Female Development.* New York: Norton, 1980.

Mayer, A. *La persistance de l'ancien régime.* Paris: Flammarion, 1983.

Mayer, W. "Live Composers, Dead Audiences." *New York Times Sunday Magazine,* 2 February 1975.

Merton, R. *Social Theory and Social Structure.* New York: The Free Press, 1964.

———. *Sociology of Science.* Chicago: University of Chicago Press, 1972.

———, and Nisbet, R. *Social Problems: A Contemporary Approach.* New York: Harcourt, Brace, Jovanovich, 1971.

Meyer, L. *Music, the Arts, and Ideas: Patterns and Predictions in Twentieth-century Culture.* Chicago: University of Chicago Press, 1967.

———. "Concerning the Arts, the Sciences and the Humanities." *Critical Inquiry* 1 (1974):163–79.

Mezzrow, M., and Wolfe, B. *Really the Blues.* New York: Random House, 1946.

Mikol, B. "The Enjoyment of New Musical Systems." In *Open and Closed Mind,* edited by M. Rokeach. New York: Basic Books, 1960, pp. 270–86.

Mitroff, I. "Norms and Counternorms in a Selected Group of the Apollo Mission's Scientists." *American Sociological Review* 39 (1974):579–96.

Mittman, B. "Keeping Order on the Stage in Paris in the Seventeenth and Eighteenth Centuries." *Theatre Research International* 5 (1980): 99–107.

———. "Les spectateurs sur la scène: Quelques chiffres tirés des registres du XVIIème siècle." *Revue d'Histoire du Théâtre* 32 (1980):199–215.

———. "Cinq documents portant sur l'enceinte de la balustrade de l'ancienne comédie." *Revue d'Histoire du Théâtre* 35 (1983):174–89.

Moers, E. *Literary Women.* New York: Doubleday, 1976.

Moore, W. "Predicting Discontinuities in Social Change." *American Sociological Review* 29 (1976):332–38.

Morgan, T. "United States Against the Princes of Porn." *New York Times Sunday Magazine,* 6 March 1977.

Mörke, E. "Nudity Is Natural for the Royal Danish Ballet." *New York Times,* 16 May 1976.

Moscovici, S. *Essai sur l'histoire humaine de la nature.* Paris: Flammarion, 1968.

———. *Society Against Nature.* London: Harvester Press, 1972.

Moulin, R. *Le marché de la peinture en France.* Paris: Les Editions de Minuit, 1967.

———. *Les Architectes.* Paris: Calmann Levy, 1973.

———. "Les intermittences économiques de l'art." *Traverses* 11 (1976): 34–48.

Mueller, K. *Twenty-Seven Major American Symphonic Orchestras: A History*

and Analysis of Their Repertoires: Seasons 1842–43 Through 1969–70. Bloomington: Indiana University Press, 1973.

de Nerval, G. *Oeuvres.* Paris: Bibliothèque de la Pleiade, 1956.

Neville, R. "Has the First Amendment Met its Match?" *New York Times Sunday Magazine,* 6 March 1977.

Nicholson, H. *Newton Demands the Muses.* Princeton: Princeton University Press, 1946.

Nightingale, B. "Why Do Playwrights Thrive in Britain?" *New York Times,* 10 July 1977.

Nisbet, R. *Sociology as an Art Form.* New York: Oxford University Press, 1976.

———. *History of the Idea of Progress.* New York: Basic Books, 1980.

Novak, B. *Nature and Culture in American Landscapes.* New York: Oxford University Press, 1980.

O'Dohorty, B. *Museums in Crisis.* New York: Braziller, 1972.

Pachter, M. *Telling Lives: The Biographers' Art.* Washington: New Republic Books, 1979.

Panofsky, E. *Architecture and Scholasticism.* London: Latrobe, 1954.

———. *Studies in Iconology.* New York: Oxford University Press, 1959.

———. *Renaissances and Renascences in Western Art.* Stockholm: Almquist and Wicksell, 1965.

Parain, B. *Recherches sur la nature et les fonctions du langage.* Paris: Gallimard, 1942.

Paris, A. "Cruse and the Crisis of Black Culture: The Case of the Black Theater." Paper delivered at the Annual Meeting of the American Sociological Association, Chicago, 1976.

Pascal, B. *Pensées.* Paris: le Seuil, 1962.

Paulhan, J. *Les fleurs de Tarbes.* Paris: Gallimard, 1941.

Peckham, M. *Art and Pornography.* New York: Basic Books, 1969.

Pelles, G. *Art, Artists and Society.* Englewood Cliffs: Prentice-Hall, 1963.

Pérec, G. *Un cabinet d'amateur.* Paris: Balland, 1969.

———, and White, C. *L'oeil ebloui.* Paris: Chêne/Hachette, 1981.

Perlis, V. "Nadia Boulanger: Twentieth-Century Music Was Born in Her Classroom." *New York Times,* 11 September 1977.

Perruchot, H. *La vie de Seurat.* Paris: Hachette, 1968.

Peterson, R. "Revitalizing the Concept of Culture." *Annual Review of Sociology* 5 (1979): 137–66.

———, and Berger, D. "Cycles in Symbol Production; The Case of Popular Music." *American Sociological Review* 40 (1975): 158–73.

Pevsner, N. *Academies of Art: Past and Present.* Cambridge: Cambridge University Press, 1940.

Philipps, H. "When New York Musicians Take to the Streets." *New York Times,* 17 August 1975.

———. "How Recordings Can Create Careers." *New York Times,* 24 April 1977.

Piaget, J. "Pensée égocentrique et pensée sociocentrique." *Cahiers Internationaux de Sociologie* 10 (1951): 34–49.

Pipolo, T. "German Filmmakers Seldom Focus on the Legacy of Nazism." *New York Times*, 1 August 1982.

Pitts, J. "Personality and the Social System." In Parsons, T., et al. *Theories of Society*. Glencoe: The Free Press, 1954, pp. 701–2.

Pizon, P. *Le rationalisme dans le peinture*. Paris: Dessain et Tolra, 1978.

Poggioli, R. *Theory of the Avant-Garde*. New York: Harper & Row, 1971.

Polanyi, M. *Personal Knowledge*. Chicago: University of Chicago Press, 1958.

Poulot, D. "Le reste dans les musées." *Traverses* 12 (1978): 92–99.

Pouton, R. "Programme esthetique et accumulation du capital symbolique." *Revue Française de Sociologie* 14 (1973): 205–20.

Price De Solla, D. *Little Science, Big Science*. New Haven: Yale University Press, 1962.

Rands, C., and Riley, C. "Diffusion and Discontinuous Distributions." *American Anthropologist* 60 (1958): 274–87.

Ratcliffe, C. "The Art Establishment." *New York Magazine*, 11 November 1958.

Reich, W. *The Functions of the Orgasm: Sex and Economic Problems of Biological Energy*. New York: Farrar Straus and Giroux, 1973.

Reiff, R. "The Frenzied Market for Major Art." *New York Times*, 18 November 1979.

Reitlinger, G. *The Economics of Taste*. London: Barry and Rockliff, 1961–70.

Renoir, J. *Renoir*. Paris: Hachette, 1960.

Rheims, M. *The Glorious Obsession*. New York: St. Martin's Press, 1980.

Rhyne, C. "Lionel Constable's East Berlin Sketchbook." *Art News* 77 (1978): 92–93.

Rieff, P. *The Triumph of the Therapeutic*. New York: Harper & Row, 1968.

———. "The Impossible Culture." *Encounter* 35 (1970): 33–46.

Rimbaud, A. *Oeuvres*. Paris: Club Français du Livre, 1949.

Robertson, W. "The Convertible Play in Prints." *Fortune*, November 1970, pp. 177–80.

Rockwell, J. "Why Are Ballet Orchestras Bad?" *New York Times*, 12 September 1976.

———. "New York as a Big Gamble for Foreign Artists." *New York Times*, 26 November 1976.

———. "Today's Blank Art Explores the Space Behind the Obvious." *New York Times*, 17 July 1977.

———. "Why Do They Still Give Debut Recitals?" *New York Times*, 27 May 1979.

———. "Does the American Conductor Have a Future?" *New York Times*, 18 November 1979.

———. "What Hope for the Young American Conductor." *New York Times*, 20 January 1980.

Rolph, H. *The Trial of Lady Chatterley*. London: Penguin, 1961.

Rosenberg, B., and Fliegel, M. *The Vanguard Artist*. Chicago: Quadrangle Press, 1967.

Rosenberg, H. "Death and the Artist." *New Yorker*, 24 March 1976.

———. "Being Outside." *New Yorker*, 22 August 1977.

Rothenberg, A. *The Emerging Goddess*. Chicago: University of Chicago Press, 1979.

Rothstein, E. "Musical Freedom and Why Dictators Fear It." *New York Times*, 23 August 1981.

———. "Mathematics and Music: One Deeper Link." *New York Times*, 29 August 1982.

Russell, J. "The Arts in the 70's: New Tastemakers on Stage." *New York Times*, 23 January 1977.

———. "The Tannhauser Collection: A Mini-Museum of Modern Art." *New York Times*, 24 December 1977.

Ryder, N. "The Concept of Cohort in the Study of Social Change." *American Sociological Review* 30 (1965): 840–61.

Salem, M. *Organizational Survival in the Performing Arts: The Making of the Seattle Opera*. New York: Praeger, 1976.

Sartre, J. P. *L'existentialisme est-il un humanisme?* Paris: Denoel, 1974.

Schapiro, M. *Modern Art: Nineteenth and Twentieth Centuries*. London: Chatto and Windus, 1978.

Schneider, P. "Shows Feel the Mystery of Le Nain." *New York Times*, 27 December 1978.

Schonberg, H. "How Did They Sing *Puritani* in 1835?" *New York Times*, 22 February 1975.

———. "Aida–Louselle, Caruso and a Herd of Camels." *New York Times*, 15 February 1976.

———. "Defining Music Is Not as Easy as You Think." *New York Times*, 23 January 1977.

———. "The Latest Fashion in Musical Instruments." *New York Times*, 6 February 1977.

———. "How Sex Plays a Role at the Piano." *New York Times*, 27 May 1979.

———. "The Latest Fashion in Old Instruments." *New York Times*, 6 June 1980.

Schorske, C. *Fin de siècle Vienna: Politics and Culture*. New York: Knopf, 1979.

Schücking, L. *Sociology of the Literary Taste*. London: Kegan Paul, Trench, Trutner and Co., 1944.

Segall, M., Campbell, D. T., and Herskovitz, M. *The Influence of Culture on Visual Perception*. Indianapolis: Bobbs Merrill, 1966.

Semple, R. "Tate Gallery Buys Pile of Bricks, or Is It Art?" *New York Times*, 20 February 1976.

Sennett, R. *The Fall of Public Man*. New York: Vintage Books, 1978.

Serre, M. *Le parasite*. Paris: Grasset, 1980.

Serrulaz, M. "Les techniques du dessin." *Estampille* 127 (1980): 18–26.

Shapiro, M. *Modern Art: Nineteenth and Twentieth Centuries*. New York: Braziller, 1978.

Sharf, A. *Art and Photography*. London: Penguin, 1974.

Shumsky, M. "Medical Diagnosis: The Heart of Clinical Medicine." *Sociological Symposium* 19 (1977): 37–61.

Siegmeister, E. "A New Day Is Dawning for American Composers." *New York Times*, 23 January 1977.

Simmel, G. *On Individuality and Social Forms*. Chicago: University of Chicago Press, 1971.

Simon, H. *The Science of the Artificial*. Cambridge: MIT Press, 1969.

Simon, W., and Gagnon, J. "The Anomie of Affluence." *American Journal of Sociology* 82 (1976): 356–76.

Sontag, S. *On Photography*. New York: Farrar Straus and Giroux, 1977.

Soriano, M. *Les contes de Perrault: Culture savante et traditions populaires*. Paris: Gallimard, 1968.

Sorokin, P. *Social and Cultural Dynamics*. New York: American Books, 1937.

Spackas, P. *The Female Imagination*. New York: Avon, 1976.

Spector, M., and Kitsuse, J. *Constructing Social Problems*. Menlo Park, Ca.: Cummings, 1977.

de Staël, G. *De la littérature considerée dans ses rapports avec les institutions sociales*. Paris: Charpentier, 1842.

Strauss, A. "The Art School and Its Students." In *The Sociology of Art and Literature*, edited by M. Albrecht, J. Barnett, and P. Griff. New York: Praeger, 1970.

Strauss, L. *Persecution and the Art of Writing*. Glencoe: The Free Press, 1952.

Taine, H. *Philosophie des beaux arts*. Paris: Hachette, 1895.

Taylor, J. *The Fine Arts in America*. Chicago: University of Chicago Press, 1979.

———, and Brooke, B. *The Art Dealers*. New York: Charles Scribner's Sons, 1969.

Temps Modernes (Les). Numéro special sur les livres de poche, 227, April 1965.

Terry, K. "Jazz Musicians and Classical Musicians Interact." *New York Times*, 23 July 1978.

Thierry, A. *Le procés de "Madame Bovary."* Amiens: Annales du Centre Régional de l'Academie d'Amiens, 1966.

Thompson, R. "Rubbish Theory: The Creation and Destruction of Values." *Encounter* 52 (1979): 12–24.

———. *Rubbish Theory*. New York: Oxford University Press, 1979.

Tiryakian, E. "L'école Durkheimienne à la recherche de la société perdue: La sociologie naissante et son milieu culturel." *Cahiers Internationaux de Sociologie* 56 (1979): 98–114.

Tobia, T. "Drag Ballet: Can Men Make It in a Women's World?" *New York Times*, 2 March 1977.

Toch, H. *The Social Psychology of Social Movements*. Indianapolis: Bobbs Merrill, 1965.

Toumin, D., and Toumin, S. "Harris Bank Facelift Raises Legal Questions." *New Art Examiner*, 9 October 1981.

Touraine, A. *La société invisible régards 1974–76*. Paris: Le Seuil, 1976.

Trotski, L. *Littérature et révolution*. Paris: Julliard, 1964.

Turner, R. "Sponsored and Contest Mobility Systems." *American Sociological Review* 25 (1960): 855–67.

———. "The Real Self: From Institutions to Impulses." *American Journal of Sociology* 81 (1976): 989–1016.

Tyler, R. "The Artist as Millionaire." *New York Times*, 8 January 1978.

Valadez, J. "Habitat as Experiment: Theory as Practice." *Urban Ecology* (1982/83): 281–305.

Veblen, T. *Theory of the Leisure Class*. New York: Viking Press, 1931.

Versini, L. *Laclos: Essai sur la source et la tradition des "Liaisons Dangereuses."* Paris: Klinsieck, 1969.

Vonnegut, K. *Slaughterhouse-Five*. New York: Delacorte, 1969.

Werner, O. "On the Limits of Social Science Theory." In *Linguistics and Anthropology*, edited by M. Kinkade, K. Hale, and O. Werner. Liesse: The Peter de Ridder Press, 1975, pp. 677 -90.

White, H., and White, C. *Canvases and Careers*. New York: John Wiley and Sons, 1965.

White, W. "Videodance, It May be a Whole New Art Form." *New York Times*, 18 January 1976.

Whitehead, A. N. *Science and the Modern World*. New York: The Free Press, 1952.

William, R. *Russian Art and American Money*. Cambridge: Harvard University Press, 1979.

Wilson, R. *Man Made Plain*. Cleveland: Howard Allen, 1958.

Winch, R. *Mate Selection*. New York: Harper & Row, 1958.

Winn, M. "Zubin Comes to Town." *New York Times Sunday Magazine*, 19 November 1978.

Winner, L. *Autonomous Technology*. Cambridge: MIT Press, 1977.

Wittkover, R., and Wittkover, M. *Born Under Saturn*. New York: Norton, 1969.

Wolf, J. *The Social Production of Art*. New York: St. Martin's Press, 1981.

Wolfe, T. "The Painted Word." *Harper's Magazine* 250, no. 1499, April 1975, pp. 57–92.

Zerubavel, E. *Hidden Rhythms*. Chicago: University of Chicago Press, 1982.

Zidjerveld, A. *The Abstract Society*. New York: Doubleday, 1970.

Ziegrosser, C., and Gaehlde, C. *A Guide to the Collecting and Care of Original Prints*. New York: Crown, 1965.

Zolberg, V. "The Art Institute of Chicago." Ph.D. dissertation, University of Chicago, 1974.

———. "Displayed Art and Performed Art: Selected Innovations and the Structure of Artistic Media." Unpublished paper. Purdue University, Department of Sociology, 1977.

———. "Why Contemporary Displayed Art Is Innovative When Performing Art Is Not." Paper delivered at the South Sociological Association meetings, Atlanta, 1978.

———. "Conflicting Visions in American Art Museums." *Theory and Society* 10 (1981): 103–25.

Zuckerman, E. "Rhapsodizing over Musical Instruments." *New York Times*, 12 August 1979.

Zurcher, L., and Kirkpatrick, R. *Citizens for Decency*. Austin: University of Texas Press, 1976.

NAME INDEX

SUBJECT INDEX

abstract expressionism, 10, 41, 63, 136
academies, 9, 25, 27, 50, 118, 243
académique, 2
accommodation. *See* Assimilation
action, collective, 12
agenda building, in artistic revolutions, 186–90
aging, in artistic careers, 107–13
alienation, 21, 35, 49
America: artists in, 98, 118, 121, 122, 123, 124, 140; censorship in, 187, 188, 198; cinema in, 200, 202; collectors in, 135–36; museums in, 143–45; public in, 146, 160; theater in, 64
anomaly. *See* Errors
anomie, in art world, 140–41, 264
Apollonian. *See* Creativity
appreciation: categories of (durable, rubbish, or transient), 129–30, 164–67, 204; conflicts in judgments, 182–83; of literature, 159–64; of music, 148–59; of visual arts, 130–42
architecture, 27, 30–31, 41, 43, 215; access to the profession, 101; relations with other disciplines, 7, 22
art: Black art in America, 121–22,

art (*continued*)
123–24, 259; naif, 37, 53, 126, 240; normal vs. revolutionary, 4–5, 17–18, 34, 52, 70, 92, 94, 96, 99, 102, 113, 123, 136, 212–23; pure vs. applied, 53–54, 105
assimilation, in aesthetic learning and teaching activities, 84–85, 105, 250
astrology, as explanation of creativity, 100
audiences, 5, 15, 73, 180
avant-garde, 65, 88, 137

ballet. *See* Dance
Berliner Ensemble, 25, 69
boycott. *See* Censorship *and* Reinforcers
brain, vs. mind in aesthetic creativity, 39, 96, 213

canons, aesthetic, 41, 284. *See also* Norms
capital, cultural, 146–47, 157–58
censorship, 54, 181, 185, 187–88, 200. *See also* Reinforcers
centralization, 9, 143, 188, 209, 210, 220, 280, 284

309